M000098390

The Girl from the Lighthouse

With *The Girl from the Lighthouse*, Willard Thompson has once again captured both my imagination and taught me. I was immediately drawn into Emma's world by Mr. Thompson's use of both the first person and the present tense. Emma is a strong and memorable character who transforms from California girl to Parisian artist over the second half of the 19th century. Mr. Thompson gives us a window into the art world of Paris during the Franco/Prussian War, the Commune Uprising, and the advent of Impressionism. I was engrossed in Emma's story, as well as the historical events and people that affected her life. Thank you, Mr. Thompson!

Jo Halderman, Author of *In The Shadow of the White House*

In *The Girl from the Lighthouse*, Mr. Thompson has fused history, art history, and personal struggle into a heady cocktail that will intoxicate the reader.

The novel is a cinematic sweep through Paris of the late 19th century, a dynamic and vibrant immersion that makes me feel I am actually on Paris streets, in its parks and cafés, with all the exciting tumult of the time around me.

Kia McInerny, author of *Bond Hunter* and *Max in Filmland*

Through the eyes of Emma Dobbins, a young American artist, Willard Thompson takes us back to the era of the Impressionist painters in Paris and the rarefied company of Morisot, Degas, Bazille and other artists in the late 1800s. Her ups and downs as a beautiful young model help her career when women were rejected at the art schools in Paris. Thompson has beautifully captured the socio-political ambiance of the period through the adventures and misadventures of his heroine and tells her story with great charm and skill.

Mary Tonetti Dorra, author of *Demeter's Choice*

With *The Girl From the Lighthouse*, Willard Thompson sets his new story in *Belle Époque* Paris. Emma comes to Paris planning to study art, but she has no money, speaks no French, and is laughed out of the *École des Beaux-Arts*.

Emma's efforts to develop her talent require her to navigate a turbulent period in French history—the Franco-Prussian war, the siege of Paris, and the Paris Commune.

Against this backdrop, Emma meets and works with artists whose paintings have been rejected by the Académie and who struggle financially while trying to develop a new style of painting. Claude Monet, Auguste Renoir, and others would later become giants of Impressionism—but, like Emma, their work brought them little money or contemporary recognition.

Emma succeeds in her quest because of a personality formed in the remote California lighthouse where she was raised by a her father and three lighthouse keepers.

James Patillo, author of *Killing the Hangman* and *Skim*

All true exploration is heroic. The main character of Thompson's novel is a young female Californian who chooses to explore life far from her homeland...in 19th century Paris. She continues her exploration by insisting that she wants to become a painter. And finally she explores many of the principal characters of the Impressionist movement. Thompson is also exploring. He is not a female, not a painter and not an Impressionist.

Yet hand in hand with his main character, Emma, he successfully explores these three worlds: 19th century Paris, the world of creating art and the Impressionists' movement. The novel's story line is truly fascinating, but watching the author's successful exploration of the unknown is every bit as riveting.

Frank Goss, Santa Barbara Art Dealer

The Girl From The Lighthouse

A Novel

By Willard Thompson

Rincon Publishing

Santa Barbara, California

Copyright © 2019 Willard Thompson

ISBN 978-ISBN 0-9797552-9-3

ISBN 0-9797552-9-8

Cover Design: BespokeBookCovers.com

Interior Design: Gwen Gades

The girl from the lighthouse : a novel / by Willard Thompson.

Santa Barbara, California : Rincon Publishing, [2019]

ISBN: 978-0-9797552-8-6 | 0-9797552-8-X

LCSH: Women artists—France—Paris—19th century—Fiction. | Artists—France—Paris—19th century—Fiction. | California—History—Fiction. | Point Conception Lighthouse (Calif.)— Fiction. | Art—History—France—19th century—Fiction. | Impressionism (Art)—France—Paris—Fiction. | Art nouveau—France—Paris—Fiction. | Franco-Prussian War, 1870-1871— France—Fiction. | Paris (France)—History—Commune, 1871—Fiction. | France—Politics and government—19th century—Fiction.| LCGFT: Historical fiction.

LCC: PS3620.H698 G57 2018 | DDC: 813./6—dc23

The Girl From The Lighthouse

A Novel

By Willard Thompson

Other Books by Willard Thompson

Fiction

The Chronicles of California

Dream Helper

Delfina's Gold

Their Golden Dreams

Non-Fiction

Keepers of the Light:

The History of the Point Conception Lighthouse

THE GIRL FROM THE LIGHTHOUSE
CAST OF CHARACTERS

Martin Aboud
Nov. 23, 1844—June 3, 1889, Stone Cutter

Clarise Aboud
Jan. 4, 1873—Sept. 13, 1957, Grace's Daughter/Art Historian

Pauline Allard
Jan. 19, 1836—May 31, 1890, Assistant at Maison Worth

Gaston Bazille
Nov. 4, 1818—July 17, 1888, Frederic's Father

Camille Bazille
May 3, 1824—Dec. 17, 1892, Frederic's Mother

Frederic Bazille
Dec. 6, 1841—Nov. 28, 1870, Artist/Soldier

Sarah Bernhardt
October 1844—Mar. 26, 1923, Actress

Eugene Boudin
July 12, 1824—Aug. 8, 1898, Artist

Camille Corot
July, 19, 1796—Feb. 2, 1875, Artist

Madame **Crystalle**
Aug. 12, 1832—June 18, 1893, Retired Dressmaker

Amélie Crystalle
March 7, 1849—Jan. 4, 1903, *Madame* Crystalle's Daughter

Edgar Degas
July 19, 1834—Sept. 27, 1917, Artist

Willard Thompson

Emma Dobbins
June 20, 1852—Sept. 11, 1932, artist

Asa Dobbins
Apr 21, 1820—Sept. 15, 1865, Emma's Father, Lighthouse Keeper

Grace Durand
June 17, 1851—May 14, 1876, Station Worker/Laundress

Hector Durand
May 23, 1828—Mar. 13, 1875, Grace's Father/Roofer

Clarise Durand
Sept 11, 1831—Feb. 21, 1874, Grace's Mother

Leo Durand
Jan. 31, 1847—May 9, 1871, Grace's brother/ National Guard

Paul Durand-Ruel
Oct. 31, 1831—Feb. 5, 1922, Art Gallery Owner

Ned Eaton
Nov. 11, 1828—Sept. 14, 1870, Lighthouse Keeper

Lucinda Jackson
Apr. 19, 1834—Feb. 14, 1869, Photographer

Rachel McKay
Aug. 11, 1833—June 12, 1890, Emma's mother

Lucien Maître
Dec. 31, 1825—July 8, 1885, Banker

Philippe Maître
Nov. 29, 1879—Apr. 15, 1912, Lucien's son

Edouard Manet
Jan. 23, 1832—Apr. 30, 1883, Artist

Louise Michel
May 29, 1830—Jan. 9, 1905, Teacher/Activist

Claude Monet
Nov. 14, 1849—Dec. 5, 1926, Artist

Berthe Morisot
Jan. 14, 1841—Mar. 2, 1895, Artist

Pierre-Auguste Renoir
Feb. 5, 1841—Dec. 3, 1919, artist

Robert Smith
May 17, 1812—Aug. 6, 1877, Lighthouse Keeper

Charles Suisse
June 1, 1846—Aug. 9, 1906, Art Teacher

Clifford Swain
Sept. 11, 1810—Feb. 7, 1867, Lighthouse Keeper

Charles Frederic Worth
Oct. 13, 1825—March 10. 1895, Dress & Gown Designer

PROLOGUE

June 1860

AT SUPPER ON my eighth birthday, Mr. Swain, who is the head lighthouse keeper, takes a flat package, wrapped in butcher paper and tied with string, from underneath his chair.

"We all chipped in," Mr. Eaton, the first assistant, bursts out.

Mr. Swain gives him an annoyed look. "Hush!" He says, "I'm the one to tell her that, you know."

"Go ahead, Emma, open it," my papa, the second assistant keeper, urges.

In my excitement I tug and rip the package open then stare at a five-by-seven-inch book held together by two brass rings. Not knowing what to make of it, I turn to my father. "What does it say, Papa?" I ask him, pointing to words printed on the stiff cardboard cover.

"It says 'My Sketchbook.'" He picks up a thick lead pencil that has fallen on the table from the package. "It's for you to draw your pictures."

The sketchbook is the best birthday gift I ever received, and I soon realize I love to draw the images my eyes show me. Everywhere I go—along the rocky bluff overlooking the beach, or across the plateau that stretched back toward the mountains behind the lighthouse, or down into the sand and foam at the water's edge—

1

nothing escapes my eye. I record the violence of the waves, the ballet of a line of pelicans flying overhead, the fearless deer feeding so close I can almost touch them. With my sketchbook I capture the sublime beauty and raw power of wild Point Conception and the lighthouse standing resolutely alone on its barren rocks.

One fall morning, I make a bread and butter sandwich and put it in my canvas carry sack. "I'm going to see if the dolphins are swimming near the cove today," I tell papa.

"So far away, Emma? Be careful and watch the sun. Don't get caught too far down the beach at dusk."

"The cove's the best place to draw them, Papa. Don't worry."

He hugs me. "I'm just a father looking out for his Baby Girl. It's my job to worry about you, my precious daughter."

I walk along the bluff above the beach, searching for marine life that I can sketch. Descending the steep, scrub grass-covered trail to the beach, I continue along the water's edge, playing toe tag with waves lapping on the sand, and dodging around rocks and seaweed. The air smells clean with only a hint of decaying flotsam. The coastline of steep cliffs marches off to the east. I feel the joy of being alone as I walk. Offshore, I see the fog lying along the base of San Miguel Island, like a sleeping cat on a satin pillow. Sunlight dances on the wave tops and I ponder how to draw it.

Near the sweep of the bay, about a mile from the lighthouse, I look for a vantage point from which to watch for the dolphins that come close in-shore to feed on schools of small fish. The sun is hot, and the mid-day breeze is caressing, so I take off my clothes and feel my bare skin tingle. Finding a rock worn smooth by the constant ocean that doesn't feel rough against my bare bottom, I sit, and busy myself trying to reproduce the light reflecting off wavelets as they roll in on my sketchpad, often

erasing my work in frustration and starting over. I finally give up and just sit, pencil and sketchbook at the ready, waiting for dolphins to appear.

"It is impossible to capture a wave. They don't wait for you."

At first I thought it was a voice in my head, but turning I see an old, white-haired Indian woman sitting on a rock nearby. "I didn't hear you come up," I tell her, surprise in my voice.

The old woman sighed. "I am always around."

"Do you live near here?"

"For now. Soon I will return to the Peaceful Place across the water from where my people came," she says. "I am not ready yet for the journey." She stops talking and stares at me. "You are a beautiful child. You have an innocent look in your dark eyes. But you are too young to be alone. Where are your parents?"

"I'm not alone. I have my papa and Mr. Swain and Mr. Eaton back at the lighthouse."

"But no mother to teach you? Or other children to tame you?"

"My mother ran away when I was five." Then, a little boldly I tell her, "I don't need a mother. Or other children either. I have everything I need. I please myself with my sketchbook. My papa says I am very independent." I look at the woman's craggy face then start to sketch her as if to show her I mean what I say.

The old Indian nods and sits up straighter on the rock. "You are a wild child," she says after a minute. "What will become of you? Who will teach you the rules?"

"What rules?"

"The rules of life. Life is easier if you follow the rules your village lives by."

"I have no village. We have rules at the lighthouse, is that what you mean?"

"Mothers teach daughters."

The old Indian is beginning to make me angry, so I close the sketchbook and stand up. "I don't understand about rules. I don't need them. I have my papa! I have to go back to him now. He takes care of me."

"Will you put your clothes on?"

Embarrassed, I grab my drawers and chemise and walk away. Hurrying along the path on the bluff and climbing back up the trail, I arrive at the lighthouse and run to hug my papa who is just finishing his day's work.

"A good day?" He asks.

"Yes, Papa," I tell him, then go to the kitchen to see what is for dinner. Mr. Swain is cooking. "Look what I sketched today," I interrupt him, sticking the sketchbook in his face.

He puts down the spoon, wipes his hands on an old dish rag, and smiles. For a long moment he stares at my drawing before he gives me a pat on the head. "You have a fine imagination, child," he says. "Where did you get the idea to draw an old Indian woman?"

"She was sitting on a rock next to me. See?"

Mr. Swain gives me a perplexed look. "Sitting on a rock next to you? You're sure you saw her?"

"Yes, at Cojo Bay."

When Mr. Eaton and papa have gathered at the table, Mr. Swain asks me to show them my drawing. Each man examines it in silence, but each darts a quick looks at the others. I stay quiet, watching their faces until papa gives the sketchbook back to me. "She sat on a rock next to me and we talked while I sketched," I tell him proudly.

Putting a gentle hand on my head, he pulls me closer. "Are you sure you saw her, Emma? Perhaps she came from your imagination."

"No, Papa, she was real."

"No Indians have lived near Point Conception for twenty, thirty years, Baby Girl," he says in a soothing voice. "Perhaps sitting in the sun made you sleepy. You closed your eyes and imagined her."

Angry, and then hurt that no one believes me, I start to cry. I get up from the table and run from the kitchen to hide my tears.

The next morning I race back to the rocks on the beach at Cojo Bay and sit patiently waiting for the Indian woman to appear again. The sun rises high over the eastern horizon, chasing the fog bank out into the channel as the morning passes. I sit alone, watching gulls, shearwaters and other seabirds converge not far off the beach, fluttering just above a patch of excited water. They dive quick, jabbing dives, then rise again with small fish impaled on their beaks. The dorsal fins of a pod of dolphins appear, joining the melee from the west, herding the tiny fish the birds have spotted, swimming round and round them in ever tightening circles so they are concentrated and can't escape. The dolphins begin their killing feast while the birds—hundreds now making screeching cries—wheel and flutter and dive, but never colliding, attacking the fish being forced to the surface.

I pick up my sketchbook to capture the chaotic scene, and don't notice the appearance of the white-haired Indian. "The way of the world," she says referring to the frenzied water.

I turn and stare silently at her for several moments. "What do you mean?" I ask at last.

"Pay heed to what you see, young girl. You must be strong for your life ahead."

After studying the woman for a long time before speaking again, I tell her, "My father and the other men say you're not real, only in my imagination."

"See with your eyes," she responds.

"I do see you with my eyes."

"Eyes look outward and inward."

"How can that be?"

"See with your heart also. Believe what your eyes and heart see, not what the rest of the world tells you to see."

At supper that evening I show the keepers the sketch I made of the dolphin feeding frenzy, but I never again say a word about the old white-haired Indian woman.

Book One

How apt though art, O Paris, To bewitch and seduce.
Pierre de la Celle

CHAPTER ONE

January 1869

WHEN LUCINDA AND I were on deck earlier this afternoon, the First Officer pointed off into the distance and told us, the steamship was leaving the Celtic Sea and turning into the English Channel. "Your voyage will soon be over," he said.

We take him at his word because we can't see a thing beyond the ship's rail. The dull gray-green ocean water and opaque fog obscure the horizon as if it were an ancient memory. Gripping the moist rail, we watched the endless march of waves approach the ship, lifting us up as they roll under and setting us down again when they roll on.

"I don't feel well," Lucinda, the older woman who is bringing me to Paris to model for her photographs, told me. "I'm going back to the cabin."

The next morning, after tossing and turning on the narrow bunk all night, Lucinda feels worse. I'm standing at the porthole again, dressed to disembark, impatient for our journey to be over, and anxious to get to Paris to start my art education. With a start, I turn around, joyously calling to her, "Look, Lucinda, I can see land. It must be France. We'll be in Paris soon."

She rises slowly on one elbow, wincing at the effort and trying to see past me out the porthole. "We dock at *Le Havre*. Paris is

two hours by train. Maybe later today." She hesitates a moment. "Please fetch the doctor, Emma. Tell him I'm unwell. Ask if there is some medication he can give me to get us to Paris?"

The ship's doctor is at the purser's desk on the main deck. A handsome man, he has a robust physique and deep tan. When I tell him why I've come his face darkens.

"Weak and nauseous, you say? My God no, not another one!" After a pause, he puts his hand reassuringly on my shoulder. "Miss Dobbins, collect all your luggage from your cabin right now and bring it down here. Don't get close to Miss Jackson. She may be contagious. Several other passengers are showing the same symptoms. When we get to *Le Havre*, we'll take them all to the hospital in *Rouen*, to be examined. They'll have to be kept in quarantine until they're not contagious."

I'm so stunned I don't know how to react to what he's telling me. I have a bad feeling in the pit of my stomach. All I can do is stand there, staring at the doctor. "I want to stay with her," I finally tell him.

"You can't," he says in a commanding voice. "I wouldn't want to see your face scarred for life if you aren't already infected. Anyway, you can't stay with her. She must be quarantined, that's the law in France."

The thought of being without Lucinda on this journey has never entered my mind. Now, suddenly, it's all too real and I'm desperate. "What should I do?" I plead with him.

"I can't help you with that, Miss Dobbins. I'm sorry. Go back to your cabin and get your things together as quickly as you can. Bring them here. I'll send someone to your cabin as soon as I can to help Miss Jackson. We're so close to *Le Havre* now, I'll keep her in the cabin until we get all the other passengers off."

Lucinda bursts into tears when I tell her what the doctor said.

"Oh, no," she moans weakly, "Hospital? Quarantine?"

"I'll go to *Rouen* with you until you're better, Lucinda. I'll find a place to stay."

"I promised to keep you safe with me, Emma."

We're interrupted by one of the ship's crew knocking on the cabin door. He enters wearing a gauze mask over his nose and mouth and hands me one to put on. "The doctor said you should go to the main deck, Miss," he says. "Best if you go right away. I'll take care of your companion until we dock."

"I want to stay with her."

"No, do as the mate says." Lucinda snaps at me. "I won't stay long in the hospital. I'll catch up with you in Paris." She grabs a scrap of paper from the nightstand by her bunk and scribbles on it. "Take the train to Paris as we planned. When you get there find this man. I've written his name here—Nadar. He'll take care of you until I get there. The doctor is making too much of this." She hands the paper to me. "Find Mister Nadar."

My eyes are filled with tears. Frantic, not really aware of what I'm doing, I stuff the paper in the reticule on my wrist without looking at it and pull the drawstring tight. I start to hug Lucinda goodbye, but the mate pushes between us and hustles me out of the cabin. Carrying my valise for me, he leads me down to the main deck. As I hurry along behind him I can see how close we are to the coastline of France.

⁓

The *Le Havre* train blusters to a stop in Paris' *Gare Saint-Lazare*, iron wheels screeching and a heavy cloud of sooty black smoke billowing up under the station roof like a storm cloud. A thick haze greets passengers stepping onto the platform. Sitting alone in a second class car long after the other passengers have

departed, breathing stale, suffocating air, I'm scared. Deep inside I have a sinking feeling. The impact of Lucinda's sickness and her quarantine in the Rouen hospital were so unexpected. Now my thoughts are in turmoil, an irrational jumble. It all happened so fast I haven't had time to think about my situation.

I'm startled alert when a trainman stops in the aisle beside my seat. "*Vous devez quitter le train maintenant, Mademoiselle,*" he says.

I don't respond because I don't know what he's said. It comes as a shock. After a moment I look up at him and ask, "*¿Habla inglés o español?*"

"*Je ne manque pas, je ne parle que le français.*" The look he gives me and his gestures leave no doubt what he wants while he stands over me waiting.

Desperate tears flood my face as it slowly sinks in I don't understand the language he is speaking. A sob, more like a gasp of panic, escapes my mouth. "I thought you..." I say out loud and then stop in mid-sentence, knowing he won't understand and doesn't care. I have no choice. Pulling on my gloves and fixing my straw hat on my head, I take the valise from the overhead rack and loop the reticule over my wrist. Finally standing up from the seat, I stumble my way along the aisle, feeling as if I'm in a bad dream, and step onto the platform.

The chaos of *Gare Saint-Lazare* makes the nightmare worse. Acrid smoke and hissing steam from a line of locomotives, looking like a line of black fortresses, attack my eyes and throat. Men and a few women rush by in all directions, whirling around me in a dance of confusion. The train noise, unintelligible cries of vendors, pungent odors of stale food on pushcarts along the walls, overload my senses. In a continuing panic, I turn right, then left, then back right again, not knowing where to go, searching for safety. Making my way cautiously toward an exit,

I'm tossed and jousted by men in bowler hats and black suits. An old man, hobbling along on a cane, barely avoids a collision, shaking his cane at me and uttering strange grunt-like sounds.

The monumental architecture outside the station feels as if it is pressing in on me. I am overcome by fetid smells—a witch's brew of animal and human wastes, rotting food and assorted street filth, all floating in stale water scum in the gutters. Gagging, I grab my handkerchief from my pocket and press it to my nose.

The street is a commotion of horse-drawn, two-tiered omnibuses, drays pulled by oxen, carriages, and people, all stymied by obstacles in their intended paths. Teamsters curse their animals, cracking whips that sound like gunshots to me. They shout at people on the street to clear the way, meanly gesturing with hands and arms. A man pushing a handcart yells at me to get out of his way as he goes by, almost knocking me down. Other men rush by on all sides, cursing as they dodge around me, standing frozen on the sidewalk.

Shaking in fear for my life, I reach into the reticule for the scrap of paper among all the other items I've stuffed into it leaving the steamship. People continue to jostle me as they scurry by. Trying to watch out for people pushing past me, my hand doesn't find it. My panic almost overwhelms me.

As my terror mounts second by second, all I can think to do is rush back through the same door I just excited to search for the paper. Inside the station again, I look for a safe place. A woman in a long black skirt and bonnet almost collides with me as she brushes by, mumbling *"merde"* as she forces me to a wall to get by. It's the only security I can find, so I press my back against it, shaking and breathless. Taking the reticule off my wrist, I open the drawstring wide and search through its contents. My trembling starts again when I can't find it. I remember putting it

in there when I left Lucinda in the cabin, but now it is nowhere to be found. A jolt of memory reminds me that the contents spilled out when the conductor demanded my ticket. The slip of paper must have slid down behind the seat. I don't remember the name Lucinda wrote on it and I have no idea what to do next. I press against the stone wall, trying to control my panic.

The incongruous aroma of warm vegetable soup—a memory of the Feliz's Hotel in Santa Barbara where I worked—embraces me. It's comforting and familiar, making me think I'm imagining it. Looking to my right I see a pushcart I hadn't noticed before a few steps away. The vendor is a young, plain-looking, round-faced girl, close to my age, dressed in a clean, but worn, white blouse and a floor-length black skirt, ragged around the hem. Like other station workers, she wears a blue smock. Her light brown hair is barely visible under a white cap. Watching for several minutes, I see she occasionally holds up a mug for the rushing crowd to see and calls out in a strong voice that can be heard over the staccato of the station, hawking her soup. The pleasant smell reminds me how long it has been since I've eaten.

After a few minutes without customers, the girl smiles warmly and beckons me to the pushcart. Urging me closer, she speaks in a soft, personal voice that has a lilt to it. I raise both palms to the girl and shrug in a gesture of frustration. "I don't understand," I tell her.

The girl nods and ladles soup from the bowl embedded in the pushcart into a ceramic mug and offers it to me. I smile appreciation. Setting my valise down, I take the mug from her hand and can feel its warmth through my gloves. I raise it to my lips, drinking the watery broth of carrot bits, green beans, lettuce and other chopped vegetables. The girl watches, a smile on her face. I down the whole mug in several gulps and give her

an embarrassed smile. "Thank you, I haven't eaten all day," I tell her, handing the mug back.

She takes it and holds out her hand.

Realizing my mistake, I tell her, "I have no French money to pay you."

"*Je ne te comprends pas,*" the girl says.

"I don't understand," I respond. Then raising the palms of my hands to show they are empty. She looks, shrugs, smiles weakly, and takes a coin from the pocket of her skirt and drops it into the box beside the soup bowl. We look at each other for a moment and then burst out laughing. We begin a wordless conversation using facial expressions, hand gestures and lots of laughter to communicate.

After a few minutes the girl gives me a serious look. She puts her hands together alongside her head, to indicate sleep. I shake my head, no. Twice more she tries to ask the question, but each time I tell her, no. She frowns, studying me with a concerned look. Then she covers the soup bowl with a wooden lid from the bottom of the cart. Taking me by the hand, she crosses the station and enters a small office hidden away against a far wall with a sign reading *Chef de Gare* on the glass door. A flurry of words passes between her and a rotund, middle-aged man, sitting behind a desk in a wrinkled black uniform, with bulging eyes and no hair visible under his officer's cap.

When the conversation stops, the stationmaster looks up at me, clinging tightly to my valise. "*Bonjour, Mademoiselle,*" he says. "*Mademoiselle* Durand tells me you speak no French. And I speak only a little English. You have no place to sleep, she says. Is correct?"

Slowly the recognition of familiar words comes through to me. I break out in a flurry of my own. "I'm alone. I don't know what to do. I didn't know you speak a different language here. I

came to Paris to go to art school, but I have lost the name of a man I was supposed to find. Now I'm lost." I stop for a breath and can see the stationmaster doesn't understand most of what I have just said.

"To school, you say?"

"Yes, art school." I feel a sense of relief, realizing I have finally communicated at least a little.

The stationmaster shakes his head dubiously and gives me a sympathetic half-smile. "Art school," he says again, and then says *"École d'art"* to *Mademoiselle* Durand to make sure she understands. His face darkens. With his forehead creased deeply, and his thin eyebrows in a straight line across his forehead, he directs a stern look at me. "No sleeping in my station," he warns, shaking a finger at me. *"Pas de sommeil dans ma station."* Understand? Must find other place."

Tears start again as my desperate situation comes clear to me. "I have no place to go," I sob.

The stationmaster rises from behind the desk, takes a step back from me, and looks out into his crowded station as if he is asking the deity why these problems come to him. On the other side of the glass wall the muted sound of a train whistle sends a flock of men, and a few women carrying baskets and leading children by the hand, scurrying across the station in the direction of a puff of white smoke from an impatient engine. Looking back, he pulls himself to his full height, smoothing his uniform jacket over his paunch in a display of authority. "No one sleeps in my station," he says again in an authoritative voice.

A series of exchanges between the stationmaster and *Mademoiselle* Durand follows. She makes the sleeping gesture with her hands again, while I watch, dabbing at tears with my handkerchief and struggling with the frustration of not

understanding. When the conversation ends the stationmaster smiles for the first time—a broad smile of relief and paternal authority—and resumes his seat behind the desk. "*Mademoiselle Durand vous ramènera à la maison quand son travail sera terminé,*" he says, repeating, "She will take you home when her work is done." Then he looks down at his papers and ignores both of us.

At the end of the day, the girl closes down her cart and pushes it to an alcove at the back of the station. Turning to me, she points to herself. "Grace," she says. Then she points at me and I say "Emma." We both laugh. Grace leads me, still clutching my valise, into the maelstrom of traffic out the back of the station. Immediately, I grab for my handkerchief again to cover my nose. Grace gives me a sad smile. "*Ce n'est pas bon,*" she says then shrugs. *Oui?*"

We walk together to a wide, tree-lined street called *blvd Malesherbes* and head north. We cross another broad boulevard together and continue on until we reach *rue Cardinet,* a smaller side street where she points to a stone four-story building just two windows wide. "*Ma maison,*" she says with a smile that lights up her plain face. "*Je vis ici avec mes parents,*" she adds, leading me into the building and up three flights of narrow wooden stairs. She opens the door into a modest apartment where a middle-aged woman with a slightly rounded body emerges from the kitchen to greet her. Her uncombed hair falls around her face in disarray as she wipes her hands on a rag towel, and then pushes her hair back. A look of surprise captures her face when she sees me.

"*Alors, qu'est-ce?*" She asks Grace.

"*Une américaine. Elle seul n's de pas d'endroit pour dormir. Je lui ai dit qu'elle pouvait dormir ici. Elle s'appelle Emma. Elle ne parle pas notre langue.*"

I give the older woman a little curtsey when I hear Grace say

my name, I say, "Hello," then step back.

A mother-daughter conversation ensues that ends with Grace leading me down a short hallway into her bedroom, not much bigger than my room in the lighthouse. It's just large enough for a bed with painted iron head and foot boards, and a dusty statuette of the Virgin hanging on the wall over it. The only other furniture is a small wardrobe painted white. A lone window looks down on a tiny rear garden where a few vegetables grow.

Grace smiles again and points to the bed. She motioning me to sit, then returns to the kitchen. I strain to hear mother and daughter speaking in lowered voices through the thin walls. Unable to understand what they are saying—although I know it's about me—my anxiety wells up again. I try not to think about what might have happened if Grace hadn't taken pity on me, but then I think, what if her mother wants me to leave?

Through the thin walls I hear the front door opening and closing, and then the deep voice of a man.

"*Hallo*," he calls out.

"*Bonsoir, Papa*," Grace calls back.

"*Entrez dans la cuisine*, Hector," Grace's mother commands her husband.

Another conversation follows, but I can no longer hear it. I can only make out Grace saying my name. My heart pounds in my chest and I repeat, please let me stay tonight, over and over in my head. Then I hear Hector Durand raise his voice, but calm down quickly. The conversation continued a long time then the voices stop. Grace returns to the bedroom, giving me a big smile. She hugs me and makes hand signs for eating and sleeping.

CHAPTER TWO

January 1869

I PRETEND TO be asleep when Grace gets out of our shared bed at dawn the next morning. Through half-shut eyes I watch her hurry across the cold floor to the wardrobe in her nightdress. She puts on the same frayed black skirt and white blouse she wore the day before. Then she covers her light brown hair with her cap, puts on her blue over-blouse, and tiptoes out of the bedroom. A few minutes later, I hear the front door open, and Grace calls, "*Au revoir, Maman.*"

For the next ten minutes I am sure I will be put out on the streets of Paris, alone, without Grace to protect me. When the bedroom door opens, Clarise Durand marches straight to the bed and shakes my shoulder. She points to my dress in the wardrobe and then retreats to her kitchen. I feel sure there is no way I will escape being banished. Dressing reluctantly, I follow her to the kitchen where she points to a painted wood table with four chairs tucked into a corner by the lone window. "*Asseyez vous chaise,*" she says.

There is an instant before recognition sets in, and then I sit down. Out the window, a steady line of workingclass people trudges along *rue Cardinet* three stories below. Clarise Durand sets a cup of black coffee in front of me. "*Café,*" she

says. She continues the same process with other words in rapid succession—*coupe, table, fenétre, porte*—as she points to objects around the kitchen one after another. I take a gulp of the strong, hot liquid, and try to keep up. A quick thought comes to me and I jump up from the table and rush to the bedroom, startling Clarise. Returning a moment later I have my sketchbook and a pencil in hand. I hurriedly draw each item she points to and write the words I think I've heard her say. She smiles and gives me an understanding nod, then she sits beside me to watch me sketch.

After I've eaten a few pieces of fresh *baguette* smeared with fruit jam Clarise spoons from a ceramic pot, saying the words as she does, she gets up and goes to the door. "*Nous allons au marché,*" she announces. Tucking the sketchbook under my arm, I follow her out the door and down three flights of stairs into the street. With her leading, we hurry together down *rue Cardinet* to the shops on *ave de Villiers*, a street of low, white stone buildings with small shops displaying their merchandise on carts along the sidewalk. In rapid order she does her daily shopping at the local butcher, baker, pastry store, and fruit and vegetable market, naming everything she purchases. She never stops talking, and I am breathless following her. She weaves in and out among the other women on the crowded street, with me racing to keep up while making notes in my sketchbook. She nods to a few women she passes and stops long enough for a kiss on each cheek and brief conversations with a couple of good friends. At the end of the street, she pauses at a stand to select flowers for her evening table, and finally visits an *atelier* for a few minutes of gossip with a neighbor who works there, pointing to me as she talks.

In the early evening Grace returns to the apartment. She greets me warmly with a hug and kisses, and chatters about her

day while she changes out of her work clothes. She has a brief conversation with her mother, and then takes my hand, and leads me back down to the street. We walk along *rue Cardinet* to the corner of *ave de Villiers* and then to *blvd Courcelles*. As we walk, I practice saying the street names and the shops Clarise and I visited earlier in the day. Grace laughs and applauds.

At *Parc Monceau*, she guides us through the gold-trimmed, iron gate that separates the park from the street noise, and up a path along an undulating green meadow where men and couples lie about on the grass. We sit on a bench shaded by tall evergreen and plane trees. Farther down the walk we can hear calliope music and the shouts of children riding a carousel.

"*Un Manége*," Grace says. My face brightens with a smile of understanding.

"*Le son me rend heureux aussi*," she adds laughing, and I can tell she enjoys the music. Her laughter brings pleasing dimples to her full cheeks. Her hair swirls around her face and shoulders, and her bangs bounce a little on her forehead as she laughs. When she smiles at me, her soft, brown, iridescent eyes are flecked with gold.

I pretend to understand what she has just said and join her laughter, feeling so happy to be with her. And safe. Yet inside, I am feeling frustrated because I want to tell her about why I was panic-stricken in the station, but lack the French words to do it.

We spend the next half hour looking at the pictures I've drawn in the sketchbook. Grace corrects the words I scribbled down as I raced after Clarise, pronouncing each of them for me. As dusk descends, arm-in-arm, we walk back to the Durand apartment and climb to the third floor.

The kitchen table is covered with a plain white cloth. A ceramic vase, holding the assorted flowers Clarise purchased

in the market, brightens the center. Hector Durand sits at the head, with wife and daughter flanking him on either side. I sit across from him, where he can study me through his steel-rimmed eyeglasses. I don't understand the family conversation— sometimes it sounds heated and argumentative and sometimes pleading and cajoling—but I can tell it must be about me. Hector is no match for the two women aligned against him, even though he sits in the family's place of highest respect and frowns at the women. When the meal and the discussion end, Clarise and Grace both rise happily and come to hug me. Reluctantly, Hector rises too. Solemnly, he offers me his hand. Standing stiffly beside me a moment, his smile finally breaks through, and he gives me a hug, too.

The following morning, when Grace gets out of bed, she pokes me awake. Going to the wardrobe, she takes out an older work uniform like her own and indicates I should put it on. After coffee and a piece of *baguette*, we walk the same route to the train station we had taken the first day. I assume she will have me work at the soup cart, but holding my hand, she leads me back to the stationmaster's office, stopping outside to give me a reassuring smile before we enter, and making the scratching of her palm gesture. "*Voila!*" She says.

The nervous stationmaster argues briefly with Grace and then throws up his hands and takes us to a work closet near the back of the station, overflowing with mops and pails. He tells Grace what he wants me to do, and she gestures to me. Then he hands me a blue over-blouse like Grace's.

For the next ten hours, with only a short break, I move around the station, mopping dirty floors and scrubbing putrid-smelling toilets, trying to stay out of the way of travelers hurrying to catch trains. More often than not I get in their way and suffer the harsh

curses they fling at me when they nearly trip over my mop or pail. I hear their words, not understanding their meaning but sure of their intent, and try to remember the most often repeated ones, practicing them in my head as I move around the station.

At least a dozen times during each day that follows, I think about leaving the mop and pail in a far corner and walking away from the disgusting work. I don't know how many times I think about going back to California. But then I think papa is dead, I can't live at the lighthouse. There's nothing there for me but making beds and waiting tables at the hotel.

"I'm sorry," I tell a woman who trips over my pail, and keep her from falling by taking her arm. I help her pick up the packages lying on the cement floor. Straightening up and pulling away from me, the woman says, "*Putain!*" Almost spitting the word at me. "*Vous fille maladroite!*" She snaps and then hurries on.

If this is what I have to do to survive in Paris, I will do it, I tell myself. So at the end of every week I give the few *sous* and *centimes* I'm paid by the stationmaster to Hector Durand. He and Clarise give me food and shelter. They make me feel safe—how could I walk away from them? Without Lucinda's scrap of paper I wouldn't know where to go.

On a bright afternoon six months later, I rest against the mop handle in the middle of the soot-stained, smoke-filled *Gare Saint-Lazare*. How did I ever come to this, I wonder, watching the harried travelers rushing to and from the hissing locomotives? Taking a deep breath, I pick up the pail, put it back in the work closet and go to the stationmaster's office.

"*J'arrete!*" I tell him on entering. "*J'ai fini de nettoyer ces toilettes sales.*"

The stationmaster raises his head from the papers he is looking at on his desk. He stares at me for a moment with the same woebegone look. It is not a happy expression. "So finally," he says, "you've learned enough."

"*Oui*," I tell him and take off my worker's smock. "*Merci*," I say, tossing it on his desk as I walk out of his office. Before leaving the station, I stop at Grace's soup cart. "I've had enough," I tell her.

"It's time," she agrees.

"Can I still stay at your apartment?"

"Papa needs the money. If you can contribute each week."

"I'll find some way."

I walk back to the Durand's apartment lost in anxious thoughts about what I'll do, oblivious to the people passing by on the street. I want to find an art school, but I also have to keep the Durands happy. I'm not sure I can do both.

Turning the corner from *blvd Malesherbes* into *rue Cardinet* I become conscious of someone coming up behind me. I quicken my pace. The footsteps behind me quicken, too. Arriving safely at the Durand apartment building, I stop and turn to see who has been following behind me. A young man in military uniform—bright red pants, dark boots and blue tunic with brass buttons—stops short on the sidewalk and gives me a sharp, challenging look.

"Who are you?" He calls out.

Speechlessly, I stare at him, intimidated, but slightly impressed by his uniform. Tall, slender, wearing a red kepi on his head, he has a dark countenance and deep eyes that frighten me.

"Who are you?" I call back. "I live here."

"No you don't!" he shouts. "I know all the families here. I've never seen you before."

"I live with the Durand family."

The young soldier's face softens. He removes the kepi, revealing close-cut black hair. "*Désolé, Mademoiselle.* I have not been home in a year. I am Leo Durand, Grace's brother."

My relief is physical. I relax my tense shoulders and take a deep breath, returning his smile with a tentative one of my own.

"I apologize if I startled you," Leo Durand says, his smile widening across his whole face. "I was trying to catch up to you because you are such a pretty girl. The prettiest I've seen in quite a time."

I can't hide my interest in him, but I try to keep my voice stern. "You shouldn't have come up behind me like that. Heaven knows what you might have been up to. You were rude." With that I open the door, turning my back on him, and rush up the stairs, breathless by the time I open the apartment door.

I join the Durand family celebration of their son's return from his military training at the crowded dinner table that evening. I have been moved to an extra chair beside Grace, giving Leo his usual place across from Hector. "Did you tell papa?" Grace whispers as we sit side-by-side.

"No, I didn't want to spoil your brother's homecoming."

"What are you going to do?"

"I came to Paris to go to art school and I'm not giving up on that. I'll look for a school and get another job if I must to pay for it, but I'm not scrubbing smelly toilets anymore. Do you think that could be our secret for the next few days, Grace?"

"Oui, but how will you pay for art lessons?"

"I don't know. I'll find a way."

⤜⤐

Sitting proudly erect at the dinner table, Leo regales his family

25

with stories from his military training in the south of France. I listen and watch the family's joy at having him home. I can't help but notice that he takes quick looks at me from time to time.

"Will you have to go back, son?" Hector asks.

"Not unless France has a war, Papa. Then I'll be recalled."

"*Prie Dieu...*" Clarise begins in a solemn voice.

"Agreed," Hector adds before his wife can say more, "but there's no telling what the emperor might do if he takes a mind to it. Look what he's done in Mexico while the Americans were fighting each other."

"And Empress Charlotte has gone mad, poor thing," Clarise adds sadly.

"If the emperor commands I will do my duty," Leo says strongly.

"None of this talk!" Grace breaks in. "It's Leo's first night home. We should be happy." She turned her gaze on her brother and teases, "What will you do now to keep out of trouble?"

"Try to find work, I suppose... And chase pretty girls." He darts a look at me again.

"Still a lot of construction, son," Hector says. "Pays pretty well, too. Glad to have you back with us to help out. Things have been tight with you away. We're happy to have *Mademoiselle* Dobbins to contribute."

Later that evening Grace and I sit on the bed in our nightdresses, brushing our hair. Grace gives a quiet little laugh. "Did you see the way Leo looked at you at the table tonight?" She says.

I look up from my brushing. "Did he?"

Grace gives me a wary look. "Yes, he did—you know he did. Leo's a good brother. We fight and tease a lot when he's around, but he always looks out for me. You'll like him when you get to know him." She gives me another look. "He told me after dinner

he thinks you are a very attractive girl."

I smile, but don't respond for several moments while I think about her remark. Then I say, "There were no boys where I grew up."

"No boys?"

"I was the only child."

"Tell me what it was like?"

"The first thing I remember...

I was standing on the deck of a steamship as it made its way into the roadstead of Santa Barbara in 1857. I was five years old and so excited I ran to my mother's side and tugged on her faded blue dress, pointing to the tiny houses scattered along the beach. "Look, Momma!" I said. "It's like the little village in the storybook papa reads to me."

My momma slapped my hands away from her dress. "Mr. Dobbins," she called out, "Take her away from me."

Without a word my papa—Asa—crossed the deck and took my hand, guiding me away from momma to the other side of the ship.

A few seconds she called out, "Emma, run down to the cabin and fetch me my bonnet."

When I came back on deck and handed her the bonnet, I told her proudly, "I picked this one out for you because it makes you look so pretty. It's my favorite."

"You stupid child! This isn't right," she snapped. "I wanted the blue one to match my dress. Can't you do anything right?" She grabbed the bonnet out of my hand and stalked off to the cabin. I started to cry.

Papa knelt down beside me to wipe the tears from my cheeks.

He combed through my hair with his fingers. "It's okay, Baby Girl, your mother didn't mean to scold you. You couldn't know which bonnet she wanted. Momma gets impatient with me sometimes, too."

When she returned on deck, momma came straight to papa's side, ignoring me. "Where's this lighthouse of yours?" she demanded of him. "I don't see it."

"Not here, Rachel. Back up the coast a few miles."

"Not here?" She repeated, "Not here!" She flung the words back at him. "Then where?"

"At Point Conception."

"You lied! You said it was at Santa Barbara."

"Near Santa Barbara is what I said. There's no point discussing this again, Rachel. We had no choice."

"You've ruined my life, Asa!" Turning her back on him, momma went to the far rail and stared over the narrowing span of water at the little village of mud-brick houses.

"Will she be happy when we get to our new home?" I asked him. "I want her to be happy."

Papa grimaced. "I don't know, Baby Girl, momma doesn't ever seem happy these days."

When the steamship stopped, rocking on its anchor in the gentle swell, a tender pushed off from the beach with four men manning the oars. Coming alongside, the boatmen assisted passengers disembarking down a rope ladder. They took seats on wooden benches. Papa held me securely in his arms as he climbed down. Momma followed, holding up the hems of her long skirt. Taking her seat I saw her notice one of the boatmen staring at her. For an instant, she stared back then turned away.

When the tender scraped against the small rocks on the shore, two of the boatmen jumped into the shallow water and dragged

it further up the sandy beach, leaving just a narrow patch of water for us to cross. One of the men told us that he and his mates would be happy to help any of the women stay dry by carrying them in their arms the short distance to the dry beach. He assured them they intend no disrespect, but in Santa Barbara it was the only possible way to stay dry. I locked my arms tight around papa's neck as he stepped over the side into the water with me in his arms and moved onto the beach.

Momma held back until she was the only one remaining in the boat, looking for a way to avoid being carried. Standing next to papa and holding his hand, I watched her finally give a shrug and allow the boatman to pick her up.

"It's fine, Ma'am," the boatman, who was staring at her earlier, said, grinning, "I'll keep ya dry. Just put yer arms around my neck and I'll carry ya across."

Momma did, but I could see she held her body rigid in his arms and never looked at him.

"Pardon, Ma'am," he asked when he held her securely, "Have I met ya before?"

"Absolutely not!" She snapped.

"You do look familiar."

"I'm sure we've never met. Just set me down."

"You look just like a woman I knew back east Ma'am. Younger, of course—no offense—I was younger then too. I worked lumber schooners on Lake Huron before coming west for the gold. Any chance I knew ya in Port Huron or Detroit or one of the Canadian ports?"

"Put me down!" Momma shouted. "I never would have known a rude man of your sort." She struggled out of his arms, splashing the hem of her dress as she landed. She charged up the beach and stopped where we waited for her.

"Ya look awful familiar to me," he called out to her. "I'd remember a beautiful face like yers."

It didn't take long for papa to find the harbormaster, a weathered older man, his deep brown skin and face creased by years of squinting, telling of his maritime life. "I'm the new keeper for Point Conception," papa introduced himself.

"New keeper? We've been on the lookout for ya. Second assistant is it?"

"Signed on in San Francisco and caught the first steamer coming this way."

The harbormaster looked at momma and me but didn't speak for several minutes. Finally, he looked back to papa. "Your family gonna live at Point Conception with ya?" He asked.

"They are."

The man stared at us again several seconds, nodding his head up and down slightly, as if trying to understand the information papa had just given him.

"How do we get to the lighthouse?" Papa asked when the harbormaster didn't say any more.

"No easy task that is," came his slow reply, after a few more moments of thought.

"What's it like at the lighthouse?" Momma interrupted impatiently.

"Lonely place, Ma'am. Wild place." The harbormaster nodded several times more. "Beautiful place, too, if'n you're cut out for it. No womenfolk out there now, only the other two keepers." He stopped talking as if to rest after expressing such a long thought. "A wagon will take you out there. You'll do them a kind thing, Ma'am, I'm guessing, keeping house for all of them. Gotta be careful to keep the little one safe though."

"Where can I hire a wagon?" Papa asked. "We're in a hurry to

get there and settle in."

The old man pointed to a cluster of rough wooden buildings. "Livery stable just over there on State Street. But you won't get out there today. No sir! It's a full day's travel—along the beach part way. You'll have to go on a slack tide. Best you arrange for a wagon and driver to go early tomorrow, then find some rooms for you and the missus and child."

Papa led the way to the livery stable, holding me. Over his shoulder I saw the harbormaster still staring after us as we walked off. The stable owner agreed to have the wagon and a driver available before daylight the next morning. Then he pointed the way to a one-story mud building he called the local boarding house. There we were shown a simple room with a small window looking out to a back garden.

"I can't stay here," momma said, standing in the doorway, refusing to come into the room.

"What do you mean?" Papa asked.

"What I said! I can't stay here. I won't stay here! This is not what I agreed to. Not the life I bargained for."

I jumped off the bed and ran to her, throwing my arms around her legs. "Momma, please stay."

"It's not the life I bargained for either," papa said, worry on his face, "but it's the life we have just now, Rachel, until things get better and we're back on our feet."

"You promised we'd have gold."

"We were doing fine for a while."

Momma freed herself from my grip and gave papa a sardonic laugh. "You'll never get back on your feet. I should have known long ago you were a deadbeat."

Tears were running down my cheeks at her harsh words. My nose began to run.

Papa stared out the back window at the garden. "Don't leave us, Rachel," he said softly over his shoulder. "We'll live well enough at Point Conception and save to go back to San Francisco. You'll see."

Crawling back on the bed sobbing, I lay down. Papa came to sit beside me, comforting me in his arms.

Momma stared at us a few more moments. Then she came into the room far enough to grab her suitcase and satchel. Without another word she turned her back and walked out.

The next morning I opened my eyes in the unfamiliar room and looked around. I was alone in the bed, surrounded by darkness. I started to close them again but felt papa gathering me up in his arms. To keep my eyes open, I rubbed them with my fists. Papa picked up the remaining tattered valise and we left the boardinghouse. Outside, it was still dark. I put my arms around papa's neck and snuggled closer to avoid the chill air as we made our way back to the livery stable.

The stable's interior was a dark chasm where a stranger was hitching a horse to the rear of a small wagon. An ox was yoked in front. Smells of wet straw and manure pricked at my nose, bringing me fully awake. Papa spoke a few words to the man who introduced himself as the teamster who would take us to Point Conception.

"It's okay, Baby Girl," papa calmed me when I got restless in his arms. "Soon we'll be on our way to our new home."

When the teamster said all was in readiness for the long drive he told us to climb aboard. A horse whinnied at the rear of the stable and a shadow emerged from the darkness, startling all of us. The teamster dropped the reins. His hand slid down to the pistol holstered on his hip. "Who's there?" he called out.

When the figure was almost beside him without acknowledging the command, papa realized it was momma, carrying her cardboard

valise and satchel. "Momma!" I called out, immediately wide-awake and happy. "Momma where have you been? Oh, Momma, you've come back." In the dim light I saw she was wearing the same long blue dress she wore on the steamer, wrinkled now, with pieces of straw clinging to it. Her long, light brown hair that she usually pulled back was parted down the middle of her head and hung about her shoulders in disarray.

"I have," she mumbled. Looking directly at papa, she said, "I'm going to the lighthouse with you." She put her belongings in the back of the wagon and climbed up on the seat behind the teamster without another word. Still holding me, papa climbed into the seat next to her.

The sun was barely above the horizon when the ox-drawn wagon left the sleeping village and joined the main road leading west. It passed over a flat plateau bounded by ocean water to the south and a serrated mountain range a mile or so to the north. In between, grazing cattle moved about the park-like setting. It was a silent world, save for occasional birdcalls.

We rode across the silent land in silence, each one of us with our own thoughts, each feeling the tension. I was happy momma was with us again. Sitting on the right side of the wagon, she kept her eyes looking off toward the mountains, while papa, on the left, studied the channel waters. In between them, I clutched my rag bear and whispered my thoughts privately to it.

Papa broke the silence. Without looking at momma, he asked, "Why'd you come back?"

"Had no choice," she said, still looking away from him.

We rode another mile or more in the wagon with no further exchange.

"Because of the boatman who spoke to you on the beach?" Papa asked finally.

Momma twisted the fabric of her skirt but didn't answer.

"You knew him, didn't you? From back east."

"How'd you know?"

Papa allowed a sardonic grin to cross his face. "I know much more than you credit me for," he said. "I know about all your dalliances back east. You aren't all that clever or discreet, you know."

Momma stayed silent.

I left papa's side and squirmed over to her, burying my face in her lap and covering my ears. She paid no attention and let me lie there without touching me.

"Why did you come back?" Papa asked again.

"He threatened me. Said I owed him money."

"That why you left him for me back then?"

"You were older—much older. Thought you were a better bet. Shows how good a judge of men I am, huh?"

The teamster cracked his whip over the ox's head to encourage it to more effort on a slight rise in the trail, startling me, and causing me to sit up and look around. We were now traveling along a series of bluffs several hundred feet above the channel whose waters sparkled with reflected sunlight.

Several miles farther, momma finally turned to look at papa again. "If you knew all along, why'd you stay with me?"

"Thought we might make a fair life together, I suppose. You were pretty—still are, in fact. Not many other women gave me the time of day. I knew you favored men with money, but I thought—"

"Thought you'd find gold in California, that's why I came with you," she interrupted.

"We did pretty well on the Yuba," he mused. "Probably shouldn't have left the river so soon. That was our mistake." He pauses for a moment. "Then Emma came along."

At the sound of my name, I perked up, ending my conversation with the bear. "Where are we?" I asked. "I'm hungry."

"I was careless," momma mumbled.

The teamster turned to us. "We'll stop in just a while now. There's a small place where you can buy tortillas and beans, and I can feed and water my horse and the ox. After that, we'll be going the rest of the way along the beach."

"I'm hungry now," I whined. I left momma and put my arms around papa's neck again. "Will we be at our new home soon?"

Descending from the plateau at a place the teamster called Gaviota—Gaviota means seagull in Spanish, he told us—the tide was slack so we rode on the firm sand. A chain of islands formed a barrier to the open ocean offshore, calming the waters so they lapped with a quiet sizzling sound on the shore and occasionally came under the wagon's wheels. Papa watched a lone ship sailing eastward down the channel and pointed it out to me. We made a kind of game of it that helped pass the time. But after a while I got tired and decided to take a nap in his lap.

"My God!" Momma exploded late in the afternoon, "Where is this lighthouse we're going to? How much farther?"

"You can barely see it up ahead if you know where to look," the driver called back to her. "See that high place that looks like it just rises up out of the ocean?" He pointed. "That's Point Conception. The lighthouse sits at the very top of the point."

"So this is how we have to travel to get back to Santa Barbara?"

"This or by boat. There's a cove that's good for landing small boats yonder. You'll have a lighthouse tender come by every month or so, bringing supplies. This is your ox and wagon. You can drive it to town when you need to, now you've learned the way."

"Other than that we're alone out here?" I heard a forlorn sound, almost a groan in momma's voice, and saw a look of

desperation on her face.

"Not alone exactly," the teamster shrugged. "There are two other keepers there. You'll share lodgings with them." He cracked his whip in earnest, driving the ox through some dry sand as we moved away from the beach, climbing slowly back onto the plateau again. Point Conception stood out as a high promontory at the water's edge. At the top, a small house faced the turbulent water where the channel joined the open ocean. A light tower rose from the middle of its roof.

Momma looked around when the wagon stopped. "What have I done?" She moaned. "I might as well be dead." She slumped down on the seat.

CHAPTER THREE

July 1869

EARLY NEXT MORNING Grace and I leave the apartment for work as usual, but at the corner I turn toward *rue de Rome*, leaving Grace to continue on to the station. With my sketchbook tucked in the pocket of my cape, I start down the wide street, stopping at the corner to wait for a safe break in the oncoming traffic to cross. I feel a hand on my shoulder that makes me tense up.

"*Bonjour, Mademoiselle,*" the voice says softly in my ear.

"*Monsieur* Durand." Surprised, I turn at the sound of his voice to see Leo standing close behind me. "What are you doing here?"

"Following you, of course."

"How did you know?"

"Grace told me last night, so I thought you might want company today."

"I don't! I have things to do."

"Let me buy you a *café crème.*"

"Please let me go."

"But I want to get to know you better."

There is warmth in his face I hadn't seen the day before. His lips curl up into a shy smile, showing a dimple in his chin. His eyes are not as hard as I had imagined either, brown like his

sister's. "Perhaps I would like that another time, *Monsieur*, but not today," I tell him. "Please leave me now."

Crestfallen, Leo steps back. He smiles again, a big, embarrassed smile, and bows. "A girl as pretty as you are is worth waiting for," he says, then he turns on his heels and strides away.

Continuing down *rue de Rome*, thinking about Leo brings a private smile. His attention is a new experience for me, and I'm not sure what to feel. Lost in my thoughts, but deciding I would like to know him better, I'm oblivious to the morning traffic around me. At a wide, tree-lined boulevard that crosses *rue de Rome*, I walk east and stop at a *café* where a waiter is just setting out chairs and tables on the sidewalk. Picking a table set back against the building, I order tea, feeling a little guilty I hadn't agreed to stop with Leo. "*Oui*," the waiter nods and hustles inside.

For a few minutes, I stare out at the carriages, pushcarts, trams, and double-decked omnibuses passing on the boulevard, still absorbed by thoughts of Leo—what's it like to be friends with a boy, I keep asking myself? The clanging of hammers on stone rising above the cacophony of other street sounds draws my attention to a group of stoneworkers preparing the facing for the front of a new building. Out comes my sketchbook and I start to draw. A large, white, open carriage passes in front of me, pulled by a brace of matched white horses. Bright morning sun reflecting off their silver harnesses demands my attention. With rapid pencil strokes, I catch the solemn-faced, liveried coachman in top hat and dark suit on the front bench, impatient with the traffic, restraining the prancing pair. A middle-aged woman sits alone on a cushion of white satin in the back. The beautiful silk, rust-colored dress she wears captivates me. It has a voluminous flounced skirt that covers her ample hips and legs. A gold belt restrains her waist that pushes against it for freedom. The bodice

has gold buttons, and the cuffs and long sleeves are embroidered with golden thread. Perched atop her dark brown hair, a black top hat, like the coachman's, is decorated with feathers and a veil and seems to sit precariously. Her partially hidden, wrinkled face is blank like her driver's.

I continue adding details to my sketch, before the carriage moves on down the boulevard, oblivious of all the other activity on the street, so I don't notice the waiter standing beside me with a small serving tray. He sets the ceramic cup down, but instead of leaving continues to stand at my shoulder watching my pencil dart about the paper.

"*Voilá,*" he says when I set the pencil down and pick up the tea cup. "*Mademoiselle* you have captured the Princess perfectly."

"Princess?" I give him a questioning face.

"*Oui,* Princess Mathilde. She comes this way each morning and all the traffic on the boulevard moves to the side to allow her passage."

"A real princess?"

"The emperor's niece. You have done a wonderful likeness of her, *Mademoiselle.* And so swiftly. Are you trained?"

"I hope to be."

"If I am not too bold to ask, may I look at your other drawings in the book?"

Sitting back to enjoy watching people rushing by, I sip my tea while the short, round, waiter, with balding head and large white apron, turns the pages. Occasionally, I sneak a look at him to judge his response.

"Ah," he says at one point, "a lighthouse. On the coast is it?"

I laugh. "Oh no, *Monsieur.* A lighthouse in California...where I grew up," I add as an afterthought. "My father was a keeper."

He finishes looking through my sketchbook and hands it back.

"So you are in training?"

"I'm looking for an art school, but I don't know any, do you?"

"Of course," he nods, "there is *École des Beaux-Arts*. Everyone knows that school—it's the oldest. The only one I know."

I feel a rush of excitement. "Where is it? How do I get there?"

The waiter stops to think for a moment, rubbing his chin whiskers as he does. "I don't really know where," he says, his brow furrowed. "Left Bank. A long walk from here. A *mademoiselle* such as yourself should not go that far unescorted. You could take an omnibus across the river and ask directions when you get there."

I thank him with my best smile and quickly finish the tea. Leaving him a few *centimes*, and lifting my skirts against the dust the stonecutters' hammers are making, I head down the boulevard toward the omnibus stop on the next corner. When the driver pulls a team of horses to a stop in front of me, only a few people disembark and the waiting crowd surges on. Seeing too many riders already inside, I grab the railing and start climbing to the open upper deck.

"Oh, no! No, *mademoiselle*! *Ce n'est pas permis*," the driver shouts and waves his hat at me from the front of the vehicle.

Startled, I look in his direction. "But there are seats..."

"It is not allowed," he interrupts. "Women not permitted. No!"

"There are no seats inside."

"*Oui. Je suis désolé.*" The driver raises his palms and shrugs. "No seats inside so you must wait."

It is a long walk to the river. I cross *Pont Neuf* at *Isle de la Cité* to the left bank. "*Comment vais-je touver École des Beaux-Arts?*" I query strangers hurrying over the bridge. Most ignore me, some simply shrug, "*Je suis désolé*," and keep going, but one well-dressed gentleman wearing a bowler, stops and smiles. "Ah,

École des Beaux-Arts, rue Bonaparte," he says, pointing the way, and then continuing. Following his directions, and after walking several more blocks, I am standing in a courtyard flanked on three sides by a classical stone building. The imposing sight of this venerable three-story structure makes me gasp for breath.

A lump forms in my throat, and I want to turn around and hurry away, back to the safety of *Batignolles* and the Durand apartment. How could I ever...? My sketchbook feels trivial, certainly not good enough for *École des Beaux-Arts.* And yet this is why I came, I tell myself, trying to bolster my confidence. Why I came to France with Lucinda all those months ago and cleaned the toilets in the station while I learned the language. I will not turn back now. Taking a few deep breaths to steady my nerves, I walk up the short flight of marble steps to the main doors. Young men hurry past. They act as if they know what they are about and ignore me. But I can do just as well as they can, I tell myself, still inwardly doubting. Then I pull the main door open and go inside.

Standing in the main hall, nervous and short of breath, I look around for some sign of where to go. The long marble corridor is empty, but almost immediately an older man, wearing academic robes comes out of a door and then rushes down the hall. "Stop! What is it you want?" He calls out, still a few feet away and fluttering like a nervous crow. He blocks my path and plants his hands on his hips, coming to stand face to face. Wearing a full beard and mustache, with an overbearing countenance that reminds me of an ogre from one of my nightmares, he glares at me. "Are you here for kitchen work? Or the laundry? Perhaps you want the service entrance, *Mademoiselle.* It's at the rear of the building. Clearly, you can see you don't belong here."

I'm overwhelmed by his intimidating manner. The urge to

41

turn and run before this monster devours me grows stronger, but his disdainful expression only makes me more determined, and keeps me firmly rooted in front of him. This is my chance. Maybe the only one I'll have. The dryness in my throat makes my voice crack. When I start to speak, the words come out weakly. "I want to enroll as a student. I want to be an artist."

The man's face pales then grows belligerent. He stares at me through hostile, heavy-lidded eyes for several moments. Finally, he bursts out laughing—an almost demonic laugh that sends a shiver up my spine—and again I think about fleeing from him before he devours me. "A student you say? Learn to paint, is it? Oh, no. No! Preposterous, *Mademoiselle*. You are clearly in the wrong place—you don't belong here. No female students are allowed, and never will be. Besides you hardly speak intelligible French. Go away! Find some run down school up some back alley in *Montmartre*, if they will tolerate you. We will not! We do not accept women because women have no place in the world of classical fine art. And never will!"

After a dejected walk from the Left Bank back to *Batignolles*, when I arrive at the Durand apartment, Grace grabs me. She pulls me off into a corner of the cramped parlor. "Exciting news," she says in a hushed voice, bubbling with excitement.

"Tell me," I plead, definitely in need of some good news to replace my disappointment. "Cheer me up."

"*Mademoiselle* Dobbins," Hector Durand comes out of the kitchen and interrupts. Clarise is close behind him. "When you did not return from the station with Grace we began to worry. Are you all right? Where have you been?"

I hesitate, glancing at Grace, but get no sign of support, and

then look back at Hector with a blank expression. I put on a bright smile, pretty sure I know what is coming next, but hoping to avoid his interrogation. "I didn't mean to cause you and *maman* worry, Papa. I have left my employment at the station." I stop and try to gauge his reaction.

"Grace told us," he admits.

Waiting a moment before answering, I tell him, "I have been looking for other jobs."

The cheerful grin regains its place on Hector's tired face. "I am pleased to hear that. Were you successful?"

"No Papa, not successful. But don't worry, I still have some *sous* so I will be able to pay my weekly rent."

He puts his arm around my shoulder and draws me a little closer to him. "*Très bon. Madame* Durand and I like having you live here with us, you are a good companion for our Grace. *Madame* Durand and I often speak of you; you have almost become like another daughter to us—such a pleasant young woman to have with us. So charming—you brighten up our humble home."

I breathe a sigh of relief. Hector isn't a tall man, but he is solidly built, showing the body of a man doing physical work all day long. In his fifties, a roofer, balding, with a shiny round head, his eyes twinkle with a kind of patriarchal smile. I know that my contributions to the family's income are necessary to cover my keep. And I know Hector really means I am welcome to stay as long as I can contribute.

"There are not too many jobs in Paris for young women, even with the new prosperity the emperor has created," Hector continues. "So I hope you can be successful soon. Grace is fortunate to have her job at the *Gare Saint-Lazare*..." He thinks for a moment. "I hear they are always looking for girls to make paper flowers in *Montmartre*, you could try up there."

"There are jobs for laundresses, too," Clarise Durand adds.

My smile fades. "I was hoping to find a better job than that so I could afford art lessons." Thoughts of cleaning toilets give me a shiver.

Hector and Clarise seem puzzled. *"Est-ce vrai?* Really?" They say almost in unison, looking at each other. Then Hector continues, "Most jobs in France are for men. Our young women usually take up simple work while they wait to be married and start families. We hope that will be true for Grace before long."

"I am not ready, Papa," she breaks in. "Neither is Emma. We want to have some fun before that. There is a dance Sunday at the *café-concert* on *blvd de Clichy*. Leo has invited Emma and me to go with him. Can we, Papa?"

Hector looks to his wife. She nods. *"D'accord,"* he says, "if Leo is with you it is fine. He's a good boy. But be moderate with the drinks and be careful who you dance with. We are a respectable family."

Blvd de Clichy is alive with Sunday families in their best clothes, chattering and calling out to friends as they walk along the sidewalks, amid the savory aromas that mingle with the unyielding stench of horse manure. Sunday is the only day the working people of *Batignolles*, and the other neighborhoods of Paris, get a reprieve from the tedium of their manual labors. Some, but not all, and not many, go as a family to the local church dedicated to *Saint-Marie*. It is a modest Catholic house of worship, appropriate for the district—more chapel than cathedral—and a convenient walk from the Durand's *rue Cardinet* apartment. Many more citizens, especially now, as fall is giving way to the burden of a Parisian winter, head for *Parc*

Monceau toward the other end of *rue Legendre*. Their children run free or beg carousel rides from their parents, who take up positions on benches along the walks. Some sit to watch courting young couples strolling by, others spread blankets under the pine and plane trees to recline on the grass. Still others, with enough extra money earned during the week in their pockets, treat their wives by taking the whole family—from *grandpere* to the smallest *enfant*—to lunch at a nearby *café*.

Escorted by Leo, Grace and I make our way toward *Place Pigalle* and the dance hall where the *bal musette* is being held. When we arrive a crowd of young women and men is already gathered at tables, talking loudly, drinking beer and cheap wine. The young girls are all wearing their best dresses, some with pert bonnets or fresh flowers woven in their clean hair. I feel self-conscious. The long wool dress I brought from California is not quite long enough anymore, and not so colorful or free-flowing as the French girls' dresses. I wish I had extra *francs* to buy myself new clothes.

Leo leads the way to an empty table. Then he goes to the bar, coming back with mugs and a large pitcher of beer. As he sits down with us, three men in the front of the room pick up their instruments—a bellows-driven bagpipe, hurdy-gurdy, and an accordion—and begin to play a *valse musette*, a dance of small quick steps. Leo startles me by grabbing my arm and pulling me to my feet. "Let's dance," he says.

I pull back and resist. "I don't know how. I only ever danced with my papa when I was a little girl."

"Have no worry, there's nothing to it. I'll show you." He grins broadly and takes my hand, leading me, still resisting slightly, toward the dancing floor already overflowing with couples.

I stop again and turn to look over my shoulder for help. "But

Grace is alone," I protest.

Paying no attention, he looks for a spot on the dance floor and laughs. His eyes are bright and lustrous as he beams at me. "She'll be fine. Come on." Taking my hand, and pulling me tightly to him, he starts moving his feet to the rapid beat of the hurdy-gurdy. I try to follow, stumbling over my own feet at first. I feel trapped in Leo's grip, far different than dancing with papa. "You are holding me very tight," I tell him.

"That's the way we have to dance in these crowded *guinguettes*," he says into my ear just loud enough to be heard over the music. "Does it bother you?"

It doesn't bother me as much as I thought it would, once I get used to feeling his arms holding me tight. In fact, it feels good to be in his arms. I feel little tingles of pleasure at the base of my spine. New sensations I've not experienced before. "No," I murmur.

We dance in silence for a few minutes. Watching the other girls in their long cotton dresses of white and pastel colors, some plain and some with dainty stripes, swirling past me, I'm caught up in the gay mood of the dance. The young men, sporting fledgling beards and wearing tight pants and jackets, with bowlers or jaunty straw hats on their heads, seem serious and intent. The girls laugh and flirt with their eyes as they twirl around. I watch and try to emulate them.

"Do not try so hard," Leo urges in his soft, private voice. "Just let yourself feel the music and move with it."

I try to relax but still step on Leo's toes once in a while. The other couples seem to be moving even faster around the crowded room in a dizzying display. I feel I have to run to keep up. As he whirls me around the dance floor, I start having the feeling that everyone in the room is staring at me. "Everyone is watching

us," I tell him. "I'm embarrassed I wore this dress."

"Of course they're watching," he says, laughing again. "Watching you, that is. You are the prettiest girl here—the other girls are jealous." After a pause, he says softly in my ear, "I am sorry if I offended you when I followed you the other day. I only wanted to get to know the wonderful girl who had just come into my life. You are very attractive, Emma—Emma is not a French name is it? It is hard for me to say, but I want to learn to say it."

I know I'm blushing but don't care. I'm at a loss for words. The tingles on my spine have grown to shivers of happiness that please me almost to the point of giggling. Totally in Leo's control, as we whirl around the room, I stop trying to resist.

After several dances, breathless, I lead him back to the table, saying I need to rest. A tall, muscular man is sitting beside Grace, leaning forward, his muscled arms on the table, beer mug in hand, gazing at her.

"Who are you?" Leo calls out as we approach, moving to stand protectively close to his sister.

The other man stands, confronting Leo.

"He's doing no harm," Grace snaps at her brother. "I invited him to sit with me."

"Who are you?" Leo demands again, stepping toward the stranger in a threatening kind of way.

"I'm just chatting with this charming girl. Perhaps she doesn't need your protection."

Leo turns to confront Grace. "You should not be so friendly with men we do not know," he tells her.

"Don't tell me what to do, Leo. I came to dance and have some fun."

I'm not sure what to do so I move close to Grace and take her hand.

"And perhaps you should leave—"Leo tells the stranger.

"No!" Grace interrupts, looking first at her brother and then the stranger. "Sit down, both of you."

Neither one sits. I watch Leo bristle and wonder if he would be as protective of me as he is of his sister. Or is it just a family thing?

"I have never seen you before," Leo charges. "Who are you?" he asks for the third time.

"My name is Martin Aboud..."

"Stop questioning him," Grace interrupts. "He's a stonecutter. He told me he came from the *Creuse* in the *Massif Central* to find work in the rebuilding. Sit down, Leo," she commands.

"Where is *Creuse*?" I ask.

"A poor area in the South, *Mademoiselle*, where there is no work. And you?" Aboud looks to Leo.

"Leo Durand," Leo says, easing himself down onto the bench and motioning me to sit beside him.

"And do you work, Leo Durand?" Aboud asks, relaxing his defenses. He sits alongside Grace again.

"I have just finished training with the National Guard."

"Ah, so you do not work," Aboud taunts him. "Perhaps you are too interested in the wonderful girl next to you to spend time away from her?"

I blush, but Leo is on his feet again. "Be careful how you speak about her, *Monsieur*. I will fight to defend France if the emperor calls upon me," he says, his face reddening again. "Fighting is my work."

"Ha! Louis Napoleon! I will never fight for that man. You would be a fool to fight for him!"

"Why are you so angry?" I ask Aboud, watching his face turn red. "There is no need for it here."

"He has not done anything for the poor people of my village—stonecutters like my father and grandfather before me.

Leo takes a step toward Aboud.

"Stop!" Grace shouts. "Both of you!"

The words have flown back and forth so rapidly I'm not sure I understand all that's been said, but I am afraid of what Leo might do. Martin Aboud is taller and more strongly built than Leo. His thin white shirt, with sleeves rolled up above his elbows, shows off his bulging muscles. His black hat shades his chiseled face and dark eyes, but his pointed nose aims aggressively at Leo. I stand up and take Leo's arm.

"You two are baiting each other like fighting cocks," I interrupt their menacing back and forth stares, hoping I've chosen the right French words. "There is no reason why we cannot share this table and talk civilly."

Grace agrees. She touches Aboud's arm to coax him back down.

"Your pretty friend is right," Aboud tells her. "We come here to drink and dance. Tell me, *Mademoiselle*—your French is not so good—where is it you come from?"

I tell him.

"Ah, California. Where gold lies in the streets to be picked up by anyone who bends over. I must hear more." He gets up from the bench. "I will buy another pitcher to quench our thirsts first." He makes his way through the crowd of dancers to the bar, giving Leo and Grace a chance to calm down. Returning, Aboud refills all our glasses and sits even closer to Grace, gauging Leo's reaction. Grace looks into his face, smiling sweetly, her lips curving upward into a petite bow, and thanks him.

"Why have you come to Paris, *Mademoiselle*? And how should I call you?"

Leo starts to bristle again. Grace gives him a threatening look that stops him. "Her name is *Mademoiselle* Emma Dobbins," she says, giving her brother a mean look.

I watch Leo to make sure he won't start another verbal attack before answering. "I came to France with another woman—an older woman—who wanted me to model for her. I want to go to an art school here."

"You are an artist then?" Aboud asked.

"I draw and paint watercolors," I correct him, "but I want to be a professional artist."

"I know nothing about this, but I would guess it is a hard path for a woman."

"I didn't know it was going to be so hard when I agreed to come with her."

"And this woman?"

"She got sick on the ship in *Le Havre* and was taken to a hospital. I haven't seen her since. Grace rescued me when I arrived in Paris. Her family has taken me in."

Aboud turns to Grace. "A rescuing angel you are," he says. Turning to Leo across the table he adds, "You are a fortunate man to have such a beautiful young woman befriended by your sister." Before Leo can interrupt, Aboud turns back to me, "And are you going to art school?"

"I was rejected at *Ecole des Beaux-Arts*. An angry old man threw me out. He was so rude. Said there was no place for a woman. So now I don't know what I will do."

"I am sure you will find another school."

Leo doesn't wait for me to answer. He sits forward, placing one hand on the table and the other on my arm, caressing it with gentle fingers. "I have news for you, Emma. I've waited to tell you," he says with a soft, sweet tone to his voice. "After you

left me on *rue de Rome*, I walked around *Batignolles* and into *Place Pigalle*. I found a building there with a sign on it that says Suisse Art School. Not far from here."

It sounds as if the musicians are playing louder and the dancers dancing faster, but I know it is only my own anger rising. I shove his hand away and give him a sharp, penetrating stare. "How did you know what I was looking for?"

"Grace told me."

"You let me walk all the way across the river?"

"You told me not to follow you."

I think for a moment and then snap at him. "I don't need you to solve my problems. I can do for myself, Leo." I get up from the table and hurry out the door, with Grace quickly jumping up and running after me.

CHAPTER FOUR

July 1869

GRACE AND I leave the Durand apartment together the following morning. The sky is bright, but gray-bellied clouds sulk on the northern horizon. At the corner Grace stops and lowers her voice to a conspiratorial whisper as if the passersby on *rue Cardinet* might be eavesdropping.

"Martin wants to see me again," she says.

"Will you?"

"Oh, *oui*."

"What about Leo?"

"I don't care about Leo. He's a grumpy old street dog who barks at everyone who comes near." She stops and looks down at the sidewalk, then back at me with a serious, almost sad face. "I know I'm not a pretty girl like you. I probably don't have too many chances to find a husband, so I can't afford to turn down any opportunities."

I don't know how to respond so I stay silent. She smiles and takes my hand. "And you?" She asks. "I can see Leo is fond of you. Do you have feelings for him?"

"I don't know what I feel, Grace. I know I didn't come to Paris to find a husband if that's what you're asking. I'm here to learn to be a serious artist. I like Leo well enough. We had fun dancing

yesterday, and I'd like to do it again, but I'm not ready for anything serious." After giving what Grace has said some thought, I add, "I hope I can continue to live with you no matter what."

"He told me he invited you to lunch tomorrow. Will you go?"

"We'll see. I think I need to apologize for what I said to him yesterday."

We trade kisses and part. Grace goes on to the station and I walk to *blvd Clichy* and then on to *Place Pigalle*, not far from yesterday's *café-concert*. Workingwomen in long skirts, white blouses and simple hats hurry along the plaza. Finer dressed *bourgeois* ladies gossip near a narrow building wedged between other small, wood and stone structures spread in an arch around the cobblestoned *Place*. I walk past them before I see the small sign over the doorway.

ACADÉMIE DU CHARLES SUISSE, ACADÉMIE D'ART

An arrow points up the staircase. At three stories, it is shorter than its neighbors. The old *Abbaye de Thélème*, once a religious house and now a shabby *café*, sits to one side, and *Le Rat Mort*, an unfortunately named restaurant on the other side has a dentist's office on an upper floor.

I climb the well-grooved wooden steps to the top floor. On the landing, a large studio with two floor-to-ceiling windows at the side and rear of the building stands open. The smell of unwashed bodies of a half dozen mostly bearded young men drifts out the door. They slouch at easels scattered randomly around a pedestal that holds a bowl of fruit. Intent on their subject, none of them notice me. Uncertain what to do, I stand in the entrance. After what seems like a long wait, an old man in a black beret, with a gray-white beard that matches his smock, comes from the rear of the studio.

"*Bonjour, Mademoiselle,*" he says. "As you can obviously see you are in the wrong place. Can I direct you to the location you are seeking?"

"I think I am in the right place, *Monsieur,*" I tell him, standing my ground. "This is the Academy of Art described on the sign on the street, is it not? You are *Monsieur* Suisse, no?"

Without saying a word, he looks me over from head to foot for several moments, with an appraising eye that makes me self-conscious. When he's done, he takes a step forward, forcing me to step back from the studio door and toward the stairs. "It is," he acknowledges finally. "What do you want?"

Drawing a deep breath, I look him straight in the eye. "I want to be a student in your school."

Monsieur Suisse continues to stare, fingering his beard as he does. Then he lets out a sigh of resignation. "I don't train *dilettantes!*" he says with a low-throated growl."

"I don't know what a *dilettante* is," I fire back, "but I intend to be a serious artist, *Monsieur.*"

"Why is it you want to learn to paint?" He asks. "Is it that your father wants you to be more cultured so you can secure a better husband? Or perhaps you are married and your husband worries you have too much idle time and might stray from him? I have heard just about every reason a young woman can offer for joining my academy and wasting my time."

For just a moment I think about fleeing. It passes. My eyes narrow and I focus my expression into the aggressive look of a hungry street cat. With strength growing in my voice, I tell Suisse, "Your sign on the street says, 'Women students accepted.' Do you?"

"I must buy a new sign," Suisse mumbles under his breath. Then he points into his studio. "Do you see any women in there?"

I don't but still hold my ground. "I want you to teach me. I am not married, not being courted by any man. Let me show you my work."

Taking the big pad of watercolor pages I have under my arm, I thrust it at him with a confident look, a much stronger look than I actually feel. "Please give me a chance," I beg him. "I've come all the way from California to study with you."

Monsieur Suisse puffs up like a rooster in a chicken coop. I hope my little lie will go unchallenged. He takes the pad but doesn't open it. "All the way from California, you say," he says showing me his first smile. "I think, as the saying goes, you are gilding the lily, *Mademoiselle*. Tell the truth, why do you want to learn to paint?"

"I have never wanted anything else in my life, Sir. I got a sketchbook for my eighth birthday and have been making pictures ever since."

"Wait here," he says, abruptly snatching the pad from me. Turning his back, he walks into the studio and over to one of the large windows. Standing there he goes from page to page, studying each watercolor.

The time seems to drag by. I shift nervously from foot to foot, watching him from the doorway. The only sounds are the occasional grunts from the student artists and noises drifting up from the street, a chorus of animal cries and human voices, unintelligible three flights up. For no reason I untie and retie the ribbon of my hat under my chin. Minutes tick by. I begin to think he is trying to ignore me so I will go away, but I have no intention of leaving.

The interval feels endless, but in fact is not quite ten minutes. Suisse closes the pad and comes back across the studio. He holds a slight semblance of a smile on his pale face as he hands it back,

but nothing that might indicate his reaction to my work.

"There are a few signs of talent here," he says. "Perhaps more talent than many of the young men in my studio have. Who has trained you—where did you say—California was it?"

"I've had no training, *Monsieur* Suisse. I learned from my mistakes."

He nods. "You have learned well, it appears. This picture of the lighthouse—was that in California? Quite nice. What did you say your name is?"

"Emma Dobbins, *Monsieur*." I take in a deep breath. "Will you let me study with you?"

He throws up his hands and shrugs. "Alas, as you can see my studio is full as it is. I have no room for you. You might come back in six months or a year to see if any of the students have dropped out. Good luck to you, *Mademoiselle* Dobbins and goodbye." He starts to turn away.

Crestfallen I grab the pad out of his hands and turn my back so he won't see the tears forming in my eyes. I start down the stairs and go about five steps before he calls out. "Please come back, *Mademoiselle*." A feeling of reprieve floods over me, I have a glimmer of hope. With the fingers of my free hand, I swipe the tears from my cheeks. When I stand in front of him again, he offers another weak smile. "There is one possibility," he starts. The expression on my face brightens. Then he stops and gives me the same appraising look he had at the start of our conversation.

"You are a very handsome young woman, one of the prettiest *mademoiselles* I have seen in a long time, and you have a delightfully innocent look about you. I would be willing to have you come to the studio and pose for my students. That way you might learn while you are here. And if someone leaves, who knows, a place for you might become available."

56

I consider his offer, looking at him without saying a word. With the sweetest look I can muster, I extend my hand and thank him for the offer. "If we could come to some terms that might be acceptable..." I say, "but I won't pose for your students without receiving compensation. I have rent to pay."

"Oh, well then, I am sorry," he says. I give him a knowing look and start back down the stairs. Over my shoulder, I tell him, "I may be a woman, *Monsieur*, but not a stupid woman. I won't do your work for free."

"Wait, *Mademoiselle!*" he calls out. "Please wait."

"Only if you pay me the same wage you pay other models."

"Agreed," he says, heaving a deep sigh as if he has just offered me his last *centime*. "Can you come tomorrow? My students are getting restless painting fruit bowls."

When I arrive at Suisse's studio the next morning, he gives me a startled look. "Oh, you're the girl from yesterday. I didn't think you would come back. *Voilá!* Right this way...your name again?" Not waiting for an answer, he sits me at a table in the center of the room that has replaced the pedestal and fruit bowl. "Place your hands on the table just so," he tells me. "Spread and keep your fingers pointed straight. Do not move!"

For the next two hours, my back and hands aching, I stay in that position while the students pull their easels up close and fix their gaze on my fingers. The sounds of horses clopping along on the cobblestones below, people greeting each other as they pass, and music from an accordion, drift through the open window. The eager students sketch my hand with their charcoal pencils, occasionally uttering the involuntary grunts of their efforts, and only glancing up at my face when they need to rest their hands. At the end of the time I get up stiffly from the table and smile when *Monsieur* hands me three well-worn copper *sous* as I head

for the door. "Can you return tomorrow?" he asks. "Many of these, shall I say, gentlemen, have not yet finished this simple assignment. Then we go on to something new."

Leaving as quickly as I can, fingering the coins in my pocket with a smile on my face, and feeling a thrill of accomplishment, I hurry down the stairs onto *Place Pigalle*. The workingwomen are gathered in the small garden in the center of the plaza, passing their brief lunchtime gossiping. I give the man playing the accordion, with a tin cup set on the sidewalk beside him, a smile and a nod, but don't drop anything in his cup.

Hurrying for the *café* in *Batignolles* where I promised to meet Leo for lunch, I hear footsteps, and a man's voice calls out behind me, "*Mademoiselle* Dobbins, please wait."

Turning around, I see a very tall young man, with dark hair and well-trimmed beard, coming quickly behind me. Standing beside me I'm struck by how handsome he is. His facial features are well formed and pleasant to look at—fine straight nose, broad forehead, firm chin—but what captures my attention most compellingly are his strong, dark brows, almost joining over his nose, and his deep blue-gray eyes recessed beneath them. Feeling a pleasant sensation run through me, I smile but wait for him to speak.

"*Mademoiselle* Dobbins, I saw you modeling when I stopped into Suisse's studio this morning to speak with him."

"Oh?" My smile changes to a questioning look, but I still wait for him to continue. He has a shy look, perhaps a little embarrassed to go on now that he has approached me, and he hesitates a moment before speaking.

"It is your eyes, *Mademoiselle*, the most enchanting dark eyes I have ever seen in a young woman. Almost black, but flecked with little spots of gold. They are lovely, and your lashes give you a look of youthful innocence."

I give him a slight curtsey to acknowledge his compliment. "*Merci, Monsieur,*" I tell him.

"If I am not too forward or out of place I wanted to ask you if you would sit for me."

"*Monsieur* Suisse has already asked me to come back tomorrow."

Quickly interrupting me, he says, "No, *Mademoiselle* Dobbins, I mean in my studio. Let me introduce myself, I am Frederic Bazille."

"You have your own studio?"

"Oh yes," he answers with more confidence in his voice. "I rarely go to Suisse's anymore these days, but I am glad I went today and saw you. You are a beautiful young woman with captivating eyes. I want to paint you. I will pay, of course, and more than the stingy Suisse."

For the first time, I study Frederic Bazille's clothes—all clearly of fine fabrics, well sewn, clean and perfectly fitted. Looking back into his face, I can't help giggling a little. "So you are not a struggling student like the others?"

"I am fortunate to have a father who supports me... although he would prefer I become a doctor. And I have made a few sales at the Salon," he adds. "Will you model for me?"

Despite feeling my good fortune—*sous* for modeling this morning and now another modeling job—I shrug my shoulders, an unintended gesture of frustration. "I will be pleased to sit for you, *Monsieur*, but you should know I am intent on becoming an artist myself."

"Then you are wasting your time at old Suisse's studio, *Mademoiselle* Dobbins. He rarely teaches anyone anything. He only walks around the studio looking over everyone's shoulders and mumbling to himself."

"How will I ever get the training I need then?" I ask him with a sigh, and look away across the plaza.

"Go to the *Louvre Museum*, get a permit to be a copyist—they're free—and go there whenever you can with your drawing supplies to copy the paintings. In doing so you will begin to understand how the great artists achieved their masterpieces. That is what I did after leaving Suisse. But please, *Mademoiselle*, send me word when you will come to my studio to pose. I will need you for several sittings... and pay you well for your time."

I am breathless when I arrive at the small *café* on *rue de Rome*. I can't get the pleasant image of the tall, handsome Frederic Bazille out of my mind. Not only has he been quite insistent in asking me to pose for him, but he has also given me the first step toward becoming a real artist. Seeing Leo waiting for me at a table tucked into a back corner near the kitchen door makes me frown just briefly. I will it away and hurry to him, trying to clear my thoughts of Bazille. "I modeled at the school you told me about, Leo," I say coming to his table. "I got paid. Thank you. I am sorry I was rude to you at the dance." It all comes out in a rush.

Leo's face darkens for just an instant and then becomes a smile, like a dark cloud passing the sun. "That is good, Emma. I know how papa counts on you to help."

The thought comes suddenly to me that one day I might live on my own. I brush it aside as not unrealistic. Around me, the low-voiced conversations of the *café's* customers create a collective buzz, like flies around seaweed I remember on the beach.

I'm glad Leo and I have some measure of privacy back in this corner. Breathing the warm savory aromas coming from the kitchen in deeply, I settle on the high-backed wooden bench next to him. The proximity of his hip almost touching mine gives me a tingle of excitement. Leo seems proud sitting next to me, and I can't help noticing how he preens and looks around to see

if others see him sitting with a beautiful young woman. I'm more than that, I chide myself for the thought, but he doesn't see it.

"I am glad Grace rescued you at the station," he says. "Glad you and my sister have become friends. I'd like to spend more time with you, Emma."

The image of handsome Frederic Bazille flits through my mind.

"If you feel the same way perhaps we could go to the park Sunday, just to talk and know each other better."

"That would be nice, Leo. Would Grace come along with us?

"No, just you and me on Sunday."

I smile. "That would be nice," I say again. "And I will wear a fine dress for you. Maybe I'll buy a new one."

"Don't be too extravagant, Emma. Your old one would please me just as well. To me you look fine in whatever you wear."

I can't get over thinking how lucky I have been since coming to live with the Durands. "Oh, I almost forgot," I tell him. "An artist I met this morning wants to paint me. He asked me to pose in his studio."

All of a sudden, it seems the entire *café* has gone silent, and all the people are now giving me their disapproving looks. But then I realize it is only Leo doing that.

He stares in disbelief, a pained look on his face as if someone had just kicked his dog. His hand comes up from the bench where it had rested, barely touching mine, and grabs the edge of the table. Looking straight ahead, not at me, his words seem harsh and clipped, and make me feel like crawling under the table. I can't understand what has come over him. "Young ladies don't go to men's apartments or studios without a *chaperone*," he says.

I stare at him, speechless. It takes me several moments to gather my words. "I like being with you, Leo," I tell him, "but I

want you to know right now that not you or anyone else has the right to tell me what I should and should not do. I intend to live my life freely, as I see fit, not how someone tells me to."

CHAPTER FIVE

August 1869

"*EXCUSEZ-MOI, MADEMOISELLE, puis-je vous aider?*"

Turning to look at the voice coming over my shoulder, I see a tall, slender, almost thin woman, probably in her late twenties, with hair as dark as my own, and brooding eyes set deep in her long face, standing beside me.

"*Oui. Merci.*" A look of relief replaces my intense concentration. "I don't know where to go."

"*Oui.* The *Louvre* is that way. Your first time?"

I nod apologetically. "*Oui, Mademoiselle.*"

"I have been coming here a number of years, and yet I still must pause to consider my destination. Can I guess by the sketching pad in your hand that you are an art student? I am too, so perhaps I can help."

I look down, feeling slightly embarrassed. But then, sensing the woman's good intentions, relax. Looking at her and smiling, I tell her, "I have never been in a museum before today. I don't know anything about the great French artists of the past or their masterpieces."

"No great museums, *Mademoiselle?*

"I came from California."

"Come with me. My name is Berthe Morisot, and it will be

63

my pleasure to introduce you to France's greatest museum." She hooks her arm with mine and leads me to the *Louvre's* Grand Gallery.

I am awestruck walking arm-in-arm with her down the magnificent hall lined with large paintings in ornate gilt frames. I turn my head from side to side like a nervous bird, trying not to miss anything. Breathless from keeping up with her, when Berthe Morisot stops in front of a large canvas, my head is swirling with the dazzling panoply of images we have passed.

We stand in front of a painting depicting a procession of richly dressed men and women walking downhill on an island toward a barge at water's edge. She pauses a moment for me to take in the details of the scene. Then, with a teasing gleam in her eyes, she says, "This painting is more than one hundred years old, painted by Watteau, one of France's greatest artists. Tell me what you see."

I gulp, not sure where to start, so I say the first thing that comes into my mind. "The colors—they are beautiful—bright and pure. The contrasts draw your eye from place to place on the canvas."

"*Bon*, now tell me about the people."

Warming to her challenge, I tell her, "They are all in their finest clothes... I think they must be lovers—they are all coupled together."

"One more question," she asks. "Are they coming to the island or leaving it?"

I have to pause and study every detail of the painting carefully, looking for clues. Finally, gathering my thoughts, I tell her, "It is hard to tell. It could be either. But I think they are leaving the island. There is a kind of sad atmosphere about the picture— look at the mist in the distance—as if they don't know where

they are going. It's as if they have spent a happy afternoon of love and now they must depart."

"Very good. You have an artist's eye for details. If you come often you can study all the great works in this gallery. When you are more comfortable you can start to sketch them on your pad to better understand how the artist accomplished his masterpiece. Then you can set up an easel and try to copy them. I am often here, so perhaps we can sit together for tea afterward and talk about what we have done."

"Thank you. I'm sure you can teach me a lot."

"You have much work ahead of you if you truly want to be an artist. It is not an easy road for a woman, I can tell you. You must dedicate yourself to the work and let nothing else matter."

The gray dampness of my second winter in Paris lurks ahead, like an unseen assassin hiding from the debauching revelers in Watteau's painting. The sun is timid and tepid, but the people in *Batignolles* act as if they don't know winter is about to descend upon them. They cling to the good memories of a lost summer. Children noisily welcome the waning sunshine in *Parc Monceau*, and young lovers flock there in search of one last *unchaperoned* afternoon.

Wearing my new olive green dress, with its cream-colored mantle over my shoulders and tied in front, and Leo in his Guards uniform, we stroll the boulevard together. Entering the park through the gold-trimmed wrought iron gate, he pauses and reaches for my hand. "I am so glad to be able to spend time with you, *Mademoiselle* Dobbins. You were a welcome sight when I called for you."

"If we are going to walk about freely in public perhaps it is time for you to be less formal and call me Emma," I reply.

"Your new frock is very attractive, Emma," he says, delighted in using my given name that he pronounces awkwardly. His smile broadens into a grin that shows most of his teeth and crinkles the skin of his cheeks. "You look quite handsome today."

I acknowledge his compliment by lifting the hem of my skirt just slightly and curtseying, oblivious to the smiles and snickers of passersby. I feel a swell of happiness at his attention. "I know you do not approve of the way I earn my living these days at the art school but the money I earn has paid for my new dress."

He emits a low grunt of displeasure, but steers the conversation into safer territory. "Shall we walk down toward the carousel?"

He starts to offer me his arm, but tactfully I withdraw it out of his reach. "Did you know Grace and I sat by the carousel when I first met her?" I ask him, giggling at the memory. "I didn't know any French then, but we used hand signs to communicate with each other."

Several couples chatter back and forth as they hurry past to get on the carousel before it starts up again.

"My sister loved riding that carousel when she was younger," Leo says proudly, returning his hand unobtrusively to his side. "It was my job to make sure she stayed safe."

"And you still protect her. I saw it at the *café-concert*."

"French families are very close."

As we walk, the sounds of the calliope, set in a small grove of tall trees, grows louder, along with the shouts and squeals of delight from the children riding the carousel.

"Would you like to ride?" he asks.

Before I can answer, he spots Grace on the far side of the carrousel holding hands with Martin Aboud. Ignoring me, he quickens his steps toward them. I'm jolted from the pleasant feeling of being with him to a new sense of dread as he drags me along.

Grace tries to shield Aboud when she sees her brother hurrying toward her, scowling and gritting his teeth as he comes. The sweet softness of her round face morphs into a belligerent mask. She seems set for an impact.

"Leave us—" She starts.

Before she can get another word out, Leo confronts her in a voice loud enough to startle the parents and strangers standing around the carousel. "You are shameless!" He accuses her. "Look how you act in public with this country peasant!"

"Leave us alone," Grace finally gets the words out. "I am old enough to court whoever I want."

"Not while you are living in your father's home," he shoots back, his hands on his hips. "You embarrass yourself with the way you act in public. Worse, you bring shame to the fine name our father has given us."

Still holding on to her hand, Martin Aboud steps in front of Grace. He leers at Leo, showing his yellowed teeth. "*Bonjour, Leo,*" he says with a taunting grin on his face. He nods briefly to me. "*Bonjour, Mademoiselle.*"

"You look a disgrace to be with my sister."

I take a good look at Martin; Leo is right. Wearing a faded pair of pants, soiled with ground-in stone dust and mortar, and held up by old suspenders, I agree he is not appropriately dressed to be with her. His white shirt is sweat-stained, showing years of hard use. He has rolled his sleeves up above his elbows again, showing muscles that bulge on his biceps and forearms.

"I am a simple workingman and proud of my craft," he replies. "And you look like a toy soldier ready to parade in front of your emperor."

"The Emperor of France, you mean."

"Not my emperor!" Aboud balls his hands into fists defiantly.

"I am sworn to defend Louis Napoleon and our country. This uniform is my badge of loyalty." Leo takes a confrontational step closer to Aboud. "I do not like the way you insult the emperor."

Grace and I are paralyzed, watching the men face off again like rutting bulls. They look at each other with anxious eyes, as if each wants the other to be first to say something, or take some action that will disarm the conflict. Grace edges away from Martin Aboud. I step closer to her. A crowd begins to gather at a safe distance to watch the combatants square off.

"Defend the emperor is it?" Aboud almost shouts. "More likely he will lead you into a war of his own making against Prussia." He steps closer so they are now standing nose to nose. He looks hard into Leo's face.

"To the glory of *La Belle France!*"

"To the glory of Napoleon III, you mean. Most of his subjects despise your emperor. I do! He gives Parisians new boulevards and parks while the rest of the nation still pisses in the streets, and spends their days eking out enough to feed their families each night. Your emperor will fall just like his puppet Maximilian in Mexico. And the people will cheer!"

Leo lunges at him, his fist barely brushing Aboud's face. Then they grapple, clinging to each other like dancing bears going round in a circle, each locked in the other's grip, trying to gain the advantage over the other, swaying back and forth on the grass of *Parc Monceau*. People cluster around them watching open-mouthed at the spectacle. Some start to cheer for one or the other, while the steam calliope whistles its tune for the children's entertainment.

"Stop it, you two!" Grace shouts over and over. She grabs at Martin's arm and tries to tug him out of Leo's grasp. I stay frozen for several moments. I don't understand what brings men

so easily to do stupid things like fighting. I grab Leo's tunic and plead in his ear to stop. The four of us seem locked together in a kind of macabre dance back and forth on the grass. Finally, each one, winded from his initial assault, and as if by some unseen agreement, they let go of each other. With still-clenched fists, each trying to show a more threatening scowl than the other, they take a step back. Grace grabs Martin by the arm and pulls him down the path toward the main gate. I lead Leo in the opposite direction, toward a *faux* Roman folly standing on the near side of a small pond beyond the carousel, where fallen leaves float like toy boats on the surface.

He stops, leaning his back against one of the stone columns, gasping for breath, and trying to calm his aggression. My emotions swirling inside me standing at his side. How can I be drawn to a man so quick to anger? I ask myself. What would life be like with him? And yet, at the same time he can be so caring of me. I look deep into his face, searching for answers.

"*Merci*, Emma," he says at last. "You saved me from a fight I did not want to have."

"Why does Martin irritate you so much?"

"You wouldn't understand. You're not French."

"Understand what?"

"Aboud is a peasant from the south. We are Parisians. He is below our class. Grace should find a better match among our own people."

"Does it matter that much? They seem happy together."

"Yes, it does matter. Our whole world revolves around everyone knowing his or her place. My family is not royalty, not even *bourgeois*, but not peasants either. It would be folly to try to be otherwise. Aboud will drag Grace down to his level."

I feel my body stiffen and look aggressively into his face. "What

about me? What class do you put me in, Leo? I am the daughter of a worker. I cleaned the toilets in the *Gare Saint-Lazare* for six months. Does that make me a peasant?" Saying the words, my eyes stay steady on him. I feel repulsed by his assertion, but I'm more confused than angry. Why is everyone in Paris assigned a class? Who assigns them? And why can't they move from one class to the next if they try hard enough? I give up thinking about it. It is really not my concern. I am fond of Grace and her parents, appreciative of them taking me in, but really I'm only here to learn my craft, not be a part of their culture.

Leo rubs his chin. He runs his hands through his close-cropped dark hair, seeming perplexed. After a moment his face gives up its darkness, replaced by a wide smile that brings a flush to his cheeks. "You are a special girl," he starts. "A girl I think God has sent my way. I think you were meant for me—I thought that the first time I saw you standing on the sidewalk." Without warning he reaches out for my hand, and when he has it, pulls me closer. "I feel as if we could have a good future together if you are willing," he says, his face so close to mine I can feel his breath. Abruptly, he takes my face in his hands and pulls me even closer. He plants his lips on mine.

❧

That evening, in our nightdresses, Grace and I sit on the edge of the bed we share, each of us quiet and reflective, reluctant to face the implications of the afternoon's events. She gently runs a brush through her hair, seeming to me as if all her thoughts are far away.

"You have very pretty brown hair and take such good care of it," I tell her to soften the silence.

"Martin likes touching my hair. He tells me how soft it feels,

but I wish I had dark hair like yours."

"We always want something we don't have."

We look at each other and laugh, but I am thinking about what Leo had told her, picturing how Aboud looked in the park.

"Men are so stupid!" Grace's words surprise me, but I nod and wait for her to go on. "Didn't they look like big dogs today, with their paws up on each other's shoulders? I think it was good for my brother that they didn't actually fight—Martin is so much bigger and stronger."

I want to respond in defense of Leo. Instead, I say, "Your brother is very protective of you. It must be nice to know how much he cares about you."

Grace sets her brush aside. "Nice? I don't know, Emma. I love Leo, but I am nineteen now, able to make my own decisions, and Leo needs to let me. I'm fond of Martin for all his faults. He may be the best I can hope for. After we left you and Leo, he took me to a small *café* on the boulevard. He drank a couple of beers and we talked for a long time. He thinks the workers of France might one day overthrow the emperor like they've done before. I don't pay any attention to talk like that, but it scared me when he said it. Did Leo calm down?"

I think twice before rushing to answer, searching for the right response. I don't want Grace to laugh if I make too light of it, and on the other hand, I don't want it to sound too serious. "I wasn't expecting it," I start finally, "but your brother kissed me as we stood by the folly looking into the pond."

She doesn't laugh but I can see the startled look in her eyes.

"Has Martin kissed you?" I ask.

Grace blushes. She looks down, away from me, before nodding her head. "Yes," she says finally, very quietly. "Once. It was my first kiss."

"I've been kissed before. In Santa Barbara when I worked in the hotel."

Grace gives me a very suspicious stare, as if in disbelief. "What was it like?"

One afternoon, after all the beds in the hotel had been remade and the noon dishes washed and reset on the tables for supper, I left the kitchen with my precious mahogany watercolor box under my arm. Across the backyard, I saw a splendid gray Arabian mare tethered outside the stable the hotel maintained for its guests' horses. Approaching cautiously, my hand felt the mare tremble at my touch as I caressed her velvety nose.

When I sat on the bench beside the stable door to begin sketching her, a voice called out from inside, "What are you doing? That's not your horse. Why are you here?"

Startled, I saw the stable boy standing in the doorway behind me and I got quickly to my feet. He was tall, with wavy black hair and dark eyes. His skin was the color of coconut husks. I felt accused, as if I had invaded the private world this boy inhabited. But he had a gentle face, with finely drawn features—a face like no other I had ever seen before. For a moment its handsome features took my breath away.

"Can I help you put the mare away?" I asked him. Walking into the stable, I stammered, "I just wanted to help."

The boy's face lit up with an ear-to-ear grin. "You can stay and talk. I don't have many visitors. I'm José."

"Sure, but only until I have to help serve the dinner. I'm Emma."

"Come with me." José led me into the back corner of the

stable and pointed to a ladder." Can you climb up? It's very comfortable up there... We can talk if you're not afraid."

"Course I'm not afraid. I climbed an iron-runged ladder into the lighthouse tower most evenings with my papa. I can do anything you can." Almost shoving him aside, I climbed up first.

"Sorry," José said when we were both settled on the straw covering the loft floor. "I don't know the right things to say to a girl."

I awarded him a smile and surprised myself by reaching out to touch him then quickly pulling my hand back. "Oh, sorry," I said.

"Look at us. We're misfits who don't know how to act."

"I'm not very comfortable around other people either."

José watched as I paused to collect my thoughts, but didn't speak.

"It was different at the lighthouse," I started. "I always had to do for myself. I liked that—didn't know any different, really— but I did what I wanted and never thought about what others would think. Never had to dress up or learn to be polite. There weren't any children to play with, so I was always on my own."

"How old are you?" He asked.

"Almost fourteen."

"I'm almost fifteen. Tell what it's like living in a lighthouse. Didn't your momma teach you your manners?" José interrupted.

"Momma left us when I was five—I don't remember much about her. My papa loved me. He took care of me until he died, but he was busy working most of the time so I could do whatever I wanted."

José's face held an understanding grimace. "No one ever paid me any attention either," he said. "I learned to take care of myself. Stayed away from other people." He moved a little closer to me.

"A minute ago, when I touched you, it seemed such a strange feeling," I said to him. "I pulled back. I'm not accustomed to touching anyone."

"Didn't you ever kiss anyone?"

"Oh, no! Only my papa."

"I don't think that's the same as kissing a boy. Would you like to kiss me?"

"Would you want to?"

"I don't know...Yeah, I guess I would. If you kiss me back."

"Go ahead. I won't mind."

José leaned closer. Tentatively, he brought his face up to mine. Our lips touched for just the briefest of moments. We both pulled back.

"That wasn't very good," I told him. "Let's try again."

This time I held steady as José moved close enough to lightly rest his hand on my cheek. When our lips met, we held them together for several seconds that felt like an eternity, before I pulled back. "That felt funny," I told him softly.

"Felt strange to me, too."

We stayed sitting close together, but each of us looked away. Unsure what to say, but not wanting to hurt José's feelings, I said, "Maybe we don't know the right way. Or it's something you have to practice."

He nodded agreement. "When I touched your face I felt a little shiver, but nothing from the kiss."

"One time at the lighthouse one of the keepers touched me, and I remember having that kind of shiver... I don't know if I liked it or not."

"Where did he touch you?"

"Here." I put my hand on my blouse to show him.

"Can I touch you? Your blouse?"

"My breast?"

"Yes."

"No. I don't think that would be good. My father didn't like

the other keeper touching me."

"Can I look at your breasts?"

I had to think about that for several moments, but I couldn't find anything wrong with it. "Sure," I said. "I don't mind you looking. At Point Conception I often went without any clothes. But you have to take your clothes off too."

"All of them?"

"Okay!"

Can I touch you?"

"You can if you never tell anyone."

Grace frowns. "You're different than my other friends. You're more adventurous. I've never let Martin touch my breast. Not till I'm married, *maman* says."

After we are both silent for several moments, I say, "This might be difficult for us." When she still doesn't say anything, I reach out for her hand. "Do you want me to find another place to live?" I ask in a timid voice.

A fierce look comes quickly into Grace's eyes. "Never!" she says too loudly. "I don't want to lose a friend like you—not over two foolish men, not for anything. I want us to be friends forever."

CHAPTER SIX

September 1869

WALKING ALONG BLVD de Batignolles, heading toward Suisse's Art School for another morning of posing several weeks later, my thoughts come back to Leo. I'm troubled by his impetuous kiss at *Parc Monceau*. I wasn't ready for it. And I am not prepared for any kind of commitment with him. I'm fond of him, but nothing more, and his kiss did nothing to change how I feel. More troubling for me, really, is what effect his feud with Martin Aboud might have on whether I can continue living in the Durand apartment. That it might drive a wedge between Grace and me is a worry I can't shake. I don't earn enough to afford a place of my own, and it would take more than occasional modeling jobs at Suisse's to change that.

Crossing *place de Clichy* deep in thought, I'm oblivious to the shouts of draymen cursing their stubborn animals when double-decked omnibuses and black *fiacres*, carriages for hire, jam the intersection, blocking their progress. I hardly notice men in dark suits and women out on daily errands crowding around me to avoid being splashed by water running in the gutter when vehicles drive by. Finally crossing to *blvd de Clichy*, I'm startled out of my reverie by a crowd of workingmen in overalls and blue *blousons* milling around on the sidewalk, spilling out into

the street in front of a small *boulangerie*. Their rough shouts and curses overwhelm the street noises. Going closer, I see the men are milling around, shouting curses at each other. A few flail their fists. Cautious, but curious, I approach the melee to get a better look. I'm startled to see they are fighting over crumbled and crushed *baguettes* strewn about on the sidewalk. They push and shove each other so they can reach down to pick up the trampled bread. From nowhere a man carrying a bruised *baguette* darts out from the crowd and grabs my arm, forcing me back from the mob.

"*Salut, Mademoiselle* Dobbins. It is not safe to get too close to these men. Stand back here with me."

"What are they doing?"

"Picking up the bread."

"No, I mean why are they doing it?"

"When they came for their *baguettes* this morning the men found the baker had raised his price overnight and they became angry. They started shouting. Then a few men rushed into the shop, swearing they would not pay the higher price. They dumped all the *baguettes* on the sidewalk. More men fought to claim the free bread—that is what you are seeing now."

I point at the crumbled *baguette* in his hand. "You picked that up off the street, Martin?"

"*Oui, Mademoiselle*, bread is precious, worth fighting over. It was not right that the baker raised his price. Workingmen can barely afford bread. The price of all our food goes up, but our wages do not." Aboud gives vent to his frustration with a helpless shrug of his shoulders. Then, weakly, he tries to smile at me. As he does, two men, arms loaded with crumbled *baguettes*, rush past.

"Grace's brother does not understand, *Mademoiselle*," Martin continues. "He is blinded by his military service and his

misplaced loyalty to the emperor. He does not see how angry we are. The emperor's government does nothing to help us. This can't go on much longer."

"Men actually fight in the street for a trampled *baguette*. I would not have believed you if I hadn't come this way."

"*Oui*! I am sorry you had to see it, but it is our reality. It is the way we live. I fear another revolution is coming, *Mademoiselle*. Then we will all lose our work, and the fighting will be cruel, no? But the emperor does not see it coming. He postures to the other nations of Europe that France is so great and powerful."

Impressed by seeing his words playing out in front of me, I compliment him. "You are such a smart man, Martin."

He gives me a wry grin. "No, *Mademoiselle*, not smart. If I were smart, I would have had myself born into a *bourgeois* family, not a family of three generations of stone-cutting peasants. Better still, born like you outside of France so I could arrive here without a past, free to join any class I cared to."

"You think that of me?"

"You are fortunate not to have been born into a life where there is no possibility of improvement, yes." He continues staring at me and finally asks, "Would you go with me to a *café* sometime?"

I ignore his question. We stand silently together a few more minutes watching the men scuffling on the sidewalk. Then I feel a gentle hand on my shoulder. Turning to see who is behind me, my heart stops.

"*Mademoiselle* Dobbins, how lucky I am to finally find you again. I didn't know where to look."

Not wanting to show too much excitement in seeing Frederic Bazille, and perhaps wanting to punish him just a little for his failure to keep his word, I stay silent, looking at the men for several seconds still scooping up the *baguettes*. Then, turning to

him with a blank look and a neutral tone of voice. I ask him, "Why didn't you leave a note for me at Suisse's?"

"*Oui*, I did," he says. "Over a week ago." His face has a concerned look. "When you didn't reply or come to my studio I thought you were no longer interested."

"Of course I am interested," I tell him with new excitement in my voice.

"Old goat Suisse never gave you my note, did he?" he says.

Martin gives Frederic an appraising look, seemingly undecided whether to walk away or join our conversation. Finally, he thrusts his hand out and introduces himself. Then, turning to me, he says, "Is this a friend of Leo's?"

"No, Martin," I grimace. "This is *Monsieur* Frederic Bazille, a very successful artist who wants to paint my portrait." I exaggerate and puff up a bit.

"What brings you here this morning, *Monsieur*?" Aboud asks.

"Like the rest of you, I came for bread and some cheese. I didn't expect to have to pick it up from the gutter though." He laughs awkwardly. "Friends of mine are waiting for it at my studio, but I see I am too late. All the good *baguettes* are already stepped on."

Aboud laughs. "Lord give us this day our crumbled bread," he replies. "If you don't tell your friends and brush the dirt off you might salvage a few pieces. If your friends are as poor as the rest of us, I'm sure they will be content." He laughs again, a mocking, kind of laugh. Addressing me in a lowered voice, he asks again if I would meet him at a *café*.

Hoping to change the tone of the conversation, I tell Frederic, "*Monsieur* Aboud is a friend of my friend Grace. I share lodgings with her. When is it you want me to sit for you? Old man Suisse was probably afraid to share me for fear of having to pay more."

"Indeed," Frederic says, "The sly fox! Can you come back with me to my study now so we can talk? It's just a short walk back on *rue la Condamine* and you can meet my friends Renoir and Monet. I'm sure they'll survive a day without me feeding them."

My face brightens. "That's close to where I live."

We bid Martin Aboud *adieu*. He has a disappointed frown on his face as we walk away.

While walking toward his studio, Frederic says, "Really, I share the studio with Renoir—do you know him? Neither of us sells many paintings just now, but we will. Until then we share the studio to keep expenses down. Monet is also a friend who often comes for free food."

"You are a generous man," I tell him, looking up into his face and holding on to my bonnet with one hand as I hurry to keep up with his long strides.

"And you are a very pretty girl," he responds.

His compliment startles me. My earlier thoughts are forgotten.

"I am fortunate," he says, "fortunate to have a father who gives me an allowance. I try to help out the others."

Rue la Condamine is a narrow residential street crowded on both sides by similar five- and six-story, hundred-year-old stone apartment buildings. Frederic's studio is on the fourth floor of a tired looking one. Together we climb deeply grooved stone stairs worn thin by years of footsteps. On the landing, he removes his top hat and ducks down to get through the studio door.

Inside is one large room, with walls thick with unsold canvases in various stages of finish. Some are framed and hung, others are stacked along the floor, one propped up in front of the next. A desk is set near a floor-to-ceiling window with abundant light pouring in, and a small piano stands next to the desk. Two easels are set apart near the window. On the wall just to the left of the

entry, a staircase climbs to a sleeping loft extending halfway over the studio.

Two men rush to meet Frederic when we enter but stop short when they see me. He introduces the man on the left as Monet, with Renoir standing next to him. I smile, offering a restrained greeting as the two unabashedly give me a thorough examination with their eyes. Monet is a bearish man, with a rounded face and piercing eyes. Only average in height, his dark hair is thick, and he sports a full beard and mustache that hangs over his lip. "Where did you find her, Bazille?" he asks in a coarse voice. "Have you been hiding her from us? And where is my *baguette* and cheese?"

"Just look at this charming girl," Renoir says. He grabs my arm and pulls me toward the window. "Come over here so I can see you in the light," he says.

"I have been imagining the cheese and a few pieces of fresh *baguette* all morning," Monet sighs when Frederic tells him what has happened. "I think I must not have eaten for at least a day. Maybe longer."

"Now turn to the left, *Mademoiselle*," Renoir commands. He is shorter than Monet, a sad-faced man with heavy-lidded, sunken eyes, thin cheeks, and a drooping mustache that gives him a sad look. "Let me see how the light strikes your hair and face. Now to the right. Chin up. There, can you see it, Monet? Her dark hair and eyes in the sunlight? Haunting eyes, yeah?"

"Her face is perfect," Monet concedes.

"She has fine breasts, too, for a young woman. A little small perhaps."

I push him off. "Enough! *Monsieur* Renoir, you are rude! You are holding me too tightly. Let go of me!"

"Renoir, just Renoir," he snaps. "And my starving friend here is just Monet."

I give Frederic an imploring look that begs for his help.

"She is going to pose for me, *Messieurs*," he announces, coming to stand next to me and putting his arm protectively on my shoulder. "I found her. Isn't she charming? I want the whole world to know her. Look at the innocence in her eyes. I have several projects in mind. You can't use her." He takes my hand, leading me away from his two friends.

"I think I should leave now," I tell him, a bit shaken by Renoir's rough words and handling.

"They are really good men—my best friends," he assures me. "Just a little overwhelmed by your handsome appearance, *Mademoiselle* Dobbins, as I am also. Are you able to find the time to pose for me in the next few days? I would like to start as soon as possible."

I give him a frown. "I do not expect to be treated like a plucked rabbit in some *boucherie* window, *Monsieur*. I demand more respect than that."

Renoir rushes to my side. "*Desolé, Mademoiselle*. I was having fun with Monet at your expense. Do forgive me."

"Oh, *Mademoiselle*," Frederic says. "I could never treat you poorly. I want us to be friends, to know each other better. I have thought about painting you ever since we first met." He pauses for a moment to cast a look at Renoir. "But in truth, you must know how a painter like Renoir sizes up every woman as a potential subject. And he is jealous I found you first."

"No, I don't know about things like that." I give him a pouty look. "I have not known any men except my papa and the other lighthouse keepers. They were not rude to me like he is. I was treated with respect, and no one ever spoke about my appearance."

"I will respect you, I promise," he says. "I want to capture

your innocence on canvas to share with others. Please say you'll pose. I promise to treat you with respect."

"For a fee—that was our agreement."

"Can we start the day after tomorrow? I will gather the clothes I want to paint you in. How about first thing in the morning so I can capture the early light on your face?"

⁓

When I emerge from behind the privacy screen Frederic has set up for me, he is still adjusting the canvas on his easel and fussing over an array of brushes. When he looks up, he grins broadly, "*Voila!* Perfect. Captivating."

For the portrait, he has me sit on a bench facing left but with my head turned directly at him. I'm wearing a white cotton dress with pink stripes, and an embroidered, modest neckline. A large rose-pink ribbon is around my waist, tied in a bow in back, and a narrow black ribbon around my neck. Coming across the room, he hands me a delicate bouquet of flowers, and he tells me to hold in my clasped hands. Then he takes a slender ribbon, the same color as the one on my dress, and very gently pulls my hair toward the back of my head and ties the ribbon to hold it there. He stands back and inspects. "*Voila*," he says again. "I will do the background later. For now, I want your head tilted ever so slightly down so your eyes are looking up at me, so." He continues to stand close, close enough that I feel a rush of excitement, a tingle at the base of my spine, as if he is about to throw his arms around me. Very gently, the fingers of his right hand make the final adjustments to the ribbon in my hair. His light touch on my cheek as he does gives me another shiver. As he steps back, I think I might have felt his lips brush my forehead.

"Are you cold, *Mademoiselle*?"

"Oh...no... I'm fine," I tell him, feeling a little embarrassed.

Then he goes back to the easel. "I hope I can do justice to you," he says as he sits and takes up a charcoal pencil and begins to draw.

It takes all the willpower I can command over the next several hours to sit without moving. The tiny bouquet begins to feel awkward in my hands. My arms no longer feel like they're a part of me, and my neck is numb from turning toward him, but I continue to look intently into his face. He looks up at me, smiling, and then back at his easel several times. It gives me a wonderful thrill that a man is looking at me and having pleasant thoughts. It eases my discomfort and makes the time go by quickly. I don't want it to end.

Finally, he puts the sketching pencil down and stands up. "Enough!" he says. "You are a fine model, Emma, you don't complain like the other girls do."

I can't help a wounded look. "Have you had a lot of other girls pose for you?" I ask.

He responds with surprise. "Of course, a few... Why do you ask?"

I pause, embarrassed, then tell him, "No reason. For a while I was imagining it was just the two of us—me giving the flowers to you. Silly, *n'est-ce pas?*"

"I've never had a model like you before," he assures me then changes the subject. "I will want you here more times."

Over the next weeks, I go back to Frederic's studio several times so he can finish my portrait, earning two *francs* on each visit. He has added color to my image, but the rest of the canvas is still blank. He also has done several quick sketches of me in other poses. When he allows me to see how he's painted me, I'm breathlessly excited. Very unprofessionally, I throw my arms around him and hug him in my joy.

"I don't know what to say," I whisper into his chest.

Our embrace feels uncomfortable, tense and awkward for a moment. Then he relaxes and gently pushes me away. "Just saying you like it is enough. I will add the landscape in the background when I go home to *Montpellier* next."

Sensing his discomfort, I step back, wondering if I've offended him. "You must think me a silly young girl," I say.

"Not at all," he answers, but his words come slowly.

He looks away so I can't read his face. I feel I ought to leave, but I'm not ready. Crossing to the large window, I look down on the lonely street. The only life I see is an old man in a black suit, top hat and walking stick, leading a small dog down the sidewalk. He stops when the dog squats, and then they continue on.

Frederic follows me to the window but stays a step behind.

"I guess you will be on to another painting soon enough," I say over my shoulder.

"I guess I will," he replies in a soft voice. "I would like to do more canvases with you as my muse."

Turning around, and taking a deep breath, I step closer to him. "I should be leaving now so you can get back to your work. I would be pleased to sit for you again whenever you ask."

He stays close to me. "I am not busy. You are welcome to stay a while if you like. We didn't talk much while I was painting. I'd like to know my muse better."

"You looked as if you were concentrating, so I didn't want to interrupt you."

"I was trying so hard to get you just right on the canvas, the way I see you."

"You did. It's beautiful."

"*Merci.*"

It feels strained so turning from the window, I start to the door.

"I'll be going then," I say, hoping he asks me to stay. "Thank you for hiring me."

He looks down at the empty street for a moment and then moves to the adjacent piano where he barely touches the keys. Finally, as I turn toward the door, he says, "Emma wait," still with his back turned. After a moment's hesitation, he gets up and comes across the studio to stand next to me again. The look on his face has changed to that of a small, insecure boy. "If I can be so bold, I would like to invite you to accompany me to the opera next week. Will you go with me?"

"The opera?" I'm startled, and can only repeat his words. "You want to escort me to the opera?" The look on my face must have been incredulous.

"I do. Actually, it is a ballet at the *Salle le Peletier*, the Opera House."

"I don't know what a ballet is."

He searches for words. Finally, he says, "It's like a play..." He stops and tries again. "It's a story told with music and dance but no words spoken. I know you will find it as enchanting as I do, and I would like to be the one to introduce you to it."

Looking into his face, embarrassed by the words I am about to say, yet determined to tell them unflinchingly, I grow serious. "You must think me a peasant girl in need of your charity, Frederic." I stop to take a breath then continue, "In a sense I guess I am. I grew up in a very primitive place, and had little education and no opportunity to learn about the things you take for granted—like ballet and opera."

His smile fades." I didn't know."

"No reason you should. Most of my life I've been on my own. My father raised me at an isolated lighthouse in California. I've had to make my own way since I was thirteen. I've very little

money, but learned to speak your language and earned enough to live on, but not enough for art lessons yet."

He put his hand lightly on my shoulder. "I don't see you as a peasant needing charity, Emma. Not at all! What I see is a beautiful young woman on the threshold of her life, quite capable of taking care of herself."

His hand on my shoulder gives me a tingly sensation, but I wonder what his intentions are toward me. "I don't want you to feel sorry for me."

"I have the means to introduce you to some of the glorious entertainments of Paris that I enjoy. I have no other motive, and I clearly don't feel sorry for you. Just say you will be my guest at *Salle le Peletier* next week."

"It is really quite out of the question," I tell him when he has finished. "I own nothing to wear that would be even close to appropriate for such a grand occasion. You would be laughed at—become the target of ridicule of the people who see me with you—and I would be embarrassed beyond anything I could possibly endure."

"I thought you might say that," he says, letting a sly smile bring a sparkle of mischief to his eyes. He continues to keep his hand on my shoulder, and his look adds to my excitement that I can't explain.

"If you agree to accompany me, I will provide you with an appropriate gown to wear—"

"Oh, no, *Monsieur!*" I interrupt before he finishes. "No, I could not allow you to buy me a gown."

"Not buy," he hastens to say, "Only provide it for the evening."

I step back and give him a scornful look. "How can that be? Do you have a closet filled with gowns you offer to young women to get them to go with you? Is that how you seduce them? Oh,

no, I could not possibly accept those terms." My words tumble out. I regret every one after I've said them.

He laughs softly. "I do not need to seduce young women with gowns or anything else," he says with a hint of arrogance in his voice, reaching out to take my hand. I start to pull it away, but think better of the idea and allow him to hold it. "I have no closet filled with gowns, only a dressmaker friend who lends gowns to me and other artists for our models to wear. She lent me the dress you wore in the portrait. She does it so other women will see her fashion designs and be attracted to her *atelier*. If you go to her, she will help you select a suitable gown and make any alterations needed. If you go now, she can have it ready in time for the performance. Tell her I sent you. I want to be surprised when I see you next week."

<center>⚬⚬⚬</center>

I fly back to the Durand apartment to share my exciting news with Grace late that afternoon. I give a quick *bonjour* and *bisous* to Clarise and then head to the bedroom. Grace is sitting on the bed we share, her legs crossed Indian-style under her, reading a tattered novel when I burst through the door.

"You will never guess where I am going, Grace," I blurt out too quickly, flopping down on the bed beside her.

She puts down the book and stares at me. Her thin lips curl up in a smile and she takes my hand in hers, trying to share my exuberant mood. "I could never guess in a thousand years, so tell me, Emma, tell me right now or I'll die of wonder—where are you going?"

"*Salle le Peletier*. Next week. The opera house, to see a ballet." The words spill from my mouth in rapid order.

Grace's face goes blank, all color draining out of it. She drops

my hand, and her eyes are dull with disbelief. "No," she says slowly, in a voice seeming to dread a further explanation. "How can that be?"

"With Frederic Bazille—the artist I've been sitting for. He invited me to be his guest."

Grace's mood deflates even further as she listens. A dark frown erases the sparkle in her brown eyes. "How can you? You hardly know this man," she says. "You must have a *chaperone*. Who knows what he might try to do?"

"Don't be a silly girl, Grace. We will be in public. I don't need a *chaperone*."

"All the worse," she retorts. "All those people will see you as a loose woman of low morals. You will get a bad reputation."

It's my turn to recoil in shock from her. I move to the edge of the bed. "Frederic comes from an *haute bourgeois* family in the south. He's a respected artist who attends the theater regularly." She gives me a penetrating stare. "What's wrong with you?" I accuse her. "You always think the worst of anything I want to do. Is it because of Leo? Are you trying to protect him?"

"No! Not at all," she cries. "No! It's because you want to go to the opera house—a place for people socially better than we are with a young man you hardly know. It isn't done in our world."

My first thought is about Grace thinking I am of the same class she is. Am I? For living with her? "Well, I am doing it!" I reject the idea "What is wrong with you French? Your whole lives seem governed by class rules. Who made them? They're not my rules. I do what feels right for me. This feels very right."

Stunned by my outburst, she stares at me in silence and sulks. A tear forms at the corner of her eye and starts a slow journey down her cheek. "If you go I will have to lie to papa and *maman* to hide what you are doing," she tells me. "Papa would throw me

out on the street if I did what you are going to do. I don't know what he might do to you." She wipes the tear away and combs her fingers through her hair. Then she becomes animated again. "You don't have a proper gown to wear. You will be laughed out of the theater."

"Frederic has thought of that," I tell her. "His friend is a dressmaker who will lend me a gown for the evening. I just came from her *atelier* where I picked one out and she fitted me. It is gorgeous—wait till you see it—bright red with black trim."

"Merciful God in Heaven can it get any worse?" She moans and turns away, burying her face in a pillow, beginning to sob.

Caught off guard, I look down at her. Then I lay down beside her, cuddling her in my arms, trying to console her. At the same time, my thoughts bring tears to my own eyes, but for different reasons than hers. Both of us sob side by side.

CHAPTER SEVEN

October 1869

BY THE EVENING of the ballet, Grace has suppressed her worries over what she calls my moral lapses enough to help me dress. She eases me into the long, red silk gown with embroidered ruffles and modest neckline.

She distracts her parents long enough to allow me to slip out of the apartment, telling them I am indisposed with monthly cramps and have gone to bed for the night.

For a moment I stand on the landing outside the door, listening to the conversation. "How much longer do you think *Mademoiselle* Dobbins will be living with us?" Hector Durand asks Grace.

"Now, now, *Monsieur* Durand," Clarise interrupts, "she is a fine young woman and brings great joy to our household...and I understand our Leo is quite smitten with her."

Grace stays quiet.

Downstairs, I wait in the building lobby for Frederic's carriage to arrive. The *concierge*, a wizened old crone with missing teeth and thick strands of dirty hair, comes to the door of her apartment and looks out. "Sneaking out with a lover, are ya?" She accuses me in a gravelly voice that speaks of too much whiskey. "I'll have none of yer whoring in my building so beware!

If I catch ya taking a man upstairs you'll be out on the street before ya can blink an eye."

I start to explain and then decide it's not important, turning my back on the churlish old woman and stepping outside. The evening sky is a shade of deepest sapphire blue, just before giving way to purple and black. The muted sour smells from the *Seine*, creeping up into *Batignolles* on the chilly December air are subdued. Even the ever-present stench from the gutters seems less offense tonight because of my excited mood. Gaslights along *rue Cardinet* are just beginning to make their presence felt when I hear the clip-clopping of a horse's hooves on the cobblestone street. An enclosed black Brougham turns the corner from *rue de Rome*. Standing on a raised platform behind the carriage, the driver draws back on the reins, bringing the horse to a halt directly in front of me. When the carriage door opens, Frederic, in top hat and long black cape, steps out.

"*Bonsoir, Mademoiselle.*" He doffs his top hat in a sweeping bow. "*Comme tu es belle ce soir.*"

My face lights up, and I laugh softly at his compliment, feeling romantic anticipation sweep over me. "And you are the handsome prince come to take me to the ball?" I respond gaily.

"Oh, *oui, oui.*" Taking my gloved hand in his and flirting with me with his eyes, he brushes it softly with his lips. Then he hands me up the step into the closed compartment. The tired-looking gray mare snorts and paws the cobblestones, impatient to be moving.

I'm on the edge of my seat, as the carriage makes its way through Paris, straining to watch our progress along the darkened streets through the small side window. As we turn from *rue La Fayette* into *rue le Peletier* I see a long line of carriages ahead of us, waiting their turn to move in front of the opera's entrance.

Captivated by the steady procession of magnificently gowned and coiffed ladies being assisted onto the sidewalk, I'm nervous when my turn comes. Formally dressed men standing in front of the building, puff on cigars and talking together, turn to stare at me. At that moment it seems all those eyes are fixed on me, and I feel as if I *am* a princess living a fairy tale. Frederic quickly takes my arm and whisks me through the onlookers into the foyer. A man standing just inside the door comes to greet him.

"This is *Monsieur* Legrand," Frederic says. "He comes to my studio now and then to see my work. I invited him to sit with us tonight."

Legrand appraises me with a slow, indifferent gaze. It gives me an unpleasant feeling I've never had before as if I were merchandise in an *atelier* window being inspected by a prospective shopper. "So this is the lovely young *Mademoiselle* you showed me on your canvas, *Monsieur?*" He asks.

Even though I am insulted by the way he has inspected me, I smile, pleased by his compliment, and politely extend my gloved hand to him. He eagerly bows. "My name is Lamar Legrand," he says, straightening up. He looks to be older than Frederic, in his mid-thirties I guess. I see that he has brown eyes and hair the color of sand on a winter beach. He isn't as tall as Frederic, but straight. The warmth of the smile he gives me is disarming. "There may be more eyes watching our box tonight than the dancers on the stage," he quips to Frederic.

I continue feeling I've entered a different world as Frederic and Lamar Legrand lead me to a box on the second tier, right side of the stage. Looking down on the extravagantly dressed audience below, I never before could have imagined that such a world existed. I take a chair close to the rail, leaving my two male escorts to greet others passing in the hallway on the way to their own boxes.

Like a flock of colorful parrots, the ladies below flutter around the mezzanine to no purpose other than flouting their frippery and eyeing their competitors. Each magnificent gown seems to surpass all others in its lavish use of silk and lace and satin to enhance and display the *décolleté* and *derriere* of its wearer. Coiffed hair is piled high in braids and ringlets and curls, adorned with feathers or flowers or jewels that reflect sparkling highlights from the chandelier high overhead.

"Quite a sight, isn't it?" Lamar Legrand says, coming to stand beside me when Frederic steps out into the hall with a stranger.

"I've never seen so many people come together in one place—it overwhelms me to see so many beautifully dressed ladies."

"Perhaps not all ladies," he quips suggestively.

I give him a quick glance but ignore his innuendo. "And this theater—all plush and gold, with a painted ceiling and hundreds of lights in the chandelier—where I come from there is nothing like this."

Legrand shrugs. "There is nowhere else in the world like Paris, but look carefully *Mademoiselle* Dobbins," he says. "Paris life is not always what it appears on the surface. Yes, tonight some aristocrats and many *Haute Bourgeoisie*—important people—have come to see the new ballet. No doubt many of them—like me—are important benefactors of the careers of artists like Frederic. But there is a much larger world outside the opera house of people who toil for just a few *sous*. You must take care. A young *mademoiselle* like you must always be on guard."

I respond with a polite smile but say nothing. Legrand takes his seat on one side of me with Frederic coming to sit on the other. As the lights dim and the ballet begins, I settle back in the soft cushions, entranced by the beauty of the music and the grace of young dancers.

When the house lights come up, signaling the start of the intermission, Frederic and Lamar Legrand escort me back down to the foyer. The audience pours out of the mezzanine to gather in small knots of conversation. We find a place in one corner to receive acquaintances that quickly surround us. A handsomely dressed woman, at least a dozen years my senior, approaches, trailing an entourage of men behind. Touching my arm, she offers a warm smile and bursts immediately into conversation. "Oh, my dear, I saw you in your box and just knew I had to meet you. We are two of a kind, you know? I am Sarah Bernhardt, principle actress at *L'Odéon Theatre.*"

Frederic briefly joins our conversation. "She is my muse, *Madame...*"

Sarah Bernhardt continues talking without noting the interruption. "How fortunate for you, at such a young age, to have a handsome gentleman on each arm."

I give her an appreciative look and feel very adult doing it.

"But beware!" She continues, "I know from experience how roughly some men can treat a pretty girl." She reaches into a tiny clutch purse and withdraws a personal card. "Please come visit me at the theater some afternoon. I'm sure we can find many things in common to talk about. Perhaps your gentlemen will escort you to one of my performances." With that, she disappears into the crowd.

During my brief conversation with Sarah Bernhardt, Frederic and Lamar have been attentive to a man who has joined them. Frederic reaches out to me and says, "*Mademoiselle* Dobbins, please meet my friend and fellow artist Edgar Degas, although I hardly compare myself to him in ability."

Degas is older, with a morose look. His eyes seem to have retreated into his long face under heavy brows. "But you will

be one day," he tells Frederic. When he turns to me with a wan smile, bowing weakly, I draw back, unsure how to respond.

"Are you a ballet student?" He asks me.

I laugh. "No, *Monsieur* Degas. This is the first ballet I have ever seen. But I marvel at the skills of the young dancers. The effects they create are quite beautiful."

"Beautiful," Degas scoffs. "You think it beautiful, do you? You must see what goes on backstage then. Come." He turns to Frederic for approval.

"*Oui*, backstage would be very interesting to see," he says.

"Follow me. I go there sometimes—they know me."

Degas leads us down a long, dimly lighted hallway on the side of the theater, past a labyrinth of small rooms, and up a flight of steps until finally we enter the cavernous space in the back of the *Salle le Peletier's* stage. My first impression is the chilled air that makes my arms shiver. The unpleasant combination of dust and mold, and oil and paint smells that seem to emanate from old scenery flats stacked against a wall, make me hurry to raise a handkerchief to my nose. As my eyes adjust to the dim light, I can make out stagehands, old men in dirty work clothes, moving scenery, suspended by ropes from the rafters high up near the roof, into position for another scene. Becoming more accustomed to the dimness, I see young girls in dancing costumes, some standing in small groups, and others sitting on benches near the wings. They drink water and wipe sweat off their foreheads while they talk in lowered voices, awaiting the call back for the second act. A few stretch their legs on *barres* along the walls or practice their positions. All of them look tired, their hair and makeup are in disarray.

Lamar leads Frederic away, suggesting they take a closer look at the young girls. Degas stays at my side. He removes his evening

cape and drapes it over my shoulders.

"*Merci*," I tell him, wrapping it around me.

"How glamorous do you find the ballet from back here?" He asks.

"Not at all. The dancers create beautiful illusions for the audience, but they are not so lovely backstage."

"All art is an illusion," he says. "*Monsieur* Bazille and I, and other artists claim to paint the reality we see before us, but in truth it becomes illusion for those who view our work. Frederic tells me you are a model who has posed for him and also that you aspire to become an artist yourself."

"I do. More an artist than a model. I agree about painting reality, not like most of the art of the *Louvre*. I have always sketched and painted what I see around me."

"So, tell me, *Mademoiselle*, if you were to paint the ballet this evening which reality would you paint, what you see before you now or what the audience sees?"

I take a moment to consider Degas's question. Finally, I answer, "You paint reality that becomes an illusion for its viewers. Here illusion becomes a reality for the audience. For the people sitting out front what they see on stage is their reality, is it not? For the dancers this is reality."

"Very good, *Mademoiselle*," he says. "For me the reality in front of the curtain is false. I prefer painting the dancers' reality." He stops to look again at the tired, perspiring girls splayed across the hard benches in the gloom of backstage. A couple of them are rubbing their feet and legs with liniment. Then he looks back at me, making sure Frederic and Lamar are out of hearing. "You would be a beautiful dancer, *Mademoiselle* Dobbins. Please consider posing for me in dancing costume. I would pay you well for your time."

The next day I return the gown to the dressmaker's *atelier*. Then I head to Frederic's studio a few blocks away so I can thank him again for a wonderful evening. Walking along the boulevard, my thoughts are so confused I am unmindful of the mid-morning sounds of commerce and the tempting aromas drifting from *cafés* and *boulangeries* I pass. What was last evening all about? Why did Frederic invite me and then spend most of the evening talking with Legrand and others? Am I just a silly girl infatuated by his good looks and charm? Thoughts flutter around in my head like colorful butterflies, none of them alighting long enough for me to capture.

"*Bonjour, Mademoiselle* Dobbins," Frederic greets me at the door of his studio.

I look around quickly to make sure Monet, Renoir or Lamar Legrand are not there before greeting him. "*Bonjour*, I've come to thank you again for last evening. It was a magical night for me. The late dinner was more than I expected. It was a thrill sitting out under the stars at the *café*. I'm sorry I left the carriage so quickly and ran to the apartment."

Frederic is scraping dollops of paint off his palette as I speak. Smiling, he looks up. "Perhaps soon you will have your own apartment."

"Perhaps. But I will need more modeling work before I can afford one. Did you know *Monsieur* Degas wants to paint me as a dancer?"

He stops scraping and studies me with searching eyes. "Really?" He asks. His face goes blank. It takes a few seconds before he recovers. "Degas is a great artist. He will do a fine painting." He goes back to cleaning his palette, then pauses again. I think I detect something different in his voice—sadness or anger, I'm not sure which—when he says, "He will pay you

well, and soon you will be looking for a new place to live. I will miss you."

"Miss me? Why would you miss me?"

"I think I would have a difficult time sharing you."

"Surely you don't think...? Frederic, there is no way I can survive on the fees one artist pays. And I am not yet ready to sell any of my paintings."

"I know," he says, as gently as he can.

"You would stop using me if I pose for *Monsieur* Degas?"

"You could still pose for the art schools. They might pay you more if they knew you sit for Degas."

"I asked you, would you stop using me?"

"It would be difficult."

I can't hide my exasperation. "What am I to do?" I ask him, throwing up my hands. "I must earn enough to live. Pay rent. Till now I've been a boarder at my friend's parents' apartment. Last night she had to lie to them so I could sneak out to you."

"I'm truly sorry that I caused you difficulties, Emma." It sounds stiff. He gets up from the easel and walks away from me toward the piano by the window.

"I didn't mean it that way. Being with you last night was magical for me."

"Then you will have to decide what course to follow. I know I can't give you enough work to support you in an apartment if that's what you are asking."

"No, not that exactly." I can't believe he thought that was what I meant. After another pause, while I gather my thoughts and try to calm myself, I tell him, "You are putting me in an impossible situation. You can't give me enough work to support me, and you won't use me if I sit for other artists. What am I to do? I don't want to sit for other artists, only you. It feels like I

am trapped." The words come out too quickly, almost a shout. My frustration is overwhelming me. "I need time to think what I will do," I say at last. "I won't sit for *Monsieur* Degas until I let you know my decision." I take a few steps toward the door. My heart has crawled into my throat and my words come hard. I'm desperate not to leave him like this. I need a reason to stay.

"It's goodbye for now then," he answers. "You are a charming young woman. It was a real pleasure to paint you," he says stiffly, looking down at the piano keys. It doesn't sound honest to me.

Reaching for the ornate brass doorknob, gripping it lightly, I'm reluctant to turn it. I finally steady myself and prepare to open the door and walk away, when he rises from the piano and comes toward me. "Wait," he calls. I take a breath, thinking there is the sound of regret in his voice. Still holding the doorknob, I turn and look back at him.

"Would you consider posing for me again, before you do anything with Degas?" He comes across the room to stand beside me, with the boyish look on his face, an imploring look. He takes my arm. The touch of his hand is electric. I take another deep breath. Then I tell him, somewhat more seductively than I intend. "Of course I would, Frederic... I need the *francs.*"

"I'm glad. I love painting you... I want to continue." He stops and fidgets with the fob on his watch chain. "Also, there is another thing I must ask you... Will you pose for a nude painting?"

The swell of emotion engulfing me at that moment is like a giant ocean wave slamming me flat on my back on the beach, gasping for breath. My hand drops from the doorknob. Color drains from my face as I stare at him. Then I look away to the window. "Without my clothes? Why?"

His face turns apologetic. "I've shocked you and I am sorry," he says. "Please forget I asked."

"Tell me why?" There is no anger in my voice, no embarrassment, no accusation in it, only my request for information. "I don't understand." My words come weakly.

"I ask because I think I could paint a fine picture. I see so much beauty in you and I am desperate to capture it."

"But why nude?" I keep my eyes level on him.

He fumbles for words at first, then, gathering confidence, he says, "A nude female is one of the most beautiful art forms in the world. Artists have always striven to capture the essence of beauty by painting nude women. To me, you are that essence of beauty, and you add the innocence of youth. I see it every time I look at you."

"I don't understand what you mean...about beauty," I interrupt. "No one ever told me I was beautiful when I was growing up, not even pretty. This is all new to me. There is more to me than my appearance, you know. Someday I will paint my own pictures."

"I know that, but an artist can only paint what he sees, and hope it reveals something deeper."

"Have the other girls who pose for you been nude?"

"Some. A few. I've never been satisfied with any of those paintings. They were pictures of flesh without feeling. You have charmed me, Emma—touched my heart—I'm sure you know that. You seem to me to possess all the wonder and newness of being a young woman. Since I started painting you I haven't been able to get you out of my mind."

"What will you do with a nude painting, Frederic, if I agree?" I can't keep the accusing tone out of my voice. "Show it to your friends, Renoir and Monet? Hang it on a wall so everyone coming to your studio can admire it? Exhibit it in a gallery where a stranger can pay your price and display it on his wall—display me on his wall?"

"No! Nothing like that! I wouldn't do that. I will keep it private, it's only for me...and you."

My expression stays blank. I try to fathom what his feelings are for me? But there is no answer. "I must tell you, Frederic," I start to speak and then pause to find the words, "I do not understand about the beauty people see in me. You say it all the time, so does my friend Leo. No one ever said that to me before, so I don't know what to believe or how to act. I grew up without anyone telling me the things I suppose most other young girls are told. My sweet papa didn't. I think he was not too good with men and women relations. He certainly never told me that naked women are beautiful." I stop momentarily to take a breath. "But he taught me life is full of risks." I pause again, taking a deep breath, and wait a moment to add emphasis to my next words. "Yes, I will pose nude for you. I want to know how it feels to be vulnerable in front of a man who says I am beautiful. I am willing to risk. I will do it whenever you are ready."

Several days later he asks, "Are you ready, Emma?"

"I think I am," I tell him. I'm not as sure as I sound.

"Do you want a *chaperone*?"

"I don't know who would be my *chaperone*. Besides, I am not one of your timid young French waifs accompanied by their mothers making sure their daughters remain virgins at the end of the session. I trust you or I would not be here."

"You can drop your robe then and we'll get started when you are ready."

The moment has come—the moment I've dreaded, and yet looked forward to with excitement at the same time. Looking straight at Frederic, summoning all my courage, I loosened the

belt and let my robe fall away. At first Frederic lowers his eyes, but after a moment we are looking directly at each other. My body quivers as he gazes at it.

"Over here," he says, recovering. "Lie down on the carpet I've spread out for you, with your head on the pillow.

I do as he directs. Lying flat on my back, with my hips raised, looking at the easel, I feel as vulnerable as I ever have in my life. Frederic comes quickly to kneel at my side, covering what papa use to call my private parts, but leaving my torso and breasts exposed.

He lifts my arm to cover my forehead and hairline, leaving my other arm at my side. Then he moves swiftly around me, checking that I am in the position he wants. "No one will know who the nude is," he tells me. "It will be a portrait of a shy young woman." As he makes an adjustment to the shawl, he adds, "I'll try to be very careful not to touch you."

"I trust you, Frederic."

CHAPTER EIGHT

August 1870

SITTING ON A bench in the *Louvre Museum* a month later, hunched over my sketching pad, I'm focused on the masterpiece in front of me, oblivious to people walking up and down the Grand Gallery. A Jacque-Louis David portrait of a reclining woman is in front of me, so elegant in its simplicity, yet so beguiling and inscrutable I can only stare at the woman, trying to imagine the thoughts going through her mind. I can't help wonder if *Madame Récamier* had any of the same feelings I did while she was being painted.

I set pencil and pad down after adding a final few strokes and turn to a friend who has just come by. "Ah, *Bonjour, Mademoiselle* Morisot. *Pardonne-moi.* I was lost and didn't notice your approach."

"*Bonjour,* Emma. I would be pleased to have you call me Berthe. I saw you and wanted to ask if you would join me for lunch."

"Yes," I tell her, "Yes, I would like that. I have done enough for today. Some days—like today—the work seems hard, and I get distracted. I haven't seen you for some time, Berthe. It will be pleasant to catch up."

"*Oui,* I have been with my family. If you are finished..."

Together we leave the museum, cross *rue de Rivoli*, and walk along the stone-canopied sidewalk to a *café* on the corner of *rue Royale*, across from the *Place de la Concorde*. We take an outdoor table. Berthe orders a meat and cheese plate with a glass of wine, and a mushroom omelet for me.

"How is your work progressing?" She asks as we settle in.

"It's been several months, and I still copy with pad and sketching pencil and sometimes watercolors. I think I have learned a great deal, but I'm still not ready for oils."

"You should try," she encourages me. "*David* is a good artist for you to copy. His portraits are beautifully executed, especially the one of *Madame Récamier* you are working on. Portraits like that are the kind of commissions you are likely to get when you are ready."

"How so?"

"There is always demand for portraits of wives and children, and other women that are best done by women artists. You should also copy some of Vigee Le Brun's portraits."

I stare at the wine in my glass, using the pause to consider Berthe's recommendation. "I hope to paint landscapes one day," I tell her.

"Difficult for a woman," she replies. "Traveling alone to paint a landscape is often..." She pauses, "How do I say, looked down upon. There are not many buyers for the work of a woman landscape artist. There was a young copyist in the *Louvre* today. Did you see her? She had copied the painting, *An Old Man and his Grandson*, an Italian Renaissance work by Domenico Ghirlandaio. It was so good the guards at the door stopped her. They had to measure it to make sure she wasn't stealing the original. I thought of you. You should look for her next time you copy."

"I want to be free to paint whatever I want."

Berthe cuts a slice of cheese from the wedge on her plate and adds it to a piece of *baguette* before taking a sip from her glass. She looks at me with her doleful dark eyes the whole time. "That can be difficult," she says at last. "Consider your decision carefully. It is easier for us to paint in a boudoir than side-by-side in a world with men." She pauses again and picks at a piece of ham.

Feeling frustrated, and looking for a response that won't offend my friend, I stab my fork at a mushroom. "It seems to me women in Paris have only limited freedom. Do you find it that way, Berthe?"

"I have never thought much about it, but yes, I do. It's just the way life is for women. Both of my older sisters are married. I think they have more freedom than I do, but they still obey their husbands." Setting her glass down, she adds quietly, "I hope to marry one day. Do you? But for now marriage can wait."

"I don't know. I find some men quite charming, but others seem brutish and demanding. I want my freedom." Thinking about Leo and Frederic, my gaze wanders off to the *Place de la Concorde*, where there is a bustle of activity. "What is going on there, Berthe?"

"Tents. For the National Guard. Did you know the emperor has declared war on Prussia?"

I'm stunned. "No, I did not. You say the National Guard has been called up?" I strain to see the activity across the boulevard.

"Louis Napoleon has mobilized the army and the National Guard. The Guard is camping over there for now. My father says they will all march off to the Rhine in the next day or two."

"All of them?"

"*Oui.* My father says Louis Napoleon has made a big mistake starting a war."

"I have a friend in the Guard. Perhaps he is over there. Will you walk with me to look for him?"

"Oh no, Emma! It would not be proper for two young women to go walking alone among all those men."

Bidding a*u revoir* to Berthe after we finish, I scramble between the carriages and lorries on *rue de Rivoli*, crossing the intersection to the broad *Place de la Concorde*. Scores of small tents are lined up in neat rows. Moving around the plaza, I squint like an owl as the blinding sunlight reflects off the white tents, but have no luck finding Leo. All the men in blue and red uniforms look the same. Stopping near the Egyptian obelisk to rest my eyes and wipe perspiration off my brow, I think of Leo marching off without me being able to say goodbye, or wish him a safe return. My anxiety growing, I continue scanning the crowd for a few more minutes without success. The men mill about in a helter-skelter, purposeless, kind of way, like the inhabitants of a disturbed anthill. My fear grows I'll miss Leo. Maybe he's not here. Perhaps he's back at the Durand apartment looking for me. Adjusting my bonnet, gone akimbo during my frantic search, and tucking my hanky into a pocket, I retreat from the *Place*, planning to hurry back to the apartment. How would I feel with him gone? I start back toward *rue de Rivoli*, walking slowly, still scanning the men. About to cross the boulevard, I hear Leo calling out behind me, "Wait! Emma! Wait!"

Greeting him with a big smile of relief erasing my dark thoughts, I am happy to see him. "Why didn't you tell me?" Still breathless, I have a touch of annoyance in my voice.

"We only learned this morning. I was afraid we would march off without me seeing you."

"Me too." I move closer to him, putting my hand on his sleeve. "Where will you go?"

"We hear we are heading north toward the border tomorrow or the next day."

"Will there be fighting?"

He gives me a questioning look as if I am not very bright. "Almost certainly," he says. "The emperor wants to force a battle to put the Prussians in their place."

"I'm scared for you, Leo. My father told me how terrible war is. I feel scared now... for you."

"Don't worry, Emma. We are well trained—the best fighting force in Europe—we'll win."

"Aren't the Prussian soldiers well trained too?"

His sad smile seems to forgive me for asking silly questions. "Maybe they are, but we are invincible—we fight for the honor of France."

The thought that his blind faith might get him wounded, or even killed, is a palpable blow. I step back. "You must stay safe." The words come out with emotion in my voice. Trying to calm myself, squeezing his arm with my fingers, as if to hold him back from marching off. "Don't take any risks you don't have to," I urge him.

He lets out a quick, dismissive laugh before turning serious. Looking at me with sad eyes that say he is not as assured as he wants me to think he is, he says, "I won't be a coward when the time comes to fight for my country. I've pledged my life to the emperor."

His words give me a shiver. Lost for a response, I just look at him. A chill creeps over me.

"I hope you will wait for me to come back," he says, a brighter look taking over his face.

"Of course I'll be here," I assure him, refusing to acknowledge any deeper meaning he might have intended.

"We'll return quickly after we win the war, I know that." He reaches out to take both my hands and holds them, looking into my face. I look down at my fingers enfolded in his, and can't stop worrying, but don't pull away.

"What I mean is when the fighting is over I hope we can start a serious courtship. Would you like that?"

"Let's wait until you return," I mumble, still looking away.

<div align="center">∞</div>

Less than a month after Leo and the National Guard march off, I walk with Grace down *rue de Rome* toward *Gare Saint-Lazare*, before continuing on to the *Louvre*. The heat and humidity of September are oppressive. The damp air is almost wet, and heavy with river odor. Workingmen and women trudge along beside us in silence. Sweat glistens on women's foreheads and stains men's shirts.

At the bridge where *Place de L'Europe* crosses over the railroad tracks, a man selling newspapers waves a copy of *Le Figaro* over his head, shouting the headline

<div align="center">

TERRIBLE DEFEAT; ARMY ROUTED;
EMPEROR IN EXILE;
PRUSSIANS MARCH ON PARIS.

</div>

People on the bridge surge around the man for news. We join the crowd—both of us looking stunned, staring at each other.

"What does it mean?"

"I don't know...don't know!" Grace snaps. "Father says nothing about the war. All I can think of is Leo."

"Leo," I repeat, throwing my arms around Grace. We hug each other, afraid to let go.

"I pray he's safe," she whispers in my ear.

"*Dégagez!*" A woman with a suitcase sneers at us as she pushes past, hurrying on toward the station. I steer Grace to the side of the bridge, where we huddle against the ironwork railing protecting the street from the maze of tracks below us.

"How terrible!" I can't find other words.

"It is," she agrees, stepping back so she can look into my face. "You have strong feelings for my brother, no?"

"Well, I don't want him hurt," I answer noncommittally. "I am fond of Leo."

Her eyes probe me for clues. "Did you know he plans to seriously court you when he returns from the war. He told me."

"I know. He told me, too."

"How do you feel?"

"How should I feel, Grace? I said I'm fond of your brother. We've shared some good times together. You know that."

"Fond enough for a life together?"

"Not yet. I'm not ready to marry anyone. You and Martin?" I ask her to change the subject. "Are you ready?"

"I long for the day Martin and I are married and can show our love openly."

I turn to look over at the *Le Figaro* man, hawking his papers so Grace won't see my expression. "Martin seems to have been right about the emperor," I tell her. "Leo so wanted to find glory in a battle, but it looks like he may be denied. When he comes home, I hope he and Martin can be friends. For your sake."

Grace bristles and looks down at the tracks. A locomotive emerges from under the bridge, moving slowly, puffing and snorting into the oppressive sky. A string of passenger cars follows. I wonder if the woman with the suitcase made her train.

Grace says, "Leo doesn't understand Martin and I are in love."

A spontaneous laugh escapes me. "Of course he understands, Grace. That's why he resents Martin. He doesn't want Martin or any other man taking his little sister away from him. He's jealous."

"You think so?"

"I'm sure."

She pauses a moment and then says, "Perhaps Leo would accept Martin and me together if he were sure of a future with you."

I turn to watch the train gain speed and grow smaller down the track, idly wondering where it's going. The line of seven cars trailing behind the locomotive reminds me of a flight of pelicans I've sketched so often—lead pelican flapping its wings and then each pelican flapping in sequence down the line. I'm not one of those flapping pelicans. I won't blindly follow any man. I tell Grace, "I am not ready to marry or start a family."

"Because that artist you posed for has your eye?"

"Why would you say that? I haven't seen Frederic in almost two months." Quickly turning away from the tracks and giving Grace a parting wave, I tell her, "I must be on my way to the museum now, and then look for more work. I hope we hear good news from Leo soon." I cross the bridge and turn toward the river.

Continuing down *rue de Rome*, I cross the wide, tree-lined boulevard to another street. Blinding sunlight reflects off the roofs of the new stone buildings under construction, like molten chips off a white-hot bar of iron from a blacksmith's hammer. I can feel those chips and hear the thunder of hammer on anvil in my head, reflecting on my conversation with Grace. How do I feel about Leo? Fondness is the word that keeps coming back. I like him, have a good time with him, but love? How should love feel? The question, never far from my thoughts, plagues me. If it's love I feel toward Leo it doesn't feel enough for a lifetime

together. And what about Frederic? Does he even think about me any more? In my mind's eye I still see my naked body, so vulnerable on the carpet in his studio. Then I laugh aloud as I walk along, several passersby stop and stare. Just a young girl's fantasy. Did he love me? As much as I loved him? Or do I mean no more to him than any of the other young women who took their clothes off for him?

<center>∽</center>

Day by day autumn gives way to winter's chilling embrace, but hunger still creeps into the city. Like a hangman's noose, the Prussian siege line grows tighter and closer, choking off food supplies. Cats and dogs disappear. Bread shops are empty. Many have locked their doors. Rioting and looting have broken out in the *Batignolles* district and other parts of the beleaguered city when rumors of food circulate. At first, the Durands had food, but now it's never enough. Throughout the city, supplies dwindle to almost nothing, first striking at the poor and workingclasses, then slithering into the ranks of the *bourgeois* who can't afford to flee the city through the siege lines to the coast.

My life drifts. I continue to copy at the *Louvre*, and now have a license to paint in oils. Futilely I seek modeling jobs that no longer exist, while hoping the Durands will have enough food to keep me. The question of what I would do if Hector Durand tells me I must leave torments me. The apartment he and Clarise share with me is my only security.

One November day, walking back to the apartment from a disheartening morning in the *Louvre* gallery, I find my steps slowing as an involuntary smile comes with a thought. I still can't forget him. Might he need me? Fantasy takes flight. I shake my head to clear it, but it doesn't clear. With no thought, I start

walking up *rue Royale* past the *Madeleine* Church and on past *Gare Saint-Lazare* back into *Batignolles*. Tired and hungry from the walk, I find myself standing on the empty sidewalk on *rue la Condamine* looking up at the large floor-to-ceiling window on the fourth floor. The neighborhood is silent, deserted. What is the harm? Perhaps he will give me another modeling job out of pity so I can buy food for the Durands.

I climb the stairs, knock on the studio door and wait. No response. After knocking again, and waiting another minute or two, I put my ear to the door. No sounds inside. I try the handle; the door is locked. I knock again and then call through the door, "Frederic...are you in there? It's Emma!"

Still no response.

Heaving a deep sigh and tucking my skirt between my legs, I flop down on the top step, undecided what to do, but wishing I had some food. My memories of all the times I spent in the studio with him come back to me.

I don't think I've daydreamed very long when I hear the sounds of heavy shoes on the stairs. My excitement grows, my heart starts to race, and I look for Frederic climbing the stairs. First, the top hat on a man's head appears at the lower landing, then sandy-colored hair visible below his hat. I sigh, already knowing it's not Frederic. The man has a nice face, but not a distinctive one. His shoulders and chest and the rest of him come into view, confirming him as well built. When he mounts the last step and stands next to me, a giant grin parts his lips. I smile back.

"*Bonjour*, Emma," he says in a low, strong voice, showing no surprise at me sitting there. His gray eyes seem to twinkle as he looks down at me. "No one is in the studio?"

I'm startled by his informality, but let it pass. Gathering my skirt I stand, deciding he isn't really so tall after all. "*Bonjour,*

Monsieur Legrand. No one has answered my knocks or calls."

"It is nice to see you again, Emma." In addition to a dark suit with white shirt and tie, he has a tall top hat and carries a gold-topped walking stick.

"*Oui*, it is nice to see you, too. I was hoping to meet with Frederic or Renoir before they left," he says, shifting his hat back and forth from hand to hand in a kind of nervous juggle. "Do you know Renoir?"

"When I sat for Frederic several times. Did they leave together?"

"Not exactly. Now I see I may have stayed too long in Paris myself."

"The war?"

"*Oui*."

"Where will you go?"

"*Normandie*, I suppose. Or any other place that will get me out of this dying city. South if the Prussians will allow me. You should leave too, before the Prussians arrive, if you know what's best for you."

"Did Frederic and Renoir leave Paris? I thought the Prussians had already won the war. Why don't they stop?"

"Indeed they have. But no French government exists to surrender to them. It's a bit of a ticklish situation, isn't it? Emperor in exile. No other government yet. So no one to surrender. I think the Prussian army will camp outside the walls waiting for a surrender to get worked out, starving us in the meantime. I hear there is still fighting south of Paris."

"I didn't know." His words frighten me, but at the same time I feel better. Frederic might still be thinking of me.

"A pretty young woman like you ought to stay away from those German monsters."

"You say you might go to *Normandie*? Is it safe there?"

"Safe so far. Safer than Paris."

Is that where Frederic has gone?"

Legrand gives me a good-natured laugh. "Oh no, Emma, quite the opposite. Those two fools have gone off to enlist in the army." He replaces the top hat on his head, and tips it to me as he starts down the stairs. "*Au revoir*, Emma," he says, "Clearly, I am too late to bid them farewell," he adds as his head begins to disappear below the landing. "I hope you stay safe."

CHAPTER NINE

December 1870

AT THE LE HAVRE train station I hail a carriage to take me on to Trouville. "Go quickly," Berthe Morisot had urged me a few days after Lamar Legrand suggested I go to *Normandie*. "My father says it is still possible for civilians to get a pass through the Prussian lines."

Feeling nervous I ask her to come with me. "We could paint there together."

"Oh, Emma, how I wish I could. I have spent so many happy days with my sisters and parents vacationing in *Brittany* and *Normandie*. But my father insists the whole family stay together here. You might go to *Trouville* and seek out Eugène Boudin. He is a fine *en plein* air artist I know there. Always willing to teach others."

"How will I find him?"

She laughed. "You need only to walk along the beach—you will find him at his easel."

The one-horse open carriage stops at the *Hotel Normandie*, a half-timbered giant of a building sprawling along the beachfront. Stepping down, and reaching in my reticule, I find a few *sous* to pay the driver. But a quick glance at the large crowd strolling the boardwalk in front of the hotel convinces me I won't find lodgings

there, and couldn't afford them if I did. I walk away from the beach into the small village, and after an hour of searching and knocking on doors, asking about room rentals, I'm greeted by an older, white-haired woman. Slight in stature, but dressed in fine clothes, she agrees to rent me the third-floor room in her house.

"Not French—foreign *mademoiselle* are you?" the woman asks breathlessly after we have climbed the rickety stairs to view the room, and I agree to pay the meager rent she asks. "I am *Madame* Crystalle."

"From California," I tell her.

She nods knowingly. "*Je vois.* Your French is hard to understand." She wags her finger in my face. "No trouble in my house or I will throw you and your clothes out on the street. How long will you stay with me?"

I can see the woman is already counting the income in her head. I turn the palms of my hands up to show my uncertainty. "Until the Prussians leave Paris, I guess...or my money runs out."

Madame Crystalle emits a low sound that might have been a laugh. "Maybe we will be good friends by then," she says. She starts back down the rickety stairs, but stops halfway down, and says, "You have no one else with you, *Mademoiselle*? No young man waiting to join you in your chambers when I look the other way?"

Blushing, I assure her I'm alone, and she continues her slow descent to the ground floor.

After I've unpacked the few clothes I've brought with me, I go back down the stairs to the dimly-lighted parlor. Heavy brocade drapes allow only minimal sunlight into the room through lace curtains. *Madame* Crystalle is sitting in a polished high-back wooden rocking chair, her fingers furiously working a crochet needle on what seems destined to become an antimacassar or placemat. She wears a long, formal day dress of impeccable style

and fabric. Looking around the parlor, I spot other examples of her handiwork in the coasters, placemats, antimacassars, and other objects I cannot name, prominently displayed.

"I am going to walk to the beach, *Madame*," I tell her. "To get better acquainted with the village."

She nods her understanding and begins putting her work in the cloth bag beside her chair that holds her yarns, laces, and needles. Then she gets up and follows me into the hallway, where she takes a crocheted shawl from a peg by the door and wraps it over her shoulders. Puzzled, I ask, "Are you going out also?"

"*Oui.*"

"Perhaps we can walk together."

"But of course, *Mademoiselle*. I cannot let you walk about *Trouville* unattended. If my neighbors saw I let you walk alone without a *chaperone*, I could never look them in the eye again."

"I don't need a *chaperone*."

"How old are you?"

"Eighteen."

"Of course you do, my dear. Come now, we'll speak no more about it. While you live in my house I will make sure you act appropriately."

I am dumbfounded, but seeing the determination on her face I give in without protest. "*Merci*. It will be nice to have a companion."

After walking toward the beach a few minutes, with *Madame* Crystalle following a few steps behind, I stop and turn to face her. "If you are going to be my *chaperone* when I walk about, I would prefer to have you by my side so we might talk and get better acquainted."

"As you wish," she says, and comes a couple of steps forward. Immediately she begins a breathless patter about the charms

118

of *Trouville* and the *Normandie* coast as if she's become my tour guide. At the boardwalk overlooking the beach, she points at a church spire a couple of streets away and says, "*Notre Dame des Victories*—where I worship. I will take you with me on Sunday."

Captivated by her assertiveness, I can only nod acceptance. Looking around at the crowd of men and women on the beach, I am surprised there are so many for a windy, overcast December day. As if interpreting my thoughts, *Madame* Crystalle indicates them with a sweeping hand. "Parisians," she says in a tone of mild disapproval.

I give her a questioning look.

"Oh, *oui*, they don't go home," she assures me. "Frightened by the rumors. Usually by September, the village has already quieted for the winter, but I'm told there are still no rooms available at any of the hotels. You are lucky to find a place with me."

I smile my gratitude. Looking out at the people on the beach, I can see that many of them seem uncomfortable. Women in long-sleeved blouses, partially covered by dark mantles, are wearing dark skirts that hide their ankles. They stand close together, braced against the ocean breeze. Most wear hats, some with veils protecting their powdered faces, and a few shielding the rays of the late-season sun with colorful parasols. Their male companions are wearing dark suits with bow ties, with either straw boaters or bowlers on their heads. Some watch a half dozen, gaff-rigged sloops scudding along not far offshore. Scattered back from the water's edge there are brightly striped, two-person canvas tents, open to the surf but protected from the wind on all other sides. Couples huddle inside on folding chairs.

"What will all these people do?" I ask.

"What will you do, my dear?" She answers me. "Wait here as best they can until Paris is free again."

"I was told to look for an artist who paints on the beach—Eugène Boudin—might you know him?"

"Oh, *oui*, I know everyone. Come."

She finds Boudin sitting behind an easel just a short walk farther north along the beach. Already balding, Boudin is middle-aged, with bushy graying beard and brows arched above his twinkling deep blue eyes. The skin of his face and hands is wrinkled and weathered to the darkness of shoe leather, and about the same texture.

"A fair young *femme* you've brought me, *Madame* Crystalle," he says, looking up from his canvas. "To what purpose?"

I don't wait for her to answer, edging in front of her, close to him. "*Mademoiselle* Berthe Morisot told me I should seek you out, *Monsieur*. My name is Emma Dobbins. I have come to France from California to learn the skills of an artist."

"Well said, *Mademoiselle*. I can see you have already enlisted the always-proper *Madame* Crystalle to shepherd you around *Trouville*. How is it I can oblige you?"

"I would like to watch you paint, and learn how you make your art, to improve my own skills."

"Wouldn't that be a sight," Boudin muses, laughing. "The doddering old artist and the comely young *Mademoiselle*—is she his mistress or his granddaughter, they will gossip behind their hands—painting side by side at *Trouville*. What a picture that would be! I bet I could sell dozens of prints."

"Control yourself," *Madame* Crystalle interrupts. "This is a proper young lady I have in my charge."

Laughing, he rises and gives us a deep, theatrical bow. "*Je vous demande pardon, Madame.* I mean no offense. Regrettably, I am finished my work for the day and it is time for my evening pint. If you would care to meet me here tomorrow, we could talk and

you can paint with me."

"*Merci, Monsieur* Boudin. It would be an honor."

"An honor? So be it. Do you have a sturdy easel to set up on the sand?"

I shake my head.

"Not to worry. Be here at nine. I will bring two."

"She will be at Mass with me in the morning." *Madame* Crystalle tells Boudin firmly. "I will escort her to you after that."

Boudin chuckles and nods agreement.

The next morning, the strong smell of bitter coffee wakes me. The bells of the church sound a muted, but incessant summons. Dressing in the same white blouse and dark skirt I wore on the train, I hurry down to the kitchen where the sizzle of bread frying in a pan on the wood stove joins the coffee aroma.

Madame Crystalle turns from the stove, holding a fork in one hand and a crocheted potholder in the other, a bright smile crinkling the corners of her eyes. "*Bonjour, Mademoiselle* Dobbins," she says, but her smile immediately fades. "You cannot go to Mass like that."

"*Bonjour Madame*," I reply. "I have never been in a church."

"What! Never?"

"My papa was a God-fearing man, *Madame*, but we lived too far from any church. A whole day's journey."

"You don't know the Blessed Virgin, Mother of Jesus?"

"At home I was taught by the nuns for a year," I tell her with no embarrassment or shame "They dragged me to the mission for Mass each week, but I didn't pay any attention."

She goes back to the stove and pokes at the slices of bread with her fork, softly muttering to herself. When she has taken all the pieces from the pan and arranged them on two china plates, she turns from the stove. "I am sorry for you," she says. "I pray

for your salvation. You will meet the Blessed Virgin this morning for the first time... but not dressed like that."

"*Pardone, Madame,* I never thought to be attending a church when I left Paris. These are the only clothes I have with me. Clothes to paint in."

"*Oui,* I understand." She pauses in the middle of the room, holding the two plates aloft, briefly in some far away reverie. Standing frozen there for several moments deep in whatever thought has captured her, she finally sets the plates down on crocheted placemats on a small round table in a corner of the room. "Go upstairs to the empty bedroom on the second floor. In the *armoire* you will find some fine dresses," she says. "Pick out one to wear."

I give the older woman a questioningly look for several seconds then ask, "Will your old dresses fit me?"

"Not mine, not old, my daughter's."

"Your daughter's?"

"She is not with me any longer," she says, and then sits at the table and begins eating.

<center>∞</center>

Over the next weeks, as stories of the Prussian Army's stranglehold on Paris sound grimmer and grimmer to us, I spend most of my days sketching and painting alongside Eugène Boudin. He is an excellent teacher and I make good progress under his tutelage. We go to several locations in *Trouville* and up and down the *Normandie* coast to paint. Boudin knows the best locations in the fishing village of *Honfleur* and on the nearby cliffs that overhang the beaches. I marvel at the way he makes just a few dabs of color with his brush on the canvas become men and women in good detail but without real faces, leaving

<center>122</center>

the viewer a compelling impression of a group enjoying a happy beach holiday.

"The scenes I paint are what you might first see if you came on the beach blindfolded and took it off," he says, "or what you might remember when you turned away from it. They are impressions that stay with you," he says. Then he laughs hoarsely. "Without identifiable features, no one can claim the painting is not of them." He gives me a smile and a wink of mischief. "That way they think it might be them, and are tempted to buy it to take home to show friends what a fine vacation they had." He laughs so hard he almost chokes. "Once in a while, when the wind blows, grains of sand stick to the paint on my canvas. The tourists like that even better. More authentic. They pay more."

The rest of Boudin's paintings—beaches, ocean, cliffs, ships—are accurately represented. He is perfect at painting the clouds that come and go over the *Normandie* coast, and I try to understand how he does them.

"I taught young Monet to paint *en plein air*, you know," he boasts one afternoon. "You know Monet, no?"

"I met him once at Frederic Bazille's studio. Renoir too," I tell him with a touch of pride in my voice.

"Ah, Bazille. That's an artist to keep your eye on. He has a bright future ahead."

One afternoon early in January 1871, I am confident enough to show Boudin my watercolors. "Fine work," he comments as he studies the pages. "You should move on to learn how to work in oil. You are ready for that." He stops on my painting of a lighthouse during a winter storm. "This is quite fine," he says. "You've captured the mood well. The turbulent waves and threatening sky. Yes, the sky is very well done."

"*Merci, Monsieur.* From you a great compliment. I grew up at a

lighthouse in California. I sketched all kinds of weather there. It was a wild and lonely place called Point Conception. Are there lighthouses along the coast we could paint?"

"Absolutely," he says. "We can drive out to one tomorrow if you like. I will pick you up at *Madame* Crystalle's in the morning."

<p style="text-align:center">⌘</p>

When Boudin arrives the next day for the long ride to the *Fécamp* lighthouse, another man is already sitting in the carriage with him. Older than Boudin, and formally dressed in a fine suit and vest buttoned almost to his chin, everything about him is immaculate save for a shock of white hair on his head that dances around in the breeze.

"This is my friend Camille Corot," Boudin introduced him. "He came to see me last evening, to escape the Hun's beasts surrounding Paris. A master landscape artist he is—no one is better—the Salon proclaims him so—you may learn some techniques from him today—he will paint with us."

"Such a handsome young *Mademoiselle*," Corot says, extending his hand and assisting me into the carriage. He seems shy, almost embarrassed by Boudin's praise. "In truth, I did little for my friend here," he says. "He was already a fine painter. No one is better at painting sky and clouds and maritime landscapes that *Monsieur* Boudin."

"And no one paints trees and plants better than *Monsieur* Corot," Boudin responds. "He is the master."

My first sight of the *Fécamp* lighthouse takes my breath away and sends pleasant memories of my early life rushing through my head. It stands like a man poised on a cliff ready to dive off into the ocean, but upright, as if reluctant to look down. Shearwaters make little headway flying against the strong wind,

<p style="text-align:center">124</p>

so they turn and glide back on black-tipped wings to the tower and cliffs where they started. Then they repeat their paths, their moaning calls all but lost in the turbulent sky. I remember them well. My heart jumps a beat when the carriage comes closer and stops. For just a moment I want to jump down into papa's waiting arms, want to throw my arms around his neck, want to feel safe in his embrace again. And then I remember...

In the fall of 1865, after school in Santa Barbara closed for the summer, Ned Eaton picked me up in the wooden, ox-drawn wagon for the day-long drive back to Point Conception. Climbing up onto the seat beside him, he patted my cheek and gave me a broad grin. "Ay, you're a sight for sore eyes, you are, young lady. We've all missed ya. A long day's drive we've got so we'd best get started straight away."

I returned his smile, but my face turned serious. "Where's my papa? I thought he would come fetch me home."

"He's feeling a bit under the weather so I volunteered to make the trip myself, seeing as how I'm your favorite lighthouse keeper, right?" When that didn't cheer me up, he hurried to add, "Nothing to worry about, Emma. Your father's just a little tired."

Riding along the coast, I chattered away about school and village life in Santa Barbara to Mister Eaton, to hide my worry about papa.

"So you've decided to come back to the lighthouse and be with us old men have ya?" he asked as the wagon bucked and lurched over the ruts in the road toward Gaviota, taking the conversation away from Asa.

"Didn't have much choice, Mister Eaton. The nun asked me to leave the school. Said I was wasting her time...the old ninny was right." I can't restrain a little chuckle. "All that book learning wasn't going to do me any good. You and the other keepers taught me all the writing and summing I need."

Eaton periodically glanced over at me and smiled, as the ox plodded along. It made me feel uncomfortable. "Why do you keep looking at me like that, Mister Eaton?" I finally asked him.

"Can't get over how you've grown up," he answered. "Thirteen years old now. You left us as a cute little girl and now you're returning as a very pretty young lady. Just on the cusp of womanhood, you are, with such a sweet smile. Can't get over it."

He made me blush and turn my head so he wouldn't notice. I look off into the distance at the mountain peaks brightly reflecting the morning sun. We rode on in silence, and I wrestled with thoughts about my papa.

The sun's fiery descent seemed to ignite the clouds, sinking toward the ocean as the wagon finally crested the last hill before the lighthouse. I jumped from the wagon before it stopped and raced across the remaining distance to embrace papa, waiting for me with the other two keepers standing behind him. It seemed to me as if we have been separated for years, not months, as I settled in his strong arms. He led me to a bench on the edge of the high promontory looking out to sea, where we used to sit to enjoy the panorama of the open ocean colliding against volcanic rocks.

"I've missed you every day, Baby Girl," he told me in an emotion-choked voice. "I am so happy to have you back..."

"Me too, Papa."

"There are some things we should talk about now you're home."

The expression on his face, as he struggled to find the right words, was strained and tired-looking. I waited for him to continue. In the brief silence, my mind raced through a list of possibilities that sent trembles of fear through me.

"I'm disappointed you didn't do better in school," he said after the pause. "We did our best to educate you here, but I could see it was not going to be enough. Now I worry about your future."

"Papa, the things Sister Catherine tried to teach me were never going to be of any use to me here."

"Well, Emma, that's another thing I worry about. You can't spend the rest of your life here. After I'm gone..."

I cut him off. "Don't say that!"

"I have to say it," he interrupted. "Someday..."

"You're all I have, Papa." My eyes filled with tears. I threw my arms around his neck and buried my head on his chest. "I'm afraid to lose you."

"I know, I know. You are my life, everything important in this world to me, too." He struggled to keep his composure, dabbing at an imaginary speck of dust in the corner of his eye with his finger. "But we have to face the fact I won't always be here..."

I started to interrupt again, but he gently pushed me off his shoulder so he could look into my face. He took my hand. "A lot of things can happen. I'm not getting any younger. What I'm saying, Baby Girl, is that things can't always stay the same, and I want you to be prepared for whatever happens in your life."

Stunned by his words, I felt a chill at the base of my spine and began to shake. Papa shook, too, struggling to hold back his own tears.

"It can be hard for a woman alone in this world, so you must be as best prepared as you can be. You're bright and curious and

capable of so much more, but you need education."

"I'm only thirteen, Papa. There's plenty of time."

"Time goes by too quickly. Things can change in a heartbeat."

Something had already changed, I could sense it. I dried my eyes and sat on the edge of the bench, staring at him, oblivious to the enduring sounds of ocean slamming against rock below us, and the screeching cries of gulls overhead. "Are you unwell, Papa? Mister Eaton says you've not been feeling up to your old self lately."

"Doing just fine," he said hastily. "Ned Eaton's a worry-wart. Nothing wrong with me. Just been a little under the weather the past few days is all.

It seemed to me as if the ox-drawn wagon has brought me to a world where everything looks the same: the keepers, the fog, and the storms were all the same, but the joy I knew before going to school was gone. No longer free to roam the empty beaches or the open fields where I walked among the timid deer with my sketchbook, my days were now filled with chores. It was as if in the return from Santa Barbara my youth had been snatched away forever.

I worked side-by-side with my father and the other men as they went through the daily routines that kept the beacon bright every night and the lens turning at the proper interval so navigators at sea could be sure of their location on the dark waters. My favorite times were in the early evening when it was papa's turn to mount the steep spiral steps and climb through the trapdoor into the tower. I went with him to open the curtains protecting the glass prisms of the lens from destructive sunlight, while he fueled the candles and wound the weight that turned the lens. When we finished, we always stood together holding hands for a few minutes, looking out at the ink-dark ocean set afire for

just an instant or two as it extinguished the sun. It was a private moment of sharing that needed no words.

One afternoon Ned Eaton invited me to climb into the tower with him at sunset. "You know I'm always pleased when we can be alone together up here away from the others," he said, taking my hand to help me up the last, steep steps from the iron stairs through the trap door.

I dropped his hand and went immediately to the large glass panes and stare out after I opened the curtains. "This is my very favorite place," I told him, but it felt uncomfortable there without papa.

Eaton went about the work of fueling the oil basin that fed the candlewicks. "Do you miss Santa Barbara?" He asked.

"No. I didn't have any friends there."

"Bet you were the prettiest girl in the school." He grinned, still kneeling by the lamp.

"I don't know. Maybe. Nobody ever said anything like that." I continued staring out at the endless, empty ocean.

Next Mister Eaton went to the clockworks that turned the lens, driven by the heavy weight that descended to the ground through the opening in the spiral staircase. "It got awfully lonely here without you," he said, and then paused to reflect for a moment. "That's always the life of a lighthouse keeper, I guess— loneliness."

Turning from the window, I looked back at him. "Why'd you become a keeper, Mister Eaton?"

"Please Emma, you can call me Ned, or Uncle Ned. I'm almost like an uncle to you." He rose and came across the short space between us. Puffing out his chest just a little, he stood a bit straighter, too. "Suppose I could've had any job I wanted, but this one seemed good enough—food, shelter and a modest wage.

My sister's husband got it for me—he's in the Navy."

"Really, Mister Eaton? My father came here because there were no jobs he could find after the gold he got at the diggings ran out. That's why my momma left him..."

"Your mother," Eaton interrupted. "I remember her. Very attractive woman. Bet that's where you get all your prettiness from, Emma." He came a step closer and stood directly in front of me.

I pressed my back against the glass. "It's time to go back down." I started to move around him, feeling uncomfortable again. "Supper will be ready."

He didn't budge. "Do you think it would be alright for your Uncle Ned to give you a little kiss, Emma?" He pinned me against the window, so close I could smell his breath.

"If I don't get back to papa now he'll worry." Feeling confused and unsettled by his words, I was scared. Pinned in place, uncertain what to do. I had a gnawing feeling in the pit of my stomach. He was only inches from me. Then I heard papa's voice calling out from below, "Emma! Baby Girl," growing closer as he mounted the steps. I could hear his breath coming in short gasps as he climbed. Without warning, the trapdoor pushed up, and papa's head appeared in the opening. My eyes deserted Mister Eaton. I saw papa's mouth fall open, as Ned Eaton's hand reached out to touch my breast, and his other hand fumbled at the buttons on my blouse. I heard papa emit an unworldly moaning sound. Then he slipped back through the opening, disappearing from sight. The only sound was his body tumbling down the stairs.

Oh, papa, I say to myself, if only you were here with me now. I would tell you I never could have done what you must have

thought I did that day in the tower. And I have so much more to tell you. I've had so many new experiences.

Stepping down from the carriage, caught up in the emotion of my own thoughts, I'm anxious to be alone for a few minutes. I walk away from Boudin and Corot toward the edge of the cliffs. Standing silent, I watch golden-headed gannets with white wings folded flat against their sides, plummet down into the wind-whipped *La Manche* for fish, emitting their *rab-rab-rab* cries. The wind tosses my hair about like coal chips from a miner's pick. I have so many questions for you, Papa, I tell him. So much has changed since you left me. The old anger swells up in my breast, but at the same time tears form in my eyes. "Why did you?" I say out loud. The words disappear into the wind. There is so much you never told me. How was I to learn without you?

After a few minutes of solitude, walking back to where Boudin and Corot are setting up easels, I calm myself. "Thank you for bringing me out here," I tell Boudin. "This lighthouse is not much different than the one where I grew up. Mine had a round tower, this one is square and taller, but they both rise out of the roof of the small house, like where I lived with my papa. I could see the lens up in the lantern room. It looks just like the one at Point Conception. I am happy to be here to paint, it brings back all sorts of memories to me."

The artists stop what they are doing and smile.

"The lens at Point Conception was made in Paris and sailed around Cape Horn to California. Did you know?" I tell them with a feeling of great pride.

"Yes," they laugh, "and did you know it was designed by a Frenchman—Augustin Fresnel?" Corot says. "A great mathematician."

"Almost every evening my papa and I climbed the steps into

the tower to light the oil lamp to keep the ships in our channel safe from the treacherous rocks. I can remember how it felt holding his hand and watching as the sun set and darkness settling on the water. Most nights the fog looked like a soft blanket covering everything." I pause momentarily, feelings tears forming again, and composing myself until I'm sure I can continue. "Oh, how I miss him." My words are almost a muted cry. I look at the two men, embarrassed. Neither one knows what to say. They look sheepishly at each other and back at me. They can only offer awkward smiles and stand by in silence. Corot put his hand on my shoulder. Finally, he says softly, "We should set our easels for the best light.

"Agreed," Boudin says, and the moment passes. I position the easel Boudin has lent me protectively between the two men.

"What is the news from Paris?" Boudin asks Corot as he squeezes paint from tubes onto his palette.

"All bad, I'm afraid. The Prussians have cut off food. Many people are starving. The animals in the zoo have all been slaughtered. Horses and dogs were already gone. Now there is word of people hunting rats in the sewers. And still the fighting goes on in the south without a surrender." He pauses a moment. "I am sorry to tell you, Eugène, we got word a week ago that our young friend Frederic Bazille was killed in a meaningless skirmish with the Prussian dogs at *Beaune la Rolande*."

An unbearable pain stabs me deep in my chest. My knees buckle and I crumble to the ground.

CHAPTER TEN

January 1871

AS I WALK down *ave de Saint-Ouen* from the city gate into *Montmartre*, Paris lays prostrate in front of me like a mortally wounded warrior. Pulling my mantle tighter around me to fight the chill in the air, I look out at the cemetery, bare and bleak. The streets of the city far below seem lifeless, stone buildings in the distance stand like tombstones. The frozen river is a thread woven in a death shroud. Closer by, the few men and women on the avenue move along like zombies. Putting one reluctant foot in front of the other, they drag their emaciated bodies over the cobblestones. Heads down, eyes glazed, ribs protruding beneath tattered clothes.

I pass a *chiffonnier* in front of an apartment building sifting through the garbage searching for anything salvageable, anything that might fetch a *centime* or a morsel of food. The stench of starvation is in the air. At the corner of *ave de Clichy* I come upon a middle age-looking woman sitting on the curb with a baby pressed against her sagging breast. Her long skirt is hiked up above her knees as she stares down at the cobblestones, her upturned palm extended. I stop for a moment and look down on her, shuddering in disbelief at her hopelessness, hopelessness that seems to have infected the city in the time I've been away.

Dropping a single coin in the woman's hand without looking at her, I continue on toward the Durands' apartment.

At the intersection with *rue la Condamine* my legs tremble, so I hold on to a lamppost to keep from fainting. The reality of my loss rumbles deep in my stomach. Never again will I see his sweet face. Never hear the joy in his voice as he stands behind his easel smiling at me. Memories of our final times together are etched in my mind. My heart aches. Tears form.

I continue on to *rue Cardinet*, anxious to be reunited with Grace and her parents. Reaching down into my purse I take out the apartment key, but then hold it without inserting it in the door. What should I expect on the other side? Is it still the safe haven I've counted on ever since I came to Paris? So much has changed. Instead of unlocking the door, I knock gently.

When the door opens, and Grace stands in front of me, disbelieving what her eyes see, I feel some relief. Then she squeals with excitement. "Emma! Praise God! You're back and safe." She lunges over the doorsill to hug me in a suffocating embrace. "Everyday I have prayed for your safe return," she whispers in my ear.

Pushing her back at arm's length for a moment, I look at her. Her cloth housedress seems shabbier than when I left, but she hugs me and holds on as if she is keeping me from drowning. I stroke the softness of her light brown hair, in disarray like her clothing, then caress her cheek with my hand. "I've missed you, too," I whisper in a voice that is strangled in my throat.

Clarise and Hector come from inside to stand behind Grace. She stiffens when they approach. "We are glad you are safe, Emma," Clarise says.

"So much has happened in your absence," Hector adds in a sad voice. "Our lives have been changed by the Prussian siege—"

"I know," I interrupt. "In *Trouville* we heard—"

"We must give you bad news," he breaks in. Then he stops to gather a breath and trembles when he starts again. "Life has been difficult for my wife and daughter. There is little work for me." He wrings his hands as if they are ready to do some kind of work. "We are barely surviving... barely." Pausing to take in another deep breath, he gathers himself and tries to stand more erect. "We are no longer able to offer you the hospitality of our home."

"Nooo!" A long, low wail comes from Grace's mouth. "Don't send her away! Papa, *Maman*, please."

Clarise wipes away her own tear. "Nothing can be done, Grace," she says, reaching out to put her arm around her daughter. Grace resists, still holding on to me.

Struggling with his own tears, Hector says, "Day by day we grow worse off. It is no longer safe in the streets. We are sorry, *Mademoiselle* Dobbins, so sorry. We wish it were not so, but there is nothing we can do. If we keep you with us for just one day, it will be that much harder to part the next. It is best for all of us if you leave our home now and find new lodgings."

I look from face to face at their sadness. Their remorse and tears drive home the truth of what I hear. "I understand." My voice is constrained, weak. I can't hide my own tears, but I try to dab them away.

Clarise comes in front of Grace to give me a hug. Then, with perhaps a sudden thought, she turns around to her husband. "It is almost dark, *Mari*," she tells him. "Too late for Emma to find new lodging. She must be tired, she has walked a long way into the city from the railroad. There's no harm in letting her sleep here one more night. She will leave us in the morning. Please give your permission."

135

Hector doesn't resist. In fact, he lets out a deep sigh. "Tonight only, *Mademoiselle*... But we have no food," he adds after a moment.

Grace hugs her father and gives Clarise a look of gratitude. "Don't worry, Emma," she says. "You will find a new place tomorrow. Many buildings are almost empty, so many families have fled."

<center>∽</center>

The next morning, I repack my nightdress in the small valise with the clothes I wore in *Trouville*. "I'll pick up the rest of my belongings when I find a place to live," I tell Grace.

Clarise is in tears again as I say good-bye and go toward the front door. "What have we come to?" She sobs, locking me in her arms.

"Don't blame yourself, *Maman*. I understand." I gently push her away. "I had to leave the lighthouse when my papa died with no place to go. It turned out well enough. I'm sure it will again."

"With Grace not working at all, and *Monsieur* Durand working fewer hours, we are barely surviving, depending on the few *sous* Leo can spare from his pay."

"I won't be far away. I'll come visit often. Good-bye."

Grace gives me a quick questioning look.

Clarise begins to shake. Grace goes to her and leads her to a chair. "This is a terrible thing for my *maman*," she says. "She is scared we will starve. Even when we have a few *francs*, there is not enough food in the market. Sometimes no food at all."

Setting my valise on the floor by the door, I come back to stand close to Clarise and Grace. From my purse I find some *sous* and set them down on the table next to the chair. "I sold some watercolors in *Normandie*," I tell them. "I wish I could do more

<center>136</center>

to help. Perhaps I can if I get more work at Suisse's..." Feeling a lump grow in my throat, I turn and leave the apartment without looking back.

The walk to Suisse's Academy in *Place Pigalle* is familiar. The crotchety white-haired old art teacher is almost alone in his studio. "Look around!" He throws his hands up in despair when I ask for more modeling work. "How can I hire you when all my students have fled Paris?"

"Please, I need any work I can get," I tell him. When he shakes his head no, I ask if he knows of any available lodging nearby.

"They're all over," he snaps. "So many people have left Paris. Try *rue Lepic*. Near *Moulin Rouge*."

Rue Lepic is a long, curving road, wending its way up the steep hill of *Montmartre*. At a nondescript six-story, stone building, about halfway up to the deserted windmills on top, with a hole-in-the-wall *café* and *boulangerie* on the street level, I knock on the *concierge's* door in response to a sign posted outside. The plain-faced Algerian woman who answers tells me there is an empty apartment on the fourth floor. Then she says it is too many stairs for her to climb. I can go look for myself and come back if I'm interested.

The apartment is starkly plain. It has a large main room with a lone floor-to-ceiling window on the street, and two small bedrooms with windows that look out on a trash-filled courtyard from which a fetid smell drifts up. The furnishings are meager—a bed, washstand and rickety chest of drawers in one bedroom, and two chairs, a settee with ripped upholstery and a table in the main room. There is no fireplace. Sanitary facilities are in the courtyard. I wander from room to room, trying to picture myself living here. Still undecided, I rest my hands on the windowsill and peer out. It's not bad, I decide, perhaps as good as the other places

I've lived—a cramped closet of a room in the lighthouse, an attic loft in Luz and Esteban Feliz's hotel, Grace's shared bed, even *Madame* Crystalle's top floor cubicle in *Trouville*—all adequate but nothing more. Maybe I should keep looking, but I decide it's doubtful I'll find anything better. I'm reminded how on the edge my life has always been. Perhaps this is an improvement. I'm a survivor, always a survivor, but never much more.

Movement down in the courtyard startles me back. A mangy gray cat is pulling apart garbage baskets in a far corner, pawing through the spilled contents in search of food.

"*Ne pas manger le chat!*" A strong female voice says behind me. "She is my cat, and you will let her live if you take the apartment."

Turning around, I am confronted by a woman standing in the doorway. Not old, but seemingly past the prime of her life. My first thought is that she bears a strong resemblance to the cat: unkempt gray hair and bushy gray eyebrows. She has an oval face, but her high forehead reminds me of an egg. Her nose dominates her face and her lips are thin and flat, almost nonexistent. Her most arresting feature is her piercing dark eyes, staring unwaveringly at me.

"You will live here," the woman says, more a statement than a question.

"I think I might," I answer.

"You are not French."

"I came from California."

"Why come here now when most are leaving?"

"The family I live with can no longer feed me."

"Ah, *oui*," the woman nods. "Everyone starves. Soon we will fight, but now we starve. So you would live here to starve by yourself." She chuckles, but it is not a happy sound.

"And you?" I decide to take control of the conversation. "Are you starving, too?"

"I live across the hall with my mother. I teach poor children. Their parents contribute what they can. So, *oui*, like my cat, I must scratch for my food. Look at me—not always so thin—but it is the children I worry for. What is your name?"

I introduce myself.

"I am Louise Michel," the woman responds, her face still expressionless. "Why do you stay in Paris?"

"I returned from *Normandie* yesterday and learned I had no place to live."

"Those *salauds* in *Versailles*," Louise Michel spits angrily. "The Republican bastards don't know the suffering they cause us. They don't care how many starve while they hold out against the Prussians. No different than the devil Napoleon, may he rot in English hell! People here can't hold on much longer. A revolution is coming, mark my words, and I pray it comes soon so I can fight the bastards."

I'm shaken by Louise Michel's outburst. I consider looking for a different place to live, not so close to this radical woman. And yet her words sound familiar, like Martin Aboud's words.

"Stay and help me care for the poor people, *Mademoiselle* Dobbins," Louise says, more of a command than a statement. "This is not a bad place to live, with a *café* on the street and water fountain not too far down *rue Lepic*. You could be comfortable enough. Do you have work?"

"For some artists nearby and in *Batignolles*," I lie. "I won't be able to help you with the children, my art is most important to me. What is the rent?"

"No rent! *Gratuit pour l'instant!*" Louise laughs. "The *Prefect* has ruled no rents while the siege continues. The rich bastard

owners are barred from collecting any rent. And well enough that is because the poor workers would fight if they tried. So you can stay here at no cost, at least until the Huns march back across the Rhine." She gives me a dubious look. "A girl like you can earn enough to get by on her looks, no? Still, I will call for your help when I need it."

I eye her, without commitment, uncertain about her meaning.

Most Parisian *cafés* are struggling from the stranglehold the siege has on food supplies. Many I pass have closed their doors to customers. But others, like *Café Guerbois* in *Place de Clichy*, still have limited menus for those able to pay the price. A few better-dressed gentlemen are sitting at street-side tables sipping *café crémes* or *kir apéritfs* as I pass by one afternoon a few days later absorbed in thought. The *rue Lepic* flat will do until I can improve my income when Paris is liberated again. Despite her rough exterior, Louise Michel seems a caring, warm-hearted woman, taking care of her aging mother and *Montmartre's* children as best she can. Almost past the *café*, a man jumps up from his table and charges up behind me, grabbing my arm. Without looking, I know who it is. This is not the time for the reunion I've been dreading, but there is no way to avoid it.

"Emma," he calls out. "I was hoping you would come by this way from *Pigalle*."

"*Bonjour*, Leo." I pause to take a deep breath. "I didn't know you were in Paris."

"I've been home over a month waiting for you. I was disappointed when Grace told me you went to *Normandie*, but this morning she said you'd come back."

"Over a month? So you sit in a *café* hoping I will come by?"

My question doesn't register. "Yes, over a month! We never had a chance to fight. We were prisoners until our officers agreed to parole and the Prussians sent us back here. All the National Guard is in Paris."

My thoughts go quickly to Frederic. "But the fighting continues...?"

"In the south, *oui*," Leo interrupts.

"How unfair."

"Unfair to us in the Guard," he whines. "We never had a chance to fight. Now we're trapped here while the siege goes on."

I can only think that here is Leo perfectly safe in a *café* in front of me while Frederic... I feel sick in my stomach. Why do men fight and kill each other? I stop myself and give Leo the best smile I can manage. "I am glad you are safe."

He gives me a reproachful look. "What good is it to be safe when France is at war and we cannot join the fighting, and the new government acts so cowardly. We are humiliated."

He is making no sense. I struggle to get the image of Frederic—lying dead in a field in *Bourgogne*—out of my mind. "I am no longer living at your parents' apartment with Grace."

He nods. "She told me this morning. Come sit with me to talk. It is wonderful to finally see you again. I have missed you so much." Without waiting, he takes my elbow and leads me back to his table. I have no choice but to go along reluctantly, noticing the other men grinning at me. Leo beckons a waiter, "An *apéritif* for *mademoiselle*," he commands, not allowing me to protest. "I've been anxious to see you," he says after I'm served. Taking a sip of the *kir* and wincing at its sweetness, I wait for him to continue. "Do you remember what I said to you before I left for the front?" He asks.

Watching his face soften as he reaches out to take my hand, I stammer, "About what?"

"About courtship." Now he shows a hint of frustration that I don't know what he refers to.

"Oh that," I say, trying to think of a way to stall this inevitable conversation, knowing that's impossible. I take another sip and hold the glass close to my mouth a moment, hiding behind it, feeling completely trapped. "I do remember. I said the war was not a good time to talk about it."

"No, Emma, you said we would talk about it when I returned. I've been thinking about us and waiting for you ever since."

When I set the glass back on the table Leo squeezes my hand in his before I can extract it. "Well?"

"I am not so sure about French ways," I smile innocently at him. "Is courtship a step couples take before marriage? Or before an official engagement? Tell me what it means to you."

It takes a moment for him to see the difference and find an answer. "A step before a couple set a date for a wedding," he says finally.

"That sounds very sudden for me, Leo. I am fond of you—very fond, you know that—I've told you that before. But I am not ready to marry. I have my art—I plan to build a career. For me, courtship would mean spending time together to know more about each other, and then decide if marriage is the right thing."

"Well, that's all the same thing, isn't it? Just different words?"

"Not for me. The only way I would agree to enter a courtship would be to know you better and see if marriage might be a good thing. I cannot promise you it would lead to our marriage. I am not ready to make that commitment. I want to devote my full time to my art."

Leaving Leo sitting dejectedly at the *café* table with my unfinished *apéritif* when there is nothing more to discuss, I continue along *ave de Clichy*. My eyes are misting, threatening

tears gushing down my cheeks at any moment when I think about the unfairness of Frederic's death. It is clear to me Leo believes he loves me, that he thinks our marriage is inevitable if only I could come to my senses. But I am far from sure, and yet I don't want to hurt him. He's been a good friend—but I'm unable to make any commitment to him. Fond? Yes—how many times have I told myself that and given Grace that excuse? But there are too many unanswered questions. Berthe says she has postponed thoughts of marriage to pursue her art. She thinks her art would suffer if a man were too important to her. What would my life with Leo be like? I will not give up my dreams. No, I tell myself, Leo doesn't even know my dreams. How can he share them? All he really wants is to possess me, cage me like an exotic bird. He would keep me in some cramped flat like his mother and father's—he doesn't know anything else. I would be his...prize. Or his prisoner. Raising his babies and cooking his dinners. I will not!

Dabbing my cheeks and quickening my steps, I still can't stop myself from turning into *rue la Condamine* and walking down the street to stand in front of Frederic's building. Looking up at the large window still brings a smile to my face.

Obsessed by thoughts of the last time I came to pose for him, I climb the four flights of stairs and stand, a little shaky, in front of the studio door. Hesitating only momentarily, I reach out for the doorknob. It turns. The old wooden door creaks on its hinges and opens. The studio beckons me inside. My heart is pounding in my chest when I walk to the center of the empty room. At the spot—my spot, I tell myself—the images flood back. Frederic stands at the easel a few feet away, watching me breathe, watching my breasts and belly move up and down. I can see his deep blue eyes, with their gray cast, devouring all of me.

When I snap back from my reverie, I shiver. My arms are clammy and the feelings low in my body return. I begin to walk about the studio, stopping here and there, trying to grasp what is different. The awareness, when it comes, makes me recoil. The studio is deserted. There are no easels in the center of the room where they always were. The piano that stood adjacent to the window wall is gone. Standing at the window for a moment I look out. The only soul on the street below is the same old man in the bowler hat I saw walking his dog the first time I came here. Today he is without the dog. Turning back into the studio, the walls are bare, discolored and scarred where paintings used to hang. No canvases are stacked along the floor or leaning against the walls. The studio is empty. Abandoned. The thought stabs my heart—Frederic is never coming back. I go quickly up the stairs to the loft and find it just as barren as the floor below. The bed is stripped and the closet empty.

Back downstairs I wander around again, hoping I've missed something, but I haven't. "Where is it?" I say out loud, my voice choked, sounding like a croak as it echoes against the empty walls. "Where is my painting? Where are all the paintings?" Sinking to my knees, I feel panic taking control of me.

CHAPTER ELEVEN

February 1871

ON A COLD February evening, Leo and I walk to *Café Guerbois*, where only a handful of somber men sit like statues at tables, speaking in low voices. Their conversations create a low, droning sound in the wood-paneled room. Martin Aboud sits alone in a dark corner, nursing his beer. I try to steer Leo away from him, but Leo heads in his direction. I wanted to talk frankly with him about our relationship—about his insistence we begin a courtship—but Aboud's presence will make that conversation impossible.

Since settling into the *rue Lepic* flat, I've been in turmoil. Continuing to struggle with the loss of Frederic, and his missing paintings, I now spend much of my time pondering my future. It's unfair for me to let Leo continue to hope, so I planned to tell him that this evening. Difficult? Yes. But it has to be done. I see no future with him. Not with any man, now that Frederic is gone. My own future is more important.

"*Bonsoir,*" Aboud calls loudly from across the room, turning heads in the *café*. He holds his mug in midcourse to his mouth hiding his aquiline nose so that his eyes seem to leer at us over the rim in a sardonic smile. "I wondered when I would see you again. Back from the war are you, Leo Durand?"

"Ha," Leo scoffs. He takes my hand, but his eyes are probing for signs of mockery on Aboud's face. "We never made it to the fighting."

"Grace said you were a prisoner. The emperor is gone."

"*Oui*. In exile."

"Come. Sit." Aboud has a conciliatory look on his face. "Perhaps we have reason to be friends now."

Leo continues studying him for a moment. Then he points me to a chair and takes one across from Aboud. He calls out for a waiter to bring two beers. "Louis Napoleon was a fool dashing off into war before the army was prepared," he says, slouching down next to me. "We could've won."

"A bigger fool than we thought," Aboud agrees. "And you, *Mademoiselle*?" He gives me an overly warm smile. "How have you survived the siege?"

"In *Normandie*," I reply. But then, as an afterthought add, "It is not good here for any of us."

Aboud nods. "*Oui*, the new government seems as blind as the old."

"Today my *concierge* told me landlords will begin collecting rents again soon. How will we pay without work?"

"Our pay has been cut too," Leo interrupts me.

"The Guard?"

"There are more than a hundred thousand of us in Paris," he says. "We will all starve."

Aboud pounds the table with a meaty fist, spilling foam from the new mugs in front of us, creating a little puddle on the table, and startling me so that I cringe at the sound. "Five billion *francs* to pay off the Prussians! A disgrace!"

Across the *café*, a couple of men set their glasses down at the sound and turn their heads to look at us. They stare at me briefly

and two say a few words in low voices before turning back to their conversation.

"An insult to France's honor, I say," Leo almost shouts. "Better to die fighting."

I put a restraining hand on his arm.

"Leave me be!" He shouts, brushing it away. "Another beer, Aboud?" He is up from the table and heading for the bar.

As soon as he's gone, Aboud smiles at me, "He is finally seeing what I have been saying for months, *Mademoiselle*. Is there a chance we could see each other to talk?"

When Leo returns with the mugs, saving me from a reply, I put my hand on his arm again. "We came to talk privately," I remind him.

"That can wait," he snaps and turns immediately back to Aboud. "I hear talk, Martin, the Guard might revolt."

Aboud puts his hands on the table. "Workers in *Montmartre* and *Belleville* are near fighting, too," he says.

Lost to the conversation, I realize it is not a night to share my thoughts with Leo. I consider getting up and leaving them to their beers and rough talk but stop for fear of walking the dark streets back to my flat alone.

An older man gets up from a table across the *café*, leaving a group that has been deep in private conversation, and comes to stand by me. "*Mademoiselle* Dobbins," he says tentatively, almost a question but not quite. "I thought I recognized you. Do you remember me?"

Startled, I turn and look up into his face with a smile of recognition. "*Monsieur* Degas, I didn't expect..."

"Nor I to see you," he interrupts. "Have you forgotten my request at the ballet?"

"To sit for you? No, I have not. I've been in *Normandie*."

"I am sorry to hear about Frederic Bazille's death, *Mademoiselle*. A fine artist... My friends have just been talking about him. What did you do in *Normandie*? Did you paint?"

Darting a look at Leo and Martin, who are staring at Degas, I smile. "*Oui, Monsieur*, a very good friend. I miss him. In *Trouville* I painted with Boudin and Corot."

"Ah, *bon*! Fine teachers," he nods. "A good opportunity for you to learn. Now I ask again, will you come to my studio and sit for me? It is close by here, just down the street. Please say yes or no."

"Yes," I tell him. "Are you here often then?"

"In the evenings. I often meet with other artists—Frederic was one. Most have fled Paris by now, but they will return when the Prussians leave. Can you come to my studio in a day or two? I am anxious to start a new project—It keeps my mind off this terrible time. I've hoped to hear from you. I see you in my painting."

His words trigger a strong reaction in me. I imagine Frederic sitting at the table across the room with a mug in hand. It brings a lump to my throat. "Yes, I'll come," I say again in a quiet voice. "What is the address?"

Leo's empty mug slamming down on the table punctuates the conversation. He pushes back his chair, scraping it against the wood floor and heads back to the bar.

�

Edgar Degas hardly acknowledges me when I enter his studio. He only nods without a word, and points to the privacy screen in the corner of the room where I am to change my clothes. Then he moves from his easel to a long oak table. He sorts through a handful of sketches and mumbles to himself. I watch for a few

seconds, waiting for his attention and instructions, but he ignores me so I go behind the screen. Laid out on a chair against the wall are a white dancing dress and white tights with embroidered flowers so dainty they are hardly visible. The dress has a fitted bodice held in place by slender straps. The skirt feels delicate and ethereal when I hold it against me. It barely falls below my knees and I feel a bit *risqué* as I look at my image in a mirror. There is also a pair of ballet slippers on the chair. Examining them skeptically, I feel how insubstantial they are, unsure I can stand on them. On the other side of the screen I can hear Degas moving about and continuing to make mumbling, grunting sounds.

Finally, he stops. "Come now, are you ready yet?" he calls out. "I don't want to lose the light."

"One minute," I plead, quickly stripping off my street dress and hanging it on the edge of the screen. I start pulling on the tights over my drawers. It doesn't work. I have to roll the tights off and tug down my drawers, looking around to make sure no one is seeing me.

"Hurry, *Mademoiselle*! You are wasting my time," Degas shouts.

With the tights on and the skirt flowing diaphanously around my hips, I feel slightly more at ease. I step out from behind the screen, thinking I look like some dancing doll.

"Oh no, no, no," a dismayed Degas almost shouts. "Come here!" Not waiting, he comes to me and fidgets with the dress, adjusting the straps on the bodice so they lie exactly where my arms and shoulders meet, and then he reties the sky blue sash around my waist and adds a large bow in the back. "The shoes!" He cries. "You must put on the shoes."

"I've never worn ballet shoes,"

"No matter, *Mademoiselle*, you won't be dancing. Put them on and come over here." He points to a ballet *barre* on a wall across

149

from his easel with a mirror behind it. "Put your left foot on it. Keep it straight!"

When I extend my leg, I have to hold onto the *barre* to keep from falling. Degas walks around, studying his composition from all angles. When he is satisfied he walks back to his easel. "A little fuller in the bosom than the dancers," he mutters to himself as if I weren't standing there. But a prettier girl."

"Is that why you asked me to pose?"

"No!" he says in a gruff voice. "Absolutely not! I want to capture the pained look on your face. Keep the grimace that tightens your mouth and pinches your forehead. I don't paint pretty pictures, *Mademoiselle*. I paint reality. Remember? Beauty is the opium that allows people to endure the harshness of their lives," he scoffs, walking back to his easel. "Now hold onto that look."

For the next hour Degas loses himself behind the easel, peering only occasionally at me through his thick glasses. Struggling to maintain my pose, my back begins to ache and my thigh and leg on the *barre* start to cramp. The strain shows in my eyes and face, apparently what Degas wants.

"Stand straight!" he calls out, "Don't look quite so pained."

"I am pained, *Monsieur*. This does not feel beautiful to me."

A few minutes later, when he snaps at me again, I ask, "Do dancers have to hold a pose for so long?"

"No. Why do you ask?" He barks. "You're not a dancer, you're a model. Keep your back straight." He goes silent again until finally, much later, he says, "Enough for today. Carefully remove the dress, please. You will wear it at least two more sessions. Maybe three if you can't hold your pose better for me."

The second day is much the same as the first, with Degas just as preoccupied as the day before, and unfeeling in his sharp

commands, except that now I know the discomfort that lies ahead as I take my pose on the *barre*. When I arrive the third morning, he is sitting in an old wooden high-back armchair with well-worn cushions showing strands of horsehair through rips in the leather. He is smoking a short, black cigar that smells like street garbage, and reads from a wrinkled newspaper with a *pince-nez* on his nose. He greets me smiling. "I think I can finish today," he says. "Change and we'll get right to it." He rises from the chair with the cigar clinging to the side of his lip. "You're a better model than I expected, Emma. Less complaining than the dancers at the ballet. I can see why Bazille liked painting you so much."

Wearing a smile behind the screen as I change into the tights and dancing dress, I let his compliment trigger memories of my days in Frederic's studio. When I think about the grueling hour ahead, my smile fades, replaced by the look of agony Degas insists on. When the session finally comes to an end, I change back into my own long green skirt and white blouse again. Adjusting my straw hat, I emerge from behind the screen. "How well did you know Frederic?" I ask.

Degas looks up from the desk where he is surrounded by scraps of paper. "Well enough. As I said, he was part of our group of artists that met regularly at *Café Guerbois*. A likable young man. Did you pose for him often?"

"Enough."

"He will be missed."

"*Oui*," I say it a little more wistfully than I intend. "I went to his studio as soon as I returned... I couldn't believe... It was empty."

He nods, but doesn't offer any comment and looks back down at the papers on his desk.

151

"Do you know what happened to all his paintings?" I ask him after waiting a moment.

He wipes a few specks of dust from his sleeves and looks up. "I do not," he says. I can tell he wants to end our talk. "He shared the studio with Renoir, did you know? Perhaps Renoir would know about Bazille's paintings."

"How can I find him?"

Degas rises from the desk and comes to me, holding out an envelope filled with *francs*. "I don't know," he says again, thoughtfully. "Thank you for posing. We are done. I hope our paths cross again. Goodbye."

Several days later Martin Aboud knocks on the door of my flat holding an envelope in his hand. "That gentleman who approached you at the *café* was looking for you last evening, *Mademoiselle*. He asked if I would deliver this to you and he gave me a few coins. Lucky for me! I was almost out of beer."

I thank him and take the envelope inside to read. It is typical Degas—short and to the point:

> *Mademoiselle Dobbins,*
>
> *Having given thought to your query regarding Renoir the artist, as I said, I do not know his whereabouts. However, he is a regular at Comtesse d'Agoult's soirée when he is in Paris. As I am also invited for next month's soirée, I would be pleased to have you accompany me as my guest and you may see him there.*
>
> *Cordially,*
>
> Edgar *Degas*
>
> *P.S. Let me know if you accept my invitation. Of course it is very important to dress in appropriate attire to attend.*

Two days later I rise early. Quickly donning a long-sleeved white blouse and my new, long black skirt Degas's *francs* have

purchased, I study the contents of my cloth reticule, deciding I don't have enough money to splurge on the omnibus. So tying my straw hat under my chin, I sling the carrying strap of the portable easel over my shoulder. Closing the apartment door behind me, I'm prepared for a long walk to Passy. I am about to step out onto *rue Lepic* when the door of the *concierge's* apartment opens a crack and the Algerian woman peeks out at me.

"*Madame* Michel left a message for you," she says. "She wants to speak with you."

"What about?"

"How should I know?" The woman snaps.

I shrug. "I'll see her later."

The old woman slams her door and I'm met by a blast of cold air when I step onto the sidewalk. I buy a small *baguette* in the *boulangerie* and leave *Montmartre,* walking south along *rue de Clichy* to rue *Saint-Lazare.* I cross to *blvd Haussmann,* where some of the finest shops and *ateliers* are located. Sidewalks are crowded with workers and shopgirls hustling to be on time as the eight o'clock hour nears. National Guardsmen in vivid blue and red uniforms idle about in twos and threes on the street corners and *cafés.* The smoke from their cigarettes and cigars reaches out to me, like irritating fingers groping for my eyes. The Guardsmen give me an unsettled feeling as they loiter against the walls watching.

At *le Printemps,* a large department store that dominates the boulevard, I press against the window displaying beautiful dresses and gowns. The vibrant silks and satins and delicate laces overwhelm me. I stand enthralled for several minutes, imagining myself in each dress, attending the upcoming *soirée* with Degas. But I cannot see any prices on the gowns so, breathing a heavy sigh, I turn from the windows, and accept the reality that all of them are beyond my reach.

"*Mademoiselle*, what is it you carry on your shoulder?"

The voice startles me. Turning, I see a National Guardsman pushing himself off the wall where he was leaning and comes toward me.

"Is it heavy?" he asks with great solicitousness. "I would be pleased to carry it for you wherever you are going. Only a few *sous* so I can buy bread."

"*Merci*, but no," I tell him. I walk away, continuing down *blvd Haussmann* to where it joins *ave de Friedland*. The guardsman mumbles something and resumes his place slouched against the *café* wall.

Arriving at *Arc de Triomphe*, a monument to the first Napoleon's victories that Leo has bragged about, I am confronted by a bewildering maze of carriages, omnibuses, lories and *fiacres*, circling the monument or trying to enter or depart the roundabout from the avenues and boulevards converging there, blocking me from crossing. I have never seen so many horse-drawn vehicles, each heedless of the others, or of me, as they jockey for paths to freedom outside the circle.

I'm like a statue fastened to the curb, shaking with dread, my heart racing, afraid to step off. A *gendarme* sees my panic and comes to my side. Without a word, he offers me his arm, which I gratefully cling to, and boldly step into the traffic. Raising his hand against the onslaught of approaching horses—as if that would halt them—and blowing on a whistle, he starts toward the center island. Certain my life is doomed if I let go, I clutch his arm. Vehicles whiz passed, barely missing us. The imperial stone arch with heroic carvings overhead seems to be bearing down on me. My breath comes in short gasps. My eyes spin around the traffic circle. I tighten my grip, pinching my fingers deeper into the *gendarme's* arm. Once on the opposite curb, he reaches

with his other hand to gently peel them off. "You are safe now, *Mademoiselle*," he tells me in a subdued voice.

Speechless, I throw both arms around his neck and hang there helpless, trying to catch my breath, slow my heartbeat, and pull myself together. "*Merci Monsieur*," I say in a constricted voice into his uniform collar. "*Merci, Merci*," I mumble again and again. "I thought I was going to die."

He laughs and gently detaches me. "*Ce n'est rien*," he says as if this chaos was nothing special, and slowly walks away.

By the time I arrive at Berthe Morisot's family home on *rue Guichard* in *Passy* I have gotten my pounding heart under control as much as possible, but breathlessly I tell her my tale of rescue by the *gendarme*. She laughs. "French men will risk much to hold a pretty woman in their arms," she says with a note of gaiety in her voice. "No doubt he was alarmed at seeing a woman trying to cross the *Arc de Triomphe* alone," she adds in a less gentle tone. "You must learn to be more cautious."

"Oh, Berthe," I breathe a frustrated sigh. "Whenever we are together you scold me about a woman's place in France. I've been here two years and I still can't understand your ways. Paris is not like California. I was independent there. I went wherever I wanted, did the things I wanted to do."

She gives me a concerned look. "In France we let our gentlemen escort us in dangerous places." She says no more, smoothing the fabric of her skirt and lifting her easel to her shoulder. "Well then, are you ready to paint? Let's go to the Hill of *Chaillot*, just a short walk from here, where there is a fine view across the river to the *Champs de Mars*.

With easels slung over our shoulders, we make the short walk to the hill overlooking the river. Crossing onto the grassy slope aiming down to the *Seine*, we pass two more men in

National Guard uniforms conversing on the street. Spotting us, they approach.

"What is your purpose in crossing, *Mesdames*?" The taller of the two, a bony man with a sunken face, asks. His uniform hangs off his shoulders like damp laundry on a back garden line.

Berthe gives him a fierce look. "To paint the scene, *Monsieur*. And why is it any of your concern to stop us? Please move away and allow us to pass."

I move closer to her, watching the men carefully.

His partner spits juice from a chew of tobacco onto the grass. "What do you have slung on your shoulders?" He demands.

"They're easels to paint on. Now move out of our way." Turning her back on the Guardsmen, she says, "Come, Emma. Pay no attention to these lazy ruffians with nothing better to do than pester us."

"Can't be too careful these days," The bony man says as we walk away. "Especially young women."

Berthe shows me a spot to set up my easel on the lawn behind a fence protecting us from the turgid, opaque waters of the river, carrying the flotsam and garbage of Paris as they swirl past. On the far side, the park-like *Champ de Mars* is a broad swath of grass stretching in front of us to the gold dome of the *Ecole Militaire* that gleams like raw copper in the overcast sky. Without conversation we set up to paint.

"We're in Paris and yet we're not," I tell her, staring into the distance in awe. "Standing here is like we are outsiders peeking in. A fine place to paint. Thank you for inviting me today."

"I have looked forward to the opportunity to share this view with you. *Champ de Mars* has played a role in our history over the years. And this is a fine opportunity to know each other better."

I'm quiet, concentrating on the scene I want to paint in front of me.

"Soon you will be painting in oils too," Berthe adds.

"I will. But I am still happy with my watercolors. I sat for *Monsieur* Degas two days ago and tried to study his brush strokes. He works very methodically."

"*Oui*, he is a fine painter. You are fortunate in being asked to pose for Bazille and now Degas. It is a good way to learn. I have learned about painting posing for *Monsieur* Manet."

I start to pick up a brush then pause. "*Monsieur* Degas invited me to attend a *soirée* with him a few weeks from now."

"Wonderful. You will meet important and interesting people."

"Do you go?"

"Sometimes." She smiles. "My mother has her own salon each month, but I am not often in attendance. I go to *Madame* Manet's *soirée* sometimes."

"May I ask you what is appropriate to wear to a *soirée* with *Monsieur* Degas?"

She pauses to consider. "You will find people wear all measure of attire, depending on their status and place in society, and sometimes just to be eccentric and stand out."

That makes me laugh. "But I have no status or place in society. I have no idea what I should wear."

She laughs with me. Her usually somber and serious face breaks out in a broad smile. Her black eyes sparkle and a kind of dark beauty illuminates her face. "Forgive me, Emma, you make this sound so serious."

"For me it is! Don't laugh, I need your help."

She seems to realize she has embarrassed me and turns serious. "How you look is very important to those people. You should honor Degas by wearing the best gown you have—not a ball gown, you know—but an evening dress, perhaps one that complements your silhouette. There will likely be many old

dowagers there who will be overdressed in order to compete with one another. You might choose a dress that enhances your youthfulness."

Blushing, I beam at her compliment but don't let on I have no dresses fine enough to fit her recommendation. Instead, I turned back to the view of *Champ de Mars*. "I will have to think about your advice," I tell her, hoping to let the subject drop. "You said earlier the sight in front of us is special. Why is that?"

"Not even ten years ago Nadar, the photographer, launched *Le Géant* from there. It was the largest hot air balloon he ever flew. It rose with a giant bag of hot gas pulling it up and a basket hanging underneath holding nine people."

"It must have been a sight to see," I have a bit of awe in my voice, never having seen a hot air balloon.

"Oh, it was, it was. You could see it all over the city before it was blown north on the wind—over Belgium and into Germany where it crashed."

"Is there more to know?"

"Yes. When the military school was built, *Champ de Mars* was a parade ground for the French Army, but after the Revolution it became a gathering place for the people of Paris. They celebrated the storming of the *Bastille* there in 1799, a year after it happened. They gathered to protest King Louis XVI."

"Why did they protest your king?"

She shrugs. "It seems we French are never happy with our king until we don't have one," she tells me. "The protest grew out of control as the hours passed. By the end of that day, the *Marquise* de Lafayette had to order the National Guard to fire on the crowd, killing a dozen or more people. It is a most historic French landscape and a part of our Revolution."

My brush pauses in mid-stroke, as I still consider the challenge

of finding an appropriate dress to wear to Degas's *soirée*. Looking around I stop and warn Berthe, "Those two guardsmen are still lingering near us and now they are coming closer."

She watches out of the corner of her eye. "Ignore them, they are beasts," she whispers to me. "Since the end of the war they are hanging around all over the city. My father fears they will stir up trouble with the new government over their grievances."

The smaller of the two guards, spits and approaches close to me. "What are the pictures you are making?" He demands.

Looking him in the eye, I snap, "I am painting with my friend, but none of this is your business. You are rude to come so close. Move away from me! Go away!"

His accomplice stands at Berthe's easel. "Do you think they are spies?" He asks his companion, "Maybe they make maps for *Versailles*? We should report them."

"We are painters *en plein* air, not spies, you ignorant man," Berthe shouts into his face. "Leave us now or I will summon a *gendarme* from the street to arrest you. You are a nuisance! Both of you!"

Hearing of a *gendarme* the men slouch off, talking to each other in low voices. Berthe turns to me, "You see the way we are treated, *Chère*? You see the trouble a woman painting a landscape can face? I never expected this in the village where I am known, but I think it is starting all over the city."

"What's wrong, Berthe? There are Guardsmen all over Paris— hundreds of them—standing around on corners, in front of *cafés*, scaring people like me who pass by. Now this. The war is over, why don't they go home where they came from? I have never been scared in Paris before. Today I have been scared several times."

"I don't know. It worries me, too. My father says they are angry about the peace treaty signed by the new government.

Embarrassed by their defeat, they wanted to continue fighting. Now they think the government at *Versailles* will make life even worse for them. Father says they are beginning to hold protest meetings in *Montmartre* and *Belleville* and *Melimontant*. I am sorry this day has not been as pleasant as I had hoped."

"A good day for me, Berthe, all considered. I have learned a lot watching you paint, but now I think I should start back to *Montmartre* before it gets dark. I hope we will have many more days to paint together."

"To be safe ride an omnibus *mon amie*. May I lend you the money?"

I frown at the offer as I pack my canvas and easel for the journey home. "That is a kind offer, but I have money to pay."

I wave farewell and walk along the right bank of the river, avoiding the *Arc de Triomphe* until I reach the *place de la Concorde* and turn toward *Montmartre*. Before going to the flat, I detour into *Batignolles* to the *atelier* where I borrowed the gown for the ballet. The *atelier* door is closed, locked when I try the doorknob. Peering through a window, I see it is dark inside. A feeling something is wrong begins to gnaw at me. I knock on the door several more times, frantic when no one answers. I look around the neighborhood for someone to ask and then go back to the locked shop with full-fledged panic pounding in my chest. Finally, I spot a handwritten sign posted on the side of the door that confirms my worst fears. "CLOSED," it says in big letters and below, the dressmaker has written, "Gone for good."

CHAPTER TWELVE

February 1871

SITTING BY THE window in my flat, watching the animals struggling to haul heavy loads up the steep curve of *rue Lepic*, broken-hearted about Frederic's lost art, and brooding about the fancy dress I'll never wear, it feels as if my life has fallen apart. And I have no idea how to put it back together. I think maybe my life has always been like this—a series of disappointments that seem to overwhelm me all of a sudden. Maybe all lives are this way. Disappointment is inevitable.

I am so deep in my thoughts, at first I miss the gentle knocking on my door. When it grows more incessant and is accompanied by a soft voice calling my name from the hallway, I finally stir.

"Oh Grace!" my mood brightens instantly and I let out a happy shriek when I open the door. "I am so glad to see you." I burst into the hallway to embrace her. "It seems such a long time."

Grace holds me in her arms and whispers into my ear, "I miss you so much, Emma. *Maman* and Papa miss you, too."

Stepping back from our embrace to get a better look at her, "What happened? Your face..."

"Oh, that's nothing." She laughs awkwardly, and without thinking brings her hand up to hide her blackened eye. "A stranger," she starts forming her words slowly, "A stranger in the

station—a large man—crashed into me as he was running for a train. His walking stick hit me in the face. It's nothing really." She takes my hand and steers me back into the flat. "I came for a quick visit—it's been too long since we talked—Leo says to say he misses you."

"I've been meaning to talk to him," I tell her, sitting back down on my chair by the window. Grace sits across from me. "How is Leo?"

"Not good," she says tentatively. "Not good at all," she continues in a stronger voice after a thoughtful pause. "He broods about the surrender all the time. He and Martin are friends now—that's good news for me—but all they do is drink together and complain about the new government. And you, Emma? How goes your life?"

"Don't ask! I have almost no work and not much money left. My painting goes hard. I think it's not just me—there is such a heavy mood in Paris these days. Everything seems different. No one knows what to expect, so I live day-to-day like everyone else. Yesterday, when I went to *Passy* to paint with my friend, Berthe Morisot, we had a strange encounter with two National Guardsmen that scared me."

"They are worrisome," Grace agrees. "It's a strange time." Then a smile puts a sparkle in her brown eyes and fills her cheeks with color. Her voice gains a happier tone. "But I have some news I came to tell you."

I look into her beaming face and wait.

"Me and Martin—he wants to get married."

Momentarily I am speechless. I give her the best smile I can and keep my thoughts private. "That's wonderful," I tell her. "Good news for these difficult times. "When will you marry?"

Her face turns serious again. "Martin wants to marry right

away, but I asked him to wait. I haven't told my parents or Leo so please keep this between us." The joy bounces back into her face. "But you know how much I've hoped and prayed for this, Emma. I do so love him. Are you happy for me?"

I'm prevented from answering by another knock on my door—this time a single, heavy thump. It pushes open before I can get up, and Louise Michel rushes in. "*Bonjour*, Emma," she says in her stentorian voice. "I have been looking for you."

"*Bonjour*, Louise. I was out yesterday."

"The *concierge* told me. Who is this?" She points at Grace.

"Grace Durand."

"You live nearby?" Louise demands.

Grace looks from Louise Michel to me and back, wide-eyed, startled by the sudden intrusion. "*Batignolles*," she stumbles to get out the word. "Emma used to live with my family."

"So," Louise continues with her interrogation, standing over us and peering down over her large nose like a raptor eyeing a meal. "You are a working girl, no? I can tell, looking at you."

"Grace works at the *gare*," I answer for her.

"You were struck by a train, then?" Louise says, pointing at Grace's bruised face, chuckling to herself.

Grace looks away out the window but doesn't answer.

"You are a working girl—like us," Louise goes on, hardly pausing. "We need women like you. Like you too, Emma. I want you all to join my women's corps."

"What is a women's corps?" Grace asks.

I'm puzzled too. "You've never spoken of this."

"When the men start fighting, the women of *Montmartre*, *Batignolles*, and other neighborhoods will have to care for them and the children. I want you both to stand with me in this."

"What fighting?" The word escapes both our lips.

"It will come," she says. "You will see. I can't say when but it is not far off. The new government—those *salauds*! The Republican bastards ignore the workers' plight. We suffer more day by day. The National Guard is also uneasy, angry because of the peace treaty and the reparations. There could well be a revolution, and we women must be ready. All of us! I will let you both know when we have our first meeting after the fighting starts. Together with our men we will stand up to the oppressors in *Versailles* and create a government that listens to us."

With that she is out the door again, leaving Grace and me staring at each other in bewilderment.

The next morning, determined to stop moping around helplessly, I count and recount my remaining *francs* and *sous* and *centimes*. Then I dress and head for *Gare Saint-Lazare*. I buy a third class ticket to *Normandie*, wincing when I see how little change I get back from twenty *francs*, and hurry across the platform, dodging around the other travelers, boarding the train before I can change my mind or lose my nerve. Arriving in *Trouville* a couple of hours later I head directly for *Madame* Crystalle's house. Her face lights up when she opens the door and finds me standing before her.

"Oh, *Mademoiselle* Dobbins! Back so soon. What a surprise!" She says with sincere enthusiasm. "What a delightful surprise it is to see you again." Her blue eyes sparkle in the morning light.

Cautiously, I embrace her. After a few seconds of hesitation, she puts her arms lightly around my shoulders.

"I left in such a hurry, I did not say a proper goodbye to you. I apologize for that, *Madame*."

"It was a sad time for you. I saw how distraught you were by the news of your artist's death. I understood. After you left I prayed to the Virgin to guide you through your dark time. Come

in. Please, come in. Let's not stand here on the sidewalk, Emma, where the neighbors can observe us."

The house is unchanged. The drapes are still drawn in the parlor, giving it a slightly funereal dimness even in the brightness of midday. Crocheted doilies and antimacassars still protect the room's furniture. The room gives me a comfortably familiar feeling. *Madame* Crystalle is unchanged, too, wearing a long, ivory-colored ensemble with delicate China blue embroidery. Her white hair is well-coiffed in a style that seems to belie her age, and her eyes are bright and animated amid the wrinkles surrounding them. Sitting near the draped window facing me, she asks with a teasing smile, "Is this the reason you returned? To apologize?"

"I owe you an apology, but no, I came to make a request of you."

"Not in trouble are you?"

I look at her uncertainly. "There is trouble all over Paris. I try not to notice, but it is inescapable."

"Not that kind of trouble—I don't mean that," she says with a hint of impatience in her voice. "Trouble with men, I mean. Parisian men are thoughtless louts for the most part. A young *mademoiselle* such as yourself is easily seduced."

"No, no trouble. I have no men in my life...now."

"The artist who died in the war—was he your *beau*?"

I search for an answer, shifting uneasily in the chair. "Not my *beau*," I say after an uncomfortable silence, and wonder why I feel so safe being honest with this woman I hardly know. "Perhaps he could have been. Or perhaps it's only a fantasy in my mind. He painted several pictures of me, but now those canvases have disappeared. They were private, and I want to get them back."

"Let me brew us a cup of tea, Emma, and you can tell me how I can help."

Without waiting, she is on her way into her kitchen, leaving me looking around the room and wondering if my trip hasn't been ill conceived. And yet I feel so strongly drawn to this older woman who seems so self-sufficient and competent in all things. In short order the kettle is whistling and she soon reappears with a tray of cups and saucers and a plate of *petite* pastries. When she sets it down, the tea service brings a gasp of delight from my lips. The pure white porcelain cups and saucers have bands of deepest cobalt blue on them, with gold inlays. When she pours the freshly brewed tea, I hold my breath so I won't tremble at the thrill of holding the magnificent cup and spill the contents, or worse, drop it.

"Lovely, aren't they?" she says. "I can see in your eyes and by the smile on your face that brings out your dimples, how much you appreciate fine things. I had a full set when I got married— they have been in my family for more than forty years—from a manufacturer in *Limoges*. My mother gave them to me on my wedding day. I brought them with me when I moved here from Paris." Setting her own cup and saucer on the table beside her, she sits forward in her chair and reaches out a hand to me. "I am so pleased you have come back to see me. Tell me how I can help you."

I'm not sure how to start. I take another sip of tea while considering my words, then set cup and saucer down on the table. "When I was with you before you took me to Mass, do you remember?" I start.

"*Oui!*" *Madame* says. "I remember you had never been before and had no proper clothes—"

"Yes, that's it," I interrupt. "You let me wear a beautiful dress you said belonged to your daughter."

"Amélie," the old woman interjects softly.

"I have been invited to a salon where I might learn the whereabouts of Frederic's—the artist's—portraits of me and—"

"And you want to wear that dress?"

"If I might *Madame*—"

"Oh, no!" She interrupts again with a shocked expression, leaning forward as if to stop any further conversation. "That would never do."

"It was wrong of me to ask. I'm sorry."

"Do not apologize, Emma," she laughs. "What I mean to say is that none of the dresses in Amélie's *armoire* would be suitable for a Paris *soirée*. Far too old and out of fashion. The grand dames in Paris would laugh you out of the room if you appeared in one of those frocks."

I feel a lump form in my throat and a sinking feeling again in my chest. Looking away, not wanting to show my disappointment, "I see," is all I'm able to say. Once again I realize I won't be with Degas at the salon after all.

"You have no fine dresses to wear, do you?" *Madame* Crystalle takes my hand again and pats it gently with her own wrinkled and veined hand. She looks at me with kindness.

I can only nod.

"And you must attend the salon to learn the whereabouts of your *beau's* paintings." It's not a question, only an acknowledgment that she understands my dilemma. We look at each other in silence, while she thinks, and I dab a tear from my cheek. Watching me, deep in thought, she finally allows a smile to play across her face, lighting up her pale blue eyes again. "I have a solution," she breaks the silence. "Perhaps you could choose one of Amélie's dresses you like, and I will make some alterations and changes so it would be suitable for the salon you wish to attend."

"You?"

"You are surprised?" she laughs heartily. "I was the one who made all those dresses for Amélie in the first place."

"You're a dressmaker? I am surprised."

Her face glowed with pride. "The finest in Paris, people said of me. Amélie was the belle of the city when I dressed her." She stops abruptly. "Enough of that—go pick out the dress you like best and let's see what we can do with it."

I look at her again, this time feeling fresh excitement, but with confusion on my face. "Will you help me? I don't know which dress would be right. I don't know what a salon is like."

For the remainder of the day, we work in the unused bedroom on the second floor where Amélie's dresses hang like lost children from another time in the *armoire*. *Madame* Crystalle makes alterations and additions to a chiffon dress she thinks best accentuates my dark hair and complexion. Unembarrassed, I take my own clothes on and off as she measures me and modifies the changes she is making. Late in the afternoon, she throws up her hands. "Enough for now," she cries out, jamming the needle she has been sewing with into a pincushion on her wrist. "My old eyes can't stay on this fine work as long as I used to. We will take a break, Emma. Come along, there is something I must show you."

Without explanation, she takes me by the arm and we leave the house, walking along the familiar streets to the beach together. The sound of the surf is familiar and comforting as we approach, a faint reminder of other times, and I feel as if all my concerns are vaporizing in the brisk ocean air. On the boardwalk, she steers me along to a giftshop where tourists browse for mementos of their *Trouville* holiday, including Boudin's beach prints and other collectibles. I'm surprised when a young couple standing by the

door points at me, and speak together in hushed voices when we enter the shop. Inside, others turn to look at me and smile. "Why are they all looking at me?" I ask her.

"You will see," she says. Taking my arm, she leads me toward a rack of art prints in a corner of the shop. Stunned, when I see why others have been staring at me, I stop short. My mouth goes slack. I feel faint as if I'm in a dream. Staring back at me from the rack is a Boudin print titled, *The Girl From The Lighthouse*. The image is clearly me walking toward the viewer with the lighthouse on the cliff in the background, just as it had been the day when I learned about Frederic's tragic death. But the lighthouse in Boudin's print is not the *Fécamp* lighthouse where he painted me. The Point Conception lighthouse has been painted in its place. I turn to *Madame* Crystalle, slack-jawed.

"Boudin's idea with Corot's help," she says, laughing. "After you returned to Paris, he found a picture of the California lighthouse and painted it in. Then he and Corot both signed it and he had a hundred prints pulled from the original. He sells them to the tourists here along with his other oils and watercolors. It is very popular."

I study the image. It evokes a deluge of old memories of my youth. And I can clearly remember the day we painted together. Tears overflow my eyes. I dab at them and try to steady myself, putting a hand on *Madame's* shoulder for support.

"I look so alone—so small—walking away from the lighthouse as if it no longer protects me the way it protects ships that pass beneath it. As if I'm leaving something safe and familiar and walking toward an unknown future."

She smiles. "That's what Boudin says he saw that afternoon."

"I must thank him before I leave. I hope he will have a copy for me."

"More than that," the older woman says. "He saves a small portion of the profits from the sales of each print for you—he calls it your sitting fee. He planned to give it to you whenever you came back."

After dinner that evening, again in the empty bedroom, as we work on the dress side-by-side, I feel more at peace than I can remember feeling for a long time. "I can't believe how lucky I have been to know you, *Madame*. It is a joy for me to spend this time with you."

"It is *my* joy to have you in my house again. Perhaps *Monsieur* Boudin will continue sending more small profits from the print and you will be able to visit me often."

"Already he has been generous," I tell her with excited joy in my voice. "Did you see how the young couple approached and asked me to add my name to the print? I didn't know what to say."

Sitting cross-legged on the bed, fascinated watching her work with needle and thread to sew a perfect hem in the dress, cautiously I ask, "Will you tell me about Amélie?"

She stops abruptly as if she has poked the needle into her finger, and looks up from her sewing. A hint of anger flashes in her eyes and quickly fades as she continues looking at me in silence. "You remind me of her," she says at last, with a touch of remorse in her voice. "A pretty girl like you, not as tall, but with the same kind of beauty. She had blond, curly hair the color of honey." *Madame* lapses into silence. After a moment of reflection she continues, "She is not with me anymore."

I wait a moment then tell her, "Those were the words you used the last time I was here. I don't mean to pry but has she died?"

"She lives in Paris, but she's dead to me."

Pondering her words, avoiding her eyes and looking about the room, I stop talking, choosing not to question her further.

She busies herself on the hem again. Several long minutes pass, measured by our two beating hearts.

"You are so much like her," she tells me finally. "I wish you were my daughter so I could protect you from her sad life."

An involuntary sob escapes my lips. My eyes start to mist. "There is no protection from life, sad or not," I tell her. "There is no way to know one's future. No one knows that better than I do. I've been alone in life since the age of thirteen, with no place to live and no idea of what my future would be. I won't pry, but I am very fond of you. I will listen if you want to talk about Amélie."

"She broke my heart," *Madame* Crystalle says, trying hard to stifle her own sob and not look at me. "We lived in Paris. I was a well-respected dressmaker, sought after by the *haute bourgeoisie*, supporting us after my husband died. Amélie was a very talented young girl. She could draw and copy pictures perfectly at a young age. I thought she might have a career in art, or could design clothes with me. As she grew up I created fine things for her to wear. Society ladies flocked to me for my designs and needlework when they saw her with me at the opera and theaters. As she grew older, she was the most lovely, sought after, young *ingénue* in Paris during the social season."

Madame stops talking. I sit silent, still cross-legged, on the bed beside her, waiting for her to continue.

"The admiration was too much for her," she goes on, picking up a scrap of chiffon and twisting it in her fingers. "All the attention and compliments overwhelmed her—she lost her way." *Madame* looks down at the scrap she is nervously twisting it in her hand and tosses it aside. "She was a devout Catholic girl but she lost track of The Holy Father and Blessed Virgin. I prayed for her, but she was already lost. One day she told me she was going to live with a gentleman, a man who lavished money and

gifts on her. When he lost interest, months later, another man pursued her and she went with him. I couldn't stand to watch what was happening to her—her own beauty was consuming her. She put aside her talents and relied on her looks to get what she wanted. It was my fault for the way I raised her, but I tell you I couldn't help her—I tried—and I couldn't stand to watch what was happening. I sold my business and moved here where I hoped she would follow, but she never has, and I have shut all the hurt she caused me out of my heart."

<p style="text-align:center">∞</p>

Late the following afternoon *Madame* Crystalle pronounces the gown finished. She accompanies me to the train station. Putting all her reserve aside, she hugs me tightly to her breast, not letting go, whispered her affection in my ear. We stand together for a long time. I promise to return often. Finally, the insistent shout of the conductor and hissing steam announce it's time. Wiping tears away, I kiss her on the cheek and board the train for Paris.

CHAPTER THIRTEEN

April 1871

I LEFT TROUVILLE with the magnificent dress *Madame* Crystalle created for me. In addition, she gave me a hat, a shawl crocheted of white yarn with golden threads, a gold necklace, and a ring with an emerald stone that matched my dress, all packed into a *portmanteau*. The few extra *francs* from Boudin jangle in my reticule. Still smiling from my short stay with this wonderful woman, I detrain at *Gare Saint-Lazare.*

"Emma! Emma Dobbins wait!" Grace's familiar voice calls out over the hubbub in the middle of the station plaza. Leaving her soup cart, she hurries across the concrete promenade to my side. "I'm surprised to see you here," she says breathlessly. "Where have you been?"

We embrace. Holding her in my arms, I'm at a loss to explain without offending her. "I made a very fast trip to *Trouville* to visit the older woman I stayed with before." I avoid details.

Grace gives me a questioning look but doesn't ask questions. Instead, her face darkens. "Things have gone from bad to worse since I saw you last," she says.

"With Martin?" My smile fades.

"With everything!"

My stomach knots. "Tell me. I've only been gone three days."

"Each day is more frightening than the one before." Grace's voice rises dramatically. "Leo says the workers and Guard are heading for a showdown with the government. The old cannons abandoned around the city when the Prussian siege ended have been dragged up to the Butte of *Montmartre*. The workers say they belong to the people because we were taxed to pay for them. The government insists they belong to the army."

"Leo? What does Leo think?"

"He is right in the middle of it." Fear overcomes Grace's voice. She clasps her hands to her breast. Worry lines are etched on her forehead. "He is one of the men guarding the cannons!" Putting her hands on my shoulders, she implores me. "What will we do if fighting starts, Emma?"

"I think the National Guard is eager for some kind of confrontation. I saw it in *Passy* before I left. And I don't doubt Leo wants to be in the center of it—he missed the war." I stop for a moment to choose my words. "He worries me, Grace. Men are stupid—all men—Grace. They think fighting is manly."

Passengers from an arriving train brush by, cursing loudly as they dodge around us, standing in the center of the station plaza.

"Have you seen much of him lately?"

"No, Grace, not much. What about Martin?"

"Same with him."

"Let's not stand here chatting. Come to my flat tomorrow."

"I will. We haven't had a long visit in a while."

❦

Early the following morning, I awaken to loud pounding on my door. Opening it a crack, Louise Michel pushes it wide and charges into the room. "You must come with me now!" She commands.

Standing slack-jawed in my nightdress, I look at her as if she is deranged. "Come with you? Where...? Why?"

"The cannons on the Butte," she says a little out of breath. "The army has marched up the hill to take them. Our men are standing guard. We need everyone to stand with them to stop the government from taking what is rightfully ours."

"What is it you mean by 'our men'?"

"Those of us who are poor workingmen and women of *Montmartre*, of all Paris."

"And what would you want of me? I don't believe this has anything to do with me."

"To stand with us," she almost shouts. "Everyone must!"

"No Louise!" I tell her. "Not me!" I back away from her, as if she is crazed, standing with her hand across her chest like a statue of Napoleon. "I am not involved in what is going on. I am not French. This is not my concern."

She begins marching about the room. "How can you say it's not your concern? It is everyone's concern—all the poor people of *Montmartre* and other workingclass neighborhoods around us," she insists. "Don't be a young fool, you are subject to the same injustices as the rest of us, whether you're French or not. Get dressed now! I'll wait for you!" Her stentorian voice commands me, stopping all discussion.

Speechless, I stare at her, trying to decide the best course of action. I think she might be slightly mad, and wonder if she's dangerous. I had planned to spend the entire day getting ready for the evening, but I can see now she isn't going to go away. "I'll dress and come with you," I tell her, throwing up my hands in surrender, "but only for a short time. I have other plans for the day." With that I leave Louise alone in the parlor, mumbling about my lack of concern, and retreat to the bedroom, shutting

the door behind me and dropping down on the edge of the bed to catch my breath. What does this have to do with me? It reminds me of a time years before when I was 12-years-old...

Huddled close to Papa, as we watched the sun drown itself in the ocean, I put my arms around him and leaned my head against his chest. It was spring—my favorite time of year—and the evenings were still chilly at twilight. He drew me close with his arm and stroked my cheek. He ran his fingers through my hair, the way he had since I was a toddler. There was a slight crack in his voice when he started to speak in a low, private tone.

"It is time for you to go to school, Baby Girl. I've dreaded this day ever coming because it means we'll be separated. But you're twelve now. I've reserved a place for you in a school in Santa Barbara, and arranged for you to live with a family there."

"No!" I jumped to my feet, staring down on him with my hands jammed on my hips. "I won't go," I interrupted him. "I won't leave you. Never!"

"Stop your tears and listen," he said firmly. "It's time. I've waited longer than I should because I couldn't stand the thought of parting with you. But you need an education, more than I can give you here."

"Why? I don't ever want to leave here, Papa. I don't need school, everything I want is here." My words poured out, one after the next. I swiped tears from my cheeks with the sleeve of my cloth jacket and gave his hand an urgent squeeze when he didn't submit. Seeing his determination, I tried a new tact. "Isn't there a school closer, so I don't have to be away?"

"We must both do what is best," he answered. "For you,

it's school and a good education. For me, it's the sadness of not having you with me every day. I've already made all the arrangements. I'll take you there at the end of the summer."

"I'm scared."

"You'll make new friends," he said and stopped. When he resumed, there was a crack in his voice. "I've taught you the best I can, Emma," he started. "But living in the civilized world will be different. I won't be able to decide what's best for you. Making good decisions will be up to you."

"How can I know?"

"Look into your heart, Baby Girl. Your heart will always tell you what's right."

I boarded with the Feliz family in Santa Barbara—Estaban, his wife, Luz, and their ten-year-old daughter Maria Angelica. They lived in a three-story Queen Ann Victorian-style hotel they owned. My small room was on the top floor.

At first, I avoided all contact with them, sobbing inconsolably in the attic room they assigned me, coiled up on the bed and threatening to strike out like a viper at anyone who came too close. I refused to go to school, but one morning, my tears spent, I finally agreed to accompany Maria Angelica. When we reached the two-room mud-brick building, I left her there and continued on to the beach to spend the day on my own, the way I had at the lighthouse.

Standing on the sand, I stared out over the water at the large island not far offshore, separating the channel from the ocean. Then I begin walking west along the beach. I came to a large rock outcropping, pointing like an accusing finger at the island. I sat there, leaning against the rock, longing to hear the thunder of crashing waves that I remembered from the Point. There was no sound of crashing waves, only the gentle hissing of wavelets

lapping against the pebbles. Nothing was the same. Nothing interested me enough to take my sketchbook out of the satchel. I felt as if the free life I'd always known was gone, taken from me, leaving only this bland, lifeless ocean. I brooded for hours, lost in my bitter thoughts. In the afternoon I wandered back to the hotel.

"Did Maria Angelica come back from school with you?" Luz asked when I arrived, a puzzled look on her face.

I shrugged and told her, "I didn't go to school."

Her dark eyes flashed with quick anger. "We expect you to go to school every day, Emma, and come back with Maria Angelica. She's too young to be left alone. You are older, you can look out for her. Those are our rules. If you are going to live with us you must obey them," she scolded.

I slipped past her and went out the door, starting to walk back to Point Conception.

I'd walked almost five miles by the time Luz told Esteban what had happened and he hitched a horse to a wagon and caught up to me. He convinced me it was not a good idea to keep walking through the night, so we returned to Santa Barbara well after dark.

From then on Esteban walked us to school each morning and waited until we went inside before returning to the hotel. I shared a desk in the two-room school with Maria Angelica. An old nun, Sister Catherine, from the Convent of Poor Clares in town, was our teacher. She was a dried up old woman, with a few strands of gray hair invariably escaping her cap and wimple. She reminded me of a shearwater protecting her nest as she fluttered and screeched around the classroom.

I quickly become the poorest student in Sister Catherine's class. I was bored and paid no attention to the lessons she taught, spending hours each day drawing in my sketchbook instead.

I slipped away from school when Sister wasn't watching, and wandered around the village sketching anything that interested me until it was time for class to end.

As I was gathering up my things and getting ready to walk back to the hotel with Maria Angelica one afternoon, Sister Catherine intercepted me at the door.

"Miss Dobbins, I want a word with you," she said in a stern voice. "Please sit back down."

I returned to my desk and Sister Catherine pulled up a chair across from me. For a few moments, she sat silently, just studying my face, like a large-eyed barn owl.

"I wanted to speak with you about your studies," she started finally. "You are not making any progress."

She hadn't asked a question so I stared at her with a blank expression and said nothing.

"Do you understand how important these studies are for you?" she asked.

"No, I don't."

Sister Catherine was taken aback. She squared herself in the chair and tried to stare through me. "Education is the key to a better life, especially for a female, you know?"

"I had a good life before I came to Santa Barbara," I told her.

Nonplused, she replied angrily, "Good life? Why child, I heard you were living like a wild thing at Point Conception. To get along in a civilized world, a young woman needs to have the best education she can. Otherwise, she'll spend her life living alone or depending on some man—cooking, cleaning and bearing his children."

I stayed quiet, still not sure what she was trying to say.

"Is there some reason why you're having trouble, child? I want to help you if I can."

My silence and my obstinance continued.

"Please answer me, child!" She snapped.

"I don't mean to be rude, Sister," I told her at last. "It's just that I'm not interested in the lessons you teach. I'd rather be outside learning about real things in the world around me, and sketching them like I've always done."

"Is that what's in your book? Let me see it." She reached her hand across the desk and waited.

I hesitated a moment, knowing Sister Catherine would not take kindly to my sketchbook, and yet I didn't care. I opened my satchel, took it out, and placed it in her outstretched hand without a word.

When she opened it she emitted a sound somewhere between surprise and anger, and immediately crossed herself. "*Por Dios*," she muttered and looked up, staring at me with her piercing owl eyes. Not saying another word, she started turning page after page without comment, pausing to linger on one page and returning to a previous page now and then. Her expression was blank. Once she paused briefly to rescue the few stray gray hairs escaping her wimple. Impatiently waiting for her to finish so I could leave, I let my fingers drum on the desktop. When she did finish, she set the sketchbook down on the desk and stared out the window, nodding her head occasionally, mumbling, "Help me Lord," in a low tone almost under her breath. When she was ready, she composed herself by sitting straighter, putting both hands on the desk and looking firmly at me.

"I see why you have done so poorly," she began. "You are wasting your time and mine. And you are making a large mistake I fear will come back to haunt you in the future." She gathered a breath. "God has blessed you with a rare talent, I can see that. These images you have drawn show a greater level of ability than

I would expect from a young girl. I am sure they afford you many hours of pleasure. But I doubt they will ever put food on your plate or earn you comfortable shelter. There is no career for a female artist in our world. You are bound for a life of poverty and subservience if you think your art will sustain you. I pray to God Almighty to lead you to a more productive path. And I pray that you give up your rebellious ways and accept a more traditional role expected of you. If you don't, I fear you could end badly."

Together, Louise Michel and I climb the winding hill of *rue Lepic*. Five-story stone buildings pinch the street breathless, leaving only a narrow slit open to the overcast sky. Men in blue *blousons*, and their long-skirted women, crowd together as if they all are going to the same Sunday outing. A few of the women carry babies in their arms or hold children by the hand. A few men wear Guard uniforms. I recognize some from the neighborhood, but most are unfamiliar. And all hurry along in the same direction, like a swarm of grasshoppers devouring the cobblestones in their wake. The sidewalks crawl with them, they spill into the street.

Crossing *rue Norvins*, we are joined by an even larger mob, flowing like a flood tide to the broad, flat plain where perhaps twenty or thirty old, dull iron cannons aim out over the city below us. They remind me of the teeth of a snarling rat. They are almost hidden in front of an angry, shouting, fist-waving, aimlessly threatening rabble. I count just a handful of Guards standing defiantly opposite a formidable line of soldiers, four ranks deep, rifles at the ready. Their commanding officer shouts to the mob to disburse.

Moment by moment the situation is changing as more people charge in from the surrounding streets, hurling curses at

the soldiers as they press forward. A couple of workers carry cobblestones loosened from the streets along the way. I have never seen anything like this horde of people before. At the same time, it scares me deep down to see the potential violence gathering like a tightening steel coil, and yet it gives me a thrill of anticipation. I regret not having my sketchbook with me.

I spot Leo immediately. Grace stands alongside him in the front rank of men. Leaving Louise and pushing the crowd in front of me out of the way, I make my way toward them. They are both surprised when I stand next to them.

"What! Emma?" is all Leo can say when he sees me.

"I am surprised you're here," Grace says. "You don't belong." She puts her hand on Leo's shoulder and gives me an angry look. "I thought you would be primping in your flat, waiting for a carriage to pick you up, acting *bourgeois*."

Her words come out of nowhere. They inflict deep cuts. I'm hurt, but I try to ignore her insults. "When I saw what was happening, I came to urge you to stay back, not get involved if fighting starts."

"Grace is right," Leo says. "You shouldn't be here. You're not part of us."

"Shouldn't be here?" I raise my voice. "And why not? Why wouldn't I come? Why wouldn't I be afraid for you both?"

"I could see you acted too fine for me—that's how you feel, isn't it?" Leo says.

"I don't want you to get hurt, Leo. Neither of you," I feel rejected, angry. I tell myself this isn't happening. I want to get away from the Butte as fast as I can. My rising emotions are making me shout over the growing tumult.

For an instant Leo's face softens. "I haven't seen you very much lately," he says in a gentler voice.

"You've been busy stirring up trouble with your friends."

He tenses again. "We have to stand up to the government. Don't you understand that?"

"No, Leo, I don't."

A voice shouts out over the confused noise on the Butte. Leo walks away as if summoned. The pressure of people flowing in from other streets forces the crowd forward, pressing us closer to the line of soldiers. An older National Guard detaches from the others and comes to Grace and me.

"*Mesdames* should move back to a safer place," he says, bowing politely. "Do not put yourselves in harm's way. There could be fighting at any moment."

The commander of the government soldiers shouts across the vanishing no man's land, ordering the crowd to disperse so his men can haul the cannons away without anyone being hurt. His words disappear like smoke. The mob curses him without knowing what he's said.

Grace has a sullen look. She turns to me with her hands balled up like fists at her side. "Leave! You don't belong with us," she says again, this time with more vehemence. "We are standing up for our rights. It doesn't concern you."

"That's true, it doesn't. But what is it you are standing up for?" I ask her. "It cannot be for those rusting cannons."

"Yes and no," she replies, more calmly than I expect. "The cannons are just a symbol of how we are mistreated. The people of Paris paid for them with our contributions. Now the new government ignores that and wants to take them away from us. We are all poor and getting poorer. The owners cut our wages. We don't have enough food for a family to live on. Did you know the government stopped paying the Guard? But there are no jobs for them! Workers—in *Batignolles* and *Montmartre*, and

all over Paris—are starving day by day while the owners enrich themselves. We are tired of having things taken away."

"Those sound like Martin's words. Where is he? Who are these owners you talk about?"

"*Oui.* Martin was right! We're ready to fight out of desperation. Leo agrees. There's no choice left. Martin saw it first in Louis Napoleon's government. The new government in *Versailles*— calling themselves a Republic—acts the same way, maybe worse. So he is at a meeting, urging workers to fight in *Batignolles*."

"We need a government led by workers!" Louise Michel shouts to the crowd, coming up behind us. "Glad you stand with us, Grace. The *salauds* of the Third Republic have abandoned Paris and fled to *Versailles*. The talk of forming a new workers commune government grows. It will come if we stand together to drive out our oppressors. You too, Emma! Are you with us? Now is the time to fight."

Looking from Grace to Louise Michel, I can see the anger and hatred written across their faces. I wish I weren't standing here with them. "I sympathize with your plight." My words sound weak, even to me. "But I don't belong in this. No one is oppressing me. I will do what I have to do to become a professional artist. I'm leaving now. Do you want to come to the apartment with me, Grace? I want you to be safe."

"You are always trying to be something you are not," she says in a biting tone. "You even had me deceive my parents so you could attend the opera." She shrugs her shoulders in a gesture of rejection and turns her back on me. I start to back away from the crowd, just as Leo returns.

"Where are you going?" he calls.

"Back to my flat."

"We must talk about our future together."

CHAPTER FOURTEEN

May 1871

LATE IN THE afternoon that same day, wearing the flowing chiffon dress *Madame* Crystalle made for me, I'm impatient for Edgar Degas's carriage to appear on the street below my window. The dress is pale green with light pink printed floral patterns. Cinched at the waist, it has a sculpted bodice and full skirt. I've piled my hair on top of my head in the same fashion Frederic had arranged it, and topped it with the lovely floral hat *Madame* made. Sounds of the angry mob still fill the air and drift in my window, punctuated by thunder west of the city. My head is filled with conflicting images from the morning.

I hurry down the stairs when Degas steps down from his *calèche*. He meets me in the lobby, rubbing the rank street smells from his nose with an offended look on his face. "*Trés bon, Madmoiselle*," he greets me, admiring me from head to toe and smiling as he does. "How pretty you look this evening." His smile fades rapidly to a dark frown as he assists me up into the carriage. "But what is happening here, *Mademoiselle* Dobbins?" he asks, sitting close beside me. "Men in uniforms with rifles of all vintages are racing along the streets of *Montmartre* and into *Batignolles*."

"I know little, *Monsieur*. The army marched up to the Butte of *Montmartre* this morning to haul away old cannons. The National

Guard and a mob of workers opposed them. I don't know the outcome." In my mind, I still see Leo and Grace—brother and sister still in their twenties—facing off against the French Army.

Degas shakes his head, looking puzzled. He signals to the driver, in top hat and tails, who clucks, and the horse trots off with the carriage. We ride out of *Montmartre* to an imposing house far to the west, on *ave Matignon*, between the *Elysée Palace* and *ave des Champs Elysée*, where a few raindrops are sprinkling around us.

The opulence of *Comtesse* D'Agoult's salon overwhelms me when I enter the drawing room on Degas's arm. This evening he is not the dour-faced man sulking around his studio. He is dapper in formal attire, looking younger than most of the other, mostly white-haired and bearded men in the room. Heads turn, and I feel as if everyone is staring at us. My breath catches in my throat and I grip his arm tightly. He chuckles at the awed look on my face.

Trying to absorb the scene in front of me, I lean my head against his shoulder. "Give me a second to recover," I entreat him.

"It is a pleasure to escort such a lovely young woman this evening," he whispers in my ear.

Staggered by the splendor around me, I realize never before in my life have I seen anything like it. This isn't the opera. It's a private home, the palace of *Comte* and *Comtesse* D'Agoult. Across the room is a large floor to ceiling mirror, acting to double the size of the drawing room and the number of the *Comtesse's* guests. Heavy velvet drapes block out all hint of the weather and outside world, isolating us in a magical fantasy where a crystal chandelier sparkles with hundreds of small, candle-like globes. Antique furniture is everywhere. Art from old masters line the walls.

Aging women huddle together in small clusters, like statues, heads close together, speaking in conspiratorial tones. As they talk, they wave their *lorgnettes* about like magic wands. I have a desperate feeling they are all staring at me and saying I don't belong. I wish I could disappear.

The only woman I recognize leaves a group huddled together and comes toward me. "Do you remember me, *Mademoiselle*? I admired that beautiful dress from across the room and had to come tell you. You are very brave to wear it."

"I do remember. You are Sarah Bernhardt. We spoke at the ballet last summer." I smile sincerely, "Why do you call me brave?"

Degas bows to us, and steps away, moving toward a group of gentlemen near the fireplace, leaving us alone in the middle of the room.

"Let us adjourn to a corner where we are not so visible," Sarah says. "The Grand Dames think I am not fine enough to be here." She takes my arm and leads me to a more private place.

"Why is that?"

"Oh, *chère*!" she gives me a big theatrical smile, "I see you have much to learn about my world. Actresses are only slightly above prostitutes in Paris society. But I turn my head away at their insults. I am here for the music."

"Then you are the brave one, not me. Am I inappropriately dressed?"

"Different, *ma chère*, not inappropriate," she coos. "Perhaps those old hens cackle together because they do not have the self-confidence to dress outside the lines of conformity. At your age you have the right to be a fashion leader."

"Oh, Sarah, I had no idea I was being different. And no desire to be a fashion leader. *Madame* Crystalle, a dressmaker who lives in *Trouville*, made the dress for me. Perhaps she did

not know the new styles."

"*Madame* Crystalle? Ah, I know the name. A well-respected Parisian dressmaker she once was. The other women are jealous to be sure. Look over there. See how you have caught the eye of *Monsieur* Worth." She glances around the room and then looks back at me. "The gentlemen are pleased to see me here this evening even though their wives sneer. They don't leave me alone for a second so I must get back to them—my admirers you know—my protectors from the old hens pecking at me this evening. We must get to know each other better. What would you say about taking a balloon ride with me?"

I'm floored by her outrageous proposal, expressed so blandly. I can only manage to stammer, "A balloon ride...? Um, that sounds like...fun, I guess."

"Then please, *chère*, contact me at the theatre. We can talk more. I do adore ballooning—you will too. The men think me so adventurous!" With that, she reaches out to squeeze my hand and quickly retreats to the other side of the room.

With a sudden thought, I grab her sleeve. "Do you know if Renoir is coming this evening?"

She shrugs her shoulders and throws up her hands, "Another *beau*? Such good-looking gentlemen always escort you. But I don't know this Renoir." Laughing and tossing her head, she moves away.

"I see you are quite capable of mastering this *soirée* without me," Degas says, coming back to stand at my side.

"Please don't leave me," I implore him. But he had already started across the room toward another group of men standing near the grand piano, leaving me stranded and feeling quite alone again.

There are several white-haired older women in gorgeous

gowns—like the ones I saw in *Le Primtemps* window—with perfect coiffures and tall, ornate headpieces, in the salon. They sit stiffly on the edge of their high back armchairs and French *settees*, like a flock of pigeons perched on an apartment rooftop, waiting for some morsel of gossip to come their way that they can all coo about.

"*Mademoiselle*, may I be so bold as to introduce myself?" A gentleman, perhaps in his forties, younger than many of the other men, approaches. My eyes are riveted on him—he wears bohemian attire, unlike any of the other men in the drawing room. It's composed of a blue velvet jacket, deep purple wide bowtie and corduroy pants—I smile, but offer him no greeting, wondering if he isn't some kind of jester come to embarrass me.

"My name is Worth, *Mademoiselle*." He introduces himself. "I have been admiring your dress from across the room, if I may take the liberty of saying that without offense."

I continue smiling, but am not sure yet how to respond.

"The chiffon material flows so gracefully around you, it does not need a crinoline. The flounces accentuate your fine figure," he continues without waiting for a response. "A very wise fashion decision."

"*Merci, Monsieur.* You seem most interested in the details of my gown." I say it not as an insult, but a warning against him becoming too familiar.

"Then you do not know who I am, do you, *Mademoiselle*? I am Charles Frederic Worth, the owner and chief designer of *Maison Worth*. I designed dresses for Empress Eugenie and her court, and now for many other fashionable women here and in England and on the Continent. I apologize if you take me to be too forward. I spoke in a strictly professional way."

I blush. "No *Monsieur*, I did not know. It is my turn to

apologize. Do you design gowns for the women here tonight?"

Worth nods. "Yes. But only the most glamorous." He chuckles softly. "May I ask who created your gown?"

"*Madame* Crystalle."

"Ah, a familiar name. A genius of design. I did not know she was still designing. I would like to have her working for me."

"She is not, Sir. She made this dress as a favor to me."

"Fortunate for you and a brilliant choice. It is perfect for your female form and complements your lovely hair and eyes."

Blushing again, I look away from him, shifting from foot to foot, like an embarrassed schoolgirl, not in any way knowing what to say.

"You are not French, am I correct?" he asks. "I am English." I nod.

"Would you be interested in working for my fashion house? I believe I could employ you in a very profitable way for both of us. I must say my breath was taken away when you came into the room. Here is my card. If you are interested, please come see me."

"*Merci Monsieur*." I offer Charles Worth a small courtesy, still unsure about him, but interested in his offer. "I speak English and French. I have posed for several artists. I would be pleased to visit your dress shop if it is something like that you have in mind." I take a deep breath. "I came this evening hoping to see the artist Renoir. Do you know him?"

"What? Renoir? No, *Mademoiselle*, I am sorry, I don't know any man by that name. I will look for your visit." He bows and backs off. I continue searching around the room, hoping to see Renoir.

Just then the *Comtesse* d'Agoult enters the drawing room from the hallway, bowing to right and left, and sharing a few words of greeting with her guests standing nearby. She claps her hands for attention. "Good evening *Mesdames* and *Messieurs*. We are

honored to have *Monsieur* Charles Lamoureux to play for our pleasure tonight. He studied violin at the Paris Conservatory and has played in London and on the Continent. He is a devotee of Handel and Wagner, so I know you will all be entertained. Please now take your seats."

The rustling of silk and satin fills the room as the ladies move to seats where Lamoureux is about to play. Men extinguish their cigars and pipes. I take a chair near the back of the room where Degas joins me. "Have you learned anything about Renoir yet?" he whispers. "I'm sorry he isn't attending tonight but pleased you accompany me."

Lamoureux picks up his instrument and makes a final check of its readiness. A hush settles in the audience and all eyes are on him. He inspects the A-string tuning peg, frowns, and turns it a notch. Then another. The string makes a twanging sound that resonates around the room as it breaks. Lamoureux rises and bows an apology to his stunned audience and works rapidly to install a new string.

There is a twitter of anticipation in the room as he raises the violin to his chin again. His audience settles themselves. I feel a slight, almost insignificant touch on my shoulder. Turning to see where it comes from, a gasp escapes my lips. "My goodness, it's you!" I whisper in a voice that causes people around me to turn and cast disparaging looks.

Lamar Legrand puts his finger to his lips and motions me to follow him into the hallway. Degas gives me a look of displeasure. I wait a few seconds and then rise, smiling an excuse at Degas, and feeling excitement heavy in my chest.

"It is so wonderful to see you tonight, Emma. After Frederic... eh, I was afraid our paths would never cross again."

"*Monsieur* Legrand." I pause briefly with a slightly unsettled

feeling. "It is nice to see you, too."

"A sad thing."

"Very sad. My heart is broken."

"Mine also. The loss is incomprehensible to me. Such a waste of talent."

"Such a loss of a fine man," I reply. "I cling to the happy memory of the three of us at the ballet."

"I see you are with Edgar Degas tonight. Do you pose for him, also?"

"I have. I am with him this evening in the hope of finding Auguste Renoir."

"Ah, I know Renoir. Why do you seek him, *Mademoiselle*? I would like to see how Degas depicted you on canvas."

"When I went to the studio Renoir shared with Frederic all the canvases were gone. Some of them belonged to me and I would like to find them."

Legrand goes silent to give me a questioning look. "Belonged to you, you say. I didn't know."

"Do you know what happened to Frederic's paintings?"

He pauses again to think before answering, and while he does he fingers his pocket watch nervously. "I know Renoir collected all of his canvases and took them to his new studio..."

"...And Frederic's?"

Legrand hesitates again. "Ah, Emma, I believe they disappeared quite quickly following the news of his death."

"I am lost if I don't find them. Do you know who took them?"

"No, I do not."

I stay quiet, feeling my despair deepen. Legrand watches me dab carefully at the corner of my eye with a linen hanky so not to disturb my makeup, and stays silent. Finally, he takes my hand in his and looks fondly into my eyes. "I am sad for you," he says.

I nod my head.

"I would be honored if you would have a light supper with me this evening after the music if you are free. Would you?"

I look cautiously at him, thinking it might be too painful to be with him if we spend time speaking of Frederic. But then, I think it might be nice to have someone who was so close to him to talk with. I tuck the hanky into the sleeve of my dress. "I would be pleased to dine with you if *Monsieur* Degas gives his permission. I am attending as his guest this evening."

Legrand smiles and retakes my hand, leading us back to the others, already enraptured, listening to Lamoureux play Handel.

As the turning of Lamoureux's tuning peg creates increasing tension on the violin's A-string, forcing the pitch higher and higher, so the tension in Paris grows day by day. It starts with the confrontation over the cannons in *Montmartre*. That evening, while Degas and I listen to Handel, two captured French Army generals are senselessly executed by a firing squad of National Guard. Few Parisians are immediately aware, but the *Versailles* government is. Vastly outnumbered by Guard units around the city that owe it no loyalty, the high command orders the army to retreat. Later in the night, after the rain shower has ended, while Legrand and I sup on the sidewalk of *Café de la Paix*, 20,000 workers gather in front of city hall to celebrate.

The peg tightens a notch, but over the next days most Parisians still go about their daily lives.

By the end of March, the peg turns again when Louise Michel and the oppressed workers of Paris join hands with the National Guard. Another week passes, another turn of the peg, and the newly formed Central Committee self-proclaims the Paris

Commune the official government of the city. For most, our lives continue unchanged, but the *Versailles* government turns the peg to the string's maximum tension when the army takes control of the unmanned forts surrounding Paris.

I am torn. "I am not French and this is not my fight," I told Louise Michel. But Grace and Leo and Martin Aboud are all Communards now, committed to their cause. Do I owe them something? What? Bazille, Degas, the opera, the *soirée*, and Sarah Bernhardt have all cracked open a door to a different life for me. My intimate *café* supper with Lamar Legrand was an exhilarating end to the gala evening. And yet my companions are on the eve of a revolution. Where do I belong? "It is everyone's fight," Louise Michel shouted at me, "All the poor people of *Montmartre* and the other workingclass neighborhoods around us."

When the tuning peg is turned too tightly the string finally snaps.

"You must come with me." Louise Michel storms into my flat on a day in early May. "The time has come! Right now!"

"What time has come?" I insist.

"The time when workingclass women must stand by our men as they go into battle."

"Louise, I have told you before it's not..."

"Hush! Surely there must be some compassion in you. You cannot be as cold as you make out, Emma. Our men are at risk and we must support them any way we can. Think about your friend Leo."

"Tell me, Louise! Tell me what has happened! Why are the men at risk? Help me understand!"

"The National Guard cannot allow the army to control the forts and squeeze the life force from us the way the Prussians did. They are marching to liberate the southern forts and then to

continue fighting their way to *Versailles* to end this conflict once and for all."

"Oh no!" A sob constricts my throat. I feel a rush of fear, sweat beads on my forehead. "Leo?" I gasp.

"Yes, Leo Durand and all the Guardsmen and workers of Paris—all marching through the city together right now to attack the forts. It is time for us to join the battle."

"Be sensible Louise, what can we do?"

"Fight and die if called upon!" She says it with fire flashing in her wild eyes. "We can tend their wounded and comfort and feed them, give them strength to push on. We are women on the verge of a new world. Paris belongs to the workingclass of both sexes at last. Come now! There is no time to debate this—we are all called to fight. Today I am an ambulance driver in *Montmartre's* sixty-first battalion and you will be my orderly."

The Commune army quickly overruns *Fort Issy* on the southwest boundary of the City, where Louise Michel and I are sent to pick up wounded. That night we sleep on the rough-planked floor inside the fort. Louise sleeps with her Remington rifle at her side.

The next day the Commune forces bog down. The *Versailles* Army resists any further advance and pushes back. The Commune fighters are spread thinly and pinned down. As we search for wounded men, Louise Michel carries her rifle in hand. At one point we are stranded in an open field yards from a stone mill. "Courage," she calls out to me when the fighting picks up. "These bullets are like pesky flies." I press myself down in the ditch.

Day after day, along with the other women supporting the Commune fighters, we risk the hail of bullets and explosive artillery shells to rescue wounded men. With fighting going on all around us, we carry dead and wounded on stretchers back to

wagons that take them to makeshift hospitals in Paris. At times Louise Michel leaves the wounded to me and joins the men on the front line with her rifle. I lose count of hours and days. The fighting seems endless and so do the wounded.

I am subsumed in a world of mud and darkness. Rat-tat-tatting of rifle fire, whining artillery shells that thud when they hit something substantial. Smells of torn flesh and human feces. Bitter tastes of dirt and stale bread and dirty water that gag in my mouth. I cannot remember ever being so afraid before. I follow Louise Michel closely wherever she goes because I am scared of being alone in the chaos. When Louise points to a National Guard fighter lying dead in a ditch, I help lift the limp body onto a stretcher in a mind-numbed, mechanical act. When I look down and see it is Leo Durand I faint and sink into the mire.

BOOK TWO

CHAPTER FIFTEEN

Summer 1871

THE PARIS COMMUNE revolt finally ends in late May 1871, but not before 20,000 Parisians have been killed, and I hear some accounts put the number far higher. The *Hôtel de Ville*, *Tuilleries Palace*, and much of the *rue de Rivoli* have been burned out. Private residences were firebombed. The Commune Army never reached *Versailles*. Louise Michel and other Commune leaders are arrested and tried for treason. She is exiled to New Caledonia in the South Pacific for her role in the uprising.

At the simple funeral service for Leo Durand, I embrace Clarise and Hector, expressing my sorrow for their loss. While a grim-faced Martin Aboud looks on, my embrace with Grace is more restrained.

"He loved you," she sobs, resentment burning in her eyes before she turns away.

Sitting alone in my apartment on *rue Lepic* later that day, with the stench of burned flesh still hanging in the air, overpowering the endemic stink of *Montmartre*, I cry privately for Leo, and shed tears for Frederic and papa, too. The men in my life all gone. Then I take stock of my own life. Just nineteen and I have little to show for it. Barely surviving in this shabby apartment, four exhausting flights of stairs above a street too poor for *chiffonniers*

to bother sorting through the sidewalk trash, I have no paintings to sell, and the struggling young artists I sit for are barely able to pay me a pittance. Not what I came to Paris for! Stuck between the girl who thrived at the lighthouse and the talented artist I dream about being, time is slipping by and I have no plan.

A polite tapping on the door brings me back from my self-pity. Getting up from the window seat, I take a minute to smooth the wrinkles from my dress and run my fingers through my hair before opening the door. A tired-looking, older gentleman in a messenger's uniform, twisting his cap in his hands, stands there. "*Bonjour, Mademoiselle*," he greets me, extending a small envelope. "A message from *Monsieur* Legrand."

I take it from his gnarled hand, smiling an awkward thanks. He continues to stand in front of me without moving. I'm embarrassed because I have no coins to give him. After the silent pause, he says, "*Monsieur* Legrand has paid me to await your reply."

"Oh!" I gasp. "*Désolé*," I apologize. My fingers fumble with the embossed, wax-sealed envelope and I read the note.

> *Mademoiselle Dobbins*, it says. *I will be meeting Auguste Renoir this evening for supper. If you would still like to speak with him I would be pleased to have you join us. If you agree, I will send my carriage to pick you up at seven o'clock and bring you to the restaurant.*
>
> *With kind regards,*
> *Lamar Legrand*

The gentle knocking comes again at precisely seven. Wearing my olive green dress with cream-colored mantle over my shoulders—the same dress I wore when Leo stole his kiss at *Parc Monceau*—I'm embarrassed, but *Madame* Crystalle's gown would

hardly be appropriate. I dab a drop of lemon verbena behind each ear before going to the door.

A carriage driver, in a neat gray uniform, with well-polished high black boots, bows. "*Bonsoir, Mademoiselle. Monsieur* Legrand's carriage is below." He looks me over without comment and offers me his arm. "May I escort you down the stairs?"

On the street, the enclosed, horse-drawn Brougham, gleaming black in the dim light of an early evening streetlight, awaits. The driver opens the door and helps me in.

A world of plush, wine-red velvet cushions welcomes me inside. When the carriage door closes behind me, I am protected from the outside world in a private space. I can look out the narrow side windows at activity on the street without anyone seeing in. The driver climbs up on the box and whistles to the coal black gelding that snorts and jingles his silver harness, and gently moves away from the curb.

The carriage stops at restaurant Lucas Carton, a stone building across the plaza from *Le Madeleine Église* on *rue Royale*. A doorman, haughty with disdain, opens the carriage door and helps me down. The look on his face grows more contemptuous as I step into his view. Embarrassed, I pretend not to notice and hurry through the open door into the restaurant. The doorman turns up his nose and sniffs as I pass by. The main room is a long, narrow one, with black leather-upholstered high back booths and tables covered with gleaming white linen and set with glistening silver and glassware, spaced along wainscoted walls. Down the center of the room, another row of tables forms a precise line, like soldiers standing inspection under a crystal chandelier. The *maître de maison* hurries up to me, a look of terror on his face as if a *chiffonnier* has stumbled in by accident. "May I help you, *Mademoiselle*?" He growls in a less than gracious voice.

"*Bonsoir*." I smile brightly, trying to disarm the look on his face. I have entered a world far beyond my experience, and I am frightfully embarrassed, but I summons every bit of boldness I can and ask in my nicest voice, "Can you direct me to *Monsieur* Lamar Legrand's table? I am joining him this evening."

"*Monsieur* Legrand?" The man's look is quizzical as if he doubts me. "*Monsieur* Legrand, you say? You have been invited?" He stares at me for what seems an eternity, examining me from head to foot, perhaps searching for some reason to take me seriously. Finally, having made a judgment about my lower social class, a knowing look brings a smug smile and he nods, then bows. "Certainly, *Mademoiselle*. This way. *Monsieur* Legrand has a private room upstairs."

Leading me quickly away from his other, elegantly-dressed, patrons to the back of the restaurant, he takes me up a flight of stairs, where rooms with closed doors stretch down a long hallway. A quiet knock on one brings a muffled reply. The door opens, revealing an intimate room with cushioned settees and armchairs and a table set for three against a floor-to-ceiling window.

Lamar Legrand greets me at the door. Renoir, shorter and bearded, rises from a chair and comes to stand behind him. My eyes had hardly strayed from Frederic at the ballet, but now, as Legrand, in tailored formal dinner attire, stands close in front of me, I notice how handsome he is. His strong, masculine presence gives me a slight chill. He has a broad, welcoming smile on his chiseled face.

"*Mademoiselle* Dobbins I am so pleased you have joined us this evening," he says formally, taking my hand and bowing to it. Surreptitiously looking me over, he flinches slightly at my dress but quickly hides his disapproval. "Please come sit with us a few minutes before we dine," he says, regaining his smile. "Renoir

tells me you and he have met before."

Taking a seat in one of the upholstered armchairs so I can watch Lamar and Renoir on the settee across from me, I say to Renoir, "I hear you have just recently returned to Paris."

"*Oui, Mademoiselle* Dobbins, it was a terrifying experience that made me leave."

"Have you heard of Auguste's miraculous escape from the National Guard during the uprising?" Lamar asks.

"Oh, it was horrible," Renoir insists, "I might have been shot dead, you know."

I look from face to face. "Tell me, please."

"Minding my own business, I was," he begins. "Actually, I was painting a scene along the *Seine* one fine April afternoon when a group of Guardsmen came marching along the *quai*. As if they owned Paris all to themselves, they demanded to see my papers. 'What papers?' I asked. Naturally, I didn't have any identification with me, being in my painting clothes just out for the afternoon."

"The arrogance of the National Guard!" Lamar interrupts. "I'm saddened by all the killing, but, indeed, they had to be put in their proper place, didn't they? They were only workers and part time soldiers."

"Please," I break in, "tell what happened, Renoir."

"I will. Of course. It was despicable. Without identification they surrounded me, grabbed me up, tied my arms behind my back, and marched me along to their headquarters at *Hôtel de Ville*, paying no attention to being careful for my canvas and easel. Without further interrogation another group judged me a spy. They said I was painting a scene of the vicinity around *Pont Neuf* for the government army in *Versailles*. They ordered I should be stood up against a wall and shot dead by a firing squad. Oh,

it was so horrible! Can you imagine how I shook with fright?"

As I listen, Renoir is trembling and twisting his hands together, reliving his ordeal. I'm on the edge of my chair, leaning close and watching his facial reactions. "What happened?" I gasp. "How did you escape the firing squad?"

Lamar sits back with a satisfied look as if he knows the outcome.

"It was a miracle, there's no other explanation," Renoir exclaims. "The men were lining up with their rifles, about to blindfold me, when another Guardsman came along, a man I had known a long time ago when we were in school together. He recognized me and vouched for who I said I was. He told them I was harmless—which I didn't like hearing him say—and they should let me go. So naturally, when they did, I fled Paris until all the fighting was over."

Sadness overcomes me when he stops talking. I'm trembling and getting a little weepy, thinking about all the carnage of the last months. "I'm so happy you escaped," I tell him in a choked voice. "It was all so unnecessary, too many lives wasted. I lost Frederic."

The two men look at me with surprised faces. "Bazille's death was a loss to all of us," Renoir says.

"He was a good friend," I hasten to add.

Renoir gives me a questioning look. I realize I might have said too much. "What I mean to say is that he was a good teacher for me."

Lamar's eyes twinkle a bit. "Good teacher? Perhaps more than that, *Madmoiselle* Dobbins? I thought Frederic must have been quite fond of you. He didn't take every *ingénue* who sat for him to a ballet."

Stammering a little, looking for a way to change the conversation, I protest, "Well, I didn't often pose for him, but he did talk with me about making art."

"I saw a portrait he made of you dressed as a peasant girl," Renoir says. "It was very fetching as if both of you had a special connection. I could see it in the painting—in your eyes.

I keep silent but smile.

"I would like to paint you, too" he goes on.

Lamar's face shows surprise and perhaps a bit of displeasure at Renoir's words.

"That would be nice," I respond, trying to be noncommittal. "I feel as if I know you from seeing you and Monet in the studio with Frederic."

"Would you pose nude for me?" Renoir says with a twinkle in his eyes. "I pay well."

I feel my face turning red.

"Now, Auguste, *Mademoiselle* Dobbins is a lady," Lamar interrupts.

Renoir laughs heartily. "Next to flowers, nudes are my best subjects," he says. "I would never have studied art if it weren't for the female breast."

My embarrassment is obvious. I turn away from the two men. "I would never pose nude," I tell him when I feel in control of my feelings.

"Pity." He says. "No harm in asking. Perhaps a dancing pose—I have several in mind."

I'm quick to change the subject. "I came here this evening to learn if you know what happened to Frederic's paintings?"

"I am sorry, *Mademoiselle*, I have no information for you."

Surprised by his answer, I explain, "I went looking for one he painted for me, but the studio was empty."

"One he did for you, you say?" Renoir asks.

"A gift he wanted me to have."

Lamar rises from the couch, and leaves the conversation,

going to a pull cord near the door. "Perhaps we should order our dinner now," he says over his shoulder.

"When I went to the studio, all of Bazille's work had been cleared out. I told Lamar that before the uprising started," Renoir says. "I took my own work and abandoned the studio when I realized I could no longer afford the rent on my own."

"Where do you think his paintings might have gone?"

"I have no thoughts on that," he says. "I told Lamar that, too. Perhaps you might try contacting his parents. They live in *Montpellier*, in the south of France."

"Oh no, no, nothing went to them," Lamar jumps back into the conversation. "I would know about that. I'm in the south of France often. Our dinner will be up shortly. Can I offer you anything while we wait, *Mademoiselle*? An *apéritif*? Champagne? To celebrate your being with us this evening? I hope we will be together again soon after tonight. Perhaps we will meet again at *Comtesse* d'Agoult's, where you wore that perfect dress."

Renoir hands me a card. "I often attend the salons at the Morisot and Manet homes too. And please, we must set a date for a session. I was only partly joking about doing a nude."

The following day the familiar knock on my door came again. When I open it another messenger stands there holding a large cardboard box tied with a bow. "*Monsieur* Legrand has sent a gift," he says offering it to me.

When I take it from him he bows and quickly retreats down the stairs. Puzzled why Lamar would want to send me a gift, I bring the box to the lone table in my flat and untie the ribbon. The contents are covered in tissue paper, with a single red rose and a wax-sealed envelope on top. My heart flutters at the sight

of the rose. I take the envelope to the chair by the window.

Dearest Emma, the note begins, giving me a shock and an uneasy feeling about its contents, but I read on.

> *Ever since our evening at the Opera House I have often thought about you, and twice since, including last evening. My recollection of you as a charming and beautiful young woman has been confirmed. It is sad that we have been brought together because of Frederic's untimely and unnecessary death, but I can only believe that fate meant for us to become better acquainted.*
>
> *My business will take me south, to Lyon and then to Marseilles, for the next weeks, but on my return I hope that we can be together again. There are so many things in Paris I would like to share with you. I will contact you upon my return so we can set a date to be together.*
>
> *Please accept this acknowledgment of my fondness for you. I hope you might favor it when we meet again.*
>
> *Faithfully,*
>
> *Lamar*

Going back to the table, I'm curious what I'll find in the box. Tearing away the tissue reveals a lovely royal blue, silk dinner dress. I'm overwhelmed. Clutching the note in my shaking hand, I collapse into the chair beside the table, and stare at the single rose and dress, trying to unravel the emotions I feel. The dress is gorgeous, more beautiful even than the dresses in the windows at *Le Printemps.* But the gift and note are unsettling. They don't feel appropriate. For the next hour or so I'm paralyzed in the chair, staring alternately at the dress and out the window. My mind is a jumble I can't sort through.

Still confused at the end of an hour, I force myself out of the chair and go down to the street. Without purpose or direction I

start walking. At first, I follow the familiar path to *blvd de Batignolles* and then along it to *blvd de Courcelles* into *Parc Monceau* where I sit for a few minutes watching children on the carousel, remembering my feelings when Leo kissed me. My thoughts keep returning to Lamar Legrand. He seems nice enough, I guess, but I don't know him very well, certainly not well enough to accept the blue dress. He calls himself Frederic's best friend. How do I know that's so?

I leave the park through the gate to *blvd Malesherbes* and after a few minutes walk find myself standing in front of *La Madeleine*, gazing across the small plaza at Restaurant Lucas Carton. Focused on the second-floor window, I replay the dinner conversations, searching for clues that might help me understand Lamar. Continuing on, I turn onto *rue St. Honoré* and walk to *Place Vendôme* to see the tall marble column erected to honor Napoleon I lying in pieces on the ground, pulled down by the Communards.

Finally heading back toward my flat, I walk along *rue de la Paix* and admire the luxury goods in the *atelier* windows along the street. Stopping in front of a discreet sign in the doorway of one that announces *Maison Worth*, I think for a moment, remembering the brief conversation I had with the strangely dressed Englishman at *Comtesse* d'Agoult's salon.

As soon as I enter the shop an older woman with a harried look, hurries from a back room at the sound of the tinkling bell over the doorway, instantly intercepting me.

"Ah, *Mademoiselle*, can I assist you? Perhaps you have stumbled into the wrong *atelier.*"

Ignoring her tone, I slowly look around the shop at the elegant gowns and evening dresses displayed there. Then I take a breath, still in no hurry to reply and in my most polite voice I tell the woman, "I would like to speak with *Monsieur* Worth if

you please."

"Oh dear, no! *Monsieur* Worth is far too busy completing a gown for *Comtesse* Archambault to wear this evening. He doesn't waste time with every young *mademoiselle* who comes through the door."

"I see." Pausing a moment to sift through my reticule until I locate the stiff white card with Charles Frederick Worth's name scribbled on it, I hand it to the woman. "*Monsieur* Worth requested I come see him. Perhaps there is a better time?"

The woman looks at the card. Her expression quickly becomes one of increasing scorn. "Ah, *chére*, I think every pretty young *mademoiselle* in the city has received one of these. They are not so special. *Monsieur* Worth gives them out like sweet candy to children in the park and then forgets about them. *Désolé*, *Mademoiselle*, I am busy and must return to my work."

Crestfallen, I stare at her, unable to find the right words. At last I sputter, "But he offered me a job here."

"*Oui*, like the others," the woman says with disdain in her voice. Turning her back and pushing aside the curtain to the back room, she leaves me standing alone.

"Wait! Please wait," I call her back.

The prunefaced woman turns for just a second.

"Please make sure he receives this card where he has written my name and his."

"Like the others," the woman says, snatching the card from my fingers. "*Adieu!*" She almost growls and steps through the opening to the back room.

∽

After a sleepless night, trying to understand what is happening to my life and hearing every street sound along *rue Lepic*, I'm as

confused as ever. It isn't just the gift from Lamar Legrand or the rejection by the arrogant woman at *Maison* Worth, it's a deeper feeling that my life is stalled. I dress early, buy my *baguette* at the *boulangerie* on the street, and walk to the *Louvre*. I don't take an easel or canvas and brushes with me, I'm only looking for solace in a familiar place, away from the loneliness of my apartment, where I can hide among the crowd of visitors in the galleries.

I seek out Nicolas Poussin's paintings. He is an 18th Century French artist whose work—especially his mythological lovers—I had been especially fond of copying in my first days at the museum. Studying them now, with a more trained eye, I cannot help comparing his nude females with the way Frederic had posed me. Memories flood back.

"Ah, *Mademoiselle*, we meet again," a familiar voice sounds in back of me. Turning around, I see Sarah Bernhardt standing behind me, fashionably dressed, and wearing a black chapeau tipped at a jaunty angle, trimmed with white dove feathers. It highlights her unruly mahogany-hued hair perfectly. "I missed having you visit me at the theater after our chat at the salon," she says.

"The fighting..." I start. "I would have come, but the Commune fighting was especially bad in *Montmartre*, so I stayed to myself until it was over."

"*Oui*, it was so horrible. My theater, *L'Odeon*, was used as a hospital, so we are only now starting to rehearse for a new play. Paris is returning to its normal ways."

I get up from the bench and move to her side, smiling warmly. "I am sure you are glad to return to your theater, and I hope to see you act soon."

"Perhaps the rich gentleman who found you at the salon might escort you?"

I blush for just a fraction of a second and then a thought comes to me. "Perhaps he will," I answer her. "If you are not rushing back to the theater, I would be pleased to spend a few minutes speaking with you."

"*Oui*, we can do that. Let's walk in the gardens. I have time before I must rehearse. Ah, the life of a leading lady is far from carefree, you know, but it has its few moments of reward," she laughs. "Coming here is a pleasant way for me to relax."

On the way to the garden, we pass a young woman, an easel on her back and carrying a canvas as she walks toward the exit. I can barely make out the painting she carries, but I can see it is finely done, perhaps a copy of a Renaissance portrait. I wonder if this young woman with honey-colored hair is the one Berthe has mentioned to me before. I want to go up to her, introduce myself and learn more about her copying, but she heads off in a different direction before I can approach her.

Sarah and I find a quiet place in the courtyard of the museum, away from the burned-out hulk of the *Tuilleries Palace*. I wait until we are settled and spend a few minutes in general conversation, before gathering my courage to broach the subject foremost in my mind.

"The *Louvre Museum* is a special place for me, Sarah. I came to Paris to study art in the hope of becoming a successful artist—"

"Successful artist?" She interrupts. "Ah, I see, *Mademoiselle*. One does not so often hear those two words used together, like 'successful actress'." She laughs heartily.

"But you are successful certainly. I have learned a little about you from the papers that give you rave reviews. I know you are admired by your audiences and have many men who follow wherever you go."

"They do! And don't forget the lover I drag around from place to place and provide for all his needs." She turns serious. "I am

not sure what you are asking, but I want to tell you it has not always been this way, Emma. I hope I can use your given name in our conversation and mine in yours. Is that why you have not visited me before? Are you put off by my reputation?"

I flinch at her question and don't answer immediately, looking down at my hands in my lap instead, trying to put my thoughts together in my head. At last, I look back up and tell her, "I admire your candor, Sarah. There is truth in what you say. But if I am put off, at the same time I admire what you have achieved. You are the most well-known woman in Paris."

"Well known, but not respected. Still, I am free to be my own person."

"Yes, that's it. Free to be your own person. I hadn't thought of it that way, but what I have seen of you in person and read in the papers you are always honest and genuine."

"And what is your question then?"

"It's hard to explain." I take a breath before starting. "I think most women are not well respected in France. *J'ai raison?* The women I know act subservient to men, and men seem to encourage that. Some women tell me that is the best way to live safely. Yet you are free to be whomever you choose to be. So I guess my question is how have you achieved your freedom?"

"You would like that also?"

"I would. I was alone all my early life, brought up to be independent. It is hard for me to be different."

"*Bon!* Don't be! I have worked hard to achieve whatever success I now have, and I hope for more still, but it was not always that way, as I said. You call me a free spirit, but I have worked hard at my acting craft, just as you must work hard at your art. I always believed I would succeed, even as a child with a difficult early life. Your thoughts and opinions are important, Emma. Don't let

men intimidate you. Or ever dominate you."

I'm thoughtful and hesitant again, but the conversation seems to be my best opportunity to ask questions. "If I am speaking out of place I hope you will correct me, Sarah. Do you ever receive gifts from the men in your life?"

She bursts into laughter. "*Oui, oui!* Of course! I like them! That is how they express their appreciation. I thrive on them! Look at me! I may not be as beautiful as you are but I'm not plain either—we both have our wonderful dark hair, do we not? And men find me interesting, mysterious, perhaps. So I take advantage of how I look and who I am. Why not?"

"What do men expect in return?"

"I have no idea. What they expect is their expectation, not mine, and I am not obligated to do anything beyond saying *merci monsieur* to them. The men who have higher expectations don't stay around me very long and that is fine with me. Are you asking about the gentleman you were with at the salon, Emma?"

"He has sent me an expensive gown to wear and I hardly know him."

"You are fortunate to have a man who thinks so highly of you." She lowers her voice to a whisper even though we are alone in the garden. "You are wondering if he is expecting you to get in bed with him, no?"

Embarrassed, I nod.

"With your pretty face and fine figure this may happen often in your life. Learn to enjoy the compliments gentlemen give you. But do not let it change how you feel about them. Certainly go to bed with a man if that pleases you, but never do so as an obligation, or just to please him. Never! Perhaps he gave you the dress because he thought you would look beautiful wearing it with him. Or, as you suspect he had other ideas. Who knows

which is correct? Have fun in your life the way I do, Emma, and do what feels right to you.

"I am planning on taking a balloon ride when I can find the time," she continues when she has finished with her thoughts. "Would like you to come with me? I will ask *Monsieur* Godard to make the arrangements. The two of us can look down on Paris as we float through the sky and laugh at all the folly below."

CHAPTER SIXTEEN

Summer 1871

SEVERAL DAYS LATER, Grace is waiting for me on the sidewalk in front of my flat when I return from a morning of posing at Suisse's studio. I'm upbeat because young art students are returning to Suisse's now the Commune riots have ended, and my finances are looking better. But the sight of Grace makes me apprehensive after all the bad feelings and tragedy of the uprising. After a moment of strained silence, as we stand looking at each other, trying to read each other's moods, I offer her a smile.

She responds, "Oh Emma, I cried for hours after the funeral. I've been unfair."

We embrace each other spontaneously.

"We both have been," I whisper. "Can we put those dark days behind us? We used to be sisters."

"Oh, yes, I want that," she says. "I do! They were very bad times." In a conspiratorial tone, she adds, "Can we talk? I have good news. You're the only one I can tell."

Hand in hand we go to the almost deserted *café* on the street level of my building. "*Bonjour,*" I call to the familiar waiter as we enter. He waves a greeting, and we take a corner booth. Watching Grace, I can see the happiness in her eyes, but I ask her about a faded bruise on her arm.

"Oh, that," she hurries to say when she sees my worried expression. "I have a new job, Emma. I no longer sell soup at the station. Now I work in a laundry on *rue de Rome*, not far from home. It pays a little better." After a brief pause, she adds. "The stationmaster fired me after the uprising."

I consider making a comment but don't. "That's good, Grace," I tell her. "Is that your good news?"

"No, no, not that," she says just a bit breathlessly. "Martin and I are getting married—that's the good news. I came to invite you to our wedding this Saturday."

The waiter coming to the table saves me from a quick response. "*Mesdames*?" He inquires.

I order tea. "For you too, Grace?" I ask.

She nods.

"Also a glass of water for me, please," I add, giving him a smile.

"Can you be there?" Grace asks, her excitement written across her face.

"Of course I can. How could I miss your wedding? I'm surprised you decided so quickly after the uprising. Is Martin working again?"

"Not yet, but there is a lot of rebuilding to be done so he expects to get a good stonemason's position soon."

"That's good." I keep my concern hidden.

The waiter sets two teacups and a water glass on the table and adds a pot of hot tea. He bows and retreats.

"You come here often, I see," Grace says, giving an awkward laugh. "All by yourself?"

I take several sips of water before pouring the tea. "It has been so warm this morning. The *Place Pigalle* studio was uncomfortable. Yes, I am friendly with the waiter if that's what you're asking. I stop by here most afternoons when the *café* is

216

almost always empty."

She waits until I've set the pot down before taking up her cup, staring at me the whole time with a troubled expression on her face. "Are you happy for me, Emma?" She asks. "You don't look happy."

"I am happy for you. Your announcement has caught me by surprise is all."

She relaxes back into the booth's leather cushions. "We have no reason to wait. With Leo..." She catches her breath. "With Leo gone, Martin and I need to get on with our lives. You know I want children and Martin is in a hurry to get married." That brings a little giggle. "I can't see much reason for putting it off—no Prince Charming is coming to rescue me."

I nod but don't respond. I can't shake the negative thoughts racing through my mind. After a brief silence, I tell her, "I am so sad about Leo. I miss him very much."

"Would you have married him?"

"Who can say?" I shrug. "But I am happy for you. Are Clarise and Hector happy, too, Grace?"

"Well, you know how it is, Emma, they shed tears and say how they will miss me, but I think life will be easier for them with me out of the apartment."

"They are pleased Martin will be your husband?"

She hesitates. "Not completely. They would have preferred a Parisian man. But they think he has a skill that should allow him to care for me and any children we have." She takes a sip of her tea. When she sets the cup down, she adds, "You still don't understand our ways, do you, Emma? You don't see how limited my life is. I had to make the best choice of a husband I could."

"I want the best for you. I love you as my sister," I interrupt. "You saved me when I first arrived in Paris—I will never be able

to thank you enough. And I do try to understand your life. I want what's best for you," I tell her with more emphasis.

"Trust me, this is the best."

For reasons I don't understand, tears form in my eyes as I smile at her.

"What is it then?" she asks, concern clouding her face. She slides closer so she can put her arm around me and pull me into her embrace. I bury my face in her shoulder. We are joined together in sorrow neither one can explain, but we hug each other for several moments.

"What is it, *ma chère?*" She whispers.

Pushing back and wiping my tears with a table napkin, I tell her in a choked voice, "I have missed you. Missed living with you in your apartment."

"I know," she says, still holding on to me.

"We were happy then—you with Martin and me and Leo. Remember the dance where you met Martin? We were close."

Grace giggles a little again. "I remember Martin and Leo almost fighting."

I laugh at the memory, too, but at the same time, I feel a hollowness deep in inside.

On a hot afternoon a week later—the last Saturday in July—there are few people scattered around the little plaza in front of *Saint-Marie des Batignolles,* the village church that sits on the edge of the railway freight yards. Most of them are not here to witness Grace Durand and Martin Aboud take their wedding vows. Inside the church, a couple of pews on each side of the aisle are filled with Martin's fellow stonecutters and drinking companions and Grace's new co-workers from the laundry next

door to the *guinguette* where the reception will take place. I sit with Clarise and Hector Durand in the front pew. Several old women in lace shawls and straggling gray hair are scattered at the back of the nave—not part of the wedding party—staring down as their trembling fingers knead their Rosary beads. The smells of incense, stale air, rancid candle wax and old sweat in the narrow church, all intensified by the heat of midday, give me a queasy feeling.

Grace is pretty and virginal in a white blouse, long dark skirt and boater straw hat, with her fine light brown hair well brushed underneath. She smiles, standing next to Martin, who wears his best pants and jacket, an outsized cravat and his dusty boots. The ceremony is brief. It feels as if the priest wants as little responsibility for the marriage as possible. The stonecutters and laundry girls all cheer when Martin takes Grace Aboud roughly in his arms and plants a big kiss on her mouth, signaling the start of the migration to the *guinguette*, the drinking place, where he has promised free beer for all.

In groups of threes and fours, led by the bride and groom, the stonecutters follow along down *rue de Rome*, with the laundry girls, laughing and calling out and posturing, close behind, hoping to catch the eye of one of the stonecutters. Hector, Clarise and I bring up the rear.

The *guinguette*, a shabby rectangular wooden building, dimly lighted and reeking mostly of spilled beer, is a short walk. There is a bar on one side of the room, and the rest of the space has tables and chairs and a dance floor, but the newlyweds lead their disciples through the room and out a rear door onto a patio with a picket fence defining its space. Arching grape arbors around the periphery provide privacy. Wooden tables and benches are spotted all around the patio. A lone waiter is already at work

delivering large pitchers of beer and glasses to each table.

Martin pours a glass and stands to toast his new wife, while the others look on. Then he sits down again, surrounded by his friends, and joins their boisterous conversation. Grace looks to her parents for a sign of approval, but when no affirmation is forthcoming, she pours a glass of beer for herself and joins in the celebration. She gets up and walks around the tables to bask in the compliments of her laundry mates.

Hector, Clarise and I sit at a table under one of the arbors and watch in silence. The Durands drink the beer in front of them, but I ask for a large glass of water to help me cool off. After taking a couple of sips, sensing the awkwardness she and Hector feel, I move closer to Clarise and take her hand. "If Grace hadn't been so kind to me I don't think I would have survived in Paris," I start, looking for a reaction in her face. "Living with you and Hector has taught me so much." I stop for another sip of water, and to wipe my damp forehead with a napkin. When there is little response from her beyond a nod, I continue, "Now Grace will have her own home and soon a family."

The Durands hardly acknowledge my words.

"I know you must be sad to have her leave your home," I continue, trying to fill the silence, a bit desperate to start some conversation, "but you are happy for her, yes?"

"Yes, I suppose we are," Clarise says softly then hesitates. "If only Martin can earn enough to provide for them."

"With all the rebuilding going on in Paris after the riots he should have no trouble finding work."

"That would make life a little easier for us all," she agrees, "but he spends little time looking."

"He is not one of us," Hector snaps. "She could have done better. Far better! What would we do if he takes her back to

Creuse? And we never again see her or our *petits-enfants*?"

Clarise leans closer to comfort him. "They will stay, *mon cher mari*. Soon they will bring us *bébés*. And you, Emma?" She turns back to me. "How do you do now? Living on your own? Have you found a *beau* yet to give you *bébés*?"

"No *Maman*, no *beau*."

"Leo would have welcomed you into his arms," Hector says.

I blush and glance around the patio to avoid Hector's accusing stare.

Tears come to Clarise's eyes. "Please let us not speak of him, *Mari*."

As the afternoon continues, the sun beating on the hard-packed soil of the patio intensifies the heat, adding a dry earthy odor to the celebration. The beer flows freely. The waiter hustles in and out of the building to keep pitchers filled. Laundry girls mingle with stonecutters at tables around the patio. The noise grows louder. Sweat stains appear on the girls' dresses and their hair begins to hang limply. Grace sits close by Martin's side while some of the stonecutters, sweat beading on their foreheads, play cards at one table.

As early evening descends the party grows quieter. Some of the laundry girls, tipsy and laughing loudly, have left, most with some of the stonecutters who eagerly lead them away. A few others are spread out in far corners of the patio kissing and hugging and giggling with the men who grope at their clothing. Martin stands from the table, staggering a little at first before finding his balance. Then he grabs Grace's hand, pulls her to her feet, and drags her along with him as he visits the remaining couples, coming finally to the Durands and me. Grace drops his hand to embrace her parents. At the loss of her support, Martin wavers in an effort to maintain his balance. Without warning, he lunges a few steps toward me. Frightened, I stand as he approaches,

thinking I might need to catch him. Without warning he grabs me by both shoulders, pulling me close, and kissing me on the mouth. Stunned, helpless to get out of his hold, I feel violated.

Grace gasps. "Stop it, Martin," she shouts at him. "Stop it right now!"

The Durands watch the newlyweds, horrified.

Martin wobbles back a couple of steps but continues to stare at me.

Clarise huddles under Hector's protecting arm, tears streaming down her cheeks, and I retreat closer to both of them.

"You be quiet!" Martin scolds Grace. "I'll do as I choose. This is a nice girl here," he says pointing at me, and starting toward me again until Hector moves in front of him. "Not like your new friends, the *lessive putes* of *rue de Rome*, Grace. I thought you would be my sister-in-law," he says, leering again at me. "Now you're alone, but I'll look out for you."

I shudder. A chill convulses me. I feel dizzy. Unable to stand, I collapse on the ground.

Clarise and Hector help me back to my flat. By the time we get there, I have vomited twice and soiled my undergarments. Hector leaves and goes back to the Durand apartment in *rue Cardinet*, saying this is a woman's affliction he cannot be helpful with. I'm collapsed against Clarise as we climb the stairs, stopping to rest on each landing as I struggle for strength to continue. Inside the flat, she helps undress me and get me into bed, piling the soiled, bad smelling clothes near the door. Then she sits in a rickety chair at my bedside holding my hand.

I try to apologize, but my voice is weak. "Hush *ma enfant*," she whispers, a worried frown spreading over her face. "Where has

this sickness come from, can you say? You were fine until Martin rushed at you. Then, of a sudden, we were picking you up from the ground."

"I started feeling warm in the church. Then...I don't know what came over me when Martin..."

She interrupts without giving thought to her words. "I know. We all saw what he did, the monster! Lay quiet. I think the water you drank was bad. You must be more careful where you drink Paris water," she says and stops to consider. "No cholera, I think. No doubt you will be fine in a day or so."

But I am no better the next day when she comes to check on me. "You don't look so good, *chère*," she says.

"I was sick all night. I've made a mess again."

"I will take care of that—I cleaned up for Grace when she was sick and I will do the same for you." She wrinkles her nose. "I'll clean up *tu vomis* now—the heat makes the smell quite strong in here." She laughs apologetically.

The heat of August grips Paris like a lover's frenzy. Those who can flee its embrace to the *Normandie* beaches or to the south, but for me and the workers of *Montmartre* and *Batignolles*, and other poor neighborhoods, there is no escape. Hour after hour I lie limply on the bed, feeling drained of all energy, barely able to sit up. My vomiting and diarrhea stop, simply because there is nothing left in my stomach. With only my thoughts, I pass the day watching the sun slip by my window and listening to the familiar street noises, hoping for an occasional breeze, and falling asleep when darkness descends.

When Clarise arrives the next morning, she brings a container of soup with her, a strong beef broth with tiny chunks of meat floating in the fat on the surface. "You look better today—more color in your face," she smiles, holding the container to my lips.

Then she settles herself in the chair beside me. "Do you need the *pot de nuit* or should I help you down the stairs to the *toilettes*?"

Groaning, I point to the ceramic pot.

When I am settled back in bed, I reach out for her hand. "Thank you for caring for me. What would I do without you?" I tell her.

She nods without speaking, perhaps lost in her thoughts. "You are alone, Emma," she says at last. "It is difficult for a young woman to be alone—especially in Paris—easy for her to fall into trouble."

"I have never been sick before."

"It is nothing, *chère*. Most likely contaminated water, Paris water is still dangerous, the new *réservoirs* are not perfect. We all must eat and drink carefully—wine or beer are safer." After reflecting for several moments, she adds, "But women need someone to care for them, too."

I laugh weakly. "You mean someone other than you."

"*Oui*, I do. A man. I count on Hector to protect me. All French women do. It isn't good living alone as you do."

For a moment I'm lost in a fantasy where Frederic Bazille is sitting at my side, not Clarise, holding my hand, worrying over me. Then, looking up at her, smiling as best I can, I tell her. "I've taken care of myself all my life, *Maman*. Ever since my papa died."

"*Oui*, I know. Grace has told me about your life before coming to France. But life in a large city is more difficult than where you grew up. Perhaps if Leo..."

"You were hopeful about Leo and me...?" I grimace. "I miss him. I cried over his death, *Maman*, but I must tell you truly, he and I were never meant to be together."

"I know, Emma, I knew it all along. Grace and I talked about

that after you moved out. She cried over it too, but I could see that you were meant for a different life. Leo was not right for you—a mother sees things like that. Leo was not as ambitious as you are."

"Do you worry about Grace?"

"I pray God will keep her safe." Clarise makes the sign of the cross on her chest. "I came from a poor family, too. I was so fortunate Hector married me. He is a hard worker. I pray that for Grace." After a pause, in which both of us share the same thought, looking into each other's faces and seeing our own sadness reflected, she says, "I must go to the market now." She rises from the chair, patting my hand, and goes directly to the door and calls back, "Perhaps you'll be well by tomorrow."

Alone again, I spend the day deep in memories.

By the end of the week my strength is returning, but I stay to myself in the flat in a dismal mood, watching a solitary spider spinning its web on the window frame. I cannot escape the fact I am alone—I'm used to that I tell myself—but alone in my heart too, and that makes me sad. Why, I ask over and over? I pinch the spider dead and let it drop out the window. My life would be perfect if Frederic were here with me, I try to tell myself. My mind rejects that thought. It was only an infatuation, a silly girlish crush. But, oh, how I do miss him! We had something—now he's gone. Who will miss the spider? All gone and I must go on.

So what am I to do? The question nags, churning me physically and ultimately bringing on tears. I understand what Clarise has told me—there is no one for me to count on. Leo Durand was not that someone, I dismiss the thought... I must do for myself.

∞

Fully recovered several weeks later, I hear the gentle tapping on my door again. I am ready, even though the tapping comes earlier than I expected. The note Lamar Legrand's messenger delivered is clear. He apologized for not contacting me when he said he would but says he has spent most of August out of the city because he couldn't bear the heat. Now he wants to make it up to me by taking me to dinner. So I am dressed in the deep blue silk dinner dress that lay on the table while I was sick when I go to the door.

Opening it, excited for a reunion evening with Lamar, I'm dumbfounded. I stare open-mouthed at the short little man in front of me.

"I hardly expected to see such a lovely vision standing before me after making my way through this nasty neighborhood," the man greets me. "Let me assure you I've had the deuce of a time finding you, *Mademoiselle* Dobbins," he adds.

He looks familiar. I search for a name, but can't place him. He is a strangely dressed, middle-aged man. His face is a long, sallow oval, devoid of color, dominated by slightly bugging eyes. A beret sits atop his bald head.

"Charles Frederick Worth, I am, and you, *Mademoiselle*, are wearing one of my fine old creations," he says. "Let me say again I've gone to great lengths to find you."

"Find me, *Monsieur*?" I break out in a sarcastic laugh. "There was no trouble for you finding me! I walked into your *atelier* after the uprising ended and the rude *Madame* who greeted me said I was wasting my time. Even when I showed her your card, she said, 'He gives his card to all the pretty *jeunes filles* in Paris', and shooed me out the door."

Worth's face takes on the look of a contrite young lad. "Oh, I should think *Madame* Allard is not cut out to be a greeter. My

226

apologies, *Mademoiselle* Dobbins. After I saw you at the salon I was perplexed why you had not come to me, but I could not get the image of you in that lovely dress out of my head. Indeed, it has taken me this long to track you down when all the time *Madame* Allard has kept you from me. A pity. I finally encountered *Monsieur* Degas who directed me to this address— not the finest neighborhood, is it? Or one I would have expected for such a pretty young woman." Worth pauses and smiles for the first time. "I can see you are not planning on spending the evening alone."

"I have a dinner invitation."

"A lucky young man, I should think. I remember that dress you are wearing this evening quite well. It is one of my designs I produced a couple of years ago."

I hear the faint, familiar sounds of a carriage driver's boots climbing the stairs a couple of flights below. "I must go now," I tell Worth.

"I won't keep you longer, but I do want you to come back to my shop to talk with me. I want to discuss a job, with you modeling some of my gowns. Please don't disappoint me again—I'll alert *Madame* Allard—she means well." He starts down the stairs, and I hear him greeting the driver one flight below.

"*Bonsoir, Mademoiselle*," the driver says, pausing for breath as he reaches the landing. "*Monsieur* Legrand awaits your company in the carriage below."

My first impression on stepping into the black Brougham is the full smile and shining gray-blue eyes of Lamar Legrand submerged in a sea of plush red velvet. "*Bonsoir, Mademoiselle*," he says, extending his hand to take mine. "You are a wonderful sight after such a long absence. I am pleased to have you joining me this evening." He continues to keep his hand on mine.

His touch and the sound of his voice bring a shiver of excitement. At the same time, I feel a warning somewhere deep inside. "I was happy to receive your note," I answer flatly.

"And you have been well in my absence?"

"Not entirely." I decide not to give Lamar details, steering the conversation politely back to him. "How were your travels?"

"Oh, quite profitable! My business does well."

"What is your business, if I may ask."

"Oh, this and that. It's nothing you would be interested in."

"I wouldn't have asked if I weren't."

"I see." Lamar stops talking to consider what I've said. "My father was a merchant in Lyon. I go there often."

Realizing he doesn't want to be more explicit, I change direction. "Did you go to *Montpellier*?"

"I was able to stop briefly in *Montpellier* to give my condolences to *Monsieur* and *Madame* Bazille if that's what you're asking," he tells me after a pause.

"Did you see any of Frederic's paintings?"

He pauses again. A frown creases his brow. "Well, yes, some."

"Any of the ones that were in his studio?"

He looks away for a moment as if he might be strolling through the Bazille family *chateau* in his mind, looking at each wall, or perhaps having some other thoughts. "Well, to be true, I don't really remember what paintings were in his studio when he left to fight so I can't say. They only had a few."

My eyes question what he is saying as I stare at him. It seems to me he, of all people, should know something about Frederic's paintings. I want to press him on it, but realize I would not know if he were truthful or not. I lapse into silence for the remainder of the ride to the restaurant, while he makes polite small talk about his travels, never asking again about my hint of unwellness.

I try to pay attention, but can't purge the missing art from my thoughts.

Breaking the silence, he tells me, "I am taking you to a different restaurant this evening. In the *Les Halles* district, and more appropriate for the two of us dining alone. *Monsieur* Victor Baltard is a highly regarded architect and a friend. He is retired now, but did much of his work in this area for Louis Napoleon in the '50s."

Entering the half-timbered building that houses the restaurant, my heart skips a beat and I feel slightly giddy. The interior is the most ornate room I have ever set eyes on. The main dining room is a swirl of velvet and gold, chandeliers and mirrors, an ambiance I never could have imagined. As the *maître de* leads us on through the room, I feel uncomfortable seeing people stare at me. We climb a circular staircase with a sweeping balustrade of polished mahogany rail and ebony balusters tipped with hand-carved gold-painted heads. Arriving at the second level, we enter a private room for two.

Lamar whispers instructions to the *maître de* as he leaves. Then, turning to me with a smug look on his face, he says, "I knew you would like it here. I have ordered champagne for us to start and a main course of mussels in cream sauce with fried potatoes, if that pleases you?"

The realization comes instantly for me that I am far beyond my own ability to make decisions about the menu. "*Oui*," I smile demurely, "It all sounds good if you say so. I have never seen a restaurant as magnificent as this before, so I am sure all the food will be wonderful."

He beams and leads me to a deep settee with gold embroidered cushions under two floor-to-ceiling windows. A mirror on the adjoining wall reflects the rest of the room.

"It's a very romantic setting for dinner, don't you agree?" He asks, taking my hand again.

The champagne gives me a slightly light-headed feeling. The main course reminds me of the mussels clinging to the rocks near Point Conception. The cream sauce makes them go down smoothly. After dinner Lamar leads us back to the settee, this time putting his arm around my shoulder.

"I have been looking for the right time to compliment you on how well you look in the dress I sent to you. You are very lovely this evening, Emma. I am so proud to have you with me."

I look straight at him and see the happiness in his face. But I know this is an important point in our relationship. "The dress fits me quite well, *Monsieur* Legrand," I start formally, then pause briefly before saying, "So I assume the other young women who have worn it were about my size, too."

Lamar is shocked. "Other young women?" He says in a constricted voice.

"Well, yes, of course," I reply. "Surely you don't suppose I think I'm the first to wear it. It is at least two seasons out of fashion—created by the House of Worth, was it not? Yes, I am quite sure it is one of Charles Frederic Worth's designs. How many other girls have worn it?"

The crestfallen look that comes over Lamar is the look of a young boy caught stealing a cookie. He searches for words, but none come immediately.

I toss off a laugh, acting far more sophisticated than I am, and touch his arm. "It is true, *Monsieur*, that I am just a simple girl from California, but I am learning the ways of the world here in Paris. I am pleased to be with you tonight and comfortable in your presence. I hope we can continue to see each other, but you must not treat me like a simpleton because I am not one.

If we continue to see each other you must promise me that you will always be truthful. That has not been the case so far this evening. You must always treat me like the most precious woman you know because I am when I'm with you." I choke just a little saying it, and silently think of Sarah Bernhardt.

Lamar straightens up and looks at me just a bit pleadingly. "You are right, Emma. I apologize from the bottom of my heart. There was only one other woman who wore the dress. I never should have sent it to you, but I did because I sensed you did not have the kind of clothes you should have to be seen at the kind of places I want to take you. That is why I did it. I didn't know what else to do. But I promise you I will always be honest in the future."

"You can continue to call me Emma," I tell him.

He changes the conversation, speaking of the events of the next few weeks, as the fall social season begins, hoping to have me accompany him, but without actually inviting me.

"If you plan to invite me I will be appropriately dressed, you can be sure," I tell him.

"I would be happy to buy you a whole new wardrobe if you allow me," he answers.

"Oh, no! No, sir! Not at all. I will wear my own clothes, not borrowed clothes and not clothes you buy me. If I don't have the right clothes, we can find other places to go together where I will not embarrass you."

We ride together in silence back to *rue Lepic* in his carriage. Sitting side by side on the velvet seat, Lamar's hand is just slightly touching my hip encased in the blue silk.

When the carriage stops, he turns to look directly at me. "It was a good evening for me," he starts. "I feel as if I know you much better, and that we understand about the future."

"The future?" I interrupt him. "Oh no, Lamar, neither of us knows about our future—that will unfold as it will."

"Be that as it may, Emma, I hope we can look forward to a future together. May I have permission to kiss you good night?"

I smile. "Yes."

He leans toward me, and I await his kiss with a thrill of anticipation. When our lips touch I feel a sense of pleasure deep inside, like no other kiss, and I put my hand on his shoulder. We linger like that for what seems to me a very long time. Finally, he says, "Goodnight, my man will see you to your door."

CHAPTER SEVENTEEN

Fall 1872

THE FOLLOWING MONDAY, a crisp September day, with benign, high-topped clouds floating over the river, and a gentle breeze playing in my hair, I retrace my steps to *Maison Worth*. No sooner have I enter the shop than *Madame* Allard charged out again from the back room.

"*Bonjour, Mademoiselle,*" she starts in her officious voice, "May I help you?"

"I'm here to speak with *Monsieur* Worth, *S'il vous plaît.*"

"Oh, no!" She starts, but I interrupt her.

"I won't have you putting me off this time, *Madame.* Lead me to him, he is anxious to meet with me."

Taken aback, *Madame* Allard studies my face and plain dress, shaking her head, as if trying to comprehend what possible reason Charles Worth might have for seeing this bohemian girl standing in front of her.

My patient expression fades as she stands mutely eyeing me. "My name is Emma Dobbins," I tell her, bringing a spark of recognition to her eyes.

"*Je suis* désolé, *Mademoiselle.*" Her face turns contrite. "You should have told me that first. *Monsieur* Worth has alerted me."

"You are so rude you drive people away," I scold her. "It's a wonder you have any customers."

"Come with me." Her dour face blooms with an obsequious smile. "*Monsieur* Worth mentioned your name. *Je suis* désolé. One of my jobs is to keep strangers from wasting his time." She reaches out to take my hand. "Please do not tell *Monsieur* Worth, *Mademoiselle*," she pats it softly. "I need to keep my job here. I have just come to Paris from the south."

I nod grudging understanding. "Then you will remember me from now on," I tell her in my softest, kindliest voice.

Frederic Worth is moving around the large workroom in the back of the shop like a caged wild beast when *Madame* Allard brings me there. In different locations around the room, women are measuring and cutting silks and velvets and laces, even some furs, and laying them out on tables for his inspection. Others hand stitch and flat iron dress components. He hurries from table to table, nodding approval or furiously correcting a worker who has misunderstood his instructions. Several assistants follow behind him, scribbling notes he shouts to them over his shoulder. When he sees me with *Madame* Allard, he pauses for only a second in mid-step to point us to his office. Then he continues moving around the room.

Presently, he appears in his office doorway, drawing a deep breath, as if he had just returned from a brisk morning constitutional down to the river and back. Wearing a white silk shirt and modest cravat, and a dark brown smoking jacket with velvet piping, He greets me. "*Bonjour, Mademoiselle* Dobbins. Come sit by my desk to talk."

Madame Allard starts to leave, but Worth signals her to stay so she stands stiffly just inside the door.

"I haven't much time, but I am pleased you've come," Worth

234

continues. As he talks, he inspects me with a focused stare that gives me an uneasy feeling. He seemed to leave no detail unnoticed.

"*Bonjour*. You asked me to come see you," I remind him.

"To be sure, I did, *Mademoiselle*. I have a business proposition to make to you if you're interested in employment with my company."

"I can't answer until you explain," I tell him, but retain my friendly smile.

"Right-o." He stops to gather his thoughts. "As you surely know," he begins, "I dress the beautiful women of Paris and Europe in the finest custom-made, hand-sewn dresses and gowns. My reputation is known throughout the countries of Europe, and now women are coming across the Atlantic from America to purchase my designs. Of course, my creations command high prices because I use only the finest materials and employ the best seamstresses."

I listen, nod, and wait.

He takes a breath, "Recently—since the war ended and the rebellion has been put down—the American ladies have started bringing their daughters along in hopes of making matches with European gentlemen—that's where you come in. You're from America, correct?"

"From California."

"Jolly good! I need a pretty young woman such as you to model the clothes the young American and English girls will buy. My other saleswomen are older, more suitable for showing my gowns to their mothers." He stops for a breath, again looking hopefully at me, but goes on. "When I saw you at *Comtesse* d'Agoult's salon I was dazzled by your appearance. I decided right then you are the one I need to present my designs to the young Americans."

"I don't know what to say."

"Don't say anything yet," he interrupts. "Let me tell you my offer. I will pay you 300 francs a month to be at my disposal for modeling our gowns. When we don't need you, you are free to pursue other opportunities—Degas tells me you sit for artists. That is fine with me as long as you wear my dresses when you are out in public."

"But I only have the one dress you saw me in the other evening."

"*Oui*, I know, and I wish we could burn it." He gives a gentle laugh. "We will provide you with a modest House of Worth wardrobe. Not so much to start, but we'll see how you do. When you go out you must wear my newest creations. *Madame* Allard will be your matron, she will see to all your needs."

I glance at her, still standing statue-like by the office door. She has a contrite look on her face.

"When our customers come to Paris they stay in one of our apartments on the *blvd de Capucines* while their gowns are being made," he continues. "That is where you will meet the young Americans or English girls, and you can dress there each time with *Madame's* help." He throws a quick look at Pauline Allard. "Perhaps in time you will think of moving from that miserable hovel on *rue Lepic*, where it is not a safe place for you, *vous savez*? So, you will start tomorrow, yes? There is a woman from Boston bringing her daughter with her. *Madame* Allard will take you to *blvd. de Capucines* now to begin training."

Worth stands and kisses me on each cheek. "Well, there you have it," he says. "*Bienvenue à la Maison Worth*." Then he dashes from the room, leaving my head spinning. *Madame* Allard gives me no time to consider. "*Viens avec moi, Mademoiselle*," she says. "We have much work to do before tomorrow."

Over the next months *Madame* Allard, who speaks no English,

and I accommodate the young American and English girls, accompanying their mothers to Paris. I quickly learn my role is to model the designs Worth thinks most suitable to these *ingénues*, and help them in making their decisions. I learn how to flatter and cajole the young girls into telling me exactly how they want to dress, but I never lie if the dresses they like don't look good on them. When there are no appointments scheduled, I am free to pursue my art or accept sittings when offers come my way.

Pauline Allard, a plain woman, well into her fifties, lives in a small alcove behind the showroom, acting as my lady's maid when I arrive on appointment days. We quickly become close, and I realize she is not the officious woman she acted at first. She is humble by nature, and very knowledgeable in the ways of *couture*, helping me dress and tending to my *coiffure*. From time to time, she finds an excuse to mark one of the dresses I model as soiled, adding them to the wardrobe for my personal use.

On a cool November day, when fall has deserted Paris, and a blustery chill comes down the river, I leave the *Louvre* to meet Berthe Morisot for lunch. On the way I recognize the copyist Berthe had mentioned just ahead of me going out the exit where the guard checks to be sure no one is stealing valuable art. I catch up with her in the courtyard and introduce myself.

"I have seen you here before," I tell her. "You are always carrying a finely done copy you have made. Each one is different. Your work is excellent."

"*Merci*," she says. Her smile is uncertain, and she seems reluctant to speak with me.

"Do you make your own paintings, too? I'd like to see them if you do. Perhaps we could talk sometime?" I tell her.

Her face turns pale. "Oh, no. All I do is copy the paintings I see." She shifts nervously from foot to foot and seems anxious to get away. After an awkward moment, she adds, "I do this only for my pleasure. Sorry, *Mademoiselle*. I must go now." With that, she turns and quickly walks off.

<center>⤸</center>

I meet Berthe at the *rue Royale* bistro where we enjoyed lunching at before the war. It is one of the buildings that escaped firebombing during the Commune uprising, but rubble still partially blocks the way.

We sit inside where it's warm. Tantalizing food aromas replace the sour smells from the street. We both select white bean *cassoulets* from the *plat de jour* menu.

"I am so pleased that you have returned to the City now the fighting's over," I tell Berthe after we order.

"It was all too horrible to bear," she says. "In fact, the fighting made me quite ill. My father took me to Cherbourg with the rest of the family. But now I am glad to be back. How was it for you?"

"Very frightening. I hardly left my rooms." My face brightens dramatically as I change subjects. "We won't talk of that. I now have a modeling job at *Maison Worth*."

Berthe listens and eats while I explain.

"That is so good for you, Emma," she says. "Now you can find a safer place to live and be closer to *Monsieur* Worth's showrooms."

"It's tempting, but I'm not ready to move yet. I'm comfortable in *Montmartre*," I tell her.

A confused look creases her brow. "Aren't you scared? Living in that part of the City alone? Where the rebellion began?"

<center>238</center>

"I'm not. Not at all! Many of the artists and art studios where I have sittings are there or nearby in *Batignolles*."

"I think I would be scared living alone anywhere in Paris. I'm glad to live with my parents, at least until I marry." At that, she gives me a coy smile.

I tease her. "Do you have a *beau* now, Berthe? How exciting. You've never mentioned one. Will you tell me the gentleman's name?"

"Nothing is definite yet... Well..." She hesitates and then her smile broadens, "His name is Eugéne Manet. Time will tell. And you? Is there a man in your life?"

I let my eyes look away as if I'm staring at something distant I can't quite make out. Breathing in the warm aroma from the *cassoulet*, I hold my spoon in abeyance. "Perhaps," I tell her and pause a moment. "I've had dinner twice with a gentleman I met at Frederic Bazille's studio. He was with us when Frederic took me to the ballet. It was a wonderful evening for me." I stop again to reflect. "I met him again at the salon I attended with Degas before the rebellion started."

"Tell me about him. His name. What is he like?" Berthe sets her spoon down and leans closer.

"It may be nothing. But he is very handsome. Tall, with sand-colored hair and gray-blue eyes. He has a cute dimple in his chin. He's thirty or more and already a successful merchant, I think, although he doesn't talk much about what he does."

"Does he have a name, Emma?" She asks impatiently.

I laugh. "Lamar Legrand is his name. I think he comes from a good family."

Berthe's face turns serious, barely avoiding a frown. "I know of his family," she says without emphasis. "I hear he is a very eligible bachelor. I didn't know he and Frederic Bazille were

close friends. My mother told me *Monsieur* Legrand knows a lot of young women in Paris. Do you like him?"

"I do, but I don't know his intentions."

"You should have more opportunities to meet young men, I think," she says, musing to herself. "Would you like to attend a *soirée* with mother and me one evening? It would be a good opportunity for you."

"I would. But you must know I am not looking for eligible men. I am quite happy living on my own, as I told you."

"But Emma," Berthe's probing eyes seem to question me, her face is stern. "It is much safer in our world to have a man who will take care of you. Hopefully, one who will love you, one you can start a family with. Everyone needs to have a family, that's what I hope for myself."

"Then I hope that for you, too, Berthe. But the only family I've ever had was three lighthouse keepers and my papa. I am happy living alone. There is nothing to distract me from my art."

❧

A few days after lunching with Berthe, early in the evening, I dress in a Worth gown Pauline has selected for me. Made of old gold silk, it is perfect to wear to the *Theatre Italien* with Lamar. It has a short bodice that buttons up the front and long skirt that has a series of flounces and ruffles. I confess to Pauline I know nothing about opera, but share my excitement about going with Lamar. "He says we're going to hear Adelina Patti sing the part of Leonora in Giuseppe Verdi's *Il Trovatore*," I tell her, "but I really don't know what that means. Do you think I look properly dressed?"

She laughs as she puts finishing touches on my hair. "Don't worry about the opera, *Mademoiselle*," she tells me. "The *Theatre Italien* is a place to be seen by others, and your beauty will radiate."

At the theatre, Lamar leads me through the lobby to a box on the first tier to the right of the stage. Along the way, he stops to chat with friends, and I wait quietly at his side. When we reach the box, my breath is taken away by the grandeur of the theatre. It rises five tiers in a horseshoe of seats that holds the stage in its open end. I go to the rail, looking around at the formally dressed men and brightly gowned women milling around the main floor. It reminds me of the ballet with Frederic.

Adelina Patti sings with the most beautiful voice I have ever heard, sweet and high and tonally pure, but Pauline was right: most of the audience is not there to listen. Four long intermissions, allowing the audience to promenade in the lobby showing off their finery, stretch the performance late into the night. As it finally draws to a close, Lamar takes my arm and hurries me off to his carriage. "You will go to the apartment where I picked you up?" he asks.

"No, Lamar, please take me to my *rue Lepic* flat," I tell him. He grimaces and gives quiet instructions to the driver of the closed carriage.

Settling against the plush cushions, I start to ask him if he had enjoyed the opera, but I don't even get the words out of my mouth before he captures me in his arms and begins kissing me. Surprised, perhaps even a little startled, I don't resist and soon return his affections.

We stay in each other's arms as the Brougham makes its way through the darkened streets. Out the side window, I notice the coach taking several different streets winding up to the cemetery at the top of *Montmartre*.

"When I hold you like this I am the happiest man in Paris," he murmurs in my ear.

I feel his hands moving against the smoothness of my dress,

enjoying the sensuous feeling that ripples through me. His kisses are long and gentle. I return them with my eyes closed tight, and feel carried away by my emotions. I am barely aware when the carriage stops, and hardly stir when his fingers slide softly and caressingly and inexorably to my breasts. Lost in the rapture of the moment, I feel him begin unbuttoning the front of my bodice. I stiffen a little as his hands trace over my body, but he doesn't stop, and I give in to the seduction taking place, beset by conflicting feelings, yet yielding with anticipation.

"You are a beautiful woman," he whispers to me finally, collapsing back onto the cushions, breathing hard, when he has finished.

I smile and lightly touch his face. "Thank you for being gentle," I purr softly, but inwardly I am filled with worry.

"You have the body of an angel, Emma. Your silk stocking gave me a thrill when I touched your legs." He lets his fingers lazily trace over my belly.

We stay silent, neither of us wanting to spoil the evening. Finally, Lamar signals the driver to go on. When the carriage stops on *rue Lepic*, he takes my hand and brushes my cheek with a kiss. "I want you to always be safe, *cherie*." He smiles lovingly at me. "Living up here is not safe, you must know that." After pausing a moment he says. "I would be pleased to provide you an apartment closer to my own so we could be together more often—not confined to the back of my carriage to share our affections."

"Be your mistress, you mean?" I give him a sharp, defiant look and sit bolt upright. "I am quite comfortable in *Montmartre*, Lamar, with many of my friends close around. Unless you invite me into your own apartment or go upstairs with me, the carriage will have to do for us." His lack of response puzzles me, but I

go on, "You must know I have feelings for you. I would like to continue seeing you, but I will never allow you or any other man to lock me away like a caged bird in an apartment he pays for. I will live on my own where I choose."

<center>∽</center>

The next morning Pauline Allard is waiting to dress me to show some gowns to American twins from Baltimore who are waiting with their mother for fittings. When the session is over, I bid the girls—rather spoiled brats—and their mother, *adieu*, then hurry to Pauline, who is tidying up the showroom.

"May we talk?"

"*Mais bien sûr*," she says. "Come sit by the window and tell me what is on your mind."

"It is a personal question I have. I don't want to offend you by asking, but I can think of no one else to ask." I feel myself tremble as I continue, "There are things about being a woman I don't know. No one ever explained them to me. Can I speak privately with you about them?"

"Of course. *Monsieur* Worth instructed me to assist you in..."

"Oh, no! None of this must get to *Monsieur* Worth. You must promise!"

"I understand. Speak freely."

I can't stop blushing. I hesitate for what feels like a long moment of silence. Finally, heaving a sigh I can't suppress, and drawing in a deeper breath, I start. "I want to know if there are ways to prevent having a baby when you make love with a man. I don't know what to do."

"You...you have a gentleman?

"Yes! Of course, me! I do not have very much experience in this."

"When?"

<center>243</center>

"Last evening."

"Come with me, Emma. She is up and taking me by the hand into the bathroom. "There are ways—that is what the bidet is for—but the best way is to take the precaution before the..." She searches for a word... "*pénétration*. But there is always a risk when you wait. It's best to take precautions before meeting with the gentleman."

"But I didn't know it would happen. What is the precaution you are talking about?"

She pauses to think for several moments. Then she gives me a maternal smile and takes my hand. "I haven't had to counsel anyone like this for a long time, *Cherie*—I was lady's maid to a courtesan many years ago. I am pleased that you have faith in me. When we first met I worried you would despise me. Now here I am teaching a young woman."

She gives me an emotional look but stops when I show her a blank face.

"Please!" I beg her.

"*Désolé*. The best method is to use a small piece of sponge, secured tightly to a thread, and then inserted. After your gentleman has left your *boudoir* you can remove it by pulling the thread. It is best to dispose of the sponge, but I know some courtesans wash them for reuse."

My face is crimson. I bury it in my hands and begin to sob. She stays by my side, as my heart wants to break. She takes me in her arms and holds me. It is a long time before I can get control of myself. "How can I be so stupid?" I moan. Finally, with the help of a hanky she produces from a pocket of her apron, I dry my tears and thank her. Then I dress and walk out to the fitting room to stare out the window at the traffic on the street below. Finally, when she joins me, I tell her, "I am very naive, Pauline.

You must think me a silly young girl."

"Perhaps you are, Emma, but it is no shame to learn, and better than making mistakes."

"But I am so naive..."

I woke up one morning in the hotel, where I was sent to work after my papa died, to find bloodstains on my nightdress. In a panic, I pulled it off and began looking for the source. When I found it, it threw me into a frenzy. I thought I was dying. I dressed quickly and then wadded the nightdress in a ball, and hurried down a flight of stairs to an empty guest room. I pulled all the sheets off the bed and rolled them up into a ball, added the nightdress to the bundle. Continuing down the stairs, I ran out the back door to the laundry tub on the far side of the building. I threw the bundle in a bin of dirty laundry the old, white-haired Mexican woman washed each day. Then I went to the kitchen and began my daily routine, pretending nothing had happened, expecting to drop dead at any moment.

In the afternoon, when I finished washing the mid-day meal dishes, Luz, the owner's wife, confronted me, holding out the bloody nightdress. "Yours?" She demanded.

Caught unprepared, I lowered my eyes and nodded my head.

"First time?" She pressed.

I looked at her with a blank stare. "What do you mean? I'm dying, aren't I?"

"Not dying. You won't die, Emma! Didn't your mother... Oh, yes... No more little girl," she told me after she paused. "You are becoming a woman." She said it with a callous tone. "This happens every full moon now till you are an old crone." She

paused again, this time to give me a harsh look to make sure I was listening. "Use old rags by the washtub. Carmen washes and boils them so they can be reused. Get one now and pin it to your underclothes." She started to walk off, but stopped short and turned back. "We do not talk about this to men," she warned me. "Never! It's God's curse on women, and we endure it in silence." She walked on a few more steps then turned again. "Have you been with a man?" She demanded, and after studying my blank face a moment, vanished back into the kitchen.

After another long, silent interval, I beg Pauline, "We will never talk of this again."

"I am only glad I am here with you, *Mademoiselle*," she replies. "I hope you will always trust in me."

I spent the rest of the day with her, withdrawn and avoiding any additional discussion. During the afternoon, when the apartment is quiet, and even the street noise coming from below seems hushed, and the air has a stale, forlorn smell about it, a note comes by messenger for me from Berthe, inviting me to go with her to a *soirée Madame* Charpentier will hold the following week.

"A *soirée*?" Pauline says with enthusiasm when I tell her. "I will discuss with *Monsieur* Worth what you should wear."

"Discuss with *Monsieur* Worth? What does it matter to him?"

"Don't fret, *ma belle jeune beauté*, I will see to him for you, and bring you some fine dresses for you to select from."

On the eve of the *soirée*, with Berthe's mother, Cornélie, acting as our *chaperone*, we arrive at the imposing townhouse of Marguerite and Georges Charpentier on *rue de Grenelle*. We are ushered into a drawing room decorated in a Japanese motif,

where an exuberant Auguste Renoir rushes up to greet us. In his excitement to kiss our cheeks, his top hat tilts crookedly to one side and almost slides off his head. Laughing, he grabs at it at the last moment. Taking my hand, he leads me a few steps away, and Berthe and her mother move to another part of the room.

"Oh, *Mademoiselle* Dobbins I am so pleased to see you. Ever since our dinner with *Monsieur* Legrand I have been anxious to see you again. And confirm our date for a sitting."

Smiling, before he can say more, I touch his sleeve and interrupt. "Are you and Lamar good friends?" I ask him.

He stops and looks intently into my face. "Oh, no, *Mademoiselle*," he says. "I barely know him. He came just once when I was there to the studio I shared with Bazille. I was quite surprised when he invited me to dinner at Lucas Corton and told me you would be there, too." Renoir gives me a bright smile and stops for a moment before continuing. "Funny though, when I was in *Montpellier* to get away from those thugs from the Commune, I thought I saw him. But if he saw me, he didn't acknowledge it. I never could catch up with him."

"Did you see Frederic's family?"

"I did. I went to their ranch for a quick visit. They were quite devastated by his death. Did you know his father had to go collect his body in *Bourgogne*?"

"Lamar said he paid his respects to them, too." I want to speak further with Renoir, ask him more about Lamar, but at that moment another man hurries up to my side and puts his hand on my shoulder. Older that Renoir, he had a dome of wispy white hair and a genuine smile of happiness at being beside me. "*Bonsoir, Mademoiselle* Dobbins. At last we meet again."

"*Monsieur* Corot!" In my excitement at seeing him again, I throw my arms around him in an impulsive display of affection.

Awkwardly he recovers and smiles. "If only all the pretty young maidens greeted me that way, I would not be an old man today," he laughs.

"But I am so happy to see you. I saw the *Girl From the Lighthouse* painting you and *Monsieur* Boudin did—it made me so happy. I have it hanging in my flat. How can I thank you?"

"I am so pleased," he answers. "That was not such a happy day for you—not for any of us. Boudin saw the image first and he was right. I only saw what he saw when the lighthouse was added. Were you running from the lighthouse or running to a new beginning? Who knows? The image asks the question. But you could thank me by posing in my studio, *Mademoiselle*."

"Tell me when and where and I will be there," I tell him, laughing.

"Wait a minute, *Pere* Corot" Renoir interrupts, "What about me?"

"*Pere* Corot?" I give Renoir a questioning look and then joke, "He doesn't want to paint your portrait."

"He is the father of us all," Renoir says and takes me by the hand. "Excuse us, *Monsieur* Corot, I must introduce Emma to *Madame* Charpentier, our hostess." Renoir leads me away, giving Corot a warm smile, I tell him over my shoulder, "I promise to come to you soon, so let me know."

Marguerite Charpentier is standing in front of a wall painted with a traditional Japanese scene of two peacocks with their tail feathers in brilliant display. She greets Renoir warmly but gives me a more subdued welcome. "I am pleased you have joined us tonight, *Mademoiselle* Dobbins. I hope it is just the first of many evenings you will be a part of our group," she says. "That is a magnificent gown you wear this evening; one of Charles Worth's designs I imagine."

"*Oui, Madame,*" I bow respectfully but don't say anything more.

"There is another young woman with us this evening," she goes on. "I hope you will introduce yourself to her. Her name is Amélie. *Excusez moi,* I must greet some other guests. Our speaker for the evening, Emile Zola, has just arrived so I must welcome him. He will talk about his new book. My husband is his publisher." She turns away before I can say another word.

Renoir leads me back into the large drawing room where men and women cluster in small conversation groups in the long room. Berthe and her mother are in a far corner with several other women.

One of the gentlemen disengages himself from his companions and approaches us. Taking my hand and bowing, he introduces himself, "I am Lucien Maître, *Mademoiselle.* I don't believe we have met before."

Lucien Maître is an impeccably dressed gentleman who appears to me to be in the prime of his life—not old, but mature. Of only average height, with brown hair sprinkled with gray about the temples, and a close-cropped beard, he has a classical appearance. His large eyes, guarded by a heavy brow, have a warm gray-green cast. I am immediately charmed by his demeanor, but cautiously offer him only a cool greeting.

Withdrawing his hand from mine, he looks to Renoir. "Is this one of your art compatriots? I have not had the pleasure of meeting her at *Madame* Charpentier's before tonight." Smiling at me again, he says, "Renoir is a good friend of his patron, Georges Charpentier, and brings along his artistic chums." He laughs softly. "You are in good company this evening, *Mademoiselle.* You know Monet over there, I presume. Sisley, Fantin-Latour and Gustave Caillebotte are huddled back in that corner likely hatching up some plan. We are all pleased to have a pretty new face among us. Welcome."

I accept his compliment with a broad smile. "*Je suis heureux de vous recontrer,*" I tell him in my best French. "I think you must not be an artist."

"Oh, no, never," he returns my smile. "Many here are merchants like our host. I am only a banker. That gentleman huddled with the artists is *Monsieur* Paul Durand-Ruel. If you paint, you will want to meet him. Do you paint, *Mademoiselle*? Durand-Ruel tries to introduce Renoir and his friends to unsuspecting collectors." Lucien Maître laughs at his little joke with a twinkle in his eyes.

"And are you one of the unsuspecting collectors, *Monsieur*?" I tease him.

"Ah, *oui*, I do confess to the art collecting addiction," he replies, still beaming happily.

While Lucien and I chat, Renoir excuses himself and walks away. My gaze strays to the far end of the room where a couple of men surround the young woman Marguerite Charpentier called Amélie. I am surprised to see she is the copyist I spoke briefly with in the *Louvre*. After a few minutes, she leaves the men she has been talking with and comes to Maître's side, nodding acknowledgment to me.

"I was asking *Messieurs* Sisley and Fantin-Latour what projects they are working on currently, *Monsieur* Maître," she says without any introduction. "And I am curious whose art has currently attracted your interest?"

Looking at her as she concentrated on Lucien, I can see that she is not as young as I originally thought when we talked at the *Louvre*. She reminds me of Grace, but is at least five or ten years older. Still, she has pretty features. She has Grace's fine hair, but of a brighter, honey color that is perfectly coiffed framing her delicate face. Her dress accentuates her figure, and I can't help

noticing the immodest upswell of her breasts at the neckline that Lucien can't seem to avoid admiring.

"We met just briefly at the *Louvre*, but you were anxious to get away." I interrupt her, realizing that she is deliberately excluding me from the conversation.

"Oh, yes, I remember," she says, turning back abruptly to Maître. "Are you adding any artists to your collection these days?"

"Ah, Amélie, you are always asking me that question and you know I don't talk much about what I am collecting. But I will tell you I am very interested in Barbizon painters just now, especially, Millet and Rousseau. Now I must move on." He looks back at me, almost apologetically that we had not had more time to get to know each other. "*Adieu, Madmoiselle* Dobbins. I hope to see you again soon." He smiles and walks away.

"I thought you said you only painted copies of the Great Masters?" As I ask her, I wonder if this is the same Amélie who is *Madame* Crystalle's daughter, but decide not to ask.

"Like that other woman in the drawing room you mean?"

"*Oui*, if you refer to *Mademoiselle* Morisot."

"I see her in the galleries, too, don't I?"

For several moments we stand facing each other without speaking, just studying each other. Finally, she says, "I am only interested in copying. How well do you know *Monsieur* Maître, *Mademoiselle*?"

"Not at all. We just met." I wait a brief moment to give my next words more emphasis. "But he seems very nice and I hope to know him better."

She scowls, but quickly controls her expression, replacing it with a sweet face. "Are you in search of a *beau, ma chère*?"

I am so startled I don't answer. She takes a step closer,

continuing to stare at me. Then, speaking in a whispering voice, she says, "Well, you can have this rich old goat—he's too old for me. But it would be challenging for both of us to entertain the same gentleman, wouldn't it?" She turns on her heels and walks away. Nonplused, I retreat to the drawing room where I stay by Berthe's side the rest of the evening, trying to understand what has just happened.

CHAPTER EIGHTEEN

Spring 1873

LAMAR LETS HIS hand play absently on my hair and down my neck and along the sensuous lavender silk fabric on my shoulders. I sit close to him, lost in the magic of an early April day, and the attention he devotes to me. The air is soft, scented by the blossoms in the flowerbeds the carriage is passing. He leans toward me, whispering endearments in my ear. Overhead, clouds are benign white puffs, like the buds opening on the chestnut trees. The clip-clopping of the horse's hooves on the hard-packed paths of the *Bois de Boulogne* are repeated countless times over by the parade of carriages carrying *haute bourgeoisie* on a Sunday drive. Today, all Paris is celebrating the arrival of spring with its guarantee of fine weather to follow, and I am comfortable to be with Lamar.

"Your dress is very lovely, Emma," he tells me in a low-throated voice, his fingers still caressing the fabric.

I return his smile. "*Monsieur* Worth is very generous," I tell him. "He insists I wear *Maison Worth* dresses when I am in public."

Lamar pauses a moment, then says, "I haven't seen you wear the blue dress I sent you lately." He takes his hand off my shoulder. "It is a *Maison Worth* gown."

I give him a reassuring pat on his arm. "It isn't appropriate for

daytime wear, but I will wear it for you some evening when we are alone if you like."

He doesn't answer right away. Instead, he looks out at the passing carriages, occasionally nodding to men he knows, as if he is showing off the pretty woman sitting next to him and accepting their praise. Then he watches the small boats plying the lake—men at the oars, with their ladies sitting primly on the rear seats. The boats move along in a stately fashion so not to disturb their elegant *chapeaux*. He seems deep in some thought. When he turns back to me, his look has regained its bright demeanor and holds a trace of pique. "It is usual for a gentleman to properly dress the lady he is courting," he tells me in a gentle voice.

"Perhaps you are fortunate, Lamar—I save you money." I give him a teasing grin that does not go well.

"I don't see your American humor." He sits more upright so he can look into my face. "Please be assured I have sufficient finances for all our needs and desires."

I continue smiling and raise my parasol against the sun when the carriage emerges from an overarching grove of elms. This is not the first time we've had this conversation, and I don't want to argue. "Don't be upset with me, Lamar. I am...we are fortunate to have Charles Worth providing my wardrobe."

"Well, then at least you should allow me to provide you with an apartment for our lovemaking so it doesn't always have to take place in my Brougham. That isn't proper. I don't want it to appear as if I am not taking proper care of you."

"It would be wonderful to have a better place," I concede, laughing lightly. "The back of your carriage is rather uncomfortable for me."

"We need another place. Your flat in *Montmartre* is unacceptable."

"And your apartment? You think I like making love on the seat of your carriage? It seems to me you have the solution."

"I've told you before, it would be inappropriate to have you there while my mother lives with me. It would be so much easier if you allowed me to provide you a suite of nearby rooms."

"Easier for you perhaps! We've had this conversation before—too many times. I will not have a man control me like that. You are very dear to me, but I would chance losing you rather than have you own me. I love that we are equals, both independent. I won't have it any other way."

I stop talking to assess his reaction, enjoying the faint scent of roses in the garden we are passing. His face is a blank, with perhaps a dour cast to his eyes. His cheeks have reddened. Still, he holds me steady in his gaze, not smiling, but not frowning either, a look of incomprehension, as if I have spoken in a language he doesn't understand.

I reach out to stroke his cheek with my gloved fingers while I gather my thoughts, taking a deep breath. "My flat feels tawdry and cheap to me when I entertain you there." I pause momentarily to look away from him, admiring the pale yellow primroses on the side of the road as we roll by. "I have a solution that will allow us to have more private time together. I will soon have my own apartment suite on *blvd des Courcelles*, not far from you. You will like it. The main room has expansive windows and a balcony looking out at *Parc Monceau*. It has a dining room, commodious master bedroom, another bedroom, and a servant's room, and a full bathroom with indoor plumbing, and a kitchen."

"So much?" His face shows his surprise. His look is not altogether pleased. Sitting straight on the seat, he withdraws his hand from mine and uses it to adjust his top hat. I have a moment of dread about what is coming next. "You have been

holding out on me," he says. The words escape his mouth, and his look suggests he wishes he could recall them.

I move closer to him, reaching up to keep my straw hat in place as the carriage bounces over rocks in the path, before answering. "Not holding out, *mon cher*," I interrupt. "It was only yesterday I made the decision. I have been waiting for the right time to tell you. I hoped you would be pleased."

"Ah," he says, with sarcasm biting at me, "you have inherited a fortune from a rich American uncle, is that it?"

"I have no rich American uncle!" My tone is icy, clearly expressing my annoyance. "It hurts me that you can say that even in jest. I came to Paris an orphan to study art, and have been living a small life, posing for artists and learning from them. It was my good fortune to meet Charles Frederic Worth who has a need for a young woman who speaks English. He is as concerned as you are about me living alone in *Montmartre*. He offered to rent an apartment for me..."

Lamar's face flushes with anger. "Oh, no, *Mademoiselle*! Do not tell me..."

"No Lamar," I cut him off. "I rent my own apartment on *blvd. des Courcelles. Monsieur* Worth is pleased enough with the job I have done for him with the English-speaking mothers and daughters that he has increased my monthly stipend. I am using it to live closer to you." I pause, trying to suppress my exasperation. "I thought you would be pleased, not angry."

It takes him several minutes to calm down as the carriage makes the loop around the lake and starts back toward *ave des Champs Elysees*. He looks everywhere except at me. I can see he is trying to hide his bruised feelings. "I see," he says, at last, more subdued, turning to me and attempting a smile that works only moderately well. "Good news for all of us then. *Monsieur* Worth

has a favored employee. You escape the dangers of *Place Pigalle*, and I will be able to spend more time with the woman I adore. Is that the way it will be?"

I wait, calming myself, and wondering if he is mocking me, before responding. The carriage turns down a lane in the park lined with towering oaks filtering the sunlight and casting shadows on the lane. He continues to look at me. I feel as if he is trying to pry into my soul and I feel my anger rising. Finally, his face softens. He reaches out to enfold me in his arms. "I am happy for you, for us," he says at last. "I don't want to lose you, Emma. Forgive me if I act as if I am competing for your affections with Charles Frederic Worth."

Hoping the storm has passed, I snuggle into his chest and let my anger fade. But I am alert to his capricious moods.

"I will try not to be a jealous lover," he whispers, then stops talking, as if a new idea has formed in his head. "There are times I want you all to myself. I think I know how we can do that. Come with me to my manor house in *Normandie*. We can spend time there together, alone—walking, making love, taking tea on the terrace, whatever we want to do. It will be wonderful."

"You've never spoken of a home in *Normandie*."

"It has been in my family for many years. I hardly use it. Say you will come with me and I'll make the arrangements to have it opened and readied, with a chef and maid to wait on us. Springtime in *Normandie* is wonderful, *cherie*. The apple trees are in bloom and their fragrance perfumes the air. How soon can you be ready? Say yes."

I kiss his lips lightly, like a fluttering butterfly. Riders in the carriages passing in the other direction smile at us. Some of the women laugh gaily, and the men doff their hats. Spring is the time for love they seem to be saying. "I will be happy to

go with you, Lamar," I whisper. "We can be together with no interruptions, and I will bring my paints along to capture the beauty of springtime in the *Normandie* you describe."

∽

Lamar's manor house, a few miles from Rouen, not far from the banks of the meandering *Seine*, is beyond my imagination. It is a fairytale mansion like the ones papa read about to me. Built before the Revolution, it is an ivy-covered stone building set in a broad field, profuse with wild daffodils, protected by ancient trees and massive purple lilac bushes, and guarded by chirping warblers. To the east, it is flanked by a dense forest, but on the west row upon row of apple trees line up like soldiers. Going from room to room I can smell the house's mustiness, but like an excited child I ignore the fact it has lain empty for so long. I marvel at the magnificence of a delicate, faded, multicolored tapestry in the salon, and a bronze statuette on the marble fireplace mantle, where the accumulated dust of decades rubs off on my fingers.

The first day we walk the grounds and explore the tiny neighboring villages, shopping for our meals at the local markets for the sheer fun of being there together. At night we make love in complete seclusion. The next day Lamar hires a small carriage he drives, and we wend our way lazily over back roads to Rouen. Standing in front of the cathedral enthralled, clutching his hand, and looking up in wonder at the soaring towers and carved stone figures over the main doors, I tell him, "Look how magnificent it is. I must come back with my easel and palette to capture this image. It would be a real challenge for me."

He looks at me indifferently and shrugs. "And what would you have me be doing while you paint?"

That evening, sipping red wine in the oak-beamed salon of the manor, I broach the subject again. "I would really like to paint while I am here, Lamar. It doesn't have to be in Rouen, I can paint out in the orchard, or set up my easel anywhere on the grounds. You can stay here and read or write or anything you like to do at leisure for the morning. In the afternoon we can explore together."

He looks at me with a strange, muted expression I cannot interpret, as if I have again spoken to him in a language he doesn't comprehend. We sit in silence for several minutes. It feels to me as if we are far apart all of a sudden, and I'm unsure why. After what seems a long time to me, he stands and walks to the fireplace mantle where he rests his arm and half turns to face me, like a stern father might. "I was just thinking," he starts, "what I would say if I had a daughter." He runs his fingers over the statuette and looks bleakly at the dust his fingertips collect. "First, I would tell her it is important for any young lady in Paris to develop whatever social skills she can, be it playing piano or singing or painting. In other words, whatever would gain her social recognition and help her to attract a husband. Then I would give her my permission to pursue whatever course she chose. But at the same time, I would caution her that whatever she decided to pursue should not become a career. Perhaps I would urge her to copy the Great Masters, but not make any new paintings if art were her interest. Do you follow what I am saying, Emma?"

For another long minute, I sit silent, my hands folded in my lap, like the dutiful daughter he seems to expect me to be. I don't look directly at him but can't help wonder what he wants our relationship to be. Lover or Great Dane? Mistress or partner? Feeling an empty place inside of me, I stand by the side of my

chair and direct the sweetest smile I can summon in his direction. "My father was not French," I start, realizing as I speak we are at another turning point in our relationship. "He was a poor American man, who could only get a job as a lighthouse keeper—a humble occupation. He died when I was thirteen years old, and I have cried for him every night since. He taught me I could be whatever I set my sights on being, and overcome any obstacle in my path if only I worked at it hard enough." I take a breath. "I did not come to Paris to find a husband. I came as a poor orphan to learn to be the best possible artist I can be to support myself. I take your meaning to be I am free to paint while I am here with you so long as it is no displeasure to you. Tomorrow I will go to the apple orchard to sketch. Please excuse me now because I am going to my room for the night with a slight headache." I leave him standing by the fireplace staring at me and do not look back.

The following morning I go to the orchard with my easel and a canvas to capture the early light and the dew on the leaves of the apple trees. I set up the easel midway between two rows and concentrate on getting the perspective just right, as the trees appear to merge in the distance. It is delicate, tedious work, but the charcoal pencil I sketch with comes alive in my fingers, eagerly welcoming the challenge. In my mind's eye I see myself in solitude on the bluff at Point Conception looking out at the headlands of the rugged California coastline merging into the mist.

"That is a very brilliant thing you have done to capture the complexity of the apple orchard fading into the distance," the voice over my shoulder says around mid-day.

When I look up, I see Lamar scrutinizing my morning's work. "The flowers are so delicate," I tell him, "So hard to get right.

Tomorrow my challenge will be to reproduce in oil what I've sketched." I pause then ask, "How has your morning been, *mon cher?*" I wait for his reaction.

"Well enough, I suppose. I've read my mail and a couple of newspapers that came with it. What do you say we drive into the village for lunch? I'm ready."

"Can you wait just a few more minutes?"

"Ah, but Emma, I am hungry now."

I heave a sigh and try to conceal it. Shrugging, I tell him, "I can be done for now. Tomorrow is another day. Let's go to the village."

The next morning I return to the orchard and begin adding color. The subtle wisps of pale pink against the white of the blossoms are caught in light and shadow by the arching petals. Tiny water beads clinging to them, and the intricate dark fuchsia buds clustered around the main bloom. A bee probes the interior. All come alive when I add color. The work is slow, and by mid-morning, after the post has been hand delivered to Lamar, I am barely begun.

"*Bonjour, ma cherie,*" he greets me, bending to kiss the back of my neck. I am so sorry to bother you, but I must."

"What is it?" Distracted, I look up from the easel and see the serious expression on his face. "Is something wrong? I'd like to keep working, I think it's going well."

"And I would like that for you, *cherie,* but it cannot be. I am sorry. A letter has arrived from Paris," he waves an envelope in his hand, "summoning me to return immediately. We must be ready to leave in an hour. I hope you can finish your painting by then."

Camille Corot is not a young man struggling to win acceptance in the French art world. He is well established, having won a number of honors from the French Academy. He has enough

inherited wealth to finance his art career so he has a large and well-ordered studio. When I arrive to sit for him, we are the only ones there save for an older woman he has hired to act as my *chaperone* and help me dress for the portrait.

"Ever since I saw the way Eugène Boudin captured you at the lighthouse I have been looking forward to painting you, Emma," he tells me after we have exchanged greetings. Immediately, I feel relaxed, at ease, and I look forward with anticipation to the hours it will take him to create the image he envisions.

"I brought along a canvas I started in *Normandie* and finished in my studio not long ago," I tell him. "I would be honored by any comments you might offer me."

"*Très bon*. Bring it over here by the window and I can take a few minutes to look it over while the woman helps you dress."

Corot props the canvas on an easel by the window, pulls up a chair and begins studying it. I follow the woman behind the modesty screen. I'm to dress as a farm girl, she tells me, laying out a long, forest green skirt and white blouse with a wide neckline that slips off one shoulder. Then she goes to work on my hair, parting it down the middle of my head so that it flows around my face onto my shoulders on either side.

When I emerge from behind the screen, Corot looks at me with a paternal smile, and, indeed, I feel as if he might be the benevolent grandfather I never had, but always imagined.

"I can see you have a fine career ahead of you," he tells me, sitting back in the chair, puffing on a pipe. The bright morning light streams through the window, illuminating his well-wrinkled face and tuft of unruly white hair. My heart dances in my chest at his first words. "You have the talent. Your task ahead is to develop and refine it. This is a wonderful interpretation of apples in springtime you have done. You should be proud of it."

Thrilled by his praise, I cautiously ask him, "Do you have any suggestions?"

He withdraws the pipe from his mouth and rests his arm on the windowsill staring out over Paris rooftops for a moment, as if gathering his thoughts about my work. "No. Definitely not. The only thing I would comment on is your technique. You paint in the style of our current crop of young artists—heavier brush strokes, a more hurried approach and thicker applications of paint than I would use. But you are not me. This is your impression of the subject and I would never criticize that. You have all the skills necessary for fine paintings. Over time you may choose to change your style, that's up to you." When he turns back to look directly at me a smile lights his face, showing laughter in his eyes. "You will do well, Emma, I'm sure. Boudin thought so, and I agree. But always protect your work. Sign your name and date each painting. What I'm telling you is important. I've had more of my paintings than I can count copied by unscrupulous forgers." Then, laying his pipe aside, he says. "Are you ready to pose now as a pretty young farm girl? I want you to put your elbow on your knee and your hand to your cheek, like so, and hold this sickle in your other hand. Look straight at me."

The session is comfortable and not too long. Camille Corot knows exactly what he wants to depict and moves quickly ahead. He tells me all background and sky will be filled in at his leisure; he concentrates solely on me.

❧

When I arrive back at the *Maison Worth* apartment, Pauline is all atwitter. "We have an assignment from *Monsieur* Worth," she says breathlessly. "He wants us to deliver a new gown to *Comtesse*

de Coligny and make sure the fitting is perfect. I have packed some traveling clothes for you."

"The *Comtesse* is not here in Paris?" I have a surprised look.

Pauline smiles as if she has played a trick on me. "Perhaps I forgot to tell you, *Comtesse* de Coligny has an estate in the south of France where she wants it delivered. It is very close to *Montpellier* so we will have a long train ride there and back. We'll be traveling for several days."

My heart skips a beat. *Montpellier* was Frederic's home.

We board the train early next morning at *Gare de Lyon* for the daylong journey, with a stop in *Lyon* for lunch—as long a journey as it took to go by wagon from Santa Barbara to the lighthouse. Pauline carries the large cardboard box containing the *Comtesse's* gown and I have the overnight valise with our nightdresses and a change of clothes safely in the overhead rack. My mind keeps repeating in my head, I'm going to Frederic's home.

The ride to *Lyon* is magical for me. I don't think I have ever traveled so fast. It's not like my train ride from *Le Havre* to Paris when I was burdened with worry over Lucinda and my own fate. I'm happy to be sitting next to Pauline as we fly along at the impressive rate of almost 100 kilometers an hour. The sound of the train clicking over the rails keeps repeating Frederic, Frederic, Frederic over and over in my head. The landscape unfolds out the window—a series of rolling hills and valleys where sheep and pure white cattle graze contentedly on the flatland near old farmhouses, and storybook villages with tall church spires perched on hilltops. After lunch in *Lyon*, the land flattens into endless orchards of fruit trees. We get off the train near suppertime in *Montpellier*.

The following morning, Pauline and I go by coach to the *Comtesse* de Coligny's estate in *Castelnau-le-Lez*. It is a minor castle with towers and crenulated walls perched on a rise

overlooking *Le Lez* in a small commune across the narrow river from *Montpellier*. The *Comtesse* is a dowager kind of woman with a beak-like nose and steel hair, but pleasant enough. No *Comte* is in sight. She wastes no time confirming that *Monsieur* Worth's measurements have been perfect and shoos us back to the city. As we climb into the carriage, I turn to Pauline. "I want to see where Frederic Bazille, the artist I've told you about, grew up. I want to meet his mother and father."

Pauline shrugs, "Why not? We can't get a train back to Paris until tomorrow morning. We have all day to spend here."

The Bazilles are a well-known *haute bourgeois* family in *Montpellier*, so it is easy to get directions to *Méric*, their estate. As it happens, it's near the center of the town. I am very nervous getting down from the carriage, thinking his mother and father will be offended by my arriving unannounced. They probably don't even know my name because he never bothered to tell them about me, I tell myself. I want to turn around and get back in the carriage without meeting them, but I'm propelled forward by my curiosity about what they know of their son's paintings. I grip Pauline's hand for support.

We are ushered by a servant to a wide veranda that looks back over the river toward *Comtesse* de Coligny's estate. Gaston and Camille Bazille are warm and welcoming when they greet us, just as I would expect of Frederic's parents. Camille is a gracious woman, plain and round of face, but with a full, welcoming smile. Her dark hair is parted and combed back without drama. Gaston's temples, sideburns and beard are salt and pepper gray. He is a stern-faced older gentleman with a high forehead and probing eyes, but they light up his face as he says, "At last," with great enthusiasm, "We get to meet the young woman our Frederic talked so much about."

I'm startled. Speechless.

Sensing my embarrassment, Camille tries to explain. "In his letters, Frederic always told us you were his favorite model." She pauses and smiles in a motherly way. "He never showed us a picture of you, but the way he described you I knew instantly when I saw you standing here who you were. Gaston and I wondered if there might have been a romance between the two of you. But then..."

"...I was much in love with your son." I tell her, struggling to get the words out, without tears. After a silence that seems awkward, with Camille and Gaston respecting my feelings, I introduce Pauline. "This is *Madame* Allard. We came to *Montpellier* to deliver a ball gown to one of your neighbors. I hope I have not interrupted any of your plans. ...I wanted to come to pay my respects."

"We are pleased to welcome you. Please stay to enjoy lunch with us here on our veranda. This was one of Frederic's favorite locations to paint. He did our family portrait here. Did you see it on the wall as you entered?"

It was as if the Bazilles had known me forever and were welcoming me back after a long absence. They seemed eager to hear about my life in Paris. Pauline told them about the work we do at *Maison Worth*, and I prattled on about the other artists I sit for, and my own art, relieved that they seemed interested. I feel like I was doing all the talking, but they listened eagerly.

As the luncheon comes to an end, I gather my courage. "Frederic was a magnificent artist. It broke my heart to lose him for so many reasons," I tell them. "He was so gentle and kind with me. When all of his paintings disappeared after..." I stop to gain control my feelings. "Did he leave any of his paintings here with you?"

"*Désolé*," They say almost in unison. "We have none of Frederic's work here except the family group portrait he did back in '67. We plan to leave it to *Musée Fabre* in *Montpellier* when we are gone. Frederic's friend, Renoir, was here soon after the war to pay his respects. He didn't know where his art disappeared to either."

"I know Renoir came. He was a great friend of your son. And Lamar Legrand mentioned he came to see you, too," I said.

Camille and Gaston look at each other for a moment, exchanging questioning looks. "No," Gaston says slowly, still looking at his wife for confirmation. "I don't think we ever met this Lamar Legrand you speak of. Certainly, we would remember if he ever came to our ranch."

As we rise from the table and say our *adieux*, Gaston orders one of their servants to ready a carriage for us. "No need for that," I told him. "We are so close we will enjoy the walk on this beautiful day. Our train doesn't leave for Paris until early tomorrow."

"If you have time this afternoon, you both might want to visit *Musée Fabre*. It's nearby. They are interested in having some of Frederic's art, too."

The *Musée* is larger, and its collections more varied, than we expected. The plaque on the wall in the interior courtyard where we enter tells us Francois-Xavier Fabre, a local artist, started the *musée* in 1825. Inside Pauline and I are both impressed by the quality of the paintings the museum has acquired, not only French but also art from other European countries. Wandering the galleries, I stop to admire a painting by an earlier artist I know, but have never seen this particular painting before. Pauline seems less interested but follows me from room to room. She stops abruptly in one room while I am studying a Delacroix

267

painting, and taps me on the shoulder. "Look here, on the other wall," she says.

When I turn the shock that greets me is staggering. My head reels. I have to grab onto Pauline's shoulder to keep from fainting. I am staring at myself in the painting, sitting on a wall with a valley landscape behind me, wearing the white dress with pink stripes Frederic had picked out for me.

"How can this be?" The words barely come out. I am almost speechless. I look at Pauline, but her face is as blank as mine. "I thought that was you," she says.

"It is. I posed in his studio, and he said he would fill in the background the next time he came to visit his parents, but where did it come from? Frederic's parents said they had not given any of his paintings to the *musée*."

"Well, you had better prepare yourself for another shock, Emma. There is another of Bazille's paintings next to it."

The pain that grips me when I turn my head and see the canvas she is pointing at feels like a knife stabbing into my heart. A dark-haired young woman lies naked on a carpet. Frederic's scrawled signature is clear along the base. It takes Pauline only a moment to study it and then look at me.

"You?"

Staring at the canvas my heart races. The memories flood back in my head. I am once again in Frederic's studio lying naked on that same carpet with only a gossamer shawl draped over me. I feel the same thrill I felt the day he painted me. I am mesmerized and continue to stare for a long time, long enough that Pauline has to gently put her hand on my shoulder and inquire softly if something is wrong. I mumble "I'm fine," and we eventually move on. But there is something I cannot put my finger on about the painting that troubles me, something that isn't right.

CHAPTER NINETEEN

Fall 1873

A FEW WEEKS after returning from *Montpellier*, a note comes from Auguste Renoir asking if I could be available in a few days to sit for a painting he is working on. Enthusiastically, I respond, *"Oui!"*

He takes me out of Paris one afternoon to the *Oise River*, a small tributary meandering slowly toward the *Seine*, dressed in a frilly white organdy dress and straw hat garnished with a bouquet of multicolored flowers. I pose on the bank, sitting with my legs curled up under me, looking down at a book in my lap.

"You are a fine model," he tells me, making quick, slashing brush strokes on the canvas, as if in a hurry to be done.

I thank him, but add with a heavy sigh "I didn't come to France to be an artist's model, you know? I came to make my own art—make my living at it."

"To make your living, you say? Are you successful at that then?" He smirks behind the easel.

"Not at all! Between my work at *Maison Worth* and sittings for artists and art schools I have little time left over to paint."

"And going to *soirées* and dinners with the likes of Lamar Legrand, too," he interrupts, a teasing smile barely showing.

"Oui, I suppose," I answer reluctantly, looking up at him. "Is

there any harm in that?"

"No harm," he says. "No harm at all. But I think that might be difficult for you." He says it looking up from the easel to make eye contact with me, holding his brush away from the canvas in mid-stroke.

"But I would still like to earn a living with my paintings."

"I see you are serious, Emma, so I don't intend any ridicule. But I think art must be a passion for someone to learn the necessary skills." He adjusts his boater to shade his face before continuing. "And then it still can take many years before you can support yourself—it's not something you can do only when you have the time. Speaking only for myself, I have spent all my adult life learning."

His words cut me. I can't respond.

"Please don't move," he says when he sees my reaction. Softening his voice and his facial expression, he continues, "None of the artists I know are earning enough money selling their art, and I only earn a little more now and then. Our friend Bazille came from a *haute bourgeois* southern family so he could indulge his passion, but in the long run, he gave up his father's request that he study to become a doctor so he could commit to painting full time."

The mention of his name gives me a chill and a recollection of *Musée Fabre,* but all I say is, "He was a talented painter."

"He was a genius, a natural! His death was a loss to art and all of France." Renoir starts to paint again but again stops. "I've given a lot of thought to how I might improve my finances. So far the only way I know takes time and as much patience as I can find in myself. I'm hoping *Madame* Charpentier will commission me to do a portrait—"

"But you aren't a portrait painter," I break in.

"But I can be. If it puts food on my table. She invites me to her *soirée*," he continues, "so I can meet her *haute bourgeois* friends who will see a portrait she commissioned hanging on the wall and perhaps approach me. Building a reputation is slow work. I wonder if you have the patience for it?"

I'm confounded. I have no ready answer for him, holding my pose, staying unmoving on the ground, while searching for an honest answer. "I have other responsibilities," I tell him weakly.

"Please straighten the ribbon around your neck," He tells me, ignoring my excuse. "It is a lovely contrast to your dress and sets off your dark hair and face perfectly."

I interrupt my pose to sit up straight again and look directly at him. "I do understand what you are telling me, Renoir, but I must try, mustn't I? To become what I have always wanted to be? Am I to be punished for having good fortune come my way?"

Setting the brush aside, he runs his fingers through his beard while he considers my question. After several seconds of contemplation, he answers, "I don't know what to tell you, Emma. I've never thought about your question. I believe only you can answer it. I have always been poor so my expectations are not so high. My road has always been narrow and straight ahead. You are at a fork in your road—only you can decide which way to steer your life." He waits and watches as I absorb his words before going on. "If you really want to test the public's reaction to what you paint you could take several canvases to the auctions at *Hôtel Drouot*—you will not make much—maybe nothing—but you have nothing to lose. Be aware though, the bidders there are a hard bunch, they can be cruel."

⤫

Hôtel Drouot is a large, four-story auction house with cavernous rooms where auctions of all kinds are held. Arriving early, I find the proper room for the art auction and turn my two canvases over to a clerk. He takes down my information without comment and places them along one of the walls, already stacked with the art of others whose work is to be auctioned. One is a maritime painting I made with Boudin at *Trouville*. The other is the apple orchard scene I finished after I returned from *Normandie*.

I find a quiet corner at the back of the auction room to wait while the bidders arrive. They fill up all the seats and stand along the walls and doorways when all the seats are taken. They are mostly men, dressed in dark suits with bowler hats. I don't recognize any of them. Just as the auctioneer is about to start, a gentleman hustles in and takes a position along the back wall near me. I recognize him as Lucien Maître, the gentleman I met at the Charpentier *soirée*. He nods and tips his hat as he brushes by.

The auctioneer tells the crowd there are well over one hundred pieces of art and sculpture to be disposed of and then hurries to the first item. Most of the art is second rate, only a few pieces sell and those at insultingly low prices. The bidders are looking only for bargains—subject matter seems hardly a consideration but size—to fit the new apartments built along the new boulevards—and color—to match the furnishings—are what attracts bids. I feel a flutter of anticipation when my maritime scene is put on the block and the auctioneer gives a brief description of the oil painting and my name as the artist. Then it's gone. No bids come from the crowd, and there's hardly a murmur of reaction to my work. I fight a feeling of despair but brighten a little when the next piece is put up, and men in the audience shout derisive comments until the auctioneer sets it aside. In fact, that is the

fate of much of the artwork offered for bidding. The number of canvases bid on and hammered down is only a fraction of the work offered. When my apple orchard perspective's turn comes, I'm shocked and disheartened by the insults hurled at it by a couple of men. No one makes a bid.

Crestfallen, I watch the afternoon creep by, too numbed by the experience to leave, hoping some miracle will bring one of my paintings back for a reprieve. I am still standing with my back against the wall as the bidders get up and desert the auction room.

"You mustn't get discouraged, *Mademoiselle*. I thought your work displayed a good level of skill."

I'm startled out of my gloom by the gentle words of Lucien Maître. I look at him and, painful as it is, smile. "No one bid on my paintings," I tell him, whining like a child.

"I think perhaps the reason no one bid is that there are too many other paintings like your seascape for auction. Your work needs to be a bit more unique to attract the interest of these men. Most come often and are very familiar with the market— for some, it's their business. You need to keep working and look for more unusual subjects."

Watching, as Lucien seems to put the best possible face on my disaster, I see the kindness in his face. He smiles all the while he is talking, reaching out to put a soothing hand on my shoulder. I am close to tears of desperation.

"In fact," he continues after watching me for several moments, still with his gentle hand on my shoulder, "I would be pleased to offer you twenty-five *francs* for the apple orchard. It pleases me a great deal, and I would like to own it in my collection."

"I think you pity me."

"No, not at all," he says sincerely. "Oh, no, I believe that is a fair price. Will you accept my offer?"

"You are a collector, *Monsieur* Maître?"

"Art is my passion, but alas, I have no skill. I stick to banking and add to my collection whenever I can. The orchard painting would be a nice addition if you accept."

I brighten. "Come with me to pick up my work. Then you can have the one you like."

"Fine, but not here," he cautions. "If the auctioneer thinks you have made a sale he will want you to pay a commission. Let me escort you to your apartment and we can do the transaction there."

One day in early September, I invite Berthe to join me for lunch on *rue Royale* again, to tell her about my experience at the auction.

"You know, my good friend," Berthe tells me with a chiding grin, "that is not so surprising to me. We have all had experiences like that. I know how painful they can be."

"Lucien Maître, a new friend from the Charpentier *soirée*, was at the auction. He told me in the nicest possible way that my work is boring, that the market is crowded with paintings like mine and I need to be more original."

"*Oui!* We all must find new and exciting ways to present our work. Those who paint pretty landscapes will always be considered mediocre artists. It is the unique, new, modern visions that command the public's attention. I know Lucien, he is a collector and good friend of the group of artists I associate with. His advice is perceptive."

"What am I to paint then, Berthe?"

"I cannot advise you on that, Emma. But remember when we first met I offered my opinion that it was tough for a woman

to become a landscape artist. Courbet and your friends Corot and Boudin are the masters of landscape. They can teach you technique, but you may never have the dramatic eye for landscapes they do."

"Renoir paint portraits in search of buyers," I tell her. "You do too. Is that what you are suggesting?"

"Not so much portraits, but I always have figures in my work, generally women and children. I told you that when we first met. If you want to paint landscapes, you would be better advised to put human figures in them. Go back to the Louvre and find Leonardo da Vinci's brilliant painting, *The Virgin and Child with St Anne*. You can tell the emotion of both women and the Christ child by the expressions he has painted on their faces. A magnificent work. Leonardo placed his subjects in a landscape."

"I will never paint like Leonardo."

"Likely not. But perhaps he can inspire you."

I ponder her words as we continue to talk over lunch.

She gives up her reserve as we come to the end of our meal. Her face brightens as if she has been waiting for just the right moment. Setting her wine glass down and sitting forward in her chair, she reaches across the table to take my hands in hers. "I have some exciting news I want to tell you, Emma. I have a new *beau*."

"How wonderful, Berthe! Tell me who."

"Wonderful for me—you are right. If I wait much longer before marriage, I'll be an old maid! My mother is getting desperate to find me a husband. He is Édouard Manet's brother, Eugéne Manet. I met him at his mother's salon several months ago. I have mentioned him to you before. We continue to see each other at social gatherings. You must come with me to *Madame Manet's* next *soirée* so I can introduce you."

"He is courting you then?"

"Not yet, but I believe it will become serious by next summer. Our mothers have arranged for us to spend time at the beach together on the *Normandie* coast at *Fécamp*. I do so want children, you know," she concludes with a heavy sigh and sits back. "And what about you? Still seeing *Monsieur* Legrand?"

"I am."

"Do you foresee a marriage ahead?"

"Oh, no! I am not interested in marriage, Berthe. He is nice enough, handsome enough—I like him, but I don't love him."

"Perhaps love is not essential if he can provide you with security and children—you do want children, don't you?" She gives me a probing stare. When I am slow to respond, her face darkens. "Be careful, Emma! Very careful. Do not allow yourself to get the reputation of being Legrand's mistress."

Lamar and I sit in silence in his darkened box at the *Comédie-Française* one balmy October evening, watching Sarah Bernhardt perform Racine's play *Phèdre*. I'm entranced by her performance, but Lamar's gaze often wanders around the audience, acknowledging friends with short waves of his hand. During the second intermission—after Sarah-as-Phèdre confesses her love for her stepson and threatens suicide—I take his arm.

"She is wonderful," I tell him with a heavy breath.

"Indeed, she's a fine actress," he answers, "Yes, indeed she is, but, like most of her kind, she's a woman you would not want to be seen with outside the theater."

"Don't you remember the night at the ballet with Frederic, when she introduced herself?"

"I do remember. And glad I was she didn't spend any more time with us that evening."

"I've visited with her since, did you not know that?" I give Lamar a look that questions his opinion. "She is a decent woman as far as I can see. In fact, she's invited me to take a balloon ride with her—I'm excited about that."

"I don't think you should be seen publicly with her. People of our class do not hold her in high regard," he tells me.

"Am I of your class?" I fix him in a neutral stare and challenge him. When he doesn't respond, I purse my lips and stare at him, demanding an answer.

"You still have a lot to learn about Parisian society," he snaps at me finally, giving a disdainful look. "Women of her class are unacceptable, especially actresses."

"And what is her class?"

"Women who don't conform to our standards, I suppose." He shrugs off my query. "Actresses are often mistresses to their theater owners or other wealthy gentlemen. Sarah Bernhardt flaunts her outrageous behavior wherever she goes, she has no modesty. You would do well to avoid becoming too familiar with her."

I try to keep the anger growing in me from showing. "It seems to me," I respond, after pausing to take in a breath, "that many wealthy gentlemen of your class have mistresses, and most are not actresses." I wait and give him a questioning look. "I will not miss the opportunity to ride the balloon with her."

He looks at me passively but doesn't speak. Shortly the curtain rises on Act Three. I lean close to him as the theater darkens, and whisper, with a trace of hostility lingering in my voice, "Perhaps I shall take a carriage back to my apartment alone tonight so there will be no gossip about us."

After sitting silently for several minutes, staring straight ahead, without looking at me, he says, "As you wish."

Sarah Bernhardt is wearing baggy canvas trousers, belted at the waist and tucked into heavy boots as I approach her in the *Tuilleries Garden*. She has a formless heavy jacket to match, but still gives the impression of fragile thinness. Her mahogany-hued hair contrasts against the more dulled blood red of the large hot air balloon behind her.

"*Bonjour,* Emma," she calls out with a laughing voice. "It is a great day. Are you ready to fly with me?"

"Ready as I can be," I say bravely, feeling a slight palpation in my chest. "The highest I've ever been before was the top of our lighthouse in California."

"Well, I've never been that high in a building! And I believe you are a brave young woman, so come along. This is *Monsieur* Godard," she points to an older, bearded man standing by the lines that hold the balloon tethered to the ground. "He will fly our balloon for us today. I only wish Nadar were here to take our picture as we ascend."

The name Nadar rings a faint bell in my head, but I can't remember why.

Godard helps me in my long dress into the wicker basket that will be our platform for the next few hours. Once in, I cling to the rail rather than sitting on one of the chairs set out for us. Sarah gingerly climbs aboard and stands alongside. In a moment two men, at Godard's command, begin easing off on the mooring lines. Slowly, the balloon began its ascent.

"Oh dear! I never..." A mixture of thrill and anxiety invigorates me as the basket rises above the trees, still secured to earth by

the lengthening lines the men on the ground play out.

Standing close to me, and putting her hand on my shoulder, Sarah says, "Paris is ours today, my dear friend. Just look."

With the *Seine* at our backs as we rise, the city slowly reveals itself like an unfolding map. I grip the edge of the basket and feel excitement charging through me.

"I've no words to describe how I feel, Sarah," I tell her. "It's as if I've climbed the highest mountain in the world, but different because we're not standing on firm ground."

"We'll go higher still," she laughs, seeing my expression. "Can you see why I beg *Monsieur* Godard for rides whenever I can? It gives me a new perspective, a new way of looking at things when I'm back on the ground. It puts my life into focus. Come sit down with me now. I'm going to ask *Monsieur* Godard to let go of the ropes so we can fly free through the air."

Laughing, I sit uneasily. "Leave it to you to seek out adventure. Yours is an enviable reputation for that." As I look into her animated face, the color of her eyes seems to morph from gray to blue and golden highlights in her hair sparkle in the sun.

"Some would not say so enviable," she responds, grinning. "People didn't want to know me when I was a shy young girl just learning to act. They didn't pay any attention then, so I learned early that I had to build my own reputation."

"I can't imagine you as a shy girl," I interrupt.

"Oh, yes! It's true. I am the bastard daughter of a Jewish mother, a Dutch courtesan—not an auspicious beginning for a woman making her way in Paris. You might not believe that my mother was a high-level courtesan who had little time for raising a child, but that is the truth. Fortunately, my father—one of her lovers—provided for my schooling. Early on I learned I had to create any success I aspired to by myself."

"I've learned that too," I agree. "Not so much for success, but just to take care of myself. My mother abandoned my father and me when I was five years old. He was a keeper at a remote lighthouse in California with other men. I was alone much of the time, free to explore the untamed and beautiful world I grew up in—nothing like the bustling Paris below us." I stop, looking away from the view and directly at Sarah. "You seem never worried about what others think when you do things other women don't do—like this."

"My life is my life, no one else's. I'm responsible for it and I intend to live it to the fullest. I make no excuses." She pauses for a moment. "But what about you? What plans do you have for your life?"

"To be an artist—a working portrait painter. I need to start getting commissions so I can earn my living."

"Would you like to paint me? If the public knew you had done a portrait of me—perhaps in the theater or sculpting in my studio at home—it might bring you commissions from others."

"Oh yes," my voice is animated. "Yes, absolutely I would, but if I did your portrait I would want to show not only your beauty but also your strong will and independence, your fearlessness. In the theater—perhaps—but not in a costume. I would want to show the real Sarah Bernhardt."

The lazy clouds cast soft shadows over parts of the city as we float past, and the balloon's darker shadow plays against the stone buildings. I stare down at the tiny carriages and tinier people moving about on the streets. At first they make me feel small and insignificant, but when I look at Sarah, I see her as strong and independent. Soon I start to feel that way myself.

"Ah, men!" She exclaims, at last, breaking into our mood. "What would men think of that portrait, seeing me in the kind

of pose you suggest? They think we live for them, am I right?" She points off to the east. "That's *Père Lachaise Cemetery* we're coming over, have you ever been there?" She asks without waiting for my answer. "That's where the government lined the last of the Communard rebels up against a wall and shot them. They fell right into their common grave." Stopping momentarily to watch the cemetery pass under us, she looks at me. "Someday we'll all be there. And what will we have to show for our lives? Not that we followed all the rules men want us to live by, I'm sure." She turns away and calls to Louis Godard, "*Monsieur*, we will have our champagne and *canapés* now."

Popping the champagne cork—which I watch spiraling down toward the earth until it grew too small to see—she fills our glasses. Setting the bottle aside she spreads *pâté de foie gras* on pieces she tears off from a baguette, offering one to me. I continue staring at the earth below as it drifts by, nibbling at the rich texture on the bread crust. My earlier anxiety is gone, replaced by a calming sensation that wraps itself around me like a comforting shawl. The sputtering of the gas heater driving the balloon is the only sound. We glide along for a few minutes, lost in the soundless solitude, approaching the old outer wall of the city. The savory pleasures of *pâte* and champagne give me a feeling of close camaraderie with Sarah. I try to put my own thoughts in perspective, and after a few minutes, I tell her, "When I see all the handsome young men surrounding you in public, I think you must have many *beaux*. Do you ever think about marriage? A family?"

"I am married! Didn't you know?" She exclaims. "I have a son."

"I didn't!" I'm surprised.

"Well, *Cherie*, marriage probably wasn't such a good idea for me." She sets her glass down on the small table between our

chairs. "At the time I thought I was in love with him. Maybe I still am." Her voice trails off, and she seems to be rambling. "I don't see him very often now, but sometimes we are on stage together. We make love when I feel the need, and I take other lovers when I choose. I am very proud of my son who is in his teen years. The men around me are theater fans who cluck at me like barnyard birds."

"Your husband doesn't mind?"

"Why should he? I do not ask him who he sleeps with, why should he ask me? We are not often together these days."

"I don't know if marriage is for me," I interrupt her. "I don't know if I could live by some man's rules," I stop momentarily. She gives me an understanding nod and waits.

"I don't have much experience," I continue, eager to share my thoughts with her and feeling safe in doing so. "Love making is still very confusing to me. When I posed for the artist who died in the war, it was the most beautiful experience I've ever known. But recently, I feel like a carousel horse where someone put a coin in a slot, jumps on, and rides me around until the music stops."

"Sometimes the ride is all there is, my dear," she replies with a grin.

By now the balloon is outside Paris, floating over the verdant countryside, where small farmhouses, with thin tendrils of smoke climbing skyward from their chimneys, and tiny villages materialize and fade as we continue eastward. Sarah offers no response for several minutes, then she calls out to Louis Godard, "We must return now. Can you steer us back to Paris?"

He turns the small engine and the balloon slows and then starts to *pirouette*. She turns again to me. "For women who are without skills or financial security, I believe marriage is the only way to survive. For me that is no longer the situation."

282

She reaches out to stroke my hair. "You and I are independent women," she says in a soft voice. "I believe we need to have our freedom to explore the world, take chances and risks, experience what we are drawn to, and experiment with all possibilities. I suspect you are currently uncertain about your relationship with a man—I understand. I could never surrender my independence to anyone, but each of us makes our own lives. Whatever you decide I hope we can always remain the good and honest friends we are today. I look forward to sitting for my portrait—let's do that soon. But keep in mind not everyone will applaud you for your art or the way you live."

The Manet home on *rue de Clichy* is strikingly different than the Charpentier home. Smaller, older, and more formally elegant, it is as different as the well-established home of *Madame* Manet, the wife of a Legion of Honor judge, and the wife of an entrepreneurial publisher can be. The Manet salon seems steeped in history, with restrained green wallpaper. Antique chairs line the walls, leaving a cavernous open space in the middle.

Berthe spots me standing uncertainly in the entrance hall and comes to my rescue. "*Bonsoir*, Emma," she greets me with a bright smile and sparkle in her dark eyes. "Please let me introduce you to *Madame* Morisot, my mother, and *Madame* Manet, our hostess this evening," she says. "Another fine gown," she comments, looking me over approvingly as we approach the two older women, "a perfect color for you."

I give her a slight bow and a smile.

I glance around the room and spot Lucien Maître in a distant corner. After a respectful time of polite conversation, Berthe leads me away from our hostesses. She stops in front of a middle-

aged gentleman in well-tailored formal attire. A bushy beard balances his high forehead and unruly red-brown hair. His deep-set eyes watch me approach and I feel slightly unsettled by their intensity. Berthe introduces him as Èdouard Manet, Eugéne's older brother.

"Ah, *Mademoiselle*, I have waited too long to meet you," he says, taking my gloved hand and brushing a kiss over it. "Berthe speaks highly and often of you and your art. She encourages me to capture you on canvas so all Paris can enjoy your beauty."

"I am flattered," I stammer, feeling awkward and far from beautiful. I cast a quick glance at Berthe and then look into Manet's compelling face, with its furrowed brow. "You are the most exciting artist in Paris, *Monsieur*," I return the compliment sincerely. "It would be my honor."

"Controversial rather that exciting, I think," he responds, laughing lightly so that his beard seemed to dance around his mouth. "I cannot claim to please the older generation at the *Ecole de Beaux Arts*—I am rejected often by them." He pauses, drawing in a breath that seems to relax the tension in his face. "But we are not here to discuss serious art this evening, are we? Only if you and *Mademoiselle* Morisot would agree to sit together for me—it would make a most remarkable portrait of contemporary beauty."

A younger man approaches us.

"Eugéne, this is my friend *Mademoiselle* Emma Dobbins," Berthe says, looking demurely happy to see him. "We paint together sometimes."

Eugéne Manet is a shorter, slimmer, softer version of his older brother with a lighter colored beard and less intense countenance. He smiles warmly at Berthe, standing at her shoulder, and nods a greeting to me. Some unspoken message seems to travel from his eyes to hers.

"What a portrait this would make," Lucien Maître joins the conversation. "I am pleased to see you all this evening, and especially you, *Mademoiselle* Dobbins. I want to tell you how I continue to enjoy your apple orchard painting—your eye for detail is quite marvelous."

"High praise from such a serious collector," Manet says, looking around the group for agreement. "I must get to know your work better," he adds, "and my offer to have you sit for me is always open if we can work out a suitable time. Now, if you all will excuse me, I must see to my wife. She is entertaining us this evening at the piano."

When he departs, Berthe and Eugéne also fade away to a private *tête-à-tête*, leaving me smiling at Lucien, but unsure what to say.

"You know, I am quite serious about your painting, *Mademoiselle*," he starts. "I hope I did not offend you at the auction house."

"No offense, Sir," I respond. "I was there to gain an education and you were very helpful in that regard."

He laughs heartily. "I've never heard an insult put in such fine language. And to think, French is not your native tongue," he says.

His attempt to soften his response is not lost on me. "This is not going well, is it? Can we start again? Your comment was not an insult, *Monsieur*! No, I would never insult someone who has paid for my art and offered me sound advice." The embarrassment I feel is acute. I have no intention of letting him know he is the only person ever to have paid for my art. "Please accept my apologies. I can tell you are a highly regarded art collector," I tell him. We still stand in the middle of the salon as it fills up with friends and acquaintances of the Manets. "I am so honored you have one of my paintings. I want you to know I have taken

your sound advice. I am concentrating on portrait painting now, using my landscapes only as backgrounds."

"Bravo for you. A good decision, I think. You saw what happens to so many landscapes at the auction."

"Sarah Bernhardt has agreed to sit for me."

Lucien's eyes open wide. "What a coup for you, *Mademoiselle*. Sarah Bernhardt is well known. I believe she will become even more famous in the years to come. Her portrait may someday be most sought after. In the meantime it could secure other commissions for you. I will follow your career with interest, and perhaps add other of your works to my collection."

"I would enjoy seeing your collection." For an instant, I worry I have been too bold, but feel comfortable with him.

He beams. "It would be my pleasure to invite you to dine with me some evening at my townhouse and to show you my paintings. We could get better acquainted. I will send you a note with some suggested dates. But for now I would be pleased if you will accompany me over to the *hors-d'oeuvres* table. I came straight from my office and apparently brought my appetite with me." He chuckles again and offers me his arm as we make our way across the wide room, filling now with knots of music lovers who have come to hear Suzanne Manet play.

"May I call you Emma?" He asks

"That would please me very much."

At a loss for anything interesting to say, as we move toward the *hors-d'oeuvres* table, with the strains of a Chopin nocturne beginning to fill the room, I ask him. "Do I remember you telling me you are a banker, Lucien?"

"You are correct."

"Here in Paris?"

"And other regions of France also."

Looking into his face, I see the sincerity in what he is saying to me in his green eyes with their bluish tint. I'm pleased by his compliments, but I have another feeling, too. One I can't quite describe—it fills me with a kind of joy. He seems such a man of great honesty, gentle, almost humble in nature. "Do you visit art galleries when you travel to other parts of France?"

"I do. All over Europe, sometimes. I talk with any artists or dealers I know whenever I have the chance."

"I visited *Musée Fabre* when I went to *Montpellier* for *Monsieur* Worth..." I stopped myself from saying anything further.

"A fine art museum," he fills my abrupt pause. "A fine one. I have been there several times."

As we reach the long table spread with a wide assortment of foods, I draw back, realizing I have no idea what I am looking at or what I am going to eat.

As if he is reading my thoughts, or perhaps seeing the dubious look on my face, he asks, "May I select a few tasty *hors-d'oeuvres* for you, Emma?"

With a grateful nod of my head, I watch as he carefully makes a few selections. "I think you will like these," he tells me, offering me the plate.

"I am at a loss, Lucien. Please tell me what you have selected for me."

He beams broadly. "Only the finest of *Madame* Manet's perfect buffet. Your plate has caviar, *gougères*, a small leek tart and baked Brie in a pastry puff."

"It all looks beautiful," I tell him, but an uneasy feeling is beginning to creep over me.

"Here is one more delicacy I want you to try," Lucien says, adding another beautifully prepared item to my plate. I am not sure what it is, but he smiles, "This is a *Madame* Manet

specialty—oyster wrapped in bacon."

I am so surprised by his words I almost drop the plate. In a kind of panic, I turn away from him and hurry over to a small alcove and sit on a chair, setting the plate down beside me, hoping to be alone. Tears I cannot explain come into my eyes. I feel absolutely miserable.

"Oh, Emma, have I offended you? I am so sorry. Tell me what I've done." Lucien moves my plate so he can sit next to me.

"You are so kind to me, and I have acted badly. I am sorry," I sob.

"What is it? Why did you walk away?"

"I am a phony! I am not what you think I am and I don't want to deceive you."

"I think you are a lovely young woman," he says, leaning close to me. "How could you deceive me?"

"I don't belong here. There was never any food like the *hors-d'oeuvres* you put on my plate where I came from. We ate very simple food—that's all we had, all we could afford. My papa was a workingman, we never had money to spend on extras," I'm sobbing now, with tears rolling down my cheeks.

He takes a linen handkerchief from his jacket pocket, handing it to me without a word.

"I can't pretend to be something I'm not," I persist. Before I can resist, he puts his arm around me, gently urging my head against his shoulder.

"I didn't know," he says slowly, looking into my face and brushing away my tears.

I start to get up. "I should leave now."

"Oh, no, please don't." His hand restrains me. "I want you to stay. To me, there is nothing phony about you, Emma. You are the sweet young woman I've recently met who is a fine, budding

artist that I want to know better. Where you've come from is not so important to me. In fact, many of the people listening to Chopin just now have less than savory backgrounds. You have more honesty about you than many of them. Dry your eyes now and let's go sit with the others and listen to Èdouard's wife play."

I managed to pull myself together, shocked that I have broken down in front of him, but relieved he understands. Together we move quietly toward the front of the room where Suzanne Manet is playing the grand piano.

CHAPTER TWENTY

Fall 1873

LEAVING THE MANET townhouse, I decide to have some time alone with my thoughts, so I walk toward *Montmartre*. The street lamps along the boulevards spill puddles of light on the sidewalks, alive with people out enjoying an evening stroll. Men tip their hats as they pass by, but I'm thinking about Lucien Maître and ignore them. He has quite suddenly come into my life, but he puzzles me, and I don't yet know what to think about him. Older than Lamar—kinder, gentler, and more straightforward. It's clear he's taken an interest in me, but for what reasons I don't understand. He likes my art—at least my apple orchard painting—but I can't help but wonder if there is more to the attention he pays me.

The ornate gate of *Parc Monceau* is locked for the night, but I spot a figure—a man—out of the streetlight's glow, sitting on a bench in the darkness. As I walk by I decide he might be familiar, but it's too dark in the shadows where he sits to tell for sure. So I walk on. Ten steps past the bench a voice calls out weakly, "*Mademoiselle* Dobbins?"

Turning to look back, I still can't make out the man's face, but his voice is familiar. After a moment's pause, I ask tentatively, "Martin?"

"Aye, *Mademoiselle*, it's me," he answers. "Long time since I've seen ya."

"It was at your wedding to Grace. You were very drunk."

"I was." He starts to rise but stumbles back down. He looks at me and shrugs, pointing to the bottle on the ground beside him. "*La fée verte*."

"And you still are, I see."

He stares bleary-eyed at me as I step closer, but he doesn't speak. The effects of absinthe are evident in his face—his eyelids droop and his mouth hangs a little slack.

"Why aren't you at home with Grace?" I ask him.

"Had to get out. Not room enough for three."

"Three? Three people?"

"Grace has a baby now," he says. "Didn't you know?" He stops talking and seems to drift off for a few seconds. When he comes back, he says, "I come here to remember the good times we had together in the park. The Carousel. The four of us. Remember?"

I'm stunned by the news of a baby. Guilt for losing contact with Grace overwhelms me. I silently punish myself for drifting apart from her. "When did she have the baby, Martin? Can you remember?"

"Sure, I remember. Couple'a months after the wedding. Why do'ya think I married her?"

"Her baby is more than a year old now?" I shiver at the thought of how long I've been neglecting her. "Boy or girl, Martin?"

He pauses as if looking back into his head to find the information. "Girl," he says slowly. "Yeah, baby girl. Grace is with her all the time when she's not workin'. No time for me." He stops and gropes for the words he wants. "It was you I wanted, you know. Leo got in the way. I remember that day in the park when I saw him kiss you. Too late when he was killed, I couldn't leave Grace with a child."

"Wouldn't have done you any good."

"No?" He puts his head down between his knees and looks up. "You're probably right. Too *haute* for me."

Several men walk by, looking at us to see if anything is wrong. One steps close beside me. "Are you safe, *Mademoiselle*?" He asks. "Do you need any help?"

"No, *merci*," I tell him, "I'm fine." Turning back to Martin, I ask, "When you are drunk do you hit Grace, Martin? Have you hurt her?"

"I don't mean to..." He lets out a little sob and brushes his hand over his face. "When I get... angry..."

"When you've been drinking?" I interrupt.

"I leave the flat." he finishes.

"Why are you here tonight?"

"I come here to remember. Better times. You were my friend. I dream of you."

Ignoring his garbled speech, I ask him. "How long have you been drinking like this?"

"My job was cut."

"Where do you live now, Martin? I want to see Grace and the baby. What's the baby's name?"

He tries to think. "Clarise," he says. "Like Grace's mother. In *Montmartre. Rue Saint-Rustique.*"

"You've got to straighten out, Martin. Stop drinking! Stop hurting Grace or... or else."

"Or else what? I've tried, but she's my wife you know. When she doesn't do as I tell her, or when dinner isn't ready, or when she spends too much time with the baby, I get angry. I can't control it."

292

It takes over an hour to walk from my apartment on *rue Lepic*, up the steep, winding incline past *Moulin de la Galette*, where the windmill blades hang like limp laundry in the still, dry air. Hiking up my skirts to avoid dirtying them, I continue higher on *rue des Saules* and find *rue Saint-Rustique*, a small, rural, all but forgotten, cow path of a street in *Montmartre*. It's barely more than a cobblestone lane between buildings that lean over the center from both sides. Sunlight barely reaches the sidewalk for only a couple of hours each afternoon. Gutters run day and night, fed by the slops tossed from windows. The stench of human wastes and garbage is compressed and magnified by the street's narrowness.

The neighborhood is silent. The smell is oppressive, pinching my nose and attacking my eyes. The boldness of the rats, thin, mean beasts, hunting food scraps in the gutters, startles me when one runs under my skirt. I search for the street number Martin has given me. Finally standing in front of the soot-stained, four-story building where they live with their new baby, I catch my breath, shuddering at the prospect of what's to come.

Hiking up my skirt again and counting the chipped and grooved wooden steps—fifty-four in all—I climb to the third floor where there are only two apartments. Unsure, which one belongs to Grace and Martin, I simply stand and listen for a moment. Soon I hear a crying infant. When I get close to the door and tap gently I can hear Grace's voice inside, soothing the child, and calling out, "*Atends un peu,*" in a weary and desperate voice. When she finally opens it, she freezes and then stares blankly at me.

"*Glorie à Dieu,*" she says, balancing the crying little girl on her hip, and still staring. "Whatever brings you here?" She steps back, trying with her free hand to run her fingers through her

hair and smooth her worn dress over the hip the child clings to. "*Bonjour*, Emma." Her voice has a chilled tone, and she covers her mouth with her free hand to cough.

"I've been away too long, Grace. I'm sorry." Tears of remorse are rolling down my cheeks as I look at her and feel the coldness in her voice. Tentatively, I reach out a hand to her.

"I thought I'd never see you again; thought you'd abandoned me now you're so *haute bourgeois*."

"I'm sorry...so sorry. I've neglected you, Grace. I never meant to..."

Her face softens slowly at my words. Stepping forward, she gives me an awkward hug, still holding on to the infant. Neither of us feels quite comfortable in the embrace. We each cry our own tears.

"You're the only real friend I have in Paris," I tell her, beginning to sob, "and I deserted you."

"You did..." She heaves a sigh and finally says, "Come in. It's not much of a flat." She looks around. "I'll find a place for you to sit. I think I have enough tea to brew a pot."

"Is Martin here?" I ask her.

She offers me a sardonic look. "He's never here during the day."

"Did he tell you I saw him last evening?"

She hesitates, and sets the child down on a blanket on the floor, going to put a teakettle on the woodstove. The little girl crawls alongside me dragging the blanket. Over her shoulder, in a small voice, Grace says, "Martin didn't come home last night."

I bend down to scoop the girl up in my arms and rewrap her in the blanket. "How old is your daughter, Grace?"

"Clarise," she says, a trace of worry coming into her voice. "Over a year now. She hasn't been well lately."

"And you, Grace?"

"You mean the cough? It's nothing."

I give my friend a quick look. Then I study the little girl. She is slight and frail, listless. The blanket I wrapped around her shoulders looks as if a rat has chewed holes in it. "You've named her for your mother. How nice."

"*Oui, maman* died during the winter. I take care of papa when I can go to him after work some days," Grace says. She carries two teacups to a leather couch, showing holes similar to the baby's blanket, and sets them on a makeshift table. I can't escape the knifepoint of guilt stabbing me again.

"Put her down and come sit with me. We won't have much time to talk while she's quiet," Grace cautions me, but I continue hugging the child.

The horror of her situation slowly grows more obvious as we sit together. Her fine brown hair is tangled and dirty. Her eyes are sunken and red-rimmed. Her cheeks pale and flat. But most alarming to me are the condition of her clothes and the red bruises on her face and arms. "Has Martin hit you?" I ask her, fearing the answer.

Her tears flow. At first, she just stares wordlessly at me as they roll down her round cheeks. Then she collapses into the couch, sobbing and moaning, unable to maintain her reserve. I set the baby down and hold Grace in my arms for a long time. Anger and sadness and guilt over come me, swirling around in my head, but I keep silent, letting her empty her wretchedness on my shoulder.

"What has happened to me?" She says when all her misery has spilled out. Sitting up, she tries to recompose herself.

"I've seen your bruises before—even before you were married—but I never guessed he was beating you. How could I? It's so terrible! I've never known a man to do that. Oh, my poor, sweet Grace, I am so terribly sorry."

Clarise manages to crawl off the couch and thuds on the hard floor. Grace watches as I hurry to collect the little girl in my arms again. "It's all gone bad," she moans. "I knew he was drinking before the wedding, but he seemed to control it until he lost his job. Maybe that was because of his drinking, but he keeps saying there is little work for stonecutters these days."

Thinking that all the rebuilding still going on in Paris should require a lot of stonecutters, I don't interrupt.

"We lived with papa and *maman* for a while," she goes on, "but Martin insisted we needed our own home with a baby on the way. This is all we could afford."

"Were you with child at the wedding?"

"Did it show...? What does it matter now?"

"Martin was beating you even before the wedding, wasn't he? I saw bruises on your arms before Leo died, but I never realized they were from him."

"They were, but what was I to do? I loved him. I thought a baby would change him."

"Did your mother know?"

"I think so, but she never brought it up. I was too embarrassed to tell her. Papa would have killed Martin."

"Perhaps he should have. Do you have enough food for Clarise?"

As if on the sound of her name, the baby begins to cry.

"Sometimes. I work at the laundry when I can. My neighbor watches Clarise most days. I wouldn't be here now except she's sick."

"And when you have to be here to care for her there's no money for milk or food, is there?"

She doesn't answer. She tries to soothe her child, but then her own sobbing starts once again. Putting her head in her hands she

moans, "I don't know what to do."

Looking away from Grace and the baby for a moment, and glancing around the tiny apartment, I'm horrified by the condition they are living in. A rat scampers along the wall near the stove. Startled, I shout and throw my shoe at it. Turning back to Grace I put my hand on her shoulder. "I want you to gather up your things right now and come live with me. We'll get food for the baby."

Grace seems jolted back to reality. "Oh, no. No, I can't," she says.

"Why not?"

"I can't leave him. He's my husband."

"Look around, Grace!" I feel my anger rising in my voice again. This time I don't even try to hide it. "Look at yourself! What has Martin done to you?"

"He's my husband," she sobs again, desperately trying to wipe the tears away while the baby wiggles in her arms trying to find her breast. She pushes her off, "I can't leave him. You still don't understand."

"You can leave him!" I explode. I stand up from the couch and stare down at mother and child. Clarise has started to cry hoarsely and flail her little fists about. "You can!" I cry out in frustration. "You can live with me. We can be together like we were at the beginning when you rescued me. You would be safe."

"So now you would rescue me? You don't owe me, Emma."

"Of course I don't. We're sisters. But why can't you leave Martin? He doesn't work, he drinks, he beats you! Why do you stay?"

She dries her eyes and runs her hands through her matted hair, trying to pull herself together. "It is a little late for you to act like my sister, Emma—how long has it been since the wedding? Where have you been? You were too busy having a fine life. I made a

mistake and now I have to live with it. Martin and I are married—the church—I can't walk away. If I did, where would I go?"

"To live with me," I interrupt her.

"Perhaps for now, but what then? What would I do when you want to marry and have a family? Where would Clarise and I go? This is the life I've made for myself. What God intended. Remember when I told you Martin was as good a man as I was likely to find? We're workingclass folks remember? We have to accept what we get... the men all drink... women learn to survive."

"That's crazy! You deserve better! Staying here is putting your baby in jeopardy."

"I know..." her voice shrinks almost to a whisper. "I'll take care of her. I'll work more to get her more food. We'll be fine. Martin will find a job and we'll get back on our feet." Her last words are spoken with a deep sob of desperation. "I still love him, Emma, I made a mistake, but I do. Please understand."

"I think you are dreaming, Grace." I am wiped out. I can't think of anything I can say to change her mind. "Let me give you some *francs* to buy food for Clarise," I tell her at last, desperate to help my friend.

"No, I'll earn the money myself. I won't take your charity." She stops talking. Then her tears gush again. "I have no money for milk."

After thinking for a moment, I tell her, "All right, I won't offer you charity. What if I pay you a fee if you let me paint you and your daughter together? Please say you will."

Grace hesitates, pursing her lips, "Where would you paint us?"

"Right here in your home."

"Oh no, I wouldn't want that. People would see."

"I want people to see, Grace! I want to help you. If you won't come live with me, and you want to stay with Martin, that's your

life, so this is where we should do the portrait."

Grace gives me a scorned look, but a kind of smile soon replaces it, spreading across her troubled face as she thinks about the offer. As she starts to speak, Clarise begins to cry again, a weak, wheezing rasp. "I must tend to her," she says, then adds, "I can't think what kind of painting you want to make of us, but I guess I have no pride left, so I'll let you. I need the *francs*. Clarise needs food. At least we can be together again while you paint, and I can pretend it's like the early days when we dreamed together about what our futures would be."

The following morning, while dressing at the Worth showroom and replaying my visit to Grace in my mind, searching for what I might have said differently, Pauline Allard knocks on the bedroom door. "A message came for you yesterday while you were away, *Mademoiselle*."

She stands watching me read the note with genuine concern. "You have not seen the gentleman in some time," she says matter-of-factly.

"He asks to see me now."

"Will you?"

"I suppose I will. Send him a reply and say I would be happy to see him this afternoon."

Several hours later, another stone-faced carriage driver barely acknowledges me as he escorts me to the Legrand Brougham waiting on *blvd de Courcelles*. Sitting on the edge of his seat, Lamar looks impatient when I approach. He thrusts open the door before I have even crossed the sidewalk.

"I am so happy to see you again, *cherie*." He takes my hand and guides me up the step into the carriage. Still holding it, he pulls

me close beside him so he can put his arm around my shoulder and kiss my cheek. "It's been far too long."

I offer little resistance but sit farther away from him than he wants, causing him to retract his arm. "It's been a while since we were together, Lamar. You must have been very busy without me."

He gives me a doubtful look but doesn't ask if I've missed him. Instead, he taps on the carriage roof, signaling the driver to drive on. "I've been in the South again on business," he says blankly.

"To *Montpellier*?"

"Yes, and *Marseilles* and *Toulouse*, too. Why do you ask?"

"No reason. Where are we going?"

"I thought we could take a ride along the river out toward *Asnieres*. There is a quiet riverside *café* there where we might stop for a glass of wine and watch the boaters."

"That sounds pleasant." My response is cautious, less-than-enthusiastic.

"Is there something amiss?" He asks as the carriage picks up the pace, heading north toward the bridge over the *Seine*.

"No, nothing." I hesitate. "It's been quite a while since we went to the theater is all."

"Too long," he responds with a grin, sliding closer to me, trying to put his arm around me again.

"I don't remember that evening ending so well," I remind him.

"Really? I guess it's slipped my mind." He leans over and kisses my cheek, trying to turn my lips toward him. When I do, they are cold and dispassionate. Without another word, he slides back to his original seat on the cushion. We ride on in silence, I'm wedged in the corner and he is sulking on his side.

The *café* is actually a floating platform secured to the riverbank, with open sides and a thatched roof. We take a table

in a corner at the far end where the river flows by, making low gurgling sounds. Lamar orders champagne for both of us, and we stay quiet until a waiter brings the bottle and glasses.

"How was your business in the south?" I ask.

"It went very well, I think. I was busy most of the time."

"What is it you do, Lamar?"

"Oh," He gives me a surprised look. "Nothing that would interest you."

"Tell me. I want to be interested in what you do."

"Well, I visit my accounts and try to make sure they are pleased with the service I provide them. To us," he says, raising his glass to clink with mine, and trying to end the conversation.

"Did you visit the Bazilles in *Montpellier* again?"

"Oh, well, I stopped by. I didn't have as much time this trip. It was a very short visit."

"To honesty," I toast, raising my glass and touching his.

"What should I take that to mean?" He sets his glass down hard on the table and freezes me with his stare.

"Take it as you wish. When we first knew each other I told you I insisted on honesty between us—do you remember? You have not been so good at that."

"And when have I failed to be honest?"

I can hear the hackles rising in his voice, but I laugh nevertheless. "How many times do you mean? The first time was about the blue dinner gown."

"Ah, yes, and I apologized for that. And since?"

"Many more times, Lamar," I laugh sardonically. "I think you have trouble telling me the truth. Perhaps you don't remember your lies. In *Normandie* you ended our stay telling me you had been called back to Paris for business, but you just wanted to end my painting in the orchard and have me pay attention to you, isn't

that right? Sometimes you're not dishonest, you just avoid telling me the complete truth. But that is all behind us now."

He is silent, looking down at his champagne glass, twirling it around so that the bubbles hurry to the surface. On the river two sailboats play hide and seek. The air smells of a beautiful, warm afternoon.

"I think you have lied to me about your visits to the Bazilles, and about your mother living with you, too." I tell him after a pause. "I've never heard you mention your mother except when I ask about going to your apartment. In fact, not once in all the times we've been together. That makes me wonder why our lovemaking is always in your carriage. Perhaps you were keeping something from me. Something you didn't want me to see."

He slams his champagne glass down again, this time so hard most of the champagne flies out of it, splashing on the table and the front of his waistcoat. He sits back in his chair and takes several breaths. "I should have known from the start you would be impossible to handle. You don't understand how relations between men and women are here. There are unwritten rules, but you don't follow them and that confuses me."

"Do you have a mistress in your apartment, Lamar?"

"Enough!" he barks. "That is enough! I can see there is no future for us." He smiles for the first time since he picked me up at the apartment, a kind of sinister smile. "I've been looking for a way to let you down easily, but you have made that unnecessary, Emma."

I interrupt him with the full force of my anger. "Is that what you were doing on the carriage ride over here—letting me down easy? I think perhaps you were hoping for one final gratification. You are a cad! Worse! I will not believe that you were ever a close friend of Fredric's. I think you used that to seduce me—another

dishonesty. We have no possible future, you're right. Please be gentleman enough now to have your man drive me back to my apartment." I start to get up.

He gets to his feet and silently accompanies me out to the carriage, giving instructions to the driver. Then, coming close, virtually pinning me against the side, he says in a deep, raspy voice filled with threat, "Listen very carefully to me. Do not ever speak of our relationship to anyone or I will ruin your life in Paris. Believe my honesty now when I say I can do that to you whenever I want. You would not be accepted in our society ever again."

I return his stare for an instant, processing his threat. Then dismissing it with a toss of my head, I climb into the carriage. "Just try, Lamar," I call down to him. "I don't believe you're serious. I'm not one of your simpering French *mademoiselles*. Don't try me!"

"Your lady's maid tells me you are an artist, Miss Dobbins," an English girl says one afternoon after she has committed her mother to buy two gowns she wants to wear to London balls.

Laughing, I reply, "*Madame* Allard is not really my lady's maid, *Mademoiselle*, she is my assistant. But yes, I do paint and study art." I give the auburn-haired girl my best smile, adding, "I would gladly have you sit for a portrait in one of your new gowns if you will be in Paris awhile longer after its finished. You do look quite special in it."

"And do you recommend my mother buy me a corset to wear the evening of the ball?"

I hesitate, studying the girl and consider my response carefully before answering. "You appear to have a very slim

waist, *Mademoiselle*. I don't see any advantage for you in wearing a corset."

"I should not like to wear one, ever so much," the English girl agrees. She looks at me for a moment, and then asks, "Do you?"

"I do not. It is a personal choice."

"Quite so. Then, no corset it is." The English girl beams. "It would indeed be a pleasure if you were to paint a fine picture of me in my new ball gown. I shall ask mummy if it is possible." The girl stops, perhaps picturing herself in the shimmering silk gown, and then, with a teasing gleam in her eyes asks, "Are you what my father would call a bohemian then? I should think he would be dreadfully impressed if he knew a bohemian artist had done my portrait."

I think for a moment then answer, "No, I think *Monsieur* Worth might be troubled if he thought I was a bohemian. Definitely not as long as I have a regular job here."

After the girl leaves, I share the conversation with Pauline Allard and we both enjoy a laugh.

"She was a hard one to please—a lass who knows her own mind, I'd say," Pauline says. "You did a fine job with her. You have a lot of patience with these spoiled girls." She reaches for a slip of paper on the corner of the desk and hands it to me. "A message came while you were fitting her—from *Monsieur* Worth himself. He wants to see you whenever you're available."

"For what reason, did he say?" I fret for a moment before making up my mind. "I'm going back to *rue Lepic* now," I tell her. "I have two half-finished portraits I must work on... And I need to be close to a friend as much as I can. With all the young girls *Monsieur* Worth keeps sending me I'm not spending nearly enough time in my flat. I never guessed we would have so many. I'll see him tomorrow." Giving Pauline a quick *bisous* and a hug,

I hurry out the door before she can stop me with questions.

The next morning, after a night of soul searching, I present myself at Charles Worth's office. In the large workroom outside, the organized chaos I had witnessed on my first occasion has already begun. At least a half-dozen women of all ages, in white smocks, hover over long worktables measuring and cutting fabric and fastening it to shapely mannequins with hourglass figures standing behind them like patient virgins. Other women sew and iron dress components, perspiring from the steam of the irons, wiping it from the foreheads to keep it from dripping on the fabrics. Still, others press and fold completed ensembles. But this is no *tableau*—the room is in constant motion. Women chirp and chatter to one another as they attend their work.

"Do come in, *Mademoiselle* Dobbins." Charles Frederic Worth beckons to me from behind his desk. His office has windows on all sides so he can watch the activity, and dash off to any part of the workroom to correct any deviation in the procedure he sees. "Thank you for coming," he says, retaking his seat and motioning me into a chair across the desk from him.

He looks at me for several moments without speaking. I wait, my eyes firmly fixed on the little man across the desk, feeling nervous and thinking how hard the next few minutes will be. Looking at his outlandish dress, topped by a purple beret, brings a smile, but I suppress it to keep tight control of the emotions I'm feeling.

"I asked for you to come see me because I want to compliment you, *Mademoiselle* Dobbins," he begins, leaning forward in his chair and putting both hands on his desk. "Well done, *Mademoiselle*! You are doing a fine job with the *jeunes filles* we send you while I fit their mothers. Indeed, the value of the garments they order for their daughters far exceeds our costs for

you and *Madame* Allard's wages and all other expenses. *Madame* Allard tells me you have a fine way with these *belles jeunes*. They speak highly of you to their mothers which is also good for our business."

"*Merci, Monsieur* Worth," I reply, showing him an appreciative smile, but beginning to feel uncomfortable about the direction in which he is steering the conversation. I keep quiet, waiting to see what he will say next.

"I should think some adjustment in your compensation is due you," he continues. "A few more *francs* after each successful fitting seem in order. By the by, perhaps a percentage of the sale would be appropriate. I am so pleased to have you here at *Maison Worth*."

"I am glad of your confidence in me," I say without expression in my voice and a sinking feeling in my stomach. "I have tried to be a good employee." I rise from the chair and take a step toward the door. "Should I go now?" I ask, thinking this is not the time for my conversation.

"No. No. Sit back down, please. I'm not through. I have more to say."

His words are like a weight pulling me down where I don't want to go. Reluctantly I return to the chair.

"I hope you will be pleased that I also have additional work for you. Many of the older women who come to me would benefit from the thoughtful way you handle the young girls. I would like you here every day to assist me so you could go back and forth from the showroom for the older women to the daughters with *Madame* Allard. I will definitely increase your compensation."

"Oh, no!" The words escape my mouth. With no way to retrieve them, I hurry to add, "I am quite happy serving the young ones, but do not want more."

Worth is nonplused. He rocks in his chair as if thrust back by the force of my words. For a moment he just stares at me. Then he picks up a pencil and taps it nervously several times on his desk. "Perhaps you didn't understand me," he says finally. "Perhaps you didn't understand that I am promoting you to a new position with me and offering you more compensation."

I feel trapped. "I'm sorry for the way I reacted, *Monsieur*. I do understand your generous offer..." Taking a deep breath, I continue, "...but I cannot accept it." Stopping briefly to be sure he understands what I have just said, I go on, "I came here this morning, *Monsieur* Worth to tell you I can no longer continue working for you."

His face is blank. The pencil continues tapping on the desk once, twice and then stops. "I don't understand. You are leaving me?"

"I have been very happy at *Maison Worth*. You have been very generous with me."

"What then?"

"I want to devote more time to my art."

"You're making your living from your art then?"

"No sir, not yet."

"Unheard of! You would walk away from earning several thousand *francs* a year working at my side for no certainty of any income? I've never heard of such a crazy thing."

His words cut into me deeply. I struggle to accept the reality Charles Worth lays out for me in no uncertain terms. How could I be so stupid? "I'm sorry," is all I can muster.

"Quite so, *Mademoiselle* Dobbins." Anger rises in his voice. "And sorrier you shall be when there is no bread on your plate. What a pity that will be. And I've reason to think your old position here might not be available when you run out of money."

"I know." I gulp another deep breath. "I'm sorry for telling

you in this way. You must think I'm crazy. Maybe I am, but I can't continue. I must do what I am meant to do."

Worth throws his hands up in frustration. "You foolish young woman! I never believed it of you. Why does your generation always think you know best when you are heading for a disaster?" He stops and stares at me again. I can see he is conflicted.

At last, he sighs, and it is like all the air going out of a balloon. "I don't want to lose you, *Mademoiselle* Dobbins. Perhaps we could just keep our arrangement the way it is now."

"I wish we could, sir," I tell him. "I truly wish we could, but I'm afraid if we did I would only disappoint you a second time."

"How so?"

"It isn't just my art, which I really do want to devote more time to, but there is a situation weighing on me."

"Oh? Can I help you?"

I hesitate to say it. Seeing the sincere look of concern on Worth's face, I struggle to find words and can't. Finally, I tell him. "I'd rather not say. It is very personal."

"Are you with child?"

"Oh, no, sir, I am not."

"I see." It's Worth's turn to reflect. He rises from the desk and walks about his office for several minutes. Then he comes to stand behind me and put his hands softly on my shoulders. "A troubling situation, I'm sure," he says with a touch of emotion in his voice. "So I will let you go as you insist. But I want you to know I shall never forget you, *Mademoiselle*. From the first time I saw you in your chiffon gown across the room at the salon, I was captivated by your youthful beauty. On the stairs of your flat you shone like a diamond wrapped in a rag, and I wanted to rescue you from that disreputable place. I was so proud to call you my employee..." He sighs. "But I can see now mine were the

misplaced expectations of a proud father. If you know what you are about I wish you the best. Come back to me if ever you have reason to change your mind."

CHAPTER TWENTY-ONE

Spring 1874

AS QUICKLY AS I can settle into my bohemian life—as the English girl had called it—free to pursue my art without the distractions of a job and dead-end romance, I pack my valise, strap my easel on my back, and head for *Gare Saint-Lazare*.

Arriving in *Trouville*, when *Madame* Crystalle opens her door I throw myself into her arms. "Oh, how I have neglected you, *Madame!*" I sob into her bosom. "I am so sorry. I have missed you so much."

"I am surprised to see you!" She answers in the same familiar voice, but I detect a rebuke in it. "Pleased to see you, I am," she continues, "but surprised. I thought you had abandoned me."

I am crushed by my guilt. "Can you ever forgive me?" I plead, hit by the full impact of how I have neglected her. My heart aches. "Can you? Please? I've been so selfish, so absorbed in my own affairs... So much has happened."

She stares at me for several moments, and her eyes seem to penetrate the depths of my soul. Then her face softens into a reserved smile. "Come in," she says, taking me by the arm and leading me into the parlor. "You must tell me all that has happened."

Feeling the pain of her remark, I'm ashamed. The words in my head scorn me for disrespecting this woman who has been

such a guiding light for me. Still fighting tears, I reach for her hand and pull her into an emotional embrace. "What can I do except beg your forgiveness? You have been such an important person in my life since I came to France, yet I have disrespected you. Can you ever forgive my inconsiderate behavior?"

She takes my face in her wrinkled hands and looks directly into my eyes. "Of course you are forgiven, *ma chère*," she soothes me. "We'll talk no more about it, but I do want you to know I felt hurt."

"The dress you made for me was perfect. You are such a dear woman for making it. I can never thank you enough. Let me tell you about all the compliments I received when I wore it. The actress Sarah Bernhardt said I was the best-dressed woman at the salon. And Charles Frederic Worth liked the dress so much he offered me a position at *Maison Worth*."

Madame is instantly up and heading for the kitchen, her pique replaced by a happier countenance. "We must have tea," she says over her shoulder. "Then we can talk. But first I'll put the kettle on."

With *Limoges* teacups in hand, we settle into chairs in the parlor. Sipping my tea and studying her over the rim, I can see a few more wrinkles, but *Madame's* kind and welcoming face, with lively eyes, seems ageless to me. I feel as if I've always known her, always felt comfortable sharing my secrets with her, and can count on her unflinching honesty. Silently, I vow I will never again take her for granted.

"At times I have seen you are a self-centered young woman," she starts when she has settled into her chair, "but at your age most young women are so deep into themselves they have no thoughts for others. I try to understand, I tried to understand that with my own daughter. Let us not talk about this anymore.

Tell me what you've been doing. Is there a young man in your life now? Is that what has kept you away from me?"

I hesitate. "No, no one. There was, but we don't see each other now."

"Did you leave him? Or was there another woman?"

"I don't know. I could not trust him, so there was no future."

"Men are like that. They think they can say things to please us regardless of the truth. My daughter is naive that way. She believes whatever rich gentlemen say to take advantage of her."

"I don't know if Lamar is rich or not. He's a merchant and acts as if he has family money."

"Lamar?" *Madame* Crystalle closes her eyes a moment. "A familiar name," she says looking back at me. "Would he be from the Legrand family of Lyon?"

"You know him?"

"I know about him. I know his family."

"It doesn't matter, I no longer see him."

"Be glad of that, my dear. I believe he is a scoundrel."

Setting my teacup down on the round mahogany table beside me, I'm shocked by the intensity of her words, I become more attentive but stay silent, waiting to see if she says more.

"Are you surprised, Emma? I've known the Legrand family a long, long time, and I'm firm in what I believe—never trust a Legrand. I was born in Lyon. Their history with my family is a long, but unpleasant one."

"Will you tell me?"

She settles comfortably back in her chair. For a just a moment she closes her eyes again. When she reopens them, I see they have a distant look. "My father was a master silk weaver in Lyon," she begins. "He was very successful, with six looms and apprentices and journeymen in his *atelier*. Lamar's father was a silk merchant

who bought cloth from master weavers, like my father, and sold it to dressmakers. The weavers all made good profits until the 1830s when the silk business turned bad. Americans stopped buying silk, cloth poured into Europe from cheap producers around the world. No one could find a market. "If we had all worked together, my father said we would have survived, but Lamar's father saw an opportunity." *Madame* pauses to take a breath and uses it to tuck a few strands of hair away from her face before continuing.

"He gave my father orders for large rolls of silk that kept our looms humming for days at a time. But when my father delivered the silk, old man Legrand told him the work was of poor quality, that he couldn't sell the cloth so he would not pay for it, but would dispose of it. That happened several times and soon my father couldn't pay his workers. Later we learned *Monsieur* Legrand was doing the same thing to other master weavers, but it was too late for us—my family never recovered."

"How terrible!"

"I had to leave school and work for my father. He could barely put food on our table. *Monsieur* Legrand's father finally bought him out at a meager price. He bought the *ateliers* of other master weavers too. He built a fortune by cheating all of us out of our rightful profits."

"It's hard to believe anyone would be so dishonest."

"It's true, Emma, every word. And I hear the son continues much like his father."

Part of me doesn't want to believe Lamar is like his father, and yet there are enough signs that cause me to question. "But that was his father, do you think Lamar is like that?"

"I've heard from others that he is always looking for a quick way to prosper without doing much work. You are better off free

of him, *chère*. Enough of this! I'll get us more tea."

When she returns, she changes the subject. "You haven't told what you are doing now." Setting the cups down, she seems anxious to move on from her painful memories.

"I worked for *Maison Worth* as a model and sales girl after *Monsieur* Worth complimented me on how well I looked in the dress you created," I tell her, blowing on the tea to cool it. "But now I have left him to devote my time to painting. I've some money saved. *Monsieur* Worth was generous with me, so I have enough to live on for a while. I'm working on portraits of Parisian women—not the ladies of the salons and *soirées*, I have attended—I want to paint the real women of all classes in Paris."

"Who will pay for those paintings?"

"I don't know. I'm not thinking about that yet. I have painted Berthe Morisot, an artist friend, the actress Sarah Bernhardt, and another friend of mine with a baby in *Montmartre*." I stop to study *Madame's* face carefully before venturing, "I have brought my paints and easel with me, and I would like to paint you, *Madame*. You are special to me. I would like to capture you on canvas in oils. Would you?"

"Oh dear," she ponders. "I suppose."

The next morning, I pose her in front of her parlor window. With needle and thread in hand, she has one of Amélie's old gowns from the upstairs *armoire* on her lap, as if she is hemming it. As I sketch her on the canvas, I ask, "How long did you live in Lyon?"

"Not long after father's business failed, although weaving silk for him gave me a love of fine fabric. When I was old enough, I came to Paris to apprentice with a dressmaker. I met my husband there. We married in '48, just before the revolution, and started our family."

"Your husband—was he a Parisian?"

"Oh, no, he came from *Bordeaux*. He was a wine merchant and did very well for a while in the '50s when Louis Napoleon named himself emperor and threw parties and costume balls to pander to the public. Everyone wanted the First Growths of *Bordeaux* then. He helped me start my own fashion *atelier*."

I see her eyes mist a little.

"He died when an omnibus ran him over...it must be ten years ago now, during all the construction. Amélie was just in her teens."

"I've met her once or twice. I've seen her at the *Louvre Museum*."

"I think I told you once before she is a skilled artist."

"Well, yes, I can see that she is. But she tells me all she does now is copy other painters' work rather than creating any of her own. Her talent seems wasted."

"Just like Legrand, she's always looking for an easy way in life without much work." *Madame* says. "She depends more on her beauty than any skill to get what she wants."

Eager to change the subject, I ask her, "Perhaps you would know of a man I just met in Paris, an older gentleman? He is building an art collection and bought one of my paintings."

"His name?"

"Lucien Maître."

"Maître! My goodness, such a wealthy man! Everyone in Paris knows of him. He has a large bank in Paris and other banks in the South of France and Italy."

"*Bonjour*, Emma," Pauline Allard greets me one afternoon in late March, smiling, but huffing for breathe, after climbing up the three flights of stairs. She stomps her feet on the wooden floor outside the flat to shake off the slush of a late winter storm. "Quite

a climb for an old lady," she complains, only half seriously, hugging me, and then smiling brightly. She inspects my dress and hair, as if she still thinks of herself as my lady's maid. Heartbroken our partnership has been dissolved, she comes to visit me regularly.

"So, *chère*, how are you faring here?" She says, throwing off her coat and looking around. "Certainly not the fine life we had before, is it?"

After embracing her and kissing both cheeks, I shrug. "It will do, Pauline. It will do just fine. And you? Are you doing well without me?"

"*C'est assez bon. Le patron* still lets me live in the apartment, but he sent me back to the workroom as soon as you moved out. More generous to me than I expected, but he is very sad that you have left him."

"I know. I'm sad too, but I had to. I hope you know that."

"*Je sais, je sais*! But *Monsieur* Worth will never see it that way. He thinks you are a strong-willed American. I miss working with you, *ma fille*. Here is some mail that has come for you so I brought it along." She hands me a small envelope.

Opening it, a public handbill, like the ones posted on the walls along the streets of *Montmartre*, flutters to the floor. In large, bold letters the word *EXPOSITION* demands attention, like a barker shouting for patrons in front of a circus tent on the boulevard. It announces an art show to be held by a group called *Soieté Anonyme des Artistes, Pentres, Sculpters, Graveurs, ETC.* Puzzled, I take the note accompanying it from the envelope. It is a message from Berthe Morisot.

My friend, it starts, I have joined a group of artists, many who you know, whose work is the new, modern approach in French art, much like the way I paint. Some of the members

are Renoir, Monet, and Degas, etc. There is a total of thirty of
us who will exhibit our work, and I will have twelve paintings
on view. I hope you will come support us.
 Berthe.

Setting the note aside, I pick up the flyer again and study it more closely while Pauline stands patiently by my side, trying to read over my shoulder. "Near the showroom on *blvd des Capucines*. It starts 15 *Avril*," I tell her.

"Will you go?"

"Oh, *oui*, to support my friends."

Standing four stories tall, with the front of the two upper floors almost entirely glass set in iron frames, the building where the *Exposition* is being held is unique. Across the front, between the third and fourth floors, the word NADAR is spelled out in large glass tubing that glows bright red as the twilight deepens. Once the studio of Paris's favorite photographer, Felix Nadar, the building was built to his specifications, including small statuettes of the muses, standing like winged sentries on the corners of the roof.

Standing across the boulevard, looking up at the sign, I have a sudden flash of recognition—Nadar—the name scribbled on the small piece of paper Lucinda gave me in *Le Havre*. Lost almost five years ago and now it's there right in front of my eyes.

Climbing the spiral staircase from the lush entrance foyer to the exhibition on the top floor, I pause in the entrance and glance around the gallery. I see some artists I've met before and many strangers. Berthe is not far off, and we greet each other with hugs and kisses, and then stand side by side, watching men and women moving around among the framed paintings on the walls.

"*Felicitations*, Berthe. This is a fine number of people who have come to your show."

"You think so?" She answers in a doubtful voice that matches the skeptical look on her face. "I think *Monsieur* Degas and the others were hoping for more."

"It's just started," I tell her, trying to be enthusiastic. I try to reassure her by gently putting my hand on her shoulder. "What a grand opportunity for you, *chère*—for all of you—to display your work. Show me your paintings."

She brightens. "I'm the only woman artist whose work is on exhibit..." She stops talking abruptly and looks directly at me. "But your paintings should have been included, too," she quickly adds. "Do you think people will like mine?" As she speaks, she points across the gallery to a painting on the far wall. "This is one of my best, I think." She takes my arm and leads me to it. "I painted it during a family vacation in *Brittany*. My sister posed for me along the waterfront."

The painting takes my breath away, and for an instant, I stare at it speechless. "Magnificent!" I tell her. "You have brought all the elements together—the landscape and the portrait of your sister are in great harmony."

"You know Frederic Bazille was a pioneer in blending portraits and landscapes. I learned from him," she adds.

At the sound of his name, I tighten my grip on her arm. A shiver momentarily interrupts my ebullient mood. But Renoir, charging toward us from across the room, gives me no time to dwell on the fleeting memory.

"*Bonsoir, Mademoiselle* Dobbins," he calls out, still several feet away, "you have no paintings in our exhibition—a pity!—and yet you are one of the most talked about women here." A playful smile, like a *Medrano Circus* clown, lights up his face.

"How so?" I ask him.

"You are in my painting on the riverbank in the next room, and again as Degas's ballerina in another room. If Bazille's work were here, as it should be, I'm sure you would be in even more paintings."

"Is there any of Frederic's art here?"

"It should be," Berthe interrupts. "He was one of us."

"Yes he should," Renoir agrees. "He should be represented, but perhaps we forgot about Frederic when we agreed only living artists in our *Soieté Anonyme*."

For a moment I'm lost to their conversation as my thoughts fly back to the days I spent in Frederic's studio. I feel the sweet pain of those memories dancing before my eyes, especially the image of me on the plush carpet, with him looking down on my nude body. It makes me ache with sexual feelings. I will the image away, and dash quick looks at my companions to see if they have noticed.

"Do you know those two men with their heads together over there in the corner?" Renoir continues, bringing me back to the conversation, as he points across the room. "Without them most of us might have given up long ago."

"Who are they?" Berthe asks.

"I know one," I tell her. "The man in the top hat is Lucien Maître."

"Correct you are," Renoir says, "and the other is Paul Durand-Ruel, the art dealer. You should know them both, Berthe. You too, Emma. They provide a lot of the sales we need to survive."

"Oh but I don't paint for money," Berthe interrupts.

"Wouldn't you like to sell some of your work, like this wonderful painting of your sister? Or will you keep it hidden away in your studio? What a shame that would be! We are here

to make sales, Berthe! Come! Let me introduce you to these gentlemen. You too, Emma."

Unabashed, Renoir charges back across the room with us following. By now the galleries are alive with the hubbub of visitors studying the art on the walls and making loud comments, some of which are not complimentary. I feel detached from the others, wishing Frederic could be here, and I could stand at his side in front of our canvas.

A broad smile spreads across Lucien Maître's face as we approach. He offers me his hand. "*Bonsoir, Mademoiselle* Dobbins. Such a pleasure to see you here this evening," he says. "But alas, I am disappointed there are none of your paintings in the exhibition." He indicates his companion, "This is my close friend and associate Paul Durand-Ruel, a man who is single-handedly working to build the careers of these painters of modern life."

"Certainly not single-handedly, *Mademoiselle* Dobbins, I assure you," Durand-Ruel says, bowing graciously. "Without collectors like *Monsieur* Maître, my gallery would soon languish." Turning to Berthe he says. "*Monsieur* Maître has pointed out your work, *Madmoiselle* Morisot, I am most pleased to meet you."

Soon to be *Madame* Manet," Renoir interrupts. "Soon to wed Eugène Manet, Èdouard's brother."

"*Felicitations, Mademoiselle*. A fine family you are joining," Durand-Ruel says, bowing to her.

Maître also bows then turns to Durand-Ruel. "I have spoken to you about Berthe's art before. I am glad you two finally meet, because I hope you will get to know her work better, Paul. I believe she is worth collecting."

"Perhaps you would be kind enough to show me what you have in the galleries, *Mademoiselle*. Do you have any representation now?" He asks as she leads him away.

"Ah, Monet is here at last," Renoir says, seeing his friend come into the gallery. "Please excuse me." He rushes away, leaving Lucien and me alone for the moment.

"How does your work progress?" He asks.

"I'm painting full time now," I tell him, my thoughts of Frederic replaced by his kind attention. "I devote more time to portrait painting than the landscapes you said were—how did you put it—too similar to other work. I am making a portrait of Sarah Bernhardt as I told you at the Manet's *soirée*, and now also a portrait of a poor young mother and child in *Montmartre*, but in the modern style of these painters. And a portrait of an older woman, a good friend who is a dressmaker."

"A man like *Monsieur* Durand-Ruel might display a Sarah Bernhardt portrait in his gallery window and attract new work for you."

"It's still unfinished, but I'm committed to it. I spend as much time as I can at my easel. I am no longer employed."

"No longer employed?"

"My painting was suffering. It is very important to me."

"And how do you support yourself?"

"I saved as much as I could while working for *Monsieur* Worth. I am near to finishing my Sarah Bernhardt."

"You must be sure to guard your work." Lucien cautions. "*Monsieur* Durand-Ruel was just telling me he is hearing from his contacts in the south that they suspect counterfeit art is beginning to appear."

"Counterfeit?"

"Paintings the artist didn't produce. Their work copied and their signatures forged."

"Camille Corot told me many of his paintings have been copied, but he didn't seem too concerned about it."

"Camille Corot never had to live off his art. He inherited a large annual stipend from his father. Did you know?"

Changing the subject, I ask, "Did you and *Monsieur* Durand-Ruel discuss buying any paintings this evening?"

"There is a lot of fine work on display. Unfortunately for these young artists, the public has not been well educated about the new attitude they have toward making their art. It will take time. *Monsieur* Durand-Ruel and I were discussing that before Renoir brought you over. The right purchases now could reap big rewards in the future. So I am always on the lookout. But there is always risk. Who knows?"

"Once you offered to show me your collection, Lucien—when we met at the *soirée*."

"I would welcome the chance to show you the collection I have put together. If I am not too bold, may I invite you to dinner at my home?" He gives a slightly uncomfortable laugh and quickly adds, "You would be well *chaperoned*, of course."

"Of course." I smile brightly. Then I tell him, perhaps too aggressively, "If you suggest a day, I would be pleased to come to your home and view your art. I'm sure your staff will serve as fine *chaperones*." I laugh and touch his arm as a gesture of playfulness, but wonder why I am flirting with him.

"I'll send you a note with some dates when I can be available, and look forward to you joining me."

I excuse myself from his side reluctantly, telling him I must visit all the paintings in the exhibition. Walking from room to room, focused on the new art, I'm oblivious to the other guests as they chatter back and forth. Spotting Edgar Degas standing by his paintings, I'm surprised to see Amélie standing with him. I stop to watch as she engages him in front of his portrait of me in the ballet dress. They exchange brief words, then, discovering

me not far off, she walks away. I hold back on the far side of the room until she has moved on to the next room and then approach Degas.

"You do me a great honor, *Monsieur* Degas," I tell him, looking at my image in the white ballet dress on the canvas.

"Perhaps it is you who have done me the honor," he replies. "Everyone comments on the lovely young ballerina I've painted."

I blush. "But I have such a pained look," I tease him. "I saw the young woman talking to you. Do you know her? "

"She admired the painting and also asked questions about my technique, about my brush strokes."

"For what reason?"

"She didn't say and walked on rather quickly. You know her, do you?"

"Only from the *Louvre* galleries. Her name is Amélie. She told me her only interest is copying old masters."

"A strange pursuit if she has talent," he replies thoughtfully.

"Are you pleased with the attendance this evening?" I ask him.

He grunts. "No, *Madmoiselle* Dobbins, not one bit. There are not many people here, and some of those are laughing at our work."

Slightly wounded by the thought of people laughing at Degas's painting of me, I spend a few more minutes in conversation with him, then start to bid him *adieu* and move off to study other works in the exhibition rooms, but he gently takes my arm to restrain me.

"I miss you these days, *Madmoiselle*. It would be my pleasure to invite you to have dinner with me some evening if you are willing."

Surprised by his offer, as politely as I can, I tell him it would be my pleasure, and he only has to suggest an evening. Then I move on.

Not all of the paintings impress me in the several galleries I walk through. Everywhere I look, I cannot help thinking about Frederic, and how his art would stand out in comparison. Where are they—his paintings—I wonder? They should be here. I can't rid my mind of memories of a man I barely knew and yet still have such strong feelings for.

Renoir now stands alone by a grouping of his paintings, nervously pacing and looking around as if expecting people to come by at any moment to admire his talent and offer a few *francs* for one of his works.

"Finally a friendly face and someone to talk with, *Mademoiselle* Dobbins," he greets me, smiling and apparently glad to have company. "Our little group of artists seems to have failed in our plan to introduce our new art to Paris."

"Is it so bad? It's only the first night. Word will spread and people are bound to come."

"You are kind. The visitors I have heard this evening are more likely to spread the word we are creatures to be laughed at, circus clowns or witless idiots pretending to be artists. Some insult us to our face. Will they ever understand what we are doing?"

Standing by him, I suddenly grab his arm for support, and begin to feel weak. I point at his painting of me. "There was no man in your painting when I posed on the riverbank," I gasp. "But now..."

"*Oui*, I added him later in the studio," He interrupts me.

"The man looks like Frederic Bazille."

"*Voilà*! Indeed, it is Frederic," he says, a broad smile on his face. "What do you think?"

My mouth is so dry I can't speak. My limbs feel weak. I grab his arm to keep from fainting. "But he was..." I can't get the words out.

"Already gone. Yes, I know," he finishes my thought. "But I had sketched him several times when we worked together so it was an easy addition. My *homage* to him."

Still at a loss for words, I look from him to the painting and back, my eyes misting. "It is a shock to see him again," I finally tell him when I regain my composure, dabbing at the corners of my eyes with my fingers, trying to be unobtrusive.

"I know you miss him," he says in an unusually gentle voice, draping his arm over my shoulder and nudging me toward him as if we were sweethearts. "I do too. He was the best of us all."

"I am honored to be in a painting you are exhibiting," I tell him, freeing myself from his arms and looking away from the disturbing image of Frederic and me together on the streamside. I step away. "I must keep moving to see it all before the exhibit closes for the night." I smile and hurry off.

"So, there is much interesting art here, no?" A male voice asked over my shoulder as I feign looking at the framed canvases in the far room of the exhibition, while still struggling to clear my mind of Frederic. Without waiting for a response, the voice continues, breaking into a derisive laugh, "Some of it not so good, don't you agree?"

Turning to look at the stranger, for a moment I feel another shock. The stranger is young, tall and slender, dark and handsome. Briefly, I think Frederic has come back to me. A palpable sensation runs through my body as I look into his heavy-browed face. Speechless, I stare at him.

"Are you an artist?" The young man asks, apparently not noticing my agitation.

I hear a slight accent in his voice. "I am." The words come slowly as I work to focus my mind.

"Same for me. I am Andrea Moretti. What is your name?"

"I really need to be leaving," I tell him, turning away.

"I won't bite you, you know. I only asked your name to be polite."

I wonder if I should, but then I tell him my name, taking a step back. I feel an attraction to him for no reason I can explain. I could easily walk away, and perhaps I should, but I don't. "What brings you here?" I ask him and chide myself for such an inadequate response.

"I am new to Paris. The people on the street are talking about how horrible the art up here is, so I had to see for myself. I don't know if it's that bad or not, but it certainly isn't art people are used to."

"These are painters of modern life," I answer him. "People are shocked because what they see in these paintings reminds them of life around them—for better or worse—and not mythological or religious images."

"Is that what you paint—modern life?"

"I suppose it is. I paint portraits of women in Paris."

"It is a frightening city when you don't know anyone."

"I know. It was like that for me when I first arrived. I'm comfortable now, but I couldn't even speak the language at first."

"Would you like to have a glass of wine with me? You could tell me what it was like for you when you first arrived."

Why I say yes, I cannot explain, but I do, thinking it was not proper for him to have asked.

As we leave Nadar's building and walk down the boulevard together searching for a *café*, memories come back to me of the times I'd done the same with Leo and Frederic—so long ago it seems. Lamar never wanted to be seen on the street. He always went about concealing us in his carriage, protected from public view as he pressed himself on me. Walking with Moretti feels risky somewhere deep within, but the freedom of walking along

the street beside him is exhilarating.

"The nights have turned warm. I think you will love Paris when you get accustomed to it," I tell him to break the silence between us.

Moretti nods. "It helps to have a lovely young woman to show me around."

When we are settled into a booth at the rear of a small *café* on the corner of *rue Auber*, he asks, "So you make your living painting?"

"I make no money yet if that is your question, *Monsieur*."

"No need to be formal with me. Please call me Andrea. I watched you moving around the exhibition, you are a very pretty girl."

"You are not French, are you?"

"A small village in northern Italy. You?"

"I came from California a few years ago. You are rather impolite."

"California! So far away. And all alone? You are a brave girl as well as a pretty one."

"Why did you come to Paris?"

"Where else?"

"Yes," I agree, and feel the excitement, perhaps the thrill of a new young man. Against my better judgment I allow our conversation to take a more personal tone.

"It is lonely here," he says, offering a seductive smile that brightens his dark eyes with pinpoints of reflected light. "I miss my friends and find it hard to make new ones. I am glad I've met you."

"I would be happy to introduce you to some of my friends who were showing their art tonight, Andrea. Perhaps it could benefit your work." I hesitate, then add. "It is getting late. I should start back to my flat. I want to paint early tomorrow."

"I feel I should accompany you. May I? It isn't wise for a young woman to be alone after dark." He gets up from the table, offering his hand to me.

At his touch I feel a tingle. Partly a warning of risk coming, but also a feeling of excitement. Returning his smile, I give his hand a squeeze as he helps me rise from the bench. We leave the *café* and head for my flat on *rue Lepic*.

The following morning, after a night of intense lovemaking, I urge Andrea out the door. Then I collapse back on my bed, utterly spent and aglow. I enjoy working at my easel the rest of the morning without worry or recriminations. There is no self-questioning on my part, no guilt about what led to my tryst with Andrea Moretti. Inwardly I smile when comparing him to the timid, unimaginative love-making of Lamar Legrand. For me, it was like escaping from a dank swamp to find sunlight in a meadow of sunflowers.

CHAPTER TWENTY-TWO

Summer 1874

LATE ONE AFTERNOON not long after, I hail a *fiacre* to take me to Lucien's townhouse on *rue Poussin* in the suburb of *Auteuil*. I'm met at the door by a butler who escorts me into a wood-paneled library. Pointing me to a high-back leather armchair, he announces, "*Monsieur* Maître will attend you shortly." I'm nervous about what the next hour will bring and sit primly on the edge of the comfortable chair.

The library is bright, open, with large floor-to-ceiling windows along one wall overlooking a garden. The room's remaining walls have floor-to-ceiling mahogany, glass-fronted bookcases filled with leather-bound books. A desk, comfortable chairs, and couches are set about the room but I can't see any personal items. The books are neatly shelved, many with German or English titles. But there is nothing that tells me anything about Lucien Maître unless it's the fact he may read three languages. There are no mementos of his life lived, no Nadar prints or family paintings.

After a few minutes of sitting alone, a door, almost hidden in the paneling at the far end of the room, opens. Lucien enters, standing for a moment in the doorway, looking at me and smiling. "Good evening Emma," he says in a soft voice, and bows.

At the sight of him, my breath catches in my throat. I have never seen a man so handsomely dressed as he is in his formal dinner attire. I feel my heart quiver a little. His trousers are well tailored of fine black cashmere. The single-breasted tailcoat he wears has velvet lapels and cuffs, showing a low-cut ivory waistcoat, pleated white shirt and bowtie.

"*Bonsoir*, Lucien," I respond to him brightly, trying to set an informal tone.

"I am sorry to have kept you waiting," he says, speaking perfect English to me for the first time. "I was delayed in leaving my office. I hope you will forgive me."

"Of course I will. I had no idea you speak English. You honor me by using it."

"My English is a necessary requirement of my position at the bank. I'm pleased I can use it tonight with you. May I offer you a glass of champagne as we walk through my gallery?"

I nod, and he goes to a pull cord on the wall to alert the butler. Coming back, he extends his hand to assist me from the chair. "I hope I have not built your expectations too high, Emma. It's not really so much of a collection, more a work in progress, as you artists say."

Together we stroll down a long hall with framed paintings spaced along both walls, perhaps eight or ten altogether, and nothing memorable. I feel a twinge of disappointment, thinking he might have exaggerated about his collection. When I realize my apple orchard painting is not even among the works of these minor artists, my mood sinks further, and I begin to wonder if he has deceived me.

"It is my goal to build a major collection," he tells me as if apologizing, "but I never seem able to devote the time to acquiring the works I want."

Taking my hand as we come to a large room off the hallway, he guides me inside. A footman is waiting there with glasses of bubbling champagne on a silver tray. Lucien hands me one and we salute each other. I am captivated by the ambiance of this large room with high ceilings and decorative moldings and wainscoting on all the walls. Looking more closely at the paintings, and assuming more of the kind we saw in the hallway, a jolt runs through me. Catching my breath before almost choking on the champagne, I'm suddenly overwhelmed by the masterpieces in gilt frames hanging from every available space on all four walls. I can't find words to describe the fine art I'm seeing. Silently, I shame myself for thinking he would disappoint me.

"Magnificent!" is the only word that comes out, and it feels inadequate to describe the art before me. I am in a pantheon of French 17th and 18th-century artists: La Tour and Le Nain, Poussin and Claude, Watteau. My mind boggles. Walking deeper into the room, a few contemporary paintings by Millet and Corot, Ingres and Delacroix, are grouped on a far wall. "There are no words to express my feelings," I tell him as we slowly enjoy each masterpiece we pass. "You do me great honor by showing them to me. I'm in awe."

When we reach the end of the room, I'm startled further to see my *Normandie* apple orchard, in a golden frame, hangs in a freshly painted spot on the wall. I take a gulp of champagne and grip his arm, almost spilling his drink, and burst out, "I don't belong here, Lucien. I am so flattered, but I don't belong in the company of such great artists. I'm embarrassed."

He puts his hand on my shoulder, beaming with pleasure. "Truly, you are right, your work belongs in a separate gallery, away from these old masters. I want to build a collection of

modern artists, but I have only started." He chuckles and gives my shoulder a gentle squeeze. "Come, I'll escort you to dinner, we can talk more."

Taking his arm, we walk deeper into the townhouse to a dining room that holds a table capable of seating twenty people. This evening it's set for just the two of us. "Are we to dine alone?" I ask him.

"Yes. Does that concern you? If you are uncomfortable..."

"Oh, no, I'm fine. I just didn't imagine you would go to all this effort for me."

"Emma, rest assured I am well pleased to be doing this for you. Dinner alone in this large house can be very lonely." With that, he holds an upholstered armchair for me to sit on his right, beside him at the head of the table. Immediately we're both seated, three footmen soundlessly appear, two with plates they place simultaneously in front of us, and a third to pour white *Burgundy* into crystal glasses.

The food tastes far better than anything served in any restaurant Lamar ever took me to, and the wine—both white and the red that follows—is opulent, seducing my palate. But then, fine dining was never as important to Lamar as making a grand impression.

Our conversation grows lively as the dinner continues from course to course. Toward the end of the meal, beginning boldly—and perhaps trying to appear more knowledgeable than I really am—I say to him, "I saw that your collection of old French masters avoids any of their religious or mythological themes. Is that on purpose?"

"Ah, I knew you were a perceptive young woman with a fine understanding of French art," he responds.

I blush. "Only from spending so much of my time at the *Louvre Museum*. I had never been in a museum before coming to France you know."

"No museums! Then you've learned well. Let me answer your question." Setting his knife and fork down on his plate and taking a sip of his wine before starting, he turns toward me so he can give me his full attention. His light green eyes sparkle in the candlelight. "I am Jewish, Emma" he starts. "Although not a practicing Jew, Christian religious art holds no appeal for me. For most of the history of French art, painters have produced mythological or quasi-religious works. I admire many of them, but I am much more interested in what I call their genre art—landscapes of real places and portraits of real people. I have sought out works that fit into my plan for a collection. You laugh because I added your apple orchard canvas—I did because to me it has a very contemporary approach to the subject. One day it will make its way into my new gallery of modern art. What are you working on these days?"

I am thrilled by his sincere interest in my work. "My plan is to paint what you would call genre portraits of women in Paris."

"Like the 18th-century rococo work of Le Brun or the fine new work of Berthe Morisot?" he gently interrupts.

"Yes and no. I admire both of those artists, but I see that Le Brun painted Louis XIV's court and European royalty, and Berthe is limited to painting *Haute Bourgeois* Parisian women and children. As an American I don't feel restricted to any social class. I have finished my portrait of Sarah Bernhardt, as I told you, and one of a poor, workingclass woman in *Montmartre* with her infant daughter. I'm now working on a portrait of my friend, *Madame* Crystalle, a retired fashion designer, as she sews on a gown. I'll look for other subjects too. So you see I am committed

to painting women in the modern world of Paris, not just the high born."

"Bravo! Keep going! I think you are on the right track. Those paintings will be important."

"I want to ask you, if I am not being too bold, Lucien, how you are sure that each of your masterpieces is authentic?"

"How do you mean 'authentic?'"

"At the exhibition you told me *Monsieur* Durand-Ruel was concerned about forgeries on the art market."

"Ah, I see. Yes. That is a difficult situation. Paul's business depends on the trust his buyers have in him. When he buys directly from the artist, he records the purchase in his logbook. His customers can see who the painting came from and the date. I have bought many paintings from him so I feel confident they are originals. He worries other buyers may not have that same assurance. Why do you ask?"

"Before the war I posed for Frederic Bazille, and he did several paintings of me. When the war started he and Renoir, who shared the studio, dashed off to enlist and locked their studio, not knowing, I suppose, when they would return. When I went to the studio after the war it was empty. Renoir had taken his paintings, but Frederic was killed in the fighting. Even so, his paintings were gone; the studio was stripped bare. I have never been able to learn where his art went." I stop to take a deep breath and look into his face when I continue. "Yet when I was in *Montpellier*, I visited the *Musée Fabre* and saw a few of his paintings hanging there, including paintings of me. One he had promised to give me."

"Perhaps his parents...?"

"No. I spoke with them, and they told me they had no idea where the museum had obtained the canvases. Renoir doesn't know either."

Lucien's countenance takes on a somber cast as he listens to my story. "That is puzzling," he says when I'm done, as he folds his napkin and lays it on the table. "You think someone stole those paintings and then sold them?"

"Maybe. Or maybe they could be forgeries, as *Monsieur* Durand-Ruel called them?"

"I see. I don't have an answer for you, but I can make some inquiries. I must travel to the south soon to visit my bank in *Marseilles*, to speak with some *vignerons*. Let me see what I can find out for you."

"*Vignerons* are farmers?"

"Yes, winegrape growers. They are facing an outbreak of a disease that's killing their vines. My bank has lent them money so we want to help them if we can."

At nine o'clock Lucien summons his carriage to take me home and sits beside me as we ride through the darkened streets along the Right Bank of the river and on to *rue Lepic*. As the carriage draws up in front of my building, he takes my hand and looks timidly into my face, almost as if seeking permission. "I have not had such a pleasant evening in a long time, Emma, and I thank you for being my guest," he says patting it softly.

I squeeze it in return. "You have been a wonderful host. I agree it has been a magical evening. Thank you."

He leans over and gently kisses my cheek. "I have a question for you," he says softly, his face still close to mine. "Do you think you would be interested in painting a man's portrait?"

"Yours?"

"Of course."

"Nothing would give me greater pleasure. I'd be honored to do it."

"We'll set a date when I return from *Marseilles*. I'll let you know if I learn anything about Frederic Bazille's art while I'm there."

One afternoon several weeks later, a messenger knocks on my door and hands me a note with a wax seal that bears the Letter M. "I'm instructed to await a reply," he says.

Taking the note, I shut the door and go back to a chair by the window overlooking the street to read it.

> *My Dear Emma,"* it starts. *I have thought about you often after our delightful dinner together and as I was traveling in the South of France. I was impressed by your knowledge of French artists, both current and ancient. Now, I would like to discuss a new project I have in mind that you might be interested in. Are you curious? I hope so. Rather than putting it in writing here, I am pleased to invite you to attend the races at Longchamp this weekend with me. Please make your reply—and I am very hopeful it will be yes—to the messenger I have sent. I want you to be my guest, and we can discuss my project in detail.*
>
> *Fondly yours,*
> *Lucien*

I scribble my acceptance on the back of the note, wondering what he could possibly have in mind. Then resealing it, I hand it back to the messenger waiting outside my door, smiling to myself all the while.

On the day of the races, Lucien's carriage driver escorts me down to the open, waiting carriage and hands me up to sit beside Lucien. "You look quite charming today," he greets me with a beaming smile showing his bright, even teeth. "I am so pleased you agreed to join me, the races should be a lot of fun."

Taking in his top hat and morning coat in a glance, and again

thinking how handsome and proper he is, I reply in a teasing
voice, "You lured me here unfairly with veiled references to
races and projects."

In the warm September sun, our *landau*, drawn by two roan
mares, joins the parade of horse-drawn, open carriages on the
way to the *Bois de Boulogne*. Their occupants sitting proudly so all
the people along the street can admire their frippery.

"I'm happy to introduce you to the sport of horse racing,
where as much of the fun is watching the people who line the rail
as watching the horses run," he says. "And besides, I so much
enjoyed your company at my home. I don't get to know many
young women, and none as lovely as you look today."

Blushing, and feeling warm inside, I settle next to him for the
ride down the *ave des Champs Élysées* and through the park to
the racetrack. When we arrive he tells me, "We can watch from
the carriage with others along the far rail or sit in my box in the
grandstand. Which do you prefer?"

"Oh, Lucien, how could I choose? This is my first time. I want
to do whatever pleases you."

He instructs his driver to take us to the grandstand. Offering
me his arm, we make our way up to his box at the very top. All
eyes in the crowd of spectators seem to turn to look at us, and, as
if by some silent command, they part, like an aisle in a church,
to make a path for us. Once seated, a waiter appears with a tray
of champagne glasses and a bottle in an ice bucket.

"Longchamp is a place where the ladies of Paris come to show
off their finery," he says, popping the cork and pouring from the
chilled bottle. "And if I may be so bold to say, you are among
the finest of them all today. Your gown and hat are a perfect
combination. Dove gray is a very flattering color for you." He
extends his glass to mine and we clink them together. I can't hide

my ebullient mood and don't try.

"*Merci, Monsieur,*" I tell him, again in a teasingly formal way. Inwardly I smile, too, thinking how lucky I am to be in his company. And how much I enjoy being with him. Below us, tightly corseted, impossibly slender-waisted women stroll along the front of the grandstand, surreptitiously peeking up at us. I feel special, appreciating how much Lucien has done to make me comfortable.

A festive atmosphere permeates the racetrack. The crowd buzzes with happy conversation. Friends call loudly to friends lined up along the rail and wave greetings. The air is filled with the aroma of warming chestnuts roasting on vendors' *braziers* behind the grandstands. Off to one side, the horses whinny and move about nervously, waiting their call to the post. I take it all in from our box, which seems second only in prestige to the exiled emperor's old box, now long abandoned and weathering from neglect. I have a giddy sensation in my stomach, being in the company of such an exalted man. Such a good man. He raises his glass and we sip, smiling fondly at each other over the rims.

A loud roar erupts from the crowd when the horses come to the starting line, trembling, prancing back and forth, quivering with pent-up energy, like tightly wound springs, as they await the starter's gun. When it goes off they explode into motion, stretching their necks, each trying to move ahead of the pack, kicking up turf at the spectators along the rail. Lucien watches through opera glasses then, apologetically, offers them to me, but I shake my head, preferring to watch the panorama without them. The crowd quiets as the horses make the turn at the far end of the course, with one dappled gray charging into the lead, increasing it with every stride along the backstretch where the people in carriages urge them on. Amid loud cheering, that

grows like the roar of an ocean wave when the horses turn for the home stretch, it crescendos when the gray flies across the finish line, hardly challenged by the others trailing behind.

The crowd ebbs away from the rail after the race and begins to flow around the grandstand again. Couples meet, exchange greetings, and move on. Looking down at the crush of people awaiting the next start, I see Berthe walking in front of the grandstand with her new husband. I call out to her, waving to catch her attention. She seems startled at first when she looks up. Then she gives me a quick, questioning look, and a happy wave. Eugéne steps close beside her and shouts a greeting up to Lucien. "Édouard is far down the rail with his easel set up, did you see him?" he shouts, pointing to the first turn of the racetrack. "He likes to paint the crowd as much as the horses." Then laughing, they walk on.

As the spectators continue milling around, waiting for the next race to start, Lucien refills my glass. Some men come up to the box, with their well-dressed ladies in tow, to pay their respects. He introduces me to each of them without explanation. I notice some of the women giving me quick, probing glances. I smile benignly at them, enjoying their attention. Far off in the crowd I think I spot Lamar standing near the horse paddock with a woman clinging to his arm. I borrow Lucien's opera glasses to be sure it's him, but by the time I can focus he has disappeared in the crowd. The woman seemed familiar, but I can't be sure.

We sit through another race, as I wonder when Lucien will talk to me about his project. Finally, I take the initiative and say to him, "I am having a wonderful time with you, but was there something you intended to talk about?"

"Yes, well..." he hesitates. "It's embarrassing for me," he says at last. "I did invite you so I could ask if you were still interested

in undertaking the special commission for me that I spoke about when we had dinner. You see my bank wants a portrait of me to hang in our Paris office, and I thought of you right away. The bank will pay you well, of course, but I didn't know if that would be awkward for you."

"Awkward? Not at all!" I can't stop myself from reaching out to give him a reassuring hand and a look of gratitude. "I would be proud—honored—to paint your portrait. Surely some more qualified artists would jump at the commission, but I won't let you down."

"I would feel more comfortable sitting for you."

"Most of my other paintings are finished so I could be available whenever you like."

"That's a relief. I thought you might only want to paint women, as we discussed at dinner. If you agree, I think it would be best if we did it at my home...That is if you are not uncomfortable with that arrangement. I could send the carriage to pick you up and deliver you back to your flat after each session, and we could have dinner together again. I did so enjoy our conversation. I didn't know if it would be awkward for you painting an older man." He picks up his champagne glass and clinks it with mine. The crowd roars. It has nothing to do with our conversation but puts an exuberant exclamation point on our agreement. "Here's to a profitable relationship." Then he pauses. "But there is something else. When you were at my home, I told you I was having trouble getting started on a collection of modern painters' works. I'd like you to work with me on that."

"Me? What would you have me do?"

"Be my agent. Work with *Monsieur* Durand-Ruel to select the very best works of the new school of artists. I truly believe they are the future of art and I want to have a grand collection of

them. I trust your eye and judgment."

I'm overwhelmed. I can't believe the faith he is placing in me. "Certainly, I'd like to do that, but I will need a lot of help and guidance," I tell him. "I'll have to get to know *Monsieur* Durand-Ruel better."

"Yes, that's important. Now we must also talk about my visit to *Musée Fabre*."

I feel a surge of apprehension. "Did you learn anything there? Did you see the paintings? How did they get there? Did you talk with Frederic's parents?" The questions tumble from my mouth in a torrent I can't control.

"Slow down, Emma. All in good time. I will explain." He takes my hand in his again, squeezing it gently to calm me down. "Yes, I went to the museum and I did see the Bazille paintings— quite good—we'll talk about that in a minute. I had not realized he was such a gifted artist. You were very fond of him, no?" He stops and looks at me, waiting for a response. But I'm a little choked up and all I can do is nod. So he continues. "I met with the museum's curator—he is very proud to have those paintings by a native son on display."

"How did he get them?" I interrupt him again.

"I'm coming to that. Please let me explain."

I can feel my heart pounding, impatient to finally know what happened to Frederic's works after he died.

"The curator told me a man had visited the museum twice and made attractive offers to sell the Bazilles. He described himself as an art dealer, but when I asked if he had a business card, the curator showed me one that only had the address of an art gallery in Paris on it. No name. And I'm suspicious about the address."

What did the man look like?"

341

"Please, Emma, give me a chance to tell you."

I apologize for my impatience, but he smiles his understanding. "You and Frederic Bazille were very close, I see that, but please let me finish. The curator remembers the man as medium height and body with sandy, light brown hair, but he never did get his name."

"What color were his eyes?"

"I'm sorry, Emma, the curator was pretty vague on the description and I didn't ask him."

I want to ask more questions, but I keep quiet to let him finish.

"I also met with Bazille's parents when I went to *Montpellier*. I learned nothing from them you don't already know. They are not the source of the paintings—five of them in the museum now—did I tell you that? *Musée Fabre* has made two purchases."

"Did the curator think there was anything strange about a man showing up at his door with fine art to sell?"

"No, not really. You have to understand the art market is quite informal. Museums outside of Paris are happy to have art to hang on their walls and don't ask too many questions about their provenance."

"I see." I'm disappointed he hasn't learned more.

"I have one other piece of information," he says after a pause. "I spoke with my employees at our bank in *Marseilles*. They are quite knowledgeable about goods that go in and out of that port. From the gossip they hear they think French art is leaving the country for other Mediterranean ports. Perhaps because it might be easier to sell. Subsequently, they informed me they saw two Frederic Bazille paintings when they went to the *Marseilles Musée Cantini* and one in the *Musée des Augustins* in *Toulouse*."

I give his arm a hug. "Lucien, I am so thankful for everything you have done to get me this information."

"Well, you are welcome. But there is something else we should

talk about." He stops and looks at me in a severe way I have never seen him look at me before. I hesitate, and we spend several moments that seem a lot longer just looking at each other.

Finally, he clears his throat and says, "You and Frederic Bazille must have been very close." I dread what might be on his mind. "The portrait of you in a white dress with pink stripes sitting on a wall is quite charming. Quite charming. It shows a strong bond between artist and subject."

I breathe a little easier. "He was an easy artist to pose for."

"I'm sure," he says as if to brush my comment aside. "But I must ask you about the nude painting the *Musée Fabre* has. Is that also of you?"

I gulp, surprised, trapped, never having thought about what his reaction to that painting might be. Nowhere for me to hide, "It is," I tell him. "It was supposed to be private."

"I suspect you and Frederic were very close for you to pose for a painting of that sort. Is that correct?"

"We were," I tell him, hoping I haven't destroyed the relationship between us. "I was in love with Frederic."

"And he with you?"

I laugh, a sad, sorrowful kind of laugh, and shrug my shoulders. "I will never know. But, yes, there was a close bond between us. There are times I still think of him. That probably explains why I have been so anxious to find his paintings. He promised the nude was only for me."

"I understand. And I didn't ask just to pry into your past. In fact, your honesty is what I expected, and it helps me know you better. I'm no prude, Emma. We all have other lifetimes before we meet. In no way does it lessen my desire to have you paint my portrait. Or work with me on a collection. Or be close to you. We should get started as soon as possible."

Over the next few days, I work on adding the final touches to my paintings. One afternoon, after two hard and long days at my easel, I get up to stretch and look out the window. Startled, I see Grace Aboud, clutching little Clarise's hand, standing on the sidewalk staring up at me. I call to her then fly down the three flights of stairs to her side. "What's wrong, Grace?" I call out breathlessly when I reach her.

"I didn't have the strength to climb the stairs," she sobs, tears streaming down her face. "I didn't know if you would want to see me."

I stare at her, horror on my face. "Of course I want to see you. What's happened?" I lose control and start to cry, too, "You're a sight! Let me help you up the stairs. We'll get you cleaned up."

Straining to support her, while she coughs weakly and leans against my shoulder, holding Clarise in my other arm, I help her up to the flat. Once inside, I settle her on my bed and hand her a cloth handkerchief she holds to her mouth. Then I get a pan of water and dab at the cuts and bruises on her face and arms with a damp rag. The child stands listlessly at her mother's side, holding tightly to her hand.

"What happened?" I ask, gently stroking her face.

Grace sobs, but doesn't speak.

"Martin?"

She nods.

I drop the cloth and throw my arms around my friend, embracing her tightly. She winces from a pain in her shoulder.

"I am so sorry for you, my sister. How could he do this?"

"Came home drunk. I didn't have any dinner for him," she moans, still holding on to Clarise and burying her head against my chest.

"You are a mess! But I'll take care of you and Clarise. Has she eaten? Have you?"

Grace shakes her head.

"Lie down here with your daughter beside you," I tell her, "and I'll go get food for both of you and come right back. Don't open the door for anyone!"

I dash back down the stairs to the *boulangerie*. When I return Grace has fallen asleep but still tosses and moans, so I take the child into the other room and feed her *baguette* crusts dipped in milk as she sits on my lap. In a soft voice I try to soothe her.

An hour later Grace stumbles out of the bedroom, her puffy face still heavy with sleep, looking ghost-white where she isn't bruised. Her hair hangs in clumps.

"What am I to do?" She begs me in a meek voice. "I've got to go back. Martin will be waiting for me."

"Absolutely not! You and Clarise are staying right here with me."

"Martin will come looking for me. He knows where you live."

"Leave Martin to me. I'll take care of him."

She hangs her head and nods. Her tears flow again.

"Why have you let this go on so long?"

"He's my husband."

"He was hitting you before you were married. I saw the marks and didn't know what they were. Why did you marry him?"

She looks up and stammers, "I didn't want to lose him."

"Lose him! My God, Grace, why would you stay with a man who beats on you? Weren't you afraid for your daughter?"

"I am afraid. That's why I've brought her here. Will you keep her for a couple of days until Martin calms down?"

"You're not going back."

"Where can I go?" She asks, coughing again into the handkerchief. "My parents are gone."

Willard Thompson

"You and Clarise are going to stay with me for as long as you need to. I'll get what you need at your flat and go back for your other things in a day or so. If Martin's there, I'll tell him he will never see the two of you again if I can help it. We'll live together here, and raise your daughter where she's safe. Where you're both safe."

"But Martin won't—"

"No buts! I'll kill him if he ever comes near you again. Kill him!"

〰

Rue Saint-Rustique looks no better than the first time I climbed up to Grace's apartment. Hurrying along, I cover my face with a handkerchief to block the stench. The door to Aboud's flat is open. Martin is slouched on the rat-eaten couch, barely conscious, with a half-empty bottle of beer beside him. He stirs when I stand in front of him, staring up at me through half-slitted eyes, mumbling in a faint voice. "Where's Grace? I'm hungry."

"You're never going to see Grace again, Martin. She's left you for good."

"Oh..." Trying to focus on me he says, "Are you going to stay with me? Will you fix my dinner?"

"No Martin, listen to me! That's all over! No one is going to fix your dinner or stay with you. I hope you understand—your wife has left you for good."

He scratches the stubble on his face. "She's with you, isn't she? I'll drag her back here. She's my wife—it's her duty. You've always been a bad influence on her."

"You will never see her again!" I almost shout at him. "If you come around looking for her I promise I will kill you. Do you hear me?"

"Stay with me, Emma. I always liked you better anyway."

"You are a pig! A detestable man! No woman would put up with you!"

"If only I could find work," he interrupts me.

"Liar, Martin! I saw the bruises on Grace's face and arms long before she married you—why she did I will never understand. French women have strange ideas about love. I saw what a pig you are at your wedding. You're not a man! A man would have loved and cherished a wonderful woman like Grace, but instead you beat her when she didn't do your bidding. I'm leaving now, but I want to be sure you understand me: if you ever come near Grace or her daughter again I will kill you myself."

He looks at me and scoffs in his murky, inebriated, far-off voice, "It's you causing all the trouble. Always has been. I'll get you for this."

I dash around the flat, gathering everything I can carry for Grace and Clarise in a couple of baskets. Then I look at Martin one last time, now passed out on the couch, before slamming the door behind me and hurrying back to my flat.

CHAPTER TWENTY-THREE

Winter 1874

I CONVERT THE empty room in the flat into a bedroom for Grace and her daughter. Away from Martin Aboud, two-year-old Clarise begins to grow stronger. She attaches herself to me, calling me her auntie, which makes me smile. We all settle into our new routines: Grace goes back to her job in the laundry on *rue de Rome*, and my days are filled with painting in the mornings and taking the little girl out in the afternoons for fresh air and play.

As 1874 comes to an end, Lucien sends a note telling me his business commitments will keep him from sitting for his portrait until January of the New Year, but he invites me to a Christmas dinner at his townhouse. I answer I don't feel right leaving Grace and her daughter alone on the holiday, so he replies he will send a carriage for all of us.

"You will like *Monsieur* Maître," I tell Grace. "He's very polite and generous. Handsome, too. I think he's lonely in his big townhouse and looks forward to having guests during the holidays."

"Oh, no, Emma. I can't go to such an *haute bourgeois* house. I have no proper manners and nothing suitable to wear. We'll stay here. You go."

"Not at all. We're all going, and I will lend you one of my dresses."

To accommodate young Clarise, a late afternoon dinner is arranged. We all eat heartily, except for Grace, who barely picks at her food. After dinner, Lucien takes me into the library for a private conversation. "I didn't know what to tell the chef to prepare when you told me the child was coming. I hope I did all right."

"Lucien, it was perfect," I assure him. "The special meal your chef made for Clarise was just right. I've eaten so much I may not eat again for days."

"I've never seen a little girl eat as much food as little Clarise! It was such a pleasure to watch her, and have her with us. As you can imagine, I don't know many small children, and I thank you for bringing your friend along."

"Grace was nervous about coming. She's had a difficult time lately."

"I can see that," he answers with a somber look on his face. "She hardly touched her food. She looks weak, her face shows all the signs of hardship. Are you concerned about her cough? Has she seen a doctor?"

"She refused to go when I urged her. Said another woman at the laundry where she works has a cough and it doesn't seem to worry her."

"Get her to a doctor as soon as you can, Emma. I can recommend a good one." He pauses to focus on me again, and his face lightens, spreading into a broad smile that gives me a pleasant warm feeling. "Let's plan on starting the portrait the week after New Year's. And we can discuss our other new project."

"How did you ever meet such an important man?" Grace asks me after we return to the flat and Clarise is asleep for the night. We sit together in the darkened studio with the streetlights of *rue Lepic* glowing outside the window. The voices of people in holiday moods moving along the street are constant, dull background noise.

"Through my artist friends," I answer her. "He bought one of my paintings at an auction and later invited me to his home to see his art collection."

"You went there alone?" she gasps. "I never would have done that."

"And you never would have met this very nice man."

"I can see he is very fond of you."

"Yes, he's a wonderful gentleman."

"We are very different, aren't we?" She says. "You've never accepted our ways, have you?" Her words stick in her throat and tears form in her eyes. She turns her head away to cough.

Getting up from my chair, I kneel down in front of her, hugging her knees and looking up into her face. "I promise I will never leave you again, *ma sœur*. You saved my life." I wait a moment and then broach the subject. "Lucien wants you to see a doctor about your cough. I think you should. He'll recommend one if you agree to go."

"No, it's nothing...please," she almost begs me to drop the subject. "I told you I got it from a girl where I work. It'll go away. If it doesn't I'll see *Monsieur* Maître's doctor, I promise."

A few days later, bundled in a cloth coat against the damp, biting chill coming off the river, I go to the laundry on *rue de*

Rome. When I ask to speak with the owner, an older woman comes from the back of the laundry, past several large tubs of boiling water, bubbling over wood fires, where young women scrub at the wet clothing.

"My friend Grace Aboud works here," I begin.

"She does, does she?" The woman snaps. She is shabbily dressed in a soiled and ripped housedress. Old caustic burn scars mar her hands and arms, and her close-cropped gray hair is singed in spots. "I haven't noticed her here for a while, so I'm getting ready to look for a replacement, I am. Plenty of dirty clothes and stained bed sheets here to wash every day, and they don't wait for your friend to decide to do us the favor of showing up."

"I know." I consider my response to the sarcastic woman before saying, "She's been sick, and that's what I came to tell you."

"No matter to me, *Mademoiselle*, I've laundry to wash every day. If she can't do it some other poor girl will."

"Grace told me another of your girls has a cough, *Madame*. She thinks that's how she got hers. Can I speak to that girl?"

"Agnés it was. Yeah, I remember Agnés hacking away... No, it was Martine, not Agnés, that's right, Martine."

"May I speak to her?"

"Oh no, Martine's no longer here. Left a month ago, couldn't stop coughing long enough to do any work. Had to let her go. Consumption it was drove her off. I got to go back to work now. Tell Grace what I said."

My face doesn't reveal my reaction to the woman's terrible news. I thank her and go back to the flat without mentioning my visit to the laundry.

When Lucien's carriage arrives at the flat on a Saturday in January, I load my easel, canvas, sketching pencils and paints, and ride to his *rue Poussin* townhouse. He is smiling, and waiting nervously for me at the door like a timid young schoolboy. "So we are finally to do this, are we?" He greets me, laughing anxiously.

I tell him I'm excited to get started and he asks me where he should pose.

"Oh, Lucien, no! I want you to be the one to select the background."

"Please, do you have suggestions? I am at a loss in this."

At that moment I realize how uncomfortable he is, and that I must take the initiative. "Well, yes, I do," I tell him to ease the moment. "Might I suggest you should be in your gallery with your favorite paintings on the wall behind you. Perhaps seated behind a desk."

"Well said." He sighs his relief. "Let's go select the spot."

He picks up my easel and, taking my hand, we walk the long hall to the gallery. A footman follows with my canvas and paint box. Setting everything down by the doorway, Lucien leads me the whole length of the gallery without saying a word, looking at every painting we pass, and then turning and coming halfway back again to the doorway. Pausing, he looks around, a lost expression on his face. "This is very difficult," he mumbles, almost to himself. To me, he adds, "As I told you, they want this portrait to hang in the bank."

It takes much discussion, all the tact I can muster, and most of the afternoon before he decides to have Corot's *The Drocourt Mill*, and Corbet's *Young Ladies of the Village* on the wall in the background as he sits at his mahogany and gilt desk looking up from his papers. Then it takes until darkness for two footmen to bring the desk from the library and position it for the best light,

and rehang the paintings.

"Sorry, it's taken so long," he says, smiling apologetically, when the arrangement is complete, looking into my face, which doesn't quite hide my frustration at losing an afternoon. "What do you say to a glass of champagne and a small supper?"

I give in without protest, accepting that my role is to make him feel at ease when we start. In the parlor, another footman is standing by to serves us champagne.

"Do you ever get lonely here?" I ask him when we are settled in two facing Louis XVI upholstered armchairs, with a small table between us.

"I don't think about it much anymore," he responds. "It is the life I lead. But yes, it became clear to me when you and Grace and the little one were here for Christmas how much I enjoy having others around me. My staff is wonderful, but I am not social with them."

Very tentatively I ask him, "You have never married?"

He gives me a sad face and purses his lips in contemplation before answering. "Up until now, it has not been my good fortune to meet the right woman to share my life with. But I have lived a very full life nevertheless. And yes," he adds as an afterthought, "Yes, the house can feel lonely at times. It would have been nice to hear the sounds of young children running about, but, alas, that was not to be for me." He is quickly on his feet. "Chef has a light dinner waiting for us," he tells me. "Bring your glass and follow me."

In the dining room, a plate of steak tartare with side vegetables is served, along with a *Bordeaux* wine. "A favorite dish of mine," he says. "I hope you will enjoy it."

"A first for me," I reply. "You have introduced me to so many new things since we first met, and you have never let me down."

"Tell me about yourself, Emma," he says when the meal is complete, and we sit with small glasses of *Calvados* in hand. "You are not like the other young Parisian women I meet."

"And do you meet a lot of them?" I answer too quickly, then laugh nervously.

He ignores my response. "You are...how can I say...different than the others."

At first, I feel stabbed by a politely phrased insult. I push my plate away and sit more upright, feeling myself becoming defensive. But as I start to speak again a softer tone takes over. I give him my best smile and a slight laugh. "Try as hard as I might I cannot seem to be like Parisian women. You are not the first to tell me that."

"Forgive me if you thought I meant that as a criticism. I find you charming and totally refreshing. Different? Yes. At times you can seem so self-contained."

"Oh, Lucien!" My voice rises with the sudden anxiety that he doesn't like me. "I don't want you to think I'm withdrawn at all. I feel very close to you."

"Well, you are not French, are you? That is plain enough to see and to hear in your voice, perhaps that is what makes you seem different. You came from California, perhaps that's the difference. What was it like to grow up there?"

"Oh yes, very different. I grew up in a remote part of California with only my papa and three other lighthouse keepers. Papa was a wonderful man, I loved him, and he took care of me. I think you would have liked him."

"Your mother?"

"I hardly remember her. She left when I was five years old..."

His voice sinks to a lower, more compassionate tone when he interrupts. "You must have been very sad when she left."

"Shall I tell you? It isn't a pleasant story."

"I would like to hear it, but only if you want to."

A dense fog rolled in from the Pacific Ocean one evening when I was five, hugging the rocks and obscuring the lighthouse where I lived. With papa, I climbed the circular staircase and steel ladder into the lantern room, something I did whenever it was his turn to light the lamp. Standing back from the tall glass panes in the iron frames of the lantern, I could look down several hundred feet where the ocean waves crash against the rocks far below, sounding to me like cannon shots. The full moon shimmered on the top of the fog bank as if a great mantle of cotton has descended over the water.

Staring out through the large windowpanes, I strained to see into the darkness. "Papa," I called out suddenly, "listen!"

He stopped winding the weight that turned the lens like a grandfather's clock and cocked his ear. "What did you hear, Baby Girl?" He asked.

"I heard a sound. I know I did."

"'I didn't hear anything," he told me.

"Papa, I know I heard something. I did."

The next morning, when I saw my mother walking the path along the cliff, I ran after her. "Where are you going, Momma?" I asked her.

"There is no place to go in this prison," she snapped.

"Can I walk with you?"

"No! I want to be alone," she said. "Go back inside."

She walked off, staring out at the ocean. I stood where I was, stung by her rejection, watching her go. The fog bank had pulled

back far offshore, and the air was filled with the smell of rotting seaweed. A lone gull was soaring in the sunlight overhead, sounding its familiar cry.

Looking down at the beach, I had to rub my eyes because I thought I was seeing a ghost step out of the water onto the sand. Frozen in place, I stood there staring.

"Halloo up there." The voice sounded ethereal.

I rubbed my eyes again, and then heard my mother shouting back, "Are you real? Or do I imagine you?"

At that, I ran to her side.

"Yes Ma'am, I'm real. And sorry I am if I've frightened ya and the child Ma'am. My schooner's hung up on those rocks yonder and I need help."

Momma shifted her gaze from the young man to where he was pointing. A two-masted schooner was perched precariously on an outcropping of rocks about twenty-five yards off the beach, almost out of the water.

"Ma'am, can you tell me where I am?" The voice shouted to Momma. "We lost our bearing in the fog last night."

"Point Conception," she hollered back.

"Point Conception, ya say? Point Conception? That's what we thought. We saw the lighthouse at dawn, but not a trace of light was there last night when we needed it. Not one trace!"

"There are others?"

"Three men still on the schooner, Ma'am. I swam ashore. How do I get to the lighthouse? We'll need help to refloat my ship."

She pointed to the steep path a little farther along the beach. "Climb up there and I'll take you to the keepers," she shouted back.

I watched the man ascend from the beach. He was young, not so old as papa. He wasn't tall, but he had the look of a man built

for work. Like the keepers. His fair hair hung in a wet queue down his back.

"M'name's Seth, Ma'am. Seth Goodnow. I'm master of the schooner *Vigilant*, that sorry sight just now out on the rocks. We were searching for the entry into the channel coming south last night. Pilot book says there's a lighthouse at Point Conception, but we never seen it. Guess ya got no fog signal neither."

"I don't know about those things," Momma said. She paused a moment then added, "I've only been here a short time. Where were you headed?"

"A load of lumber to deliver farther south, we have, Ma'am. Then we're headed back to San Francisco."

"I'm Rachel," she told him, offering a bright, overly friendly smile. "Rachel McKay. Come along with me."

When we appeared in the kitchen doorway leading the dripping wet stranger, the keepers bolted out of their chairs.

"Rachel..." Papa started and then said nothing more.

The other keepers stared at Goodnow with stupid looks on their faces. Rachel mocked, "This man's ship went on the rocks in the fog last night. I found him on the beach. Guess the light wasn't much good."

"Hellacious fog last night and no light or fog signal to warn us," Goodnow told the keepers. "Lucky, we were coasting and came to rest on the rocks as gently as we did. No damage done, I can see. My crew is still aboard, getting ready to free her. We could use your help."

I walked across the room and tugged on papa's hand. "I told you I heard something last night."

He glanced at me but stayed silent.

The head keeper told Goodnow, "We're sorry, sir, about the light. It's no damn good in a heavy fog like the one rolled in last

evening. We'll all three go down to the beach to help ya. Won't have a high tide 'till late afternoon though, but we'll see what we can do."

Papa turned to me. "You stay here with your mother while we go to help."

"I'm going to the beach," Momma said, taking a step closer to Seth Goodnow.

"I'm coming too," I told papa, and followed her out the door.

Goodnow started down the path to the beach, with Momma close behind him, and me trailing along, too. By then there was a clear, bright, cloudless sky overhead, where seabirds circled hunting food.

"I hope I'm not too forward with you, Seth—may I call you Seth?" —my mother started, "I beg you to please take me away from here when your ship is afloat again." As she spoke, she reached out to him.

I had a choking sensation in my throat watching her. I wanted to cry out, but I didn't. Instead, I turned my back.

Goodnow recoiled from Momma and walked on down the steep path without speaking. "We're sailing south to deliver the lumber before heading north again," he said when he reached the beach. "It'll be quite a long time before we're back in port."

"I don't care how long it takes," she almost pleaded. "I want to get away from this dreadful, God-forsaken place."

"How'd you get here in the first place?" Goodnow asked.

"No choice! That man over there called Asa Dobbins brought me," she said, a biting tone to her voice. "I'm his prisoner."

"My ship's not fit for a woman." He gave my mother a more serious appraisal. "We could not provide any privacy for you."

"I'll sleep on the floor in your cabin." She replied, and offered him a warm, knowing smile.

Startled, he backed away and looked her over more carefully. "Do I understand your meaning?" He asked at last.

"You do, sir." She tried to take his hand.

He continued staring at her.

"Aren't I pretty enough?" She asked.

I tried to make myself invisible and slowly inched away from momma, feeling the churning in the pit of my stomach.

As quickly as my legs could move me, I went to the wagon where the keepers were unloading their tools. From there I stole glances at Goodnow and momma. He walked away to the water's edge and shouted to his men on the deck of *Vigilant*. "No flood tide till evening. Lighthouse keepers comin' to help. I figure she'll float free if we unload the lumber. Keeper says there's a cove a mile or so east where we can anchor and reload." He turned back once to look at momma, and then came toward the wagon where the keepers were waiting.

By late afternoon the lumber had been unloaded, floated ashore and stacked on the wagon. *Vigilant* rode higher in the water as the tide started to run in. After an hour, the ship's timbers begin creaking and moaning, and the hull slid free of the rocks. The crew sailed her to the cove and anchored close to the shore. The wagon followed along the beach. Carrying the lumber off the wagon, keepers and crew floated it out to the ship through the shallow water to reload.

With the sun sinking into the western ocean, and the lumber safely back on board, Goodnow thanked the keepers for their help, and said goodbye. Wading out to his ship, he clambered aboard and ordered all sails set.

Later that evening papa climbed into the tower to light the lamp again, and pull back the curtain around the lantern. I went with him to my usual spot staring out over the darkening waters.

"There's a sailing ship out there, Papa," I told him, pointing. "Hurry and light the lamp so they'll see it. Do you think that's the ship that was on our beach today?" I asked, with a hopeful note in my voice.

"I don't think so, Baby Girl. That ship should be a long way away to the south by now." He chuckled as he patted the top of my head. "But that ship out there now will see us all right. We'll keep them safe." He stood beside me for several minutes, looking out, and sharing the quiet with me, watching the early evening sky darken imperceptibly before fading to purple and blackness.

"Who will keep us safe, Papa?"

"We're a family here, Baby Girl. We keep each other safe."

I tilted my head to one side and looked at him quizzically. "Who will keep momma safe?" I asked. "Momma's gone."

"What? How?" There was a lost look on his face.

"On the ship."

Quite stunned, he put his arm around my shoulders and stayed quiet, looking for words he wanted. "I'm so sorry for you," he said finally.

"Don't be sorry for me, Papa. I think momma didn't like us too much."

"I think you're right, Emma," he mumbled in a quiet voice.

I tilted my head again to look up into his sad eyes. Will you leave me too, Papa? You said you would keep me safe."

"Always Emma, I promise. You'll always be safe with me."

When I finished telling Lucien my story, he came to stand behind my chair, wrapping one arm around my shoulder and kissing the top of my head. "Were you lonely after that?" He asked.

It's my turn to purse my lips and pause to consider his question. After a silent moment, I tell him, "I don't think I knew what being lonely meant then, Lucien. Papa and the other men worked hard every day and took shifts tending the light at night. I had to find things to pass the time so I became quite independent. I had my sketchbook and a wild, beautiful place to explore each day."

"How exciting that sounds. Did you go to school?" He returned to his chair next to me.

"I was only in school about a year. When papa died, I had to leave the lighthouse and go to work."

"You were an orphan then," he asks me. "Why did you leave the lighthouse?"

The evening after papa was buried on the bluff at the edge of the point overlooking the ocean, I climbed to the light as I always had with him. Head Keeper Robert Smith came up behind me to light the lamp. He stayed quiet while he worked but when finished he came over to me.

"Papa and I always climbed up here together early in the evenings to light the lamp," I told him. "We loved watching the beam of light flash over the water. On stormy nights, when the clouds seemed almost to be resting on the crest of the tossing waves, it was wonderful how brightly the light pierced the darkness.

"When it was calm and peaceful under the light of the moon, or just the stars," I continued, "the silence and majesty of it was inspiring. And when a storm raged, and a lonely ship struggled along, aided by papa's light, I thought he was the strongest, most powerful man in the world."

Smith encompassed me in his bear-like arms, hugging me tightly. He struggled to find a voice to express his feelings. "I am sorry for your loss, Emma." Then he paused to gather breath and told me. "You cannot continue to live here with us any longer."

It came like a clap of thunder in a clear sky. I stared at him incredulously.

"It would not be right for a young girl to be living with three older men," he continued. "You will have to leave the lighthouse as soon as it can be arranged."

"Did you make friends in Santa Barbara?" Lucien asked.

"No, not until I came to Paris. Grace rescued me at *Gare Saint-Lazare* when I got off the train from *Le Havre*." I can feel my eyes filling up with tears. "I learned to be independent growing up, I never had anyone to be close to. I'm afraid I'm still that way. It's hard for me to make friends. Look how I neglected Grace when she needed me the most."

Saying that brings a sob so deep in my chest, I shake momentarily, and turn away from him. He quickly cradles me in his arms, holding me while I cry. He holds me like that without speaking until my tears subside, and then he takes a silk handkerchief from his pocket and dabs them from my cheeks. "I'm so sorry, I didn't mean to pry into your life," he says.

"I'm a mess," I sob, looking back into his face. "I should go away. If you don't want me to continue with the commission, I'll understand."

"Don't want you? No! We should get right back to it. Can you come tomorrow?"

Looking up into his kind face, his forehead slightly wrinkled now, showing his concern for me, I tell him, "You remind me of

papa with your gentle ways, Lucien. I've never talked like this to any man, except him. I feel safe with you. If you'll have me, I'll return as often as you like until we've captured all of your fine qualities on canvas."

"I'm really not so old, you know," he says. "Certainly not old enough to be your father, but I am honored that you have shared your story with me."

CHAPTER TWENTY-FOUR

Spring 1875

LUCIEN'S PORTRAIT PROGRESSES slowly. It seems to me he is in no hurry to bring it to a conclusion, and that's fine because I like spending time with him. My feelings for him have grown although I can't explain why.

Toward the end of January, I am surprised when a note from Edgar Degas is delivered to the flat.

> *Mademoiselle Dobbins,* he writes,
>
> *It has been four years now since I painted you as a young ballerina. In a week's time, at the grand opening of Théâtre de l'Opéra—our opulent new opera house designed by the architectural upstart Charles Garnier—I have been invited to exhibit my art in the Grand Foyer during intermissions. Paul Durand-Ruel is arranging it, and he is including my painting of you in the gossamer dancing dress. For that reason, and also because I am anxious to see you again, I invite you to accompany me on that evening.*

He goes on with details, but my eyes only skim the words as the excitement of being present with him at this important event sinks in.

A day or two later, my excitement at being with Degas when the first-night crowd at l'opera views his painting of me, dissolves like morning fog. Concluding one of our

dinners together, Lucien invites me to accompany him to the same event.

"My bank has provided much of the funds to complete this building," he tells me, "so I will offer a few words at the beginning of the performance. I would be honored if you would accompany me."

"Oh, Lucien," I hesitate, my heart is pounding. "I would so much like that..."

"It's settled then. I'll send the carriage for you."

"No, I don't think..."

"What then?"

"I can't..." I'm crushed, unable to explain.

"May I ask why?"

I take a moment to compose myself, and then tell him weakly, "I am so sorry..." I stop again and sit desolately across the dinner table from him, looking down at my plate to avoid eye contact, the way I used to do as a little girl when I was being reprimanded.

"Perhaps I should be the one to apologize," he says, after the long, awkward, silence. Letting his gaze wander to the far end of the dining room, he goes on without looking at me. "No need to explain. I should not have taken your acceptance for granted."

I gulp. "Under any other circumstance I would be proud— more than proud—to be on your arm for this important event..."

"Can you say what is keeping you?"

"Please understand. *Monsieur* Durand-Ruel has arranged for an exhibition of Edgar Degas's paintings in the foyer of *l'Opéra* that evening. The painting *Monsieur* Degas did of me in a ballet dress will be included, so he has invited me to accompany him, and stand with him at the exhibition during the intermissions."

"I see..." Lucien's voice fades off. He waits another moment. "I see," he says again. "Then you should definitely be on his

arm that evening." His voice is almost a whisper that sounds constricted in his throat. He keeps his eyes averted. "I have assumed too much—I'm sorry—but at least I will see you there." He looks at me and forces a smile.

On the eve of the event, I dress in a rust-colored silk *Maison Worth* gown and ride in the carriage with Degas to the new Opera House. I am overwhelmed by the over-wrought magnificence of its massive entrance, extravagantly illuminated by a seemingly infinite array of candles. Dominating the center of the lobby, a broad, white marble staircase rises half way up before branching to left and right and continuing up to the foyer, where the stage and boxes are hidden behind solid oak doors.

The staircase is crowded with Parisians in no hurry to find their seats, more interested in posing in their fancy gowns and top-hatted formal wear along the stairs in small, lingering, conversation groups. Clinging to Edgar Degas's arm as we climb, I am startled to see Lucien in a long-tailed evening coat standing with a small *coterie* of men on the landing where the staircase splits. More than a little uncomfortable, I scan the *haute bourgeoisie* of Paris as they arrive below us to avoid making eye contact with him. I feel a shiver of anticipation but also dread for the moment when we will come face to face. My heart races as we mount the stairs.

"*Bonsoir, Monsieur* Maître," I extend my gloved hand and hold onto his just a bit too long, giving him my best coquettish smile, but a formal greeting. "It seems as if all Paris has come out this evening to be seen in *Monsieur* Garnier's masterpiece."

He steps away from the others, bows to me, and exchanges pleasantries with Degas, but his welcome sounds guarded.

"I understand that one of your fine paintings of our *Mademoiselle* Dobbins will be on display," he says to Degas,

shifting his gaze from me, with an intensity in his eyes I have never seen before. "You are fortunate to have such a lovely young woman, and fine artist in her own right, as your companion this evening. Alas, I do not."

Degas guffaws, not getting the impact of Lucien's words. "Lovely indeed! Far fairer than your typical ballet rat, that's certain. I hope you will come by the exhibit during an intermission, Sir, to admire her on my canvas."

Still holding my arm, Degas starts to move past Lucien, but he takes a step to block us. "Has *Mademoiselle* told you she has a commission to paint my portrait? It will hang in my bank."

I turn away, to look out over the railing, praying silently there will be no confrontation between the two men.

"No, she has not," Degas says. "A good choice, I suppose. And in your bank!"

"Oh, *oui*, a very good choice." Lucien takes a step closer to Degas, pointing his finger sharply at his chest. "Did you know she and I are very close? I have purchased one of her canvases for my collection. And perhaps your painting of her in ballet dress might be available?"

"Speak to Paul Durand-Ruel, my dealer," Degas tells him. "He will be here this evening. I believe you already know him."

"*Mademoiselle* Dobbins is a wonderful artist," Lucien says again. "She is a gem to me. And, as people say, the diamond never knows its own value." With that and a quick glance at me, he bows stiffly and hurries up the final stairs to the foyer.

When we arrive at Degas's box, on the third tier of the theater, and take our seats, I can look out on a sea of shimmering crimson and gold. I'm startled when the door to the box behind us bursts open and Lucien charges in. Glancing at me, he turns to confront Degas. "*Monsieur* Degas," he starts almost breathlessly as if he

has raced up the three flights of stairs to say whatever he will say next. "I am very much committed to buying your painting of *Mademoiselle* Dobbins. Will you agree now to sell it, and I will discuss the details with Paul Durand-Ruel at the intermission?"

Nonplused, Degas nods agreement. The two men shake hands, then Lucien bows and backs out of the box as quickly as he came in, without a word to me.

"*Monsieur* Maître seems very fond of you," Degas says softly to me as the house lights dim.

I stay silent for a moment, watching the actors on stage, feeling a soft glow. "He is a very good friend to me," I tell Degas.

In the dim light he has a twinkle in his eye, but tells me in his sarcastic voice, "Good friend is it? Perhaps it would be best if I share you with him tonight. Why don't you join him in his box now, but be sure you come to stand with me during the intermissions by your portrait."

Smiling my appreciation, I touch Degas's cheek as I slip out of my seat and leave the box, quietly closing the door behind me. Entering Lucien's box, I take the empty chair next to him. Momentarily startled, he turns to me, and a smile, brighter than I've ever seen before in him, lights up his face. In the shadowy darkness of the box he takes my hand and leans over to whisper in my ear, "You are very special to me."

"And you to me," I reply.

When the first intermission comes, I hurry to the Grand Foyer and find Degas already speaking with Paul Durand-Ruel. "*Bonsoir, Mademoiselle* Dobbins," Durand-Ruel greets me. I was just telling *Monsieur* Degas how much I like the way he captures the reality of the backstage life of the dancers—not so fine as what the audience sees—*n'est-ce pas?* And his painting of you is charming, *Mademoiselle.*"

"Is that you I see on the canvas?" a loud female voice cuts through the throng of people milling around the marble-columned foyer. "Here in person and again on canvas? So fine to see you tonight, Emma." Sarah Bernhardt intrudes herself into our conversation and steps between the two men to exchange *bisous* with me. She nods a greeting to Degas, and he introduces Durand-Ruel.

"Did you know *Mademoiselle* has painted a fine portrait of me in my dressing room at *l'Odeon?*" She says to both men, secretively winking at me.

"I did not," Durand-Ruel answers, a surprised look on his face. "Perhaps you will show it to me, *Mademoiselle*," he says to me. "It might look well in the window of my gallery."

"I would be pleased to bring it to you to inspect if you like," I answer him, instantly feeling a tinge of excitement charging through me.

"On *rue de Pelletier*," he says. "At your convenience."

"Now, just a minute," Degas interrupts in a semi-jocular voice, "This is my exhibition, not the lady's. And *Monsieur* Maître has already committed to buy her portrait."

Sarah Bernhardt gives me another private wink. She turns to Degas, and gently tugs his arm, saying, "Come now, *Monsieur* Degas, there is always room for a fine young artist like Emma Dobbins. Be proud that you have already painted her so perfectly. The value of your portrait can only rise, as will her portrait of me." She smiles and nods to each of us then backs away from the conversation.

I watch her move from group to group in the foyer in her familiarly bold, almost intrusive, way. In the distance, down the long white marble corridor lined with baroque nymphs and cherubim statuettes, I am startled to see Amélie approaching.

This evening she wears an elegant gown in a turquoise blue shade that hugs her hips and leaves much of her bosom exposed. I turn away and pretend not to notice her, but she keeps on coming and stops directly in front of the easel holding my picture. I still try not to notice her.

After studying Degas's paintings a few moments, she turns to face me. "This is a fine painting of you," she says in a subdued voice.

I look at her for several moments without speaking, wondering what this strange young woman is all about. Finally, showing her the blandest face I can, I ask her, "Do you copy paintings like this one?"

"I derive pleasure copying great paintings," she says after hesitating momentarily.

"Have you copied any paintings of me before?"

The question seems to rattle her. She keeps her eyes focused on Degas's ballet art. "I don't think I understand what you mean, *Mademoiselle*? Copy you?" She stammers.

"I mean have you ever copied any paintings of me?"

"Well, no," she says after pausing to recover from the question. "Of course not. As you know, I only copy the old masters I see in the *Louvre*."

"No paintings outside the *Louvre*, is that what you would have me believe?"

"Exactly! Is there any harm in that? I only do it to amuse myself and perhaps the gentleman I am with."

Her answer puzzles me for a moment. "Do you amuse more than one gentleman then?"

"I came to admire Degas's art and compliment you, *Mademoiselle*, not to be questioned or insulted." With that she turns on her heels and stalks off down the long corridor.

Lucien and I sit hand in hand for the second act of *La Juive*,

but I leave him again at the next intermission and return to the foyer. He takes my hand and holds on for a minute, preventing me from going, but then relinquishes it when I promise to return when the intermission ends. I stay briefly with Degas again. Then I take a break and begin walking the long ornately decorated foyer, looking at each knot of opera goers I pass. Ahead of me I see Lamar Legrand is engaging several young women in conversation in a small alcove near the grand staircase. I duck behind a column that gives me some concealment so I can watch him until the end of the intermission. When the gong chimes for the third act, Amélie passes me in a hurry, going the opposite direction. When she arrives at the alcove where Lamar had been entertaining the ladies, and now stands alone, she takes his arm and together they proceed back into the theatre.

Spring of 1875 signals a farewell to lingering gray winter days. The air along Paris boulevards is filled with faint perfumes as trees creep into bloom and parks come slowly to life with flowering shrubs. I hardly notice the transition as I go back and forth from *Auteuil* to *Montmartre*, from the joy of painting Lucien to the sadness each evening when I climb three flights of creaky wooden stairs and open the door to my flat. Little Clarise rushes to wrap her arms around my legs, freed from the confines of the small room where she spends the day keeping watch on her *maman*. Grace languishes on the bed, half in, half out of sleep, coughing blood when she tries to sit up.

I take Clarise back down the stairs so she can play in the sunshine in the tiny park nearby, and then she helps her auntie shop for dinner. Peeking in again on Grace when we return, I straighten her bed and help her change her soiled nightdress.

Summoning my best smile for her—which no longer comes easily—and my softest voice, I wrap my arms around my dearest friend. "You have more color today," I tell her. "The bed rest is doing you good."

Grace attempts a weak smile, and she quickly abandons the effort. "*Le même,*" she all but moans.

"I'll bring you some food. I'll make a broth."

"*Pas de nourriture,*" she murmurs. Closing her eyes, she turns back toward the wall.

I put my hand lightly on her shoulder and hold it there for several moments. Tears moisten my cheeks.

When I go back to Lucien's townhouse the next day, I try to shake my uneasy feelings, but I can't, and Lucien judges my mood instantly. "Why don't we sit in the garden awhile to enjoy the morning," he suggests. "Come see how bright and colorful it is becoming. We can paint later."

The warmth of his voice crushes me. Looking into his face, his pale green eyes seem almost to reach out to embrace me with his caring. My torrent of tears starts without warning. Coming closer, taking me in his arms, he holds me silently while my heartache spills out on him. Without a word, he eases me to a stone bench where we sit together, still embraced, until my crying stops.

"I am sorry," I tell him in a quiet voice. "I have no right bringing my sadness to you."

"You have every right! Two people who care for each other always have that right," he answers. He stops to brush a tear from my cheek. "Would you consider moving here with Grace and her daughter to live in my house? You would not have to travel back and forth, and she would be more comfortable in her final days."

I jerk back from him and sit upright. "Don't say that! I can't bear to hear it."

"I'm right, you know," he says as gently as he can, clasping my shoulders and looking compassionately at me, "You must know your friend is dying. All we can do is make her comfortable and show her our love. We can't save her."

"I... know... I can't face it." My voice chokes. "I can't bear to lose her... I keep feeling there is something..." I stop and take a breath. "Something I can do if only I knew what." My tears flow again. When they stop, my voice takes on a bittersweet quality. "I feel so guilty about neglecting her."

"I understand. You feel helpless. I've lost loved ones too. But do you really believe you could have stopped the coughing disease?"

I fail to hear his words so wrapped up in my own misery am I. "Probably not," I concede, "but I could have provided her a better place to live than Martin's flat."

"Really? You think you could have taken her away from the man she was married to?"

"He is a monster!"

"Indeed, it appears so. Why did she marry him?"

"She told me once she had no choice. No one else would marry her, she said, so he was the best she could do."

"There is the sadness! The horrible truth," he starts, anger rising in his voice out of nowhere. "Our society is so rigid a workingclass girl like Grace feels trapped... is trapped! She is condemned to live in a rat-infested apartment, with insufficient food because there is no work for her, and her husband drinks—and, God forbid, beats her—because he can't find enough work to feed them. In Paris, workingmen earn no more than two or three *francs* each day—women even less. His manhood is lost.

That was Grace's lot in life." He stops to take a breath and looks away, staying quiet for several moments. "I'm sorry," he says, finally turning back to me, "I get angry when I see the way so many workingclass people in Paris are forced to live hopeless lives... At least I can give Grace a safe and comfortable place. She will die if she stays in your flat."

"And she won't die if she is here?" I snap.

"No, of course not. It's too late for that."

"Lucien, I must care for my friend myself. No one else! That is the least I can do for her. It's my obligation."

"And the child? Little Clarise?"

I pause and draw in a deep breath. "When the time comes, I'll raise her as my own."

Late that afternoon, on the way back to *rue Lepic*, I ask Lucien's driver to stop the carriage at the *Marché aux Fleurs* where I buy several bunches of spring flowers. Clarise claps her hands with glee as her auntie opens the door to the flat and gives her a bunch of yellow daffodils to take to her mother. I wait a moment and then follow the child into the bedroom. "Spring is really here, Grace," I tell her in a perky, hollow voice. "Look what Clarise has brought you."

She tries her best to smile. Rising up on one elbow, she enfolds her daughter in a weak arm that is bone thin. "*Merci ma belle fille*," she whispers in a shallow, gravelly, barely audible voice that rattles in her throat. "*Maintenant allez et jouer.*"

Leaving the flowers on the bed beside her mother, Clarise runs back into the main room. Grace struggles to sit up and can do so only with my help. We sit together on the edge of the bed, my arm supporting her back. "What will happen to her when I'm gone? "She asks.

I search for words. "Don't worry, *ma chère*. You'll be fine."

"Don't think my brain is addled, Emma." She summons enough breath to give her words emphasis. "I know I'm dying. Tell me you will take care of Clarise when my God beckons to me."

It is the first time we have confronted the reality facing us. Always before, one of us assured the other she would soon be well again. Now I tremble, shaken as her words sink in. It is no longer possible to deflect the truth, no longer believable to try to mask the inevitable in false promises. I stare down at her wasted body beside me on the bed and see it clearly. No longer can I pretend the limp ragdoll resembles the young woman who rescued me in the train station all those years ago.

"Do not worry, my sweet Grace," I whisper to her. "I will care for Clarise always. And she will always remember her mother. And the life you gave for her."

"Give her a better life."

Words choke in my throat and only a croaking sound emerges. I nod my head, speechless, as I look down on the life beginning to flicker.

Tossing in my bed that night I find no sleep. In the dark, small hours, when *rue Lepic* slumbers, I rise and go quietly into Grace's room. Clarise is asleep on blankets spread on the floor. The room is still. I sit on Grace's bed, then lie down beside her, taking my dearest friend—the friend I almost lost to my own selfishness—in my arms. The minutes tick by. The bells in a distance church chime the hour. A lone horse draws a wagon down the street, its hoofs echoing off the cobblestones, the bell around its neck softly ringing. In the darkness Grace's life slips away, as silently as a bird taking wing. I continue speaking to her in a quiet voice long into the dawn, telling her of my sorrow for not being a better friend. It is only when Lucien climbs the stairs hours later and taps on the door that I relinquish my embrace.

Seeing me so disconsolate and incapable of making decisions, he takes charge of the final arrangements. "We could find a peaceful spot for her final repose in the *Passy Cemetery*," he suggests.

"Oh, no!" I protest. "No, not there. Never! She would be uncomfortable surrounded by all the *haute bourgeois Parisiens* buried there. No, Lucien, we must bury Grace in *Batignolles* or *Montmartre* where she will have her parents and friends, and feel comfortable." I stop for several moments and then look desperately at him. "Will that cost? Grace had no money and I don't have very much. Can I afford a plot of ground in *Cimetière de Montmartre*?"

"Do you think I would allow you to pay?" He takes me in his arms. "I will take care of details like that."

In the sanctuary of his embrace I feel safe again. Looking up at him, the calmness of his expression washes over me. Realizing how completely I have put myself in his charge, trembling a little at the thought, and knowing without him I would be lost, I tell him softly, "Please help me. There is so much to think about, and I don't know what to do."

"I will. Will you want a priest?"

"Oh yes, Grace was very devout."

"Will you notify her friends?"

"Yes... But what about Martin?"

"I think he should know."

"He'll try to take Clarise."

"Hmm. You're right. He might follow you. I think we should take her to my townhouse."

"Your townhouse?"

"You can't stay here either. You and Clarise can come live there. There's a whole separate wing that could be yours. I

promise you will have complete privacy. And you can still use this flat as your studio—come here whenever you like."

"You've thought this all out haven't you."

"Not until now, Emma, but I think it is a good plan for many reasons if you will agree."

"You've done so much already..."

"To keep the child safe for a while. It would be my genuine pleasure to help."

I see his face brighten as he talks. I can't think of reasons to refuse, although the idea gives me an unsettled feeling. After a thoughtful pause, I smile at him. "We can try it, but you must tell me if it doesn't work for you and I will do the same. We must be honest with each other."

"There will always be honesty between us."

Mid-morning two days later, a team of coal-black horses, drawing a black hearse, stops in front of the flat. The driver and another black-suited man climb to the third floor where they heft Grace's coffin on their shoulders and take it back down the stairs. Lucien's carriage, draped with black crepe, arrives behind the hearse. In mourning attire, he climbs the stairs to escort Clarise and me, wearing new black dresses he purchased for us the day before at *Le Printemp*. My veil is drawn over my face, partially hiding the redness of my eyes, and giving me the privacy I need to mourn.

The procession starts down *rue Lepic* to *blvd de Clichy*, where a cluster of young laundry girls and a few other curious locals fall in behind. The meager procession turns into *ave de Cemetery du Nord* and enters the cemetery grounds. At the gravesite an old priest, in black cassock and flat padre hat, clasping a well-paged bible, awaits. The service is brief and impersonal. The priest mumbles a litany hardly even aware of his own words. Then the

laundry girls wander away as the wooden coffin, a cross carved into the lid, is lowered. Clarise clutches my hand, shifting from foot to foot, bored and unaware, and Lucien stands close by, holding his top hat respectfully in his hand. Twenty-five meters beyond, Martin Aboud leans against an elm tree watching. As the casket sinks below ground level, he turns away and makes no effort to approach.

CHAPTER TWENTY-FIVE

Fall 1875

THE WING OF Lucien's townhouse is actually a private apartment consisting of two bedrooms, large sitting room with windows overlooking the walled garden, a bath with indoor plumbing, and a small dining room where Clarise and I are served by one of the kitchen staff. I offer *Madame* Allard employment as my lady's maid, which she quickly accepts.

One warm, early summer evening, with only a zephyr of a breeze wafting off the river, I'm sitting in the garden watching Clarise play when Lucien joins me.

"Since we finished the portrait I don't see you as much anymore," he greets me, smiling, and sitting on the stone bench beside me, where we're shaded by one of the fruit trees. "I miss our times together," he says, taking my hand.

"I do too," I reply, snuggling a little closer, "but I'm happy you are pleased with my work."

"More than pleased," he says, squeezing my hand for emphasis.

"Where will it hang in your bank?"

"In the lobby, as soon as it's framed. I want you to be there."

"I'm excited to see it, nervous, too," I tell him. "I could never have expected one of my paintings would be seen in such a prestigious setting."

"*Oui*, a far cry from the *Hôtel Drouot* auction room, I'd say. Your art has made immense progress since then."

"You never talk about your work, Lucien, but I know you must be a very important man."

"Important? Perhaps," he responds. "But really just born to the right parents. My family claims a history in France going back a very long time."

"Really?" I stare at him with a look of awe in my eyes.

"My family can trace its roots back to the early 16th century."

"I can't believe it." His words leave a lump in my throat.

"It's true. My ancestors came from a small village called *Vienne* in southern France on the *Rhone* River. They were traders. Probably pirates too," he chuckles. "But my *maman* never talked about that."

"You are from a very wealthy family, aren't you? It must be a great fortune?"

"Our family grew rich over the years, *oui*. Many generations back they traded all over the *Ligurian Sea*, from *Marseilles* to Genoa and down the Italian coast to Livorno."

"And they become rich as pirates and traders?"

"No." He shakes his head, laughing. "No, not as pirates and traders. That was the start certainly, but as time went by they established trading companies along the Mediterranean coast. Being Jewish, they began lending money to other merchants. Eventually, those trading companies became banks."

As he talks, a darker mood comes over me. Tears form and start to roll down my cheeks. I look down at my hands and away from him.

"What is it?" he asks, sudden worry clouding his face. "Have I said something to offend you?"

Looking up at him again, I can't speak. I rub my eyes, but my tears

continue. He takes a handkerchief from his coat pocket, embracing me with one arm while his other hand dabs at my cheeks. Smiling wanly, I take his arm. "I am sorry," is the best I can manage.

"What have I said that upsets you so, *ma chèrie?*"

I try to pull myself together, clearing the tears from my face and sitting up straighter. I smooth my skirt, stalling for a little more time, but still feeling a void deep inside.

At that moment Clarise races up to us. "Auntie Emma, come quick."

"What is it, child?" I ask her, startled back to the present.

"I want you to come smell the flowers with me."

"I'm sure they're wonderful, *ma chérie*, but not now," I tell her. "Play some more while I talk, then I'll come see them with you."

She puts on a pouty face, staring at me for several moments, then runs back down the garden path.

Lucien looks at me, waiting for me to continue.

"You wouldn't understand," I tell him.

"I would try."

"I felt so tiny as you were telling me about your family. I feel like I am only a flower in your garden. I have no right to be in the company of such a distinguished gentleman with such an impressive heritage." Tears begin anew. I can barely get my words out. "I have no background... None! I told you my mother deserted us when I was five. I never knew anything about my father except that he made a fortune panning gold in California and then lost it. The only job he could find was as a lighthouse keeper... I don't even know where he came from... Or who my ancestors were. Or where they came from. I have no history."

"I understand. And I see how sad that makes you."

"No, Lucien, you don't understand!" I tell him, my voice raised. "You couldn't possibly understand."

"You're not alone now," he soothes, "you have Clarise... and me. We both love you."

I stop for just a second to let his words sink in. "Can't you see I don't even know how to be a friend? Grace was the only one I ever had, and I let her down. You can't possibly understand, Lucien, I've missed out because I was alone so much." Stopping momentarily to take a breath, then, without thinking, "And now I'm afraid I'll lose you."

"Didn't you hear me, Emma? I said I love you."

My eyes widen as I look at him. A desperate feeling contorts my face into a frightening mask.

"I think I love you, too," I tell him after a long silence, "but it scares me because I don't want to lose you."

We sit staring at each other for several moments, neither capable of expressing our feelings. The silence continues but is finally broken by Clarise running up again and tugging at my skirt. "Auntie, come see the flowers now. Bees are buzzing around them. And birds."

"In a minute, sweet girl," I tell her, feeling conflicted, pulled in two directions. "In a minute, after I finish talking with *Monsieur* Maître."

"She can call me uncle if she likes," he says, reaching out to grab Clarise and hug her to him.

She wiggles away.

"Would you like that?" I ask her, happy the subject has changed at least for the moment. "Would you like to call *Monsieur* Maître uncle?"

"*Oui*, Auntie, Uncle Maître, *oui*," she giggles.

"No, no," he interrupts, "Uncle Lucien."

"Come Auntie. Now! I want you to come with me."

I give Lucien a what-can-I-do shrug, momentarily resting a

hand on his shoulder as I get up from the bench. I welcome the break to calm my emotions. With Clarise still tugging on my skirt, I follow her down the path, looking back at him sitting on the bench, still smiling at us, and wonder what the next few minutes will bring. Clarise leads me to the far end of the garden and points to a golden-plumed bird perched in an elm tree by the far wall. Holding her hand, while she chatters away about her discovery, I try to sort out my tumultuous thoughts.

"Do you like living here, Clarise?" I ask her, as she points to the bird and then the multi-colored profusion of flowers in the carefully tended beds along the path.

"Oh, *oui*," she responds. "Smell the flowers, they're like your perfume. There are so many pretty flowers and birds here at Uncle Lucien's house."

When I can leave her and return to the bench, I'm prepared to take a new tact. "You are a wealthy man, Lucien," I say, sliding close to him. "And I am very far from that. I never think much about it, but you treat me like a... like a princess. You never talk about yourself, but the signs are all around—I'm living in your mansion with servants taking care of my every need. Your grand box at *Longchamp* and the one at the opera are the best in Paris. The finest horses draw your carriages. The funeral you arranged for Grace gave her fine dignity."

"You *are* a princess to me," he interrupts. "I've never known a young woman like you before."

"Have you always lived here alone?" I ask him, again steering the conversation in a different direction.

"Alone?" he pauses, then looks away, out toward the far end of the garden smiling at Clarise, now busily investigating insects buzzing around the flowers. "No, not always alone," he says looking back.

"I didn't mean to pry."

"You didn't. Your question just surprised me. Yes, with a woman when I was a younger man—"

"You told me before you were never married."

"Hear me out. Arranged by my family. She was a fine woman... I think, but she died just after our wedding. Cholera took her."

I hug him. "I'm so sorry. And you've lived here alone ever since? Weren't you lonely?"

"I was until I met you."

My cheeks redden. A tingle of happiness runs up my spine, and for the first time, I entertain thoughts I've never had before. I offer him a big smile and can feel the dimples at the corners of my mouth. "You rescued us," I tell him. "I don't know what we would have done without you. Look how happy Clarise is. I can't imagine not having you in our lives."

"And you? Are you happy?"

I reflect a moment then tell him, "Yes, I am. I've never thought much about being happy before. Until Grace..."

"I am so pleased to hear you say yes." He sits erect and turns more completely toward me. "I have a proposal to make to you."

For an instant, a doubt surges through me. I look away at Clarise running up the path with a handful of flowers she has picked. Unsure whether to look back at Lucien or get up and escape to the girl, I stay quiet, sitting beside him, waiting.

"I am growing tired of working so much at the bank," he begins. "I would like to take my life easier. I think it is really time to start the new art collection I mentioned at *Longchamp*. I am convinced you and the new artists who are painting modern life will make a lasting mark."

When he stops to gather his thoughts and take a breath, I feel an emotion I am unable to understand. In part, it is a sense of

relief, but it contains a large measure of disappointment, too.

"Gone are the religious and mythological paintings that hang in museums," he goes on. "Even the historical art of Meissonier and Cabinel's ultra romanticism have lost their relevance to our time. We need to collect and preserve the very best of the new art. I can't escape my family responsibilities at the bank completely, but you could be my scout and purchasing agent."

I let out a deep breath, and don't talk until my beating heart slows. "What a grand idea, Lucien. But I'm not sure I can do the kind of job you expect of me."

"Who better? You know the artists and can speak their language. You would have no concerns, you know, I have sufficient funds, and we would obtain the services of Paul Durand-Ruel. What do you think?"

Exhaling a deep breath again, and disappointed with myself for jumping to conclusions, I tell him, "I'm overwhelmed. I would like nothing better. I only worry about letting you down. Will *Monsieur* Durand-Ruel take me seriously?" I stop talking so fast and look into Lucien's eyes, seeing his happiness there in the broad smile and bright eyes. It takes only a moment for me to decide. I take his hand. "Lucien, will you marry me? So we can always be together."

Shaken, and at a loss for words, he just looks at me for several moments, grinning. "Yes!" he says, at last, almost laughing. "Yes, you have just made me the happiest man in the world." Standing, he enfolds me in his arms and kisses my lips.

⁓

A few days later Lucien assists me into his carriage. Wearing my best day dress, and carrying my portrait of Sarah Bernhardt, we head for the city. He holds my hand and I sit close to him as

we ride from *Auteuil* along the river, around the *Arc de Triomphe* and into the city's financial district where he leaves me and hurries into his bank. I instruct the driver to continue on to ll *rue Le Peletier*, where Paul Durand-Ruel's art gallery sits close to the corner of *blvd Poissonniere*. On the way, as other carriages and lorries make room for me, I recall the awe I felt watching Princess Mathilde on *rue de Rome*. Now it's me.

"*Bonjour, Mademoiselle* Dobbins," Durand-Ruel greets me. "A pleasure to see you again. Ah, I see you have brought a canvas with you."

"I brought the portrait of Sarah Bernhardt you asked to see."

"Oh, *bon, Mademoiselle.* I was pleased to help *Monsieur* Maître acquire Degas's wonderful ballet portrait of you. Now I am anxious to examine the canvas you promised that evening."

With that, he takes the painting out of my hands, puts it on an empty easel near the window, and begins scrutinizing it while I standby nervously. Taking his time, he views it from several angles, nodding occasionally and mumbling to himself. A good ten minutes pass before he turns back to me. "Very nicely done," he says. "It is a fine likeness, and I like that you have captured the reality of her backstage life rather than the glamour of the footlights. Well done. What do you say to my putting it in one of our windows to see what reactions we get?"

"That would please me, *Monsieur.* But I ask you not to sell it or make any commitments until you have spoken with me. You do understand I may not want to sell it for a while."

"Understood, as long as you agree to sell it through my gallery when you do decide."

"Agreed, but that's not the only reason I came here today."

I briefly explain the collection Lucien and I have discussed while he listens intently. "*Monsieur* Maître has purchased much

of his fine art from you, and we plan to make acquisitions of more contemporary artists," I tell him. "He is very impressed by what he saw at the exhibition people are now calling Impressionists. He has asked me to work with him on a new collection. I know you keep some inventory of those artists so I hope we can work together to start assembling a collection."

"Please come to my office, *Mademoiselle*, where we can have coffee and talk about your plan." He takes my arm and escorts me to his small office tucked into the back of the gallery. After I'm seated in an upholstered chair, he goes to a long wooden worktable where a large, leather-bound account book sits. An employee brings coffee and sets it down on a round serving table next to me. Durand-Ruel quickly thumbs through several pages, reading his listings rapidly to himself and making notes on a scratchpad. The smell of oil paint and lacquer blends with the coffee and fills the room, giving me a strong, familiar sensation as I wait for him to rejoin me.

When he finishes his search, he sits beside me and takes a creamer of warm milk from the table to add to his coffee. "I have done much business with *Monsieur* Maître over the last few years," he starts. "Indeed, he is one of my best customers, a real patron of French art. My records show recent purchases of Delacroix, Corot and Millet, and, of course only a few works by the newer artists—the so-called Impressionists. I have an inventory of Monets and Renoirs that I would be pleased to show you. I acquired them to help them out financially because they still lack patrons, and I believe in their ultimate success. But I would also suggest you look at some of the Barbizon School painters—Francois Daubigny or Thédore Rousseau might be good choices besides the Millet. I might lean more to Rousseau who has passed on since his work might tend to increase in value

more quickly. With more time I might find you an early Jacques-Louis David or an Ernest Meissonier Napoleonic work."

"Thank you, *Monsieur*," I set my coffee cup down on the table and address him earnestly. "I think the Meissonier does not fit our vision for the collection, but all the rest are good suggestions. If you can put together a private showing of those artists, I would be interested in viewing them."

"And *Monsieur* Maître? Would he make the selections?"

"You must understand how busy his business commitments keep him. He has empowered me to make recommendations, about all the art he wants to acquire, but I would always prefer to include him in the final selection of those paintings. What about the young Impressionists?" I ask him. "Which would you recommend that might have the best values?"

"As I said, I have inventory of Monet and Renoir. Also Édouard Manet and some of Albert Sisley's art, but Sisley is not French, of course. Nor is Camille Pissarro, born in St. Thomas of Danish parents, but both good artists."

"You have not mentioned Berthe Morisot Manet. I know you met her and her husband—do you not favor her work?"

"On the contrary, I do," he replies. "I favor her work very much. I am remiss in not including her. Forgive me; I tend to overlook the women artists. Rosa Bonhuer and Marie Bracquemond might both be considerations along with Berthe Morisot."

Taking a deep breath, I charge into the real point of my visit. "I want to ask about one other artist in particular. Do you own any works by the late Frederic Bazille?"

"Ah, Bazille, one of our best young artists! His career was cut short far too early by the war. I'm sorry to say no, *Mademoiselle*, I have no record of ever owning any of Bazille's work. A pity. I can only imagine how brilliant his career might have been had

he lived."

Without showing any emotion, I tell him, "I have reason to believe that Frederic Bazille's canvases were stolen immediately after he died and that some of them have been copied—or counterfeited, as you called it—and are being sold fraudulently to museums outside of Paris."

His small office suddenly becomes very still and tense. He stares at me open-mouthed. His face darkens, but his eyes seem to pierce me. "This is a very serious charge you have made, *Mademoiselle*. My business depends on the trust my clients place in my honesty. Any false representations, whether made by me or others in the art world, cast serious doubt on all of us."

"I am aware of that. You mentioned the possible existence of forgeries to Lucien at the exhibition, and Camille Carot told me, when I sat for him, his work has been forged, so I think you should not act so surprised."

"Do you have any proof of what you say?"

I knew he would ask. I've come to the point of no return. "If you will accompany me, I think you will learn first hand what has happened to Frederic Bazille's art."

Leaving his gallery, I have a huge hollow feeling in my stomach, thinking about the risk I'm taking. We join *blvd Haussmann* for the walk to *blvd Malesherbes*. As we go, I suggest to him that we use our familiar names since we will be working together in the future. "That would be fine, Emma," he says to me. I can hear the skepticism in his voice. "Please tell me why you think paintings have been counterfeited."

"I can show you better when we get to our destination. For now, just know that there are at least five of Frederic Bazille's paintings hanging in *Musée Fabre* in *Montpellier*. One he did privately for me."

"I see," he says, still in a noncommittal voice. "I hope you can show me more proof when we get where we are going."

Can I? My heart is racing.

Blvd Malesherbes is one of Baron Haussmann's new boulevards, lined with five- and six-story apartment buildings. I lead Paul up two flights of stairs in one of them, beginning to worry I have made a terrible mistake, worry that we will find nothing, and wondering how I will ever be able to redeem myself with him. Or with Lucien. I feel my anxiety rising. My hands are sweaty when I knock on the apartment door and wait. He stands well behind me as if he wants to make a quick exit back down the stairs if something goes wrong.

Seconds seem like hours before the door opens. When it does, I'm stunned beyond words by who opens it.

"What are you doing here?" The voice accuses me.

My first instinct is to turn and run back down the stairs to the street and keep going, but it's too late, and I finally understand. Straightening up, I summoned as much strength as I can. "*Bonjour*, Amélie," I greet her.

"What are you doing here?" she says again, giving me a very unfriendly look.

"I could ask you the same question," I tell her in the strongest voice I can manage. "We came to speak with Lamar. This is his apartment, no?"

"He's not here." She starts to shut the door.

Without thinking, I force the door to stay open. Pushing her aside, desperate now not to make a fool of myself in front of Paul Durand-Ruel, I push into the apartment's main room. He stays behind me in the hall.

A quick look around shows a level of disorder in the room. Books and newspapers are scattered everywhere, but none of

Frederic's paintings are in sight. The room itself is an example of the newly built apartments Lucien described to me at the *Hôtel Drouot* auction: plain bare walls with only very simple moldings—not the ornate style of the 17th century—and no high ceilings, but full height glass doors open to a narrow balcony overlooking the boulevard, and an assortment of what looks like hand-me-down furniture, not the quality chairs and couches that might have come from the Lamar family home in Lyon.

"You can't just barge in like this, Emma! You have no right."

Disregarding her protests, a feeling of panic beginning to nag at me, I charge down the hallway. The next room I come to is a bedroom, with an unmade high iron bed. "Do you and Lamar share it?" I ask her in a husky voice that surprises me as the angry words spill out.

"And why would that be any business of yours?" She almost shouts back.

Still, none of Frederic's art is visible. I'm frantic, but I hurry down the hallway to the room at the far end, a second bedroom that seems to have been converted into a study, or a workroom. And there I stop abruptly in the doorway and stare straight ahead. The nude painting of me is framed and hanging on the near wall. Gathering my wits from the shock, I see other of Frederic's paintings scattered around the room, some piled on a worktable, some stacked against the walls, at least twenty or twenty-five of them in all, I guess. My heart races. My stomach churns. My nude painting stares down at me from the wall. I feel as if I might vomit at any moment. "Paul, come in here," I call out finally to Durand-Ruel who has stayed behind in the parlor.

There is an easel set up in one corner of the room, with a half-finished canvas on it. Next to it, on a second easel, is a glorious still life—a blue and white vase on an ornate mahogany table

filled with a kaleidoscope of flowers spilling out of it. I recognize it as Frederic's.

"Look, Paul," I point around the room and at the easel, "do you need any more proof that this art is being copied?"

"That doesn't make her a forger," he reminds me in a subdued voice.

"There are at least five paintings in this room that also hang in the *Musée Fabre*, Paul, and I'm told there are paintings in *Marseilles* and *Toulouse* also."

"What is going on here?" a man's voice calls out behind us. Turning, I see Lamar Legrand striding down the hall. "Why are you here?" he shouts. "Get out Emma! Who is that man? Both of you get out of my apartment! Why did you let them in Amélie?" He comes into the room in a frenzy.

"I couldn't stop them. They forced their way in." She tells him.

"I'll call the *Gendarmes*. I'll have you both arrested."

"Just one moment, *Monsieur*," Paul intercedes.

"He has stolen Frederic's paintings, and now this woman is making copies he sells to museums," I tell Paul in a burst of words. Glaring at Lamar's face, all the lying he's done comes back to me. And now he's trying to lie his way out of this.

"This is a very serious charge *Mademoiselle* Dobbins is making." Durand-Ruel confronts Lamar.

"She's the one who's broken the law, forcing her way into my apartment and assaulting this young woman," Lamar shoots back.

"Your mistress, you mean." I almost spit my words in his face. "She's making the copies for you."

"Perhaps she is, but there's no harm in that, is there?"

"There is if it is the copies are being sold to museums as authentic," Paul responds.

"That's the reason you never brought me here to your apartment, isn't it? It wasn't your mother who was living here with you, it was your mistress, copying the art you stole from Frederic Bazille and brought here."

"Now just a minute!" Lamar steps into the center of the room so he can face all of us. "Amélie makes copies for her own amusement..."

"So she says."

Amélie slinks off into the corner behind her easel. "It's my hobby," she protests.

"Just like your mother crochets doilies, is that it?" I mock her.

"Can you prove you own these paintings, *Monsieur*?" Durand-Ruel asks Lamar.

The room goes quiet. We all stare at him, waiting. He looks around at each of us, searching for another lie, I think.

"Of course I can prove it," he says after a long silent moment. "I have a bill of sale from Frederic Bazille. He sold them to me before he went off to the war and I took possession of them after I learned of his death."

Suddenly my heart sinks. The voice in my head asks why didn't I think of this possibility? He's going to get away with it. But then the voice says what about our dinner with Renoir. That can't be right! He's trying to lie his way out of trouble.

"You used Renoir to cover yourself, didn't you? Then you tried to keep me close so I wouldn't suspect anything. You used me, too!"

"Do you have written proof of the sale with a date and a signature?" Durand-Ruel asks Lamar, giving me a very foreboding stare.

I look away, feeling my stomach tying itself in knots, imagining how badly he will think of me if this is true. And what Lucien will think.

"I said I did. I'll show you." Lamar moves toward a desk on the far side of the room, almost shoving me out of the way as he goes. He sorts through papers in the desk's drawers until he finds what he is looking for. Coming back, he all but thrusts it into Durand-Ruel's face. Paul takes it and steps back into the doorway to be alone while he studies it. Minutes pass slowly as he reads every line. My heart sinks lower and lower as they tick by. I can see my future—Lucien and my career—disappearing before my eyes.

Durand-Ruel drops his hand holding the paper to his side. He looks at me with condemnation on his face. "I'm sorry, *Mademoiselle* Dobbins, this looks to me to be a genuine bill of sale between *Messieurs* Bazille and Legrand. Everything is correct as far as I can see. Signed and dated."

"That cannot be!" I know Lamar Legrand to be a liar and a thief. My emotions are in turmoil. What can I do? He is going to get away with it. Amélie might get her hand slapped for copying a few paintings, but I can see Lamar getting away with his corrupt ways once again. Like father like son.

"All I am doing is selling off the originals and having copies made for my own enjoyment," Lamar tells Durand-Ruel. "There's no crime in that."

Trembling I reach out to Paul. "May I see the bill of sale?" I ask him, extending my hand, moving closer to him, and fearing my utter ruin.

He shrugs, nods, hands it to me, and steps back as if to escape being close to me. "See for yourself, *Mademoiselle*," he mutters. "Everything looks in order." Then he stares down at the floor.

Grabbing the paper from his hand, I scan it quickly. It looks correct to me, too. My heart sinks to the pit of my stomach. I am about to burst into hysterical tears and run from the room, never

to show my face in Paris again. Looking at Frederic's magnificent still life on the easel, I can easily picture Amélie sitting there copying it. Soon it will hang in some museum. The nude on the wall makes my stomach churn. I picture Lamar ogling me whenever he chooses. My eyes mist up. I am about to collapse. Then I stop, straighten up, and look at Amélie. Then look back at the paper, and study it a second time.

"This woman has forged Frederic's signature on the bill of sale, Paul," I accuse her. "Just as she has on the canvases she's copied. Come over here and take a look."

Hesitantly, he comes by my side. I point to the signature on the bill of sale and then to the canvas on the easel. "Look at them! They're different!" I charge him.

His eyes widen as he compares the signatures.

"The signature on this bill of sale is identical to the signature on the paintings hanging in *Musée Fabre*," I tell him. "Not only that, the signature on the nude painting of me in the *Musée* is forged. She signed those paintings! Frederic never signed the original nude because he intended it only for my eyes. Look at it up there on the wall! See for yourself! Amélie made a huge mistake when she forged the one in *Montpellier*. Look at Frederic's still life here on the easel," I urge him again, "see how different his real signature is from the one on the bill of sale."

Amélie springs from her place behind the desk and rushes at Durand-Ruel. "I did it for him," she cries, pointing to Lamar. "I didn't know he was selling the copies. He said he was selling the originals so we would have enough money to live on. He told me it was a good way to keep the images and let me amuse myself while he was out of the apartment. I didn't know what he was doing with the paintings—I did it to please him."

I stare at Lamar. Durand-Ruel turns to stare at him, too. Lamar's arms hang loosely at his side and he is hunched over, deflated.

"*Monsieur* Legrand, how did you come into possession of these paintings?" Paul demands.

I don't bother waiting for Lamar to answer. "I saw him outside the studio the day I went there when it was locked after Frederic enlisted. When I went back, after Renoir had taken his painting away, the studio was stripped empty. I think Renoir will tell you he forgot to lock the door when he left."

Lamar stares at the floor, silent.

"You're a crook just like your father." Turning back to Amélie, I tell her, "You need to go to your mother and beg forgiveness for all your bad deeds."

Paul folds the bill of sale and puts it in his pocket. "Do not touch any of these paintings," he warns Lamar. "I will send *Gendarmes* to take them away and keep them secure. We will inform them immediately of your illegal activity, so do not try to cover up your thievery before they arrive. Come, Emma, we go to call them now."

EPILOGUE

Fall 1911

FROM THE TOWNHOUSE window the view is dismal, matching my *ennui*. The sky is dark gray from horizon to horizon, with dense, rain-laden clouds lined up one behind the next, marching down on Paris from the North Sea. Accompanied by strong winds and a falling thermometer, the weather promises the imminent invasion of winter ahead. To make my mood worse, the noxious odors of automobile exhausts, and the sounds of honking horns, drift over the garden wall and seep through my window, upsetting the peace of my private sanctuary.

Sighing, and giving myself up to another dreary day, I go down to Lucien's library, where a footman has laid a warming fire in the marble fireplace. After perusing a few pieces of mail that have arrived during the morning, I toss them aside. Then I turn to an old book by Edmund and Jules de Goncourt on 18th Century French artists. It's a classic—I've read it at least twice before.

Within a matter of minutes, the library door bursts open, shatters my peace, and Philippe rushes in. "*Maman*, I have some wonderful news," he says rushing to my side. "I've just received a cable from Clarise in Chicago."

The first good news of the morning lifts my spirits. "Well? Don't make me guess. What does she say?"

"She says the Art Institute is excited about hosting an exhibition of the Maître Foundation's collection of Impressionist art next spring. Clarise and I are to finalize the arrangements, and Paul Durand-Ruel will write a contribution to the catalog."

"Wonderful news indeed, Philippe! You and Clarise have put a lot of effort into bringing a major United States exhibition together. Finally, you've done it."

He pauses to gauge my mood. "She wants both of us to attend the opening," he tells me in a tentative voice.

"Oh?" The gloom of the day is dissipated by the thought of seeing Clarise again after so many years of separation. But I'm ambivalent. She left Paris right after her graduation from *Université* to study art history in America and has not returned home since. I know she's led a wonderful life there, but I can't help being saddened by her long absence. "That's wonderful," I tell my son, "but," after further thought, I add, "perhaps I'm getting too old to travel."

"Oh, no, *Maman*. I'll travel with you and make sure you're comfortable. We can easily afford a long American visit. I'll take care of the arrangements."

I smile. My son has never been a very responsible young man. He manages the Foundation's business, which doesn't take much effort, and he still consults with me on all major decisions. The Foundation provides him with adequate free time and a generous amount of money for his amusements.

"Certainly, Philippe," I answer him. "Let Clarise know we're excited about coming over. You take care of the details. I'll talk to Paul about writing a piece for the catalog—I'm sure he'll provide a good critique." Stopping for just a moment, I add, "While you're being so busy this morning, perhaps you can get someone to close off *rue Poussin* so we don't have to choke on

the exhaust fumes from all the autos coming down the street, or listen to their blaring horns."

"Oh, *Maman*, Times have changed. You have to learn to adapt."

When he has left me alone again, I settle back in the comfortable leather armchair and pour myself a cup of tea from the *Limoges* teapot *Madame* Crystalle left to me. It brings back memories of my happy visits to her parlor in *Trouville* and I can't help but think how much I miss her. Then my thoughts drift to Clarise again. A grown, successful woman now, in my mind she's still Grace's daughter, the beautiful young girl I raised.

I bought her a bicycle for her eleventh birthday, and soon after that bought one for myself because it looked like so much fun. With help from one of the footmen, and despite the great protestations of Pauline Allard, we both learned to ride. One beautiful late spring day, I asked the butler to arrange a picnic lunch for us and deliver it to the twin lakes area in the *Bois de Boulogne*. Then Clarise and I mounted our bicycles and peddled off down the sleepy, almost empty *rue de Poussin*, crossing into the *Bois* along an old path leading to the lakes. We left the bicycles and walked hand in hand down the gentle slope near the water's edge, where we spread a blanket on the grass to sit.

In a short time, our two footmen appeared over the rise behind us carrying all the food for the picnic, as well as a table and two beautiful chairs. They set the table with china, glasses, and silverware, much to my dismay.

"Oh my goodness," I exclaimed as they began to open the baskets, "all I wanted was some cheese, a *baguette* and some wine to eat and sip here by the lake. What have you brought?"

The footmen both smiled. "The cook never would have agreed to that, *Madame*," one of them said, "and the butler insisted on the table so you didn't have to sit on the ground."

"What has cook sent for our picnic then?"

The taller of the two footmen put a large basket on the table and removed the cloth spread over the top. "Let me see, *Madame*." He peered into the basket in an overly theatrical gesture. "We have a bacon and leek *quiche*, a *haricot vert* and tomato salad with herbs of *Provence*, and a cherry *clafoutis* for dessert."

Clarise jumped up, clapping her hands in joy. "My favorite," she said in a gleeful voice.

"There is also a carafe of *rosé* here for you, *Madame*," the tall footman continued when Clarise's excitement died down, "and some flavored water for the young *mademoiselle*."

When all was in order, the footmen disappeared. Clarise rushed to the table, hardly waiting for her auntie to join her before taking a bite of the clafoutis.

"That should wait," I remember scolding her. "Let's try to act like ladies, shall we?"

Clarise gave me a sour look.

We ate with only a minimum of conversation, but when we were finished, I took my glass of *rosé* and signaled Clarise to join me on the blanket again. "There is something I want to talk to you about, *ma précieuse fille*," I began.

She gave me a bored, impatient look. "Am I in trouble again?" She asked.

"Not at all, but it is a difficult conversation for me to have with you," I told her. "I'll come right to it, Clarise. I have enrolled you in a private school for girls starting in a week. A footman will take you each morning and bring you home in the evening, but during the day you will have classes in the school."

The crestfallen look that came over her face turned quickly to defiance. "I won't go!" She snapped, her voice rising an octave.

Calmly, I gave her an imperious smile. "You will, my dear,

and it will be for your own good."

"Why can't I continue with my tutor at the townhouse?"

"For several reasons." I reached across the blanket to take her hand and reassure her as I talked. "You are a very bright girl, you know. I want you to have the best possible education. Philippe, too, when he's old enough. The sisters at the school and the other girls will challenge you to learn much more than your tutor can. And there is another equally important reason I have decided to enroll you."

She looked at me, and seeing my firmly set face, sat with her hands folded in her lap waiting.

I took a sip of wine. "It is important for you to meet other girls your age. Some will become lifelong friends, and some you may not like at all, but you must learn to become part of a group with them. I never had friends growing up. I was always alone and I didn't know how to get along with others. I don't want that for you."

"What will the other girls be like, do you think? Like me?"

"Not all of them. One of the things you need to learn is that not every young girl has the privileged life you do. I've selected a school that tries to educate workingclass girls. I am contributing scholarships in your mother's name so the sisters can afford to educate girls from workingclass families each year. It's important that all girls have a chance for better lives. Your mother never did. She was an intelligent, loving woman—you are like her in that. She should have had a better life, but never had the chance." I paused to regain my composure as tears formed.

"Are you crying, Auntie?" Clarise scooted closer. "Don't cry, please." She put her arms around my neck.

"It's all right. Whenever I think of your mother I get sad, so sad she had such a hard life when she could have had so much more. I miss her so."

"Can we still ride bikes and eat cherry *clafoutis* together?"

"Of course!" I laughed.

"I'll come back after I'm finished with school and live with you again, right?"

"By then you may want to go further with your education, perhaps to *Université*. Perhaps even in the United States where I came from a long time ago."

The next morning, I dress and call for the carriage to take me to Paul Durand-Ruel's gallery on *rue Le Peletier*. He is well on in years now, and a very distinguished looking gentleman. His snow-white hair is receding, matching his pencil-thin mustache and eyebrows. His sons manage his galleries in London, New York, and Berlin, but he comes to *rue Le Peletier* every day to keep abreast of the art world, and perhaps to reflect on the contributions he made to the popularity of the Impressionist artists. He greets me like an old friend, as well as one of his best customers. We embrace, and he takes my hand as we walk back to his private office.

"I know why you're here," he says, with a broad smile on his wrinkled face, when we sit in his comfortable chairs with cups in hand. "Your son barged in here yesterday to tell me about the exhibition in Chicago. It's a capital idea for the Foundation, and, I hope, a good opportunity for increasing our sales in America."

"You saw the opportunity before the rest of us, Paul," I tell him, sipping the hot tea cautiously. "I'm sure your investments have paid off handsomely."

"Slowly but surely," he responds, "but you are wrong about my intuition of the Impressionist movement. Lucien saw it first—he convinced me to invest in the paintings of those unknown artists to help them stay afloat until the public caught on. Quietly, he did the same." Paul stops talking and reaches out to gently

squeeze my hand again. "I miss him so much even now. He was my comrade in arms back in the day."

"And I miss him, too," I respond. "It was the best years of my life with him. Not a day passes that I don't dream of him by my side."

"He left us too soon."

"*Oui*. The heart trouble came so unexpectedly. Philippe was only five when he died. He wasn't the first to go, but after his death the movement began to break apart, didn't it?"

"You are right. Monet hardly ever leaves *Giverny* and he is one of the few still here. I hear he has lost his beloved Alice and is deeply bereaved."

"So sad. Manet and my dear friend, Berthe Morisot and her husband are gone, too. Degas has become a recluse, and Renoir has fled to the south."

"Renoir was Julie Manet's guardian, but the Dreyfus Affair alienated both of them from many of the others."

"Lucien was Jewish, you know," I tell Paul. "I'm glad he never saw his name dragged through the mud when that horrid man, Drumont, named him in his wrathful book." I stop talking to clear the memory.

Paul tries to put a cap on our sad musings. "We will always be embarrassed by the anti-Semitic streak that darkens our history. But enough! What is it I can do to help the exhibition in Chicago?"

"I'm sure Philippe has asked you about contributing to the exhibition's catalog."

"Indeed. And I'm most happy to do it."

"I'd like you to review the art we will be sending over to America with Philippe, and recommend any important paintings you feel we have missed."

"Again, it's my pleasure to loan any addition masterpieces necessary to round out the exhibition. You have done a fine job of adding to the collection since Lucien's passing. Will you also include the newer works of Cézanne, Gauguin, Seurat and Matisse to the exhibit? On that subject, too, may I ask if you will include Frederic Bazille's nude painting?"

"*Mais bien sûr.*"

"A beautiful painting. I am so pleased you've agreed to share it."

His comment gives me a jolt that vibrates throughout my body, even so long since that day in Frederic's studio. I take a moment for another sip of tea, holding my cup near my face while the memory of my struggle over the decision to take Clarise to the *Musée du Luxembourg* where my nude painting was on display when she was just blossoming into a young woman, "This is a portrait of me shortly after I came to Paris as a young girl—younger than you are now," I told her as she stared up at it, showing her embarrassment.

She gasped. "You? How could you?"

"I loved the artist very much, *chére*. I trusted him and, more importantly, I trusted myself. I was not afraid to be naked in front of him. I want you to have that same kind of confidence in yourself, Clarise."

"Did you...?"

"This isn't about me, it's about you learning to trust yourself. A long time ago an Indian woman taught me to listen to my instincts. Just remember to listen to yours as you go through life."

A couple of weeks before the Christmas holidays, I receive a note from Sarah Bernhardt telling me she has returned to Paris from her tour of America and wants to have lunch with me. Immediately, I respond, inviting her to join me in the townhouse.

"*Ma chère, nous avons été trop longtemps à part,*" she greets me when I welcome her at the door a few days later. We exchange hugs and kisses, and then I lead her to Lucien's gallery where the butler has set up a small table for us.

"I hardly ever use our dining room anymore," I tell her. "It's too big for just the two of us. You're right, it has been far too long since we were together. I've followed your world tours through the newspapers. I'm glad you thought of me when you returned to Paris."

"I've thought about you often, *cherie*. I knew when first we met we were kindred spirits. But look at you now! Living in this exquisite mansion, surrounded by some of the world's great art. What a fine journey your life has taken you on."

"Lucien assembled some of these masterpieces before I met him. And we added to them together. I enjoy eating in here whenever I can, as you say, surrounded by some of the world's greatest art, and thinking of him."

"You miss him?"

"Indeed I do. At first, my grief was almost unbearable, now, with time, it has mellowed."

"And you never took another lover."

I look at her with a noncommittal expression before answering. "I don't talk about lovers the way you do, Sarah, but as you can guess, I have been courted by a number of eligible men. I think Edgar Degas was very attracted to me, but he could never give up his bachelorhood."

"The evening of Degas's exhibition at the opera I noticed how he looked at you. But what man could give you anything you don't already have? As I remember, there was also a strange young woman eyeing you that evening."

"*Oui,* Amélie. She was Lamar Legrand's mistress it turns out.

He seduced her into making forged copies of works of art so he could sell them without telling her what he was doing. He was living off of her talents. I found him out and put a stop to his thievery. When Amélie found out he was using her she was so mad she could have killed him. But in the end it turned out it was *Madame* Crystalle, her mother, who shot Lamar dead and was arrested for it."

"How awful!"

"She had good reasons, and knew she didn't have long to live anyway. Lucien spoke to the authorities and pulled some strings for her to serve out her sentence as a prisoner here in the townhouse. What a blessing for me! She and Pauline Allard became good friends, and they both took care of me. They're gone now and I miss them terribly."

I stop talking when the footmen bring in our luncheon plates and pour a light *Provencal rosé* to accompany it.

"As I recall, Lamar Legrand could not take his eyes off you that first night we met at the old opera house, " Sarah continues when the footman has left the room. "It was as if he was bedding you right there in his mind."

"He was a dog! He seduced me, too. Perhaps I was too young to understand back then. I did learn later what a fraud he was. But look at you! You are still going strong, Sarah," I tell her, moving the conversation on. "Surely by now you could retire very comfortably, with any lover you desired."

"Once I was the *belle* of Paris, then the Dreyfus Affair marked me as the most hated Jewess in France. That's changed some now, but still, many Parisians mock me."

"But you were on the right side, along with Zola, it turned out."

"The theatre is my life, Emma, not the money and not the men," she tells me candidly as we finish eating. "I've had plenty

of both—and lost plenty of both, too—but I could not quit the theatre, so on I go. Energy creates energy, it's by spending myself that I become rich. But *ma bonne ami*, look what we have achieved—you and me—by not following the rules the men in our world set out for us! We refused to be restricted."

"I never could have dreamed how my life has turned out, *ma chère*. I never asked for riches, my life in art was all I ever wanted. Will you continue traveling and acting?"

Sarah talks about her adventures acting in theatres on three continents during her world tours as we sip the wine. Casually, she also mentions the lovers she had accumulated in her travels.

"My son and I will travel to America next spring," I gently interrupted her. "Clarise—the girl I raised from a small child—is now a curator at the Art Institute of Chicago. She has arranged for Philippe and me to attend an exhibition of our Impressionist collection of masterpieces next May. She is my daughter I adopted when my poor friend Grace died."

"I adore Chicago. It is the pulse of America. I'm sure you will enjoy being there." She stops for a moment, as if she's remembering her stage successes there, or perhaps a lover. "I have an idea," she tells me. "I will arrange for you to have the private railcars I used on my last American tour. Then you and your son can travel across the continent for as long as you like."

We all endure a cold and wet winter as the New Year begins, but it isn't as bad as the winter of 1910 when the *Seine* overwhelmed its banks and swamped much of Paris. An early spring follows, and our trip to America becomes more of a reality to me than it had been back in the fall. I began looking forward to seeing Clarise again, picturing in my mind how she would look after

so many years apart. Philippe has been thorough in making our travel plans, and before I know it, we are getting on the train at *Gare Saint-Lazare* for *Cherbourg*, where we'll catch the steamer.

"We have the best accommodations money can buy on the ship, and when we board the train in New York City we'll be riding in the private cars Sarah Bernhardt arranged for us. When we get to Chicago, we'll stay in the Palmer House Hotel in their finest suite. All befitting you, *Maman*, as the head of the Lucien Maître Fine Art Foundation."

As the train races across *Normandie*, my thoughts drift back to my first steamship voyage with Lucinda. Silently I say a prayer for her. I'll breath easier, once in New York, knowing I am that much closer to Clarise.

"Philippe," I start, breaking into our silence as the landscape flies by, "after we are finished with the exhibition opening in Chicago I would like to see more of America. Perhaps go all the way on to San Francisco and then down the coast to Point Conception. It's been a long time—a very long time—since I saw my papa's grave."

He clears his throat and gives me a look that brings back a memory of when he was a young boy, about to ask for something he wanted desperately for me to buy him. "*Maman*, I have something to tell you." He starts and then waits, but when he sees I am listening, he takes a breath and continues. "I am not going back to France after the exhibition. I plan to stay in America. I've asked Clarise to see if there might be any position for me at the Art Institute."

I feel as if I had taken a blow to my chest. It's hard to take a breath. First Clarise, now my only son. Will I lose him too? "Why Philippe? Why move to America when you have a fine life in Paris with me? You have everything you could ever want for."

"I know," he answers slowly, looking out the window at the scene rushing by. "And I love you so much for all that you've done for me. But the truth is I don't want to live in France anymore. Just look around, *Maman*! Can't you see everything is changing? War clouds are gathering. Trouble is brewing all over Europe. Sooner or later I'm afraid there's going to be a war. The French are looking for revenge for our shameful defeat in 1871. The Germans want a victory. I don't want to fight in that war. I don't want to be a soldier."

We spend the rest of our train ride in silence. When the train stops in *Cherbourg*, Philippe finds a porter with a hand wagon to take our trunks to the ship. Together, still in shock, we make the short walk from the station to the *Quai Caligny* through a drizzling, dense fog. Arriving there I stop short, trying to peer out through the thickness, and then grab his arm. "There's no ship here! Where is it?"

"Don't worry, *Maman*, the *Quai* to too small for the steamer to dock here. She's out in the harbor. A tender will take the other passengers and us out to her. You will be amazed at how beautiful she is."

Our luggage is loaded into one tender and, after about an hour's wait, we are helped down into seats in another. We sit side-by-side, alone with our thoughts, edging cautiously through the fog, slowly making our way out into the harbor. I am still distracted, worrying about losing my son to America. For long minutes I try to penetrate the gloom for a sighting of our ship. But my mind is racing, trying to understand Philippe's decision to leave me. It is breaking my heart. Every man I've ever loved has left me. Now it's his turn. Finally, barely visible through the fog I can see the outline of a large ocean liner. Getting closer, I can read the name on the ship's stern. *RMS Titanic*.

On the night of April 10, *RMS Titanic,* the largest ship afloat, an unsinkable luxury trans-Atlantic steamship with 2,224 souls aboard, but lifeboat capacity for just 1,187, strikes a massive iceberg in the North Atlantic Ocean. It disappears beneath the frigid waves several hours later.

I am rescued by *RMS Carpathia* and delivered to New York three days later. I wait for over a week before I am finally reunited with my lovely Clarise, Grace's daughter, who comes from Chicago to rescue me. Philippe's body is never recovered.

The End

Author's Note

The Girl From The Lighthouse is a work of entertainment and should be read as nothing more. The names, characters, places, and incidents portrayed in the story are the products of the author's imagination or have been used fictitiously. Any resemblance to actual persons, living or dead, businesses, companies or locals, is entirely coincidental.

The inspiration for this novel came when I stood in a gallery of the Santa Barbara Museum of Art, staring at a magnificent canvas painted by Berthe Morisot. Called *View of Paris from the Trocadero*, it shows two women with a small child standing on the hill of Chaillot looking across the Seine River to the Champ de Mars and the city of Paris in the far background. A rough wood fence runs diagonally across the painting, as a barrier preventing the women from going forward. To me it symbolized the man-made barriers preventing Victorian Age women from moving forward to gain equal status in a male-dominated world.

I have tried to create the French world of the Impressionist artists as accurately as research allows. I do confess, however, to altering some dates to suit my story, for example, the year when an Impressionist masterpiece was painted. The Impressionist artists moved about regularly during the period, especially during

the Franco-Prussian War and Commune uprising. Not all their travels have been documented. Again, the story ruled when I had to decide where a particular artist might have been at a specific time. However, Renoir's near brush with death is factual.

The Point Conception Lighthouse was one of the first lighthouses the United States Government built along the West Coast, following the end of the Mexican War. First lighted in 1856, it originally stood high on the point of land at the northern entrance to the Santa Barbara Channel, a dangerous stretch of water where the California coastline turns from a north/south direction to run east/west for about 100 miles. It is a ruggedly beautiful place, almost inaccessible at the time it was built. There were no nearby towns; supplies had to come from Santa Barbara, a full day's wagon ride east, much of it along the beach at low tide.

So high above the water, it was poorly sited. The light beaming from its large Fresnel lens flashed high above the fog banks that regularly rolled in low on the water so that ships, like the Vigilant, failed to be warned of the treacherous rocks just offshore. That problem wasn't corrected until the 1870s, when the lighthouse, and its French-made lens, were moved to a lower spot nearer the water.

In any case, the desolate lighthouse on California's rugged coast was no place to prepare a young girl to take her place in the Victorian world of the second half of the 19th century.

The Point Conception Lighthouse was not the only thing that needed rebuilding. The Paris we know and love today is a much-gentrified version of the city Emma Dobbins found when she arrived in 1869. When Louis Napoleon, then President of France's Second Republic, proclaimed himself Emperor of France's Second Empire in 1852, he ruled a dirty, smelly, slum-infested city. Dreaming of surpassing London as Europe's foremost city,

Napoleon III named Georges-Eugene Haussmann, as Prefect of the Seine, and empowered him to rebuild Paris as a modern city, with no expense spared. Baron Haussmann created a new Paris with wide, tree-lined boulevards, handsome five and six-story stone buildings, a more secure water supply, and functioning sewer system. It took more than a decade to accomplish this, and in the process Haussmann tore down the homes of the poor workingclasses in the city's midsection, forcing them to move to the outlying neighborhoods.

France had been at the pinnacle of European power for hundreds of years, despite the recent setback Louis Napoleon's uncle, Napoleon I, experienced at Waterloo. Trying to recapture some of his uncle's glory days for himself, Louis Napoleon declared war on Prussia in the summer of 1870. It was a serious mistake. Almost before fighting, began he was captured at the Battle of Sedan, not far from the Rhine River, and exiled to England. Prussian forces quickly encircled Paris and week-by-week tightened their stranglehold on the city. Cats, dogs, zoo animals, not to mention the sewer rats, were slaughtered to keep Parisians from starving, as the Prussians waited patiently for the new Third French Republic to surrender. In the meaningless, fighting that took place in Burgundy, south of Paris, Frederic Bazille, one of the brightest rising artists of the Impressionist art movement, who had enlisted to fight for France, was shot and killed by Prussian soldiers. His father had to come up from the south of France to rescue his body.

The government of the Third Republic finally signed a disgraceful surrender treaty with the Prussians that cost France five billion francs in reparations and led to more bloodshed.

The poor workingmen and their families who had been ejected from their homes by Baron Haussmann, and shunted to

the outer precincts of Paris, joined with the enraged National Guard that had been disgraced by the surrender terms, to form the Paris Commune, and started a rebellion against the government. Estimates vary, but at least 20,000 Frenchmen died in the Commune uprising. Louise Michel, a former schoolteacher turned fiery anarchist, fought side by side with the men. When the last twenty-two rebels were shot against a wall in Père-Lachaise cemetery and fell into their communal grave, she was convicted of treason and exiled to New Caledonia in the South Pacific Ocean along with other Commune agitators. Freed many years later, she returned to Paris and resumed her anarchist ways. She was jailed several more times.

In a surprisingly short time, the reparations were paid to the Prussians. Paris in the 1870s recovered quickly from a bombed and burned-out city to blossom into the Belle Èpoque—The Beautiful Time—that continued until The Great War began in 1914. Young artists, many of whom had fled Paris to escape the fighting, returned to lead Parisians into a new fine art consciousness that embraced modern life called Impressionism.

All the artists mentioned in the story were real men and women; the only exception is Emma, who is wholly a character of my imagination. I have tried to portray these Impressionists accurately based on available research, but take full responsibility for their depictions. Likewise, the artwork mentioned in the text. Impressionist as well as French 17th and 18th-century art is real and can be seen in numerous museums and galleries on both continents, and especially in the Louvre Museum and the Musée d'Orsay that face each other across the Seine in Paris. Some names have become household words in the twenty-first century, but other, lesser-remembered names are also worthy of our admiration.

Paul Durand-Ruel was one of the first art dealers in Paris. He was an early advocate for the Impressionists. He bought their paintings directly from the artists and kept careful records of those purchases so his buyers could have confidence the paintings he sold were authentic. Often though, it might be "buyer beware" if artworks changed hands on the open market. Copies and forgeries were not uncommon.

The treatment of women was considerably different in the last quarter of the nineteenth century than it is today. Frenchmen did not expect their women to work outside the home. There were very few paying jobs for women, working in laundries and making paper flowers were two of the most common, and only employed the very lowest workingclass women. Theater entertainers were never accepted in Parisian society. All women were treated with the utmost courtesy and respect, but they were also raised to accept their place in Victorian society. They were scorned if seen on the streets or in the public areas of Paris alone; etiquette required older women *chaperones* or men accompany them. To do otherwise was to invite scandal. For example, Emma was not allowed to ride the upper level of an omnibus because it was thought to be unseemly for a woman to be seen climbing the ladder, presumably because men might look at her legs as she climbed. Instead, she had to wait for another omnibus to come along that had available seats inside.

Workingclass women could also earn income as street whores, but they had no legal standing or security. Some of them might aspire to employment at bordellos, which gave them some protection, or, if they were very good at their craft, as kept mistresses. Only the highest level of courtesans could control their destinies. French women, in general, were subservient to their fathers, husbands or lovers. No one had ever taught Emma these rules of polite society.

Acknowledgments

Writing *The Girl From The Lighthouse* was a joy for me. It included hours of research into French and art history, and days of walking the streets of Paris, and visiting the city's hallowed art museums with Jo, my muse, editor, strongest critic and greatest fan, who is also my wife and soul mate. Without her, none of my writings would ever have seen the light of day.

Also, I owe a debt of thanks to people who have given generously of their time and talent in bringing the story to life, especially Gwen Gades, interior designer for her patience, world-class first readers Dinah Baumgartner, Nancy Reed, Tami Thompson and James Pattillo, an accomplished author in his own right. Moreover, another big Thank You to people too numerous to name here—you know who you are—who have contributed to the development of the story.

Much research in the 21st century can be done on-line. The Internet articles I consulted fill two large binders.

For readers who want to learn more about the Impressionist artists and the history of Paris in the *Belle Èpoque* of the last quarter of the nineteenth century, I offer here some books that contributed significantly to my setting for my novel. Not a complete bibliography for sure, but an excellent way to

learn more.

First, two DVDs that should be on everyone's list: *"From Monet to Van Gogh: A History of Impressionism"* by Professor Richard Bretell, produced by The Great Courses, Chantilly, VA. Second, *"The Impressionists,"* A BBC Production on DVD.

For a general history of Paris: *"Seven Ages of Paris"* by Alistair Horne, Vintage Books, a Division of Random House Inc.

For the rebuilding of Paris in the 1860s: *Napoleon III and the Rebuilding of Paris,"* by David H. Pinkney, Princeton University Press. Hard to find but worth the search.

For the history of France in the *Belle Èpoque*: *"France Fin de Siécle"* by Eugen Weber, The Belknap Press of Harvard University Press.

For the history of Paris in the *Belle Èpoque* and the major celebs of the time: *"Dawn of the Belle Epoque,"* by Mary McAuliffe. A great read that included much detail about the men and women of the era.

For the History of French art in the last half of the 19th Century: *"The Judgment of Paris"* by Ross King. Bloomsbury.

For biographies of the Impressionist artists: *"The Private Lives of the Impressionists,"* by Sue Roe. Harper Perennial.

For commentaries on the status of women: *"Disruptive Acts: The New Woman in Fin-de-Siécle France,"* by Mary Louise Roberts, The University of Chicago Press. A good biography of Sarah Bernhardt, and a lot more.

And a brand new book about Sarah Bernhardt: *"Playing to the Gods,"* by Peter Rader. Simon & Schuster.